A JAR OF WILD FLOWERS

A JAR OF WILD FLOWERS

ESSAYS IN CELEBRATION OF JOHN BERGER

EDITED BY YASMIN GUNARATNAM
WITH AMARJIT CHANDAN

BLOOMSBURY VISUAL ARTS
LONDON · NEW YORK · OXFORD · NEW DELHI · SYDNEY

BLOOMSBURY VISUAL ARTS
Bloomsbury Publishing Plc
50 Bedford Square, London, WC1B 3DP, UK
1385 Broadway, New York, NY 10018, USA
29 Earlsfort Terrace, Dublin 2, Ireland

BLOOMSBURY, BLOOMSBURY VISUAL ARTS and the Diana logo
are trademarks of Bloomsbury Publishing Plc

First published in Great Britain by Zed Books 2016
This edition published by Bloomsbury Visual Arts 2023

Copyright © Yasmin Gunaratnam and Amarjit Chandan, 2023

Cover design: Michael Oswell
Cover illustration © Melina Berger

A catalogue record for this book is available from the British Library.

LC record available at http://lccn.loc.gov/2015040645

ISBN: HB: 978-1-78360-880-5
PB: 978-1-35042-925-3
ePDF: 978-1-78360-881-2
eBook: 978-1-78360-882-9

Typeset by Jones Ltd, London
Printed and bound in Great Britain

To find out more about our authors and books visit
www.bloomsbury.com and sign up for our newsletters.

For all exiles.
Welcome.

CONTENTS

List of figures xi

Acknowledgements xiii

Foreword – Jean Mohr xv

Preface – Amarjit Chandan xix

INTRODUCTION
– YASMIN GUNARATNAM 1

THE COLOUR OF THE COSMOS 19

Graphite – Hans Jürgen Balmes 21

Hay – Rema Hammami and John Berger 30

Fire – Kathryn Yusoff 42

Milk – Ana Amália Alves 52

Blood – Gavin Francis 61

Forest – Nikos Papastergiadis 71

Toast – Michael Broughton 85

Oil – Tessa McWatt 90

THE TREES ARE IN THEIR PLACE 103

Fences – Nick Thorpe 105

Method – Iain Chambers 118

Life – Glenn Jordon 131

Meetings – Nirmal Puwar 142

Pain – Francisco-J. Hernández Adrián 154

Secrets – Hsiao-Hung Pai 171

ONCE THROUGH A LENS **183**

Memory – Heather Vrana 185

Stars – Vikki Bell 200

Conscience – Ram Rahman 217

Performance – Doa Aly 222

A Mirror – Rashmi Duraiswamy 235

UNDEFEATED DESPAIR **249**

Trauma – Alicia Salomone 251

Jest – Salima Hashmi 264

Hate – Mustafa Dikeç 270

Hope – Malathi de Alwis 285

Spirit – Tania Tamari Nasir 297

Propaganda – Rochelle Simmons 307

HERE IS WHERE WE MEET **321**

Notes – Amarjit Chandan 323

Verbs – Ali Smith 329

Play – N. Rajyalakshmi interviews 338
 Pushpamala N.

Tenderness – Christina Linardaki 346

Love – Julie Christie 356
Courage – Yahia Yakhlef 358
Solidarity – Ambalavaner Sivanandan 365
Tennis – John Christie 370

AFTERWORD – SALLY POTTER **379**

About the editor and contributors *387*

LIST OF FIGURES

The editors and publishers thank the copyright holders for their permission to reproduce the images used in this book.

1 John Berger, 1980, looking at Jean Mohr's photographs with him to make a selection for the book *Another Way of Telling*, Jean Mohr

2 John Berger, 1967, Jean Mohr

3 *From Titian*, John Berger, 1996

4 *Studio Interior I*, 2011, courtesy of Art Space Gallery London, Michael Richardson Contemporary Art

5 Abdelateef Mohamed Bashir at home in Cardiff, March 2012, Glenn Jordan

6 Funeral of Abdelateef Mohamed Bashir, Cardiff, June 2012, Glenn Jordan

7 *Comrade*, 2015, Salah Suliman Bakheit

8 A mural on the CUNOC campus of the University of San Carlos, CPR Urbana BlogSpot

9 Oliverio speaking while joined by other FRENTE members, Mauro Calanchina

10 Santiago Cemetery, Vikki Bell

11 Delhi, 1984 in Kayanpuri, sector 13, Ram Rahman

12 Funeral of Safdar Hashmi, January 1989, Ram Rahman

13 Salim Sandhi, Ahmedabad, in the room where his son was killed, 2012, Ram Rahman

14 N. Rajyalakshmi interviewing the artist Pushpamala N.

ACKNOWLEDGEMENTS

Our heartfelt thanks go to Yves Berger for his support throughout this project and to Melina Berger for the cover drawing. Melina made our jar of wild flowers when she was little. She must have had some inkling that it would be the perfect gift for her grandfather. We are grateful to Zac Gunaratnam-Bailey, Sukant Chandan, Navroz Chandan and Kavita Bhanot for editorial support and to Nirmal Puwar, who helped us to imagine and form the collection and commissioned some wonderful pieces. Pat Harper was a hawk-eyed copy-editor, and Ameer Ahmed and Bob Bailey provided speedy and attentive translations. Thank you. It's more than likely that without Dominic Fagan at Zed Books, this book would not have been published. Thanks to Kika Sroka-Miller and to all the team at Zed, who grasped both the idea and the spirit of the collection. The enthusiasm and generosity of the contributors kept us going throughout.

It goes without saying, but we say it anyway: John Berger, thank you for the wonder.

*

The editors and publisher would like to thank the following for permission to use copyright material:

FOREWORD

JEAN MOHR

I don't know how to describe John Berger: a writer, a poet, an essayist, a painter, a drama writer, a scriptwriter. For me it is all summed up in one word, FRIEND. He landed in my life more than forty years ago. I did not know of him and yet in London he had already smashed his way into the headlines. He had heard of me through a mutual friend, the cineaste Alain Tanner. Our first exchange was friendly and suffused with a very British restraint. 'You've just done a photo series on a doctor in the mines at Charleroi in Belgium commissioned by the World Health Organisation … I myself am planning a book on a GP in Gloucestershire in England. Might we perhaps look at a joint work with text and images?'

For my part there was no hint of hesitation. I tried hard not to let my enthusiasm show, even though the project was far from having a sound basis and there was little certainty of a reasonable return. There was the practical question 'Do we sign a contract?' 'No point in that, no paperwork. I suggest fifty/fifty, does that suit you?' I nodded enthusiastically and that was our only 'contract'.

The idea of writing about John Berger makes my head spin. I don't feel that is my role. I have taken hundreds of photos of

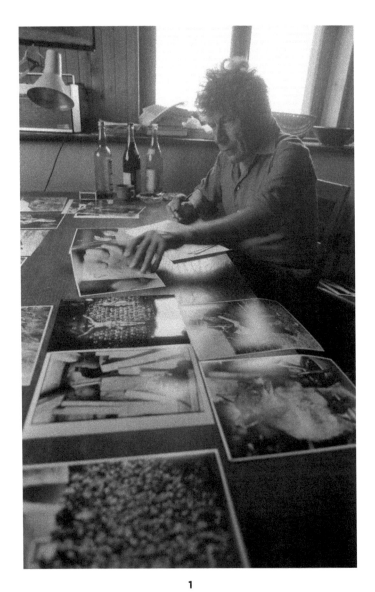

1

John Berger, 1980, looking at Jean Mohr's photographs with him to make
a selection for the book *Another Way of Telling*, photograph by Jean Mohr

him, without any specific purpose, in very different situations. It was a way of bearing witness to a man I love and admire deeply – so why try to add the load of words which I handle so incompetently?

About four years ago, we met up in London at the Royal College of Arts where we had both been invited to launch my book *At the Edge of the World*,[2] for which he had not only provided me with precious advice but had also contributed a generous Preface. We had before us a packed and supportive audience, students and teachers. At the end of the session I projected twenty or so portraits of John Berger and they received an enthusiastic response. The man was well known for his writings and for his disturbing TV appearances, but he had become something of a myth, a legend (his exile in a small Haute Savoie village), in short an abstraction. My series of often anecdotal portraits gave him back his human dimension.

Which is why I am going to revert to type here and confine myself to two pictures among the many hundreds of others with a minimum of explanation and commentary. Hoping to bring out the richness and the unity of this remarkable man over the period of several decades.

NOTES

This foreword was translated from the French by Bob Bailey.

[1] Berger, J. & Mohr, J. (1995) *Another Way of Telling*, New York: Vintage Books.
[2] Mohr, J. (1999) *At the Edge of the World*, London: Topographics.

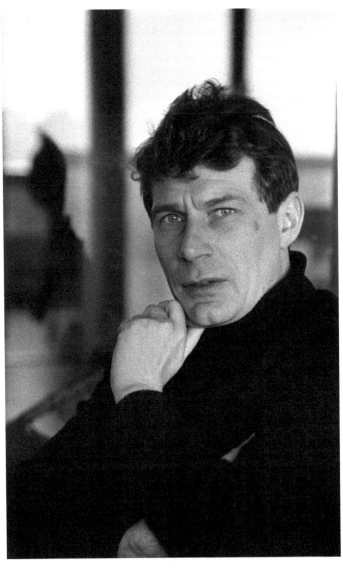

2

John Berger, 1967, photograph by Jean Mohr

PREFACE

THE MEANING
OF JOHN BERGER

AMARJIT CHANDAN

This commemorative volume *A Jar of Wild Flowers* is a small gesture of love and gratitude for John Berger on his 90th birthday. It is an effort to present something of Berger's 'marvellous and inspiring contributions over so many impressive years' (Noam Chomsky)[1] in the fields of art, literature and culture and, as important, activism.

He is *the* writer of our time. As a man and as a man of letters he is original, intense and profound. He wants to be known as a storyteller. His writing – both poetry and prose – is the compass that points to the place where the heart of the matter is. It speaks with you. He thinks with feeling, to use Brecht's expression. His writing is always an emotional journey both for him and the reader. Even his commas, his semicolons and his full stops are like stone engravings. There is something about Berger's voice too – it sounds so compelling, so intimate; like the touch.

There is a beautiful word in Sanskrit, *karuṇā*, meaning 'compassion'. This is the master key of Berger's oeuvre. This

further opens up three other central themes of his writing: home (destiny and return; multiple levels of displacement and rootedness, exile, refuge and the implied loss of language), love[2] (for humans, animals, things, surroundings) and resistance (against tyranny).

Berger has talked about the predicament of a *pardesi* – the Punjabi word for a foreigner – at length. There is no word in English which can convey the same pathos of being a foreigner (the being in/of/from the other country) in the eyes of the people left behind. Perhaps the word 'distant' commonly used in Punjabi folksongs is a bit close: 'You went to a distant land; and you became distant' – throughout history an international refugee, homeless, an outsider, an alien, a lonely man.

Every human is an island, and on that level we are on different planets speaking different languages – in the plain and metaphoric sense. Humanity is what connects readers with Berger. What is the source of his kind of humanity? Has it to do with something sacred in his writing? Once he remarked: 'two things have coexisted within me. On the one hand a kind of materialism, which includes the Marxist view of history ['Permanent Red'] and on the other a sense of the sacred [The Old Testament].' This he saw 'not as a duality, but an essential unity'.[3]

All writers deal with the abstract, and the absolute abstraction is none other than God, or you can call it by any other name. Maybe the 'Sky', as Berger has done in his several writings.

Poetry is basically about thinking with feeling, and prose without feeling would sound hollow. This negates the false dichotomy created between prose and poetry. They are the

same. Berger's each word, punctuation and pause written on the page is a testimony to that. It touches the absolute; almost.

Berger's writing has influenced and inspired a whole range of creative minds all over the world. His writing works like that. His close friend and collaborator Mike Dibb told me that once in the mid 1970s Berger's *New Society* essay about drawing his dead father inspired him to make a two-hour film 'Seeing through Drawing', still possibly the longest arts film BBC2 has ever shown.

There are many stories of how readers identify profoundly, body and soul, with Berger's storytelling, whether it is the description of the topography of Budapest or prisoners in Italy or a peasant in the Punjab leaving home for *vilāyat* – foreign land – across the proverbial seven seas, or more recently his discourse on particle physics in a film on the CERN laboratory in Geneva searching for that 'Goddamn particle'.[4] Do his readers find it liberating? Is the existential angst not further expanded with the extent of multiplied horizons? The answer is yes in both cases.

John Berger is our conscience keeper. In these days of growing turmoil and exploitation, he has turned to direct political writing 'with a greater sense of urgency'. Now Language has been trafficked and usurped – the corporate bourgeoisie have stolen it from humanity. Each word Berger writes is reclaimed from tyranny. He expresses his pain but without despair, and he asserts that there is spiritual value in it.[6] An 'I' is turned into 'We' – the personal sees the horizon of a collective.

When the book opens the Word is invoked. A poem titled '5 am' by Berger ends like this:

> When the book closes
> the pages learn
> and a pillow reads
> what is in our heads.[7]

Thank you, John. Thank you.

NOTES

[1] Personal communication, email from Noam Chomsky to the author, 11 August 2015.

[2] See Ali Smith, Verbs, this volume.

[3] Wroe, N. (2013) John Berger: A life in writing, *Guardian*, 23 April 2011, www.theguardian.com/culture/2011/apr/23/john-berger-life-in-writing

[4] *Art, Poetry and Particle Physics*, DVD, directed by Berger and K. McMullen (2005), UK: Arts Council England and University of the Arts London.

[5] Berger, J. (2007) *Hold Everything Dear: Dispatches on Survival and Resistance*, London: Verso.

[6] Berger, J. (2003) Written in the Night: The pain of living in the present world, *Le Monde Diplomatique*, 18 February 2003, http://mondediplo.com/2003/02/15pain

[7] Berger, J. (2014) 5am, *Collected Poems*, Middlesbrough: Smokestack Books, p. 127.

INTRODUCTION

LEARNING BY HEART[1]

YASMIN GUNARATNAM

'The line is never quite obedient. One has to nudge, cajole.'[2]
John Berger is in the belly of the Chauvet-Pont d'Arc cave
in the Ardèche valley, drawing with black ink on absorbent
Japanese paper. He's trying to recreate a little of the play-and-
tug felt by Palaeolithic artists some thirty thousand years ago
as they painted animals by torchlight, luring the cave walls into
their art. But wait. He's more than drawing. He's communing.
Squatting awestruck in front of an image of bears and ibex,
what does Berger see? His hearing, feeling, olfactory eyes
pick up on a conversation between his artist compatriot and
the rock: 'What the rock told him was that the animals – like
everything else that existed – were inside the rock, and that
he, with his red pigment on his finger, could persuade them to
come to the rock's surface, to brush against it and to stain it
with their smells.'[3]

It's Berger's way to take sensation and feeling as a starting
point. A line, if you like. And you never know where the line
might take you. As well as his drawings from Chauvet, there
were essays, a film with Pierre Oscar Lévy, *Dans le silence de*

la grotte Chauvet,[4] and a four-night performance *The Vertical Line* with Simon *McBurney's* Complicité – 'Part theatrical event, part archaeological dig'[5]– in a disused tube station in central London. The Chauvet work is just one incarnation of the formidable storyteller and bricoleur that is John Berger, springing ibex-like across materials, subjects, genres (see also 'Fire' by Kathryn Yusoff, this volume).

We have tried our best to capture something of Berger's spirit and range in these essays, written by artists, poets, scholars, activists and translators. In putting the collection together we also wanted to reach beyond what Nirmal Puwar (this volume) calls the 'European fraternity'. Several contributors are writing of and from settings outside Europe and North America, including Brazil, Chile, Egypt, Guatemala, India, Pakistan, Palestine and Sri Lanka. Many are working cross-culturally, and at the edges of genres and materials (prose, poetry, photography, fine art and film). This broad notion of the cross-cultural flows through the collection, registering another flavour of its 'wildness' in its postcolonial hues, its variety of voices, styles and moods.

A MAN OF INDECENT INTENSITY

Those familiar with Berger will already know why wild flowers are a fitting gift for this north-London-born organic intellectual and 'patriot of elsewhere'.[6] Berger's biography suggests an early restlessness, sustained efforts to shake off privilege and cultural capital, and a cosmopolitanism that would draw him to

outsiders and eventually away from England, and the English. 'So often I had a feeling when I was with people, when I spoke, that I embarrassed them,' he has said. 'I think they considered me indecently intense.'[7]

A love of art and the world of images began early. Berger says it flourished out of the loneliness of boarding school, where he was sent at the age of six. In an environment of hypermasculinity and militaristic rhythms, it's not hard to imagine that art was a refuge. 'By adolescence I was absolutely passionate about it and felt those paintings and those painters, whether they lived a few hundred years ago or were still alive, were somehow my companions.'[8] The 16-year-old Berger would turn his back on his north Oxford public school 'Teddies' (St Edward's) to enrol at the Central School of Art and Design in London. After two years of military service at a training camp, in 1946 he used a small grant for ex-servicemen to enrol at what is now the Chelsea College of Art and Design. During this time he also read more philosophy, including the work of Karl Marx. The next decade or so saw a drift from painting to writing, where he learned that he could enrich and delve into art without abandoning Marxism. Berger's friends and mentors then were refugee Jewish artists such as Ernst Fischer and Frederick Antal who showed how it was possible 'to survive and to create a life's work with a minimum of publicity, acclaim, or smart recognition'. As important for Berger, these men and women 'didn't give a fuck about the art market and its promoters'.[9]

In the late 1950s, when international movements for independence were sweeping colonialism away, austere, pallid

England was changing. But not enough to stem Berger's feeling that he needed to get away. In 1962, he headed to Europe, settling later near the French Alps in the hamlet of Quincy for a life among agricultural workers. 'I ran away from school when I was sixteen, and when I came here it was like arriving at a university. The old peasants, nearly all of whom have now died, were my teachers. From them, I learned about the trials by which peasants lived, not only here but all across the world.'[10] The old peasants and an old way of living with and from nature are recurring subjects in his writing, from the trilogy of novels *Into Their Labours*, to *A Seventh Man* and *Another Way of Telling* (see also Duraiswamy's essay 'A Mirror', this volume).

If the political cadences of Berger's understanding of art were the hallmark of his often controversial essays for the Fabian-inspired magazine the *New Statesman* (during 1951–1961), they appeared in their most popular version in the 1972 four-part BBC TV series (made with Mike Dibb) and accompanying book *Ways of Seeing*.[11]*Ways of Seeing* flung open the doors of art history to a bigger audience. Berger explained and showed beautifully, without too much jargon or pomp, how visual tropes shape and infuse social life. He denaturalised vision – 'A large part of seeing depends on habit and convention' (Episode 1) – and with the production team animated complex arguments through disarmingly simple techniques, such as placing the semiotics of the oil painting next to everyday publicity. 'Sometimes the visual correspondences are so close that it is possible to play a game of "Snap!".'[12] How better to show the conventions of the objectifying male gaze

than by juxtaposing European oil paintings with images from contemporary advertising, porn and girlie magazines?

In *Ways of Seeing*, attention was given to content as well as to different relationships to art (the spectator-buyer, the consumer-producer); most of all the programmes didn't bestow analysis from on high. The viewer was invited to come closer into the spaces of production and storytelling. For Tom Overton, Berger's most recent biographer, 'Berger and his collaborators' responses in *Ways of Seeing* reflect how the means of reproduction affect the majority of viewers … through Brechtian strategies of drawing attention to the studio, the camera, the cutting and the channel-hopping possibilities afforded by television.'[13]

With new technologies these strategies have been given another twist. Thanks to YouTube,[14] *Ways of Seeing* is winning over new generations of students of art, cultural studies, literature, media, and sociology. Over forty years since it was first broadcast, the connections Berger made between art and the cultural coding of everyday life continue to strike a chord, even when the scant attention to colonialism and racism in visual imagery is stark, troubling even (unwitting omission or complicity?). 'Art tells us as much about ourselves as it does about the world around us' is one YouTuber's summing-up. For others it is Berger's closing comments in Episode 1 that are especially intriguing and spooky. Ever reflexive, Berger encouraged viewers to question his interpretations. 'I hope you will consider what I arrange, but be sceptical of it.' For some, Berger foresaw the coming era of interactive technology

and YouTube. 'The images may be like words, but there is no dialogue yet,' Berger insisted, looking straight into the camera. 'You cannot reply to me. For that to become possible in the modern media of communication, access to television must be extended beyond its present narrow limits.' One commentator is emphatic: 'Berger predicts YouTube in 1972'.

The longing for dialogue is crucial for Berger, although not every story is an invitation into a conversation in any consistent sense. When he weighs into a topic, and with his most aphoristic writing, there are few breathing spaces. The writing bowls you over, carries you along. In a 1992 review of the collection *Keeping a Rendezvous*,[15] the literary scholar John Barrell talked of the Berger effect like this, 'The greater my disbelief, the more often it was suspended. For at his very best Berger can describe a painting, can evoke the aura emanating from the objects it represents, with such eloquence that he can inspire us, or me at least, with universal longings.'[16] Andy Merrifield has put this style down to the influence of George Orwell, whom Berger met when he was writing for the *New Statesman*. Merrifield describes how Berger 'asserted, sometimes at the gut or emotional level, and then proceeded to argue conceptually around that assertion, inside the assertion'.[17]

In Berger's later work, the assertions are often accompanied by a fantastical summoning up of associations, complicating a conventional history, chronology or map. 'Do I exaggerate?' he asks. 'Yes and No.'[18] Why the ambivalence? Because telling stories in this way is not so much a personal quirk. It's caught up with what Berger identified in *A Fortunate Man*[19] – a visual

ethnography of the life of an English General Practitioner – as impoverished cultural resources (discussed further in Gavin Francis's essay 'Blood', this volume). We lack words to name and make sense of what it is to live with injustice. And experience, especially for those living at times of social and political unrest, when anguish and grief are commonplace, can float away from, or exist tenuously in, ephemera (dreams, hearsay, fantasy, gossip).

To tell in such circumstances, a storyteller has to piece together a referent – the people or things represented by words and images – out of the real, the barely there, and what is imagined. She must 'make believe', the writer and sociologist Mariam Motamedi Fraser argues, because sometimes people and things do not want to, or cannot be told *of*, because '*of* is a place, a position, or a relation', and 'What if there were no "of" through which to lure a tale?' Motamedi Fraser asks.[20] On this, Berger seems to follow the advice of Janos Lavin, the protagonist in *A Painter of Our Time*: 'We have little else. Trust your imagination a little more.'[21]

The effects of Lavin's *aperçu* are everywhere in Berger's stories. 'Perhaps, as in all his writings, it has been this capacity that touches me most deeply,' Michael Broughton says of Berger's hospitality to the immaterial, 'the negation of deep truth, negative in character, brought warmly into the light – never reductive but always bodily and always tender' (in the essay 'Toast', this volume). Take Berger's visit to a megalithic burial chamber, the Cairn de Barnenez –'a ship of stones' – near Morlaix Bay in north-west France. Here his artist's appreciation

for the size, weight, colour and placing of the different stones tuned into an uncanny reverberation between the French site and other stones and other lives nearly four thousand miles away. His essay on the cairn was written in 2003,[22] the year that Berger visited Palestine (see the essays by Rema Hammami, Tania Tamari Nasir and Yahia Yakhlef, this volume). The cairn had got him thinking of how the human need to place (as noun and verb), to communicate, and to protect the dead cannot be prised apart. 'What inspired hundreds of people to work together for several months to build this ship of stones, is perhaps quite close to what inspires kids in Palestine to hurl stones at the tanks of an occupying army.'[23]

To take this far-fetched, visceral feeling out into the world is to lob a stone at received narratives, most often with Berger by working from gut feelings and testifying to hidden brutalities. 'Berger's take on invisibility is always about inclusion, has always been about the politically not-seen, the dispossessed,' Ali Smith writes in her essay 'Verbs', this volume. And neither is his a fly-by-night fronting-up. He 'came and never left', says Tania Tamari Nasir (in 'Spirit') of his long support for Palestinian self-determination. This is Rema Hammami (writing in her essay 'Hay') on meeting Berger for the first time:

I had been a fan and follower of John's work over the years. But after rivers of famous and infamous visitors that magnetic disaster sites such as Palestine receive, I had learnt to expect a gap between wonderful texts and the personalities that write them. Barely a blink and my

low expectations were sent packing. At the time, someone asked me how I found him and I wrote: 'A wizard, prince, jester, charmer, sister, rake, poet, clairvoyant all in the figure of a 70-something wrestler held together by colossal kindness.'

It is the untold story and the unearthing of what the philosopher Michel Foucault knew as 'subjugated knowledge'[24] (*le savoir de gens*) that drives so much of Berger's efforts. In the very best tradition of Marxist materialism, and with help from Spinoza, he finds no conflict in drawing from the worlds of politics, philosophy, literature and art; the real and the divine. 'You can look at what exists and interpret it in all its materiality and yet realise that the sacred lies in that materiality.'[25] Berger has long conversed with those hinterlands of modern Western thought – existence outside of scientific measurement, phenomenal time, ghosts, mythology, the alliances and overspill between human bodies, animals, and nature. Even a Brussels sprout has offered insight! The tiny vegetable's thick jacket of overlapping leaves can protect its green heart even at −20°C, Berger tells us. Writing of the photographs of Chris Killip taken during the darkness of Britain's Thatcher years, he discerns a sprout like resilience. 'In the winter of this century, children, women and men protected one another with imagination, with violence, with rage, with incomprehension, with ingenuity. The green heart is their capacity to love: their refusal of the principle of indifference.'[26] It is 'the yearnings that are not necessarily articulated as such, that [draw] Berger's attentions', Vikki

Bell writes, and 'oftentimes, these are political demands, they bespeak political inequities' (see her essay 'Stars', this volume).

THE ESSAYS

Our jar of wild flowers is above all a collective gift to John Berger, reflecting the value of collaboration in his life. When we began approaching people for the collection, we were met with huge warmth and generosity. The name John Berger brings out the best in people. What took us a little by surprise was the extent to which Berger works with and supports people all over the world. 'Central to his creative identity is the idea of collaboration, with places and communities as much as with other artists and thinkers,' says his friend Gareth Evans.[27] What you might know from his published collaborations or impassioned essays in support of dissident causes is most likely only the surface. There are many, many slow-moving and wayward projects, countless experimental and open-ended exchanges; '…where we're going is of minor consequence', says Tessa McWatt of her more than decade-long work with Berger on a film adaptation of his novel *To The Wedding*. With Berger, 'The journey is what counts' (see her essay 'Oil').

It wasn't easy to order the 34 essays in this collection, but we have organised them as best we can to gather together affinities while also showing the crosscutting themes in Berger's work. The title of each of the five sections is a Berger quote, a small thread taken from a bigger fabric of writing. The sections bring together writers from different disciplines and with different

relationships to Berger, allowing kaleidoscopic views of each theme. Some essays provide a close-up reading of a body of ideas, a project, a relationship; others are more broad-based, taking the Bergeresque spirit into contexts and to subjects that Berger has not covered – such as the on-line 'performances' of ISIS ('Performance', by Doa Aly) and urban terror ('Hate', by Mustafa Dikeç) – but where his work has been informative.

The opening essays in the first section, 'The colour of the cosmos', are about the wonder, mysteries and sensuality of life, and what Nikos Papastergiadis calls Berger's 'ontological ruminations'. An often unnoticed aspect of Berger's *Ways of Seeing* that Papastergiadis identifies is 'expressive of the link between the artistic imaginary and cosmology' (see the essay 'Forest', by Papastergiadis). The topics in this part of the collection are diverse: art, fiction, care, translation, geology, and the poetics and politics of text messaging. It is not too much to say that each piece breaks through into something beyond the obvious surface world of appearance, to that uncanny connection between artfulness and cosmology. There are glimpses in the essays of the legacy of German Idealism that flavours Berger's corpus: the belief that art gives meaning to what escapes science and language; that thought and imagination are deeply sensuous.

The next section, 'The trees are in their place', comprises reflections and reports on contemporary migration, exile and home. The quotation comes from *A Seventh Man*, and Berger's early effort with Jean Mohr to give 'proper value' to migrants' lives by understanding them 'within the context of a

world economic system'[28]. While more pertinent than ever, the Berger–Mohr analysis requires further extension as the push-and-pull that shapes migration has changed. First published in 1975, the book interwove stories, photographs, poetry, statistics and political analysis, filling up the senses with the systematic exploitation and degradations of the *Gastarbeiter* (and after three generations, they remain resident aliens in Germany, without full citizenship).[29] Rather than evidence as 'compelling proof', the sociologist Howard Becker suggests that what Berger and Mohr give us is 'existence proof', 'a showing that the thing we are talking about is possible'.[30] The 'existence proof' offered by the writers in these contributions takes the forms of journalism, oral history and photography, with essays on the lives of African and Punjabi citizens in the UK (respectively 'Life', by Glenn Jordan, and 'Meetings', by Nirmal Puwar), immigration policing at the Hungarian-Serbian border – where 'The days got shorter and the fences longer' ('Fences', by Nick Thorpe) – and undercover investigations of undocumented Chinese workers in England ('Secrets', by Hsiao-Hung Pai). Because Berger has long recognised that many kinds of frontiers are crossed in migration, the essays are themed as conversations with the question of what form these borders can take (Fences, Method, Life, Meetings, Secrets, Pain).

What and how we see recur throughout Berger's writing, films, performance, and in his collaborative projects. It is seeing and the image that are discussed in the section 'Once through a lens'. Although for Berger seeing is ultimately conservative, tinted with ideology and tending to confirm us in the status

quo of our lives, he recognises that sometimes, suddenly, we see more. Unexpectedly captivated and moved, we look at life afresh, outside of contrived cultural schema. He has likened this opening out of perception to the flicker of a cinema film, a 'half-light-of-glimpses' through which, 'we catch sight of another visible order which intersects with ours and has nothing to do with it'.[31] Each essay in 'Once through a lens' is the flicker of these other realities. What might we see? This is the question that is responded to in the short titles of the essays (Stars, Conscience, Memory, Performance, A Mirror). A related theme that also appears elsewhere in the collection (see the essays by de Alwis, Jordon, and Salomone) is Berger's thoughts on the difference in images as they exist in and sometimes move between private and public worlds. Is it possible, some authors ask, that the publicity of photographs by those resisting systematic state violence might begin to suture the public image back into history, as a part of a movement against forgetting?

'Undefeated despair' was a term used by Berger in a pamphlet on Palestine, found when he donated his archive to the British Library in 2009. Undefeated despair is a 'stance' of tormented hope, of human spirit in situations of oppression. It feels much like the Palestinian comportment of *sumud* or 'steadfastness', a word that named a means of survival and resistance in the wake of the 1967 Six Day War. For Berger, undefeated despair is profoundly ambivalent:

When somebody has the opportunity to leave a camp and cross the rubble to slightly better accommodation, it

can happen that they turn it down and choose to stay. In the camp they are a member, like a finger, of an endless body. Moving out would be an amputation. The stance of undefeated despair works like this.[32]

The essays here are bound together by the writers' attentiveness to ambivalent stances in situations of injustice, including 'Trauma' (Alicia Salomone), 'Hate' (Mustafa Dikeç) and 'Hope' (Malathi de Alwis). You will find yourself moving between real-world commentaries on Chile, Pakistan, Paris, Palestine and Sri Lanka, and a piece ('Propaganda', by Rochelle Simmons) on Berger's Booker prizewinning novel *G.* and the figures of The Four Moors.

For readers less familiar with John Berger's work, and who might like to get a sense of him through biographical details, it's probably a good idea to start with the last section, 'Here is where we meet'. Although the line between Berger's biography and his work has always been porous,[33] the essays in this part of the book show the diversity of Berger's partnerships and projects, his political engagements, and friendships. They are reflections and tributes to what Berger offers as a companion in the flesh and of thought: among other things 'Love' (Julie Christie), 'Tenderness' (Christina Linardaki), and 'Tennis' (John Christie).

Although there is some reminiscing, the collection is not a retrospective. As Sally Potter says in her Afterword, 'Looking back is not part of John's vocabulary. Even his habitual physical posture resembles someone leaning slightly into tomorrow.'

It is also pointless to try to sum up John Berger by listing and categorising his outputs. Pointless not because of the fabulous variety of what he does, but because with Berger we are invariably on the move. His projects 'are always on-going, future-orientated, more driven by a desire to keep abreast of and intervene in contemporary crises than to waste precious time over past triumphs',[34] the writer Sukhdev Sandhu has said. At the same time Berger's stories get under the skin. His work, as Ali Smith observes in her essay 'Verbs', gets up and travels across the page and screen so that it 'passes out of itself and takes up residence in the self, in correspondence with it'.

And so we move forward with John Berger, our resident companion, nudging, cajoling.

NOTES

[1] 'Learning by heart' is the title of one of Berger's poems; see Berger, J. (2014) Learning by Heart, *Collected Poems*, Middlesborough: Smoke-stack Books, p. 128.

[2] Berger, J. (2007) Le Pont d'Arc, in *Hold Everything Dear*, London: Verso, pp. 129–142. p. 138.

[3] Ibid., p. 135.

[4] *Dans le silence de la grotte Chauvet, film, directed by* P. O. Lévy (2002). Coproduction: *ARTE*France, Ardèche Images Production, Aune Productions.

[5] *The Vertical Line* (1999) was 'an oratorio of faces, voices, darkness and light', taking 'a small audience down 122 spiral steps into the bowels of the disused station, where a sequence of audio-visual installations culminated in a live performance'. See https://www.artangel.org.uk/project/the-vertical-line/

[6] The description is the novelist Colum McCann's: 'John Berger always remains by the bedside', *The Independent*, 15 October 2015, www.independent.co.uk/arts-entertainment/books/features/colum-

mccann-novelist-john-berger-always-remains-by-the-bed-side-a6704571.html

7 Berger, quoted in Merrifield, A. (2012) *John Berger*, London: Reaktion Books, p. 35.

8 Wroe, N. (2011) John Berger: A life in writing, *Guardian*, 23 April 2011, www.theguardian.com/culture/2011/apr/23/john-berger-life-in-writing

9 Berger, in the Preface to his (2015) *Portraits: John Berger on Artists*, T. Overton ed., London: Verso, pp. xi–xii, p. xii.

10 Tepper, A. (2011) John Berger on *Bento's Sketchbook*, *The Paris Review*, 22 November 2011, http://www.theparisreview.org/blog/2011/11/22/john-berger-on-%E2%80%98bento%E2%80%99s-sketchbook%E2%80%99/

11 Berger, J. (1972) *Ways of Seeing*, London: British Broadcasting Corporation and Penguin Books.

12 Ibid., p. 135.

13 Overton, T. (2012) Transcendental Homelessness: Exile and the British Library's John Berger Archive, www.craftsofworldliterature.com/transcendental-homelessness-exile-british-librarys-john-berger-archive/

14 *Ways of Seeing*, TV series, written by John Berger, produced by Mike Dibb. London: BBC Enterprises, Episode 1. Uploaded 8 October 2012, https://www.youtube.com/watch?v=0pDE4VX_9Kk

15 Berger, J. (1992) *Keeping a Rendezvous*, London: Granta.

16 Barrell, J. (1992) Back of Beyond, *London Review of Books*, April 1992, Vol. 14, No.7, p. 3.

17 Merrifield, *John Berger*, p. 30.

18 Berger, J. and Michaels, A. (2012) *Railtracks*, with photographs by Tereza Stehliková, Berkeley: Counterpoint, p. 30.

19 Berger, J. and Mohr, J. (2015/1967) *A Fortunate Man: The Story of a Country Doctor*. Edinburgh and London: Canongate.

20 Motamedi Fraser, M. (2012) *Once upon a problem. The Sociological Review*, Vol. 60, Issue Supplement, S1, pp. 84–107, p. 99.

21 Berger, J. (1958) *A Painter of Our Time*, London: Secker and Warburg, p. 236.

22 Berger, J. (2007) Stones, in his *Hold Everything Dear: Dispatches on Survival and Resistance*, London: Verso, pp. 57–76.

23 Ibid., p. 76.

24 Foucault, M. (1980) Two Lectures, in Foucault, *Power/Knowledge: Selected Interviews and Other Writings, 1972–1977*, edited by C. Gordon, New York: Vintage, pp. 78–108, p. 82.

25 Taylor, L. (2011) Laurie Taylor's interviews: Ways of seeing John Berger: Laurie Taylor meets the art historian, *New Humanist*, 26 July 2011, https://newhumanist.org.uk/articles/2629/ways-of-seeing-john-berger-laurie-taylor-meets-the-art-historian

26 Berger, J. (2013) Walking Back Home, Chris Killip: *In Fragrante* (with Sylvia Grant), in his *Understanding a Photograph*, edited by G. Dyer, London: Modern Penguin Classics, pp. 119–130, p. 128.

27 Evans, G. (2005) Introduction and Literature: Film and Television, Visual Art, Performance, in G. Evans, ed., *John Berger – A Season in London, Culture Collaboration Commitment*. London: Artevents, p. 7.

28 Berger, J. and Mohr, J. (1975/2010) *A Seventh Man*, London: Verso, p. 45.

29 Taylor, C. (2011) *Dilemmas and Connections: Selected Essays*, Cambridge, MA, and London: The Belknap Press of Harvard University Press.

30 Becker, H. (2002) Visual evidence: *A Seventh Man*, the specified generalization, and the work of the reader, *Visual Studies*, Vol.17, No.1, pp. 3–11, p. 5.

31 Berger, J. (2002/2001) *The Shape of a Pocket*, London: Bloomsbury, p. 5.

32 Berger, J. (2006) Undefeated Despair, *Open Democracy*, 13 January 2006, https://www.opendemocracy.net/conflict-vision_reflections/palestine_3176.jsp

33 Berger shies away from biography, 'There's a risk of egocentricity. And to storytellers, egocentricity is boring', quoted in Maughan, P. (2015) I think the dead are with us – John Berger at 88, *New Statesman*, 11 June 2015. http://www.newstatesman.com/culture/2015/06/i-think-dead-are-us-john-berger-88

34 Sandhu, S. (2005) Other Kinds of Dreams: Why John Berger's writing matters, in G. Evans ed., *Here is Where We Meet – A Season in London, Culture Collaboration Commitment*. London: Artevents, pp. 12–15, p. 12.

THE COLOUR
OF THE COSMOS

GRAPHITE

FOUR POSTCARDS

HANS JÜRGEN BALMES

1 IN THE MOUNTAINS

We are sitting in the kitchen in Quincy. Suddenly the room gets dark. High in the mountains, electricity is not a given thing. Blackouts are frequent, can last hours. John Berger rises, walks over to a cupboard, comes back, and lights a candle.

We are squinting into the flickering light.

John Berger moves his lips silently as if he wants to lure some words from the dark. He twitches his eyes, waits as though he has been inventing an ambush for words. Finally: 'Now our faces are paintings, in electric light we are photographs.'

Candlelight makes the shadows hospitable. With some hesitation, John Berger clears his dish, takes out a manuscript, puts it on the table, shuffles, and finally irons the pages with his elbow. He reads, slowly but with confidence. Again we have the impression that he has to cross some distance before he begins – a line of graphite to remember a gap, a silence before gaining a foothold, but into where? We are not sure, but we feel, as though we are *there*.

Maybe it is exactly these interstices that John Berger addresses in one of his last essays discussing translation: 'Because true translation is not a binary affair between two languages but a triangular affair. The third point of the triangle being what lay behind the words of the original text before it was written. True translation demands a return to the pre-verbal.'[1]

Experience demands a return to the pre-verbal, to where thinking starts and words attach themselves to the stirring tongue of the mind.

The pauses are proof of the distance that has to be covered. And making the distance visible is a form of offering hospitality to images and words, to listeners and readers. Stepping towards that point and stepping back.

The dead surround the living. The living are the core of the dead. In this core are the dimensions of time and space. What surrounds the core is timelessness.[2]

2 ROAD DIRECTIONS

Sometimes the Inuit – people who have great shamans – carry a black stone inside their parkas: graphite that they have found in dry brooks during the summer while travelling inland. They put it into their amulets. Before going on a whalehunt. They use it to draw black lines on their bleached paddles: Alinnaq, the moon spirit with his face black with soot, will help them on their dangerous journey. White symbolises life, which now

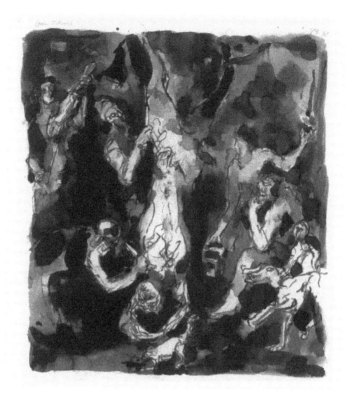

3

From Titian, John Berger, 1996

hunts in companionship with death – black and white have become partners.

If you look at the John Berger drawings *From Titian*,[3] and if you compare these to the paintings of the Venetian master, soot and graphite cross your mind. On Titian's paintings black soot surrounds the figures like velvet. Its black has nothing in common with the cold black wall that blocks the backdrop

of a memento mori. Titian's black is warm. It is a soft tissue surrounding the flesh. It is the grounding from which the honey-coloured light of his paintings takes their energy.

It seems that for Titian there was no difference in whether this light was shed on the Crucifixion, on the image of a nymph, or on the representation of the *Flaying of Marsyas*. The latter shows how the satyr Marsyas – the loser in a contest to decide who is the best reed-player – is being flayed by the victorious Apollo. It is one of the cruellest representations from a city whose inhabitants had been aware of manifold levels of cruelty. In Venice it was a common punishment for a capital crime to be sentenced to the galleys. This was called the 'thousand-fold death'. Of course members of the gentry (members of the same tribe) were excluded from such toil. The judges of those courts were Titian's clients. The soft warm light that falls onto the mythological scene of torture lends a feeling of unease and brands the painting as one of the most enigmatic in the long history of art. What did Titian think about it? His pity seems to be impartial. His attention seems to be the same towards the victim as towards the torturer. The light shed on this scene seems to be the same as in a picture of a naked woman under a tree, which he painted nearly simultaneously.

An element of unease in Titan's composition is the starting point of John Berger's drawing. His drawing concentrates on telling aspects of the painting: the satyr that hangs head over heels from a tree, the white right arm wielding a knife, the king – a figure of melancholy –who contemplates the scene, the second satyr who carries a bucket, which perhaps contains

blood that the small dog in the foreground has already begun to lick. A big dog stands next to the brooding figure with downcast eyes, and scans the scene. Its jaws are open. Its tongue seems to taste, its nose to smell. The animal is aware of the distance from where the brooding figure contemplates the scene and of the indifference of the small dog to the cruel origin of the blood it laps. In the image, the large dog appears to move. Its contours have been drawn two, three times, as if Berger did not have a patient piece of paper before him on which to copy but observed a procedure that he wanted to capture in all its density. Or perhaps he wanted to underline that being immobile like a statue renders it impossible to cope with the complexity of the scene – because if the 'wait between decision and consequence'[4] tends to be too great, any possibility for spontaneous answer and response is lost. It is just then that the moment freezes into a tableau. The abandonment, which makes the satyr a victim, fixes itself like a stone. It is that moment of timelessness that is the abandonment of the dead. The big dog is the only figure that seems to contradict this.

The wash of the drawing translates the colours of the painting, which appear to be fluid like some kind of resin, into shades of grey. These greys remind us of the shadows of a moonlit night, which are as well defined as daylight shadows. And yet their weight seems to be insubstantial. Flashes of white paper can be seen. Some of the greys come close to green and blue, seeming to point to that moment of dusk when light restores the weight and the colour of things. But despite these faint ideas of colour, John Berger´s drawings dwell in the realm of graphite, moving lines;

the black lines on a white paddle, which do not represent a final contrast but the possibility of an intimate relation.

There is a village in South India whose inhabitants have to face a peculiar difficulty if they want to go to the next town: their bus crosses a landscape that according to their shamanistic beliefs is inhabited by the dead. For some of them this bus ride causes fear and anxiety as though the bus is crossing Hieronymus Bosch's hell. This they can only do dreaming as the bus is actually taking the route.

Maybe a drawing can combine the two – dream and route? The traces of graphite on white paper: road directions.

3 IN THE GARDEN

We have spent the whole afternoon in the garden: under the green plums. They are so copious the neighbour whistled and announced that 150 bottles of *gnôle* can be made from them! John Berger remained sceptical while we ladled honey into glasses. Now late in summer the honey is dark. In early spring it had been shining yellow from all the dandelions. In between we have been drawing with John's English ink. It can be coaxed into developing colours if you add some sugar, salt. If you spit in it, some blue or red or velvet will appear in the grey wash between the black lines.

Colours. The sensual perception of colours. The taste of fruit. The texture of food. John Berger has many names for it, and sometimes he utters them aloud, moving his hands, as if he's caressing the colour like a cat's fur. The fresh green of the

plums, and later in the year their sky blue in the shadow of the leaves, the taste of the dark orange of their flesh. The world is an encyclopaedia of sensual perception, which we share with the dead: 'I often have the feeling that the dead are our fellows and contemporaries. In company with craftsmen this idea will cross your mind again and again. Maybe this has to do with their hands, you find this specially with stonemasons, with musicians, with nurses.'

His hands. Once we were visiting Winterthur's museum, Am Römerlager. His eyes and hands move freely. All his knowledge is kept inside an invisible knapsack on his back, reliably present, with no obstacle. He has come for his eyes to see. Standing in front of Goya's still life of two slabs of salmon, he is completely astonished by one detail. And we are astonished by the narrative precision with which he opens a window onto the moment when Goya painted the salmon: during the siege there had been no food in the whole of Madrid. Many had been starving, and so the salmon existed probably only in Goya's mind. 'Do you note the red trace of blood? In a fish shop that would be a most uncomfortable detail, but here it is the point where hunger breaks through the pink.'

By reconstructing the touches of the brush, the traces on the canvas, Berger insists on the individual sensual experience of each of us, on the one truth in a life's experience that too often remains hidden.

The immediacy of the brief moment in which one sees a piece of art for the first time – to capture this astonishing encounter when the intuition of the viewer touches the

intention of the painter and to turn it into a narrative – this is one of John Berger's many gifts. It is as if he makes us look into the eyes of the paintings.

And we are *there*.

4 HERE[5]

SLEEP
Method known
as la tienne
sent by Anne
method of travelling
beside one's self
stream through water
a track of grass through a field
words through words
on arrival
in Portugal
I'm on your left side
you on mine

NOTES

[1] Berger, J. (2014) Writing is an off-shoot of something deeper, *Guardian*, 12 December 2014, www.theguardian.com/books/2014/dec/12/john-berger-writing-is-an-off-shoot-of-something-deeper

[2] Berger, J. (1996) Twelve Theses on the Economy of the Dead, in his *Pages of the Wound: Poems, Drawings, Photographs, 1956-96*, London: Bloomsbury, n.p.

3 The drawing was first shown in an exhibition curated by Beat Wismer
 at Aargauer Kunsthaus in 1999. See also: Berger Andreadakis, K. and
 Berger, J. (1996), *Titian: Nymph and Shepherd*, Munich and New York:
 Prestel.
4 Berger, J. (1996) Road Directions, in *Pages of the Wound*.
5 Poem by John Berger, written at the end of the 1990s, manuscript.
 German translation first published in Berger, J. (2001), *Wegzeichnung.
 Gedichte*. Munich: Carl Hanser Verlag.

HAY

4 PALESTINE

REMA HAMMAMI
(AND JOHN BERGER)

John first came to Palestine in 2003 with his close collaborator the photographer Jean Mohr, ostensibly to do a workshop for young Palestinian artists and writers on the art of storytelling. His practical association with Palestine was limited. In 1990 he had written the introduction to a book of children's drawings about their lives under Israeli occupation in the first intifada, edited by the artist Kamal Boullata.[1] His more enduring connection was the friendship he had made with a young film student, Elia Suleiman (the award-winning Palestinian director), whom he first met as a classmate of his son Jacob.[2] My role as trip 'organiser' was a random gift of history and mutual acquaintance. I had just come to know John's close friend and Italian translator Maria Nadotti, who was the instigator of the whole scheme to get him to Palestine.

I had been a fan and follower of John's work over the years. But after rivers of famous and infamous visitors that magnetic disaster sites such as Palestine receive, I had learnt to expect a gap between wonderful texts and the personalities

that write them. Barely a blink and my low expectations were sent packing. At the time, someone asked me how I found him and I wrote: 'A wizard, prince, jester, charmer, sister, rake, poet clairvoyant all in the figure of a 70-something wrestler held together by colossal kindness.'

That first trip led to two more, the latter two made by the entire Berger clan from Quincy. It also led to a number of collaborations – many in the form of translations. There were Maria Nadotti's Italian translations of the texts John wrote after each visit; Najwan Darwish's translation of Yves Berger's poem *Destinez-moi la Palestine* into Arabic;[3] and Tania Nasir's translation of John's *A to X* into Arabic.[4] And finally there was my translation with John of Mahmud Darwish's poems *Mural* and *The Dice Player* into English.[5]

Following that first trip, John and I would stay in touch through SMS. As anyone who uses it knows, texting is like a flexible form of Morse code – one that easily lends itself to wordplay. It also breeds nicknames. Mine became Donk. When I reread the exchanges we've had over the years what strikes me most is their immediacy and humour. Reactions to what we'd seen, read, heard, worried or laughed about, tasted or smelled could be exchanged and shared, like students passing cryptic notes to each other in class. My notes were mostly sent from Palestine and were often about here. John's were from the Alpine village of Quincy and the world.

In May John always helps one of his farmer neighbours with the hay harvest. The following texts were exchanged very soon after his first visit.

J: Bonjour x here the cuckoo and the bees and hay being cut. U can smell it? And me wanting 2 be a ghost in Ramallah

R: At the Accordion checkpoint hot tired everyone eating fuschia ice lollies

J: I know its 43 degrees chez vous so im trying 2 fan u. will stop blowing and drink a cold yoghurt from [Ramallah] supermarket

Within weeks of his return to France, John became a ravenous reader of Palestinian and Arabic poetry and literature. My phone would be crammed with comments on Mourid Barghouti, Riad Beidas, Sahar Khalife and his (and Palestinians') most beloved writer, Ghassan Kanafani. Once the list of Palestinians began to run out, lines of modern and classical poetry (from Adonis, Abu Nuwas and the Persians Rumi and Saadi) took over. Mahmud Darwish's poetry kept a more constant relationship with my phone.

At one point I wrote:

R: Speechless as I watch this meal of yours – all of them feeding u and ur still not even hungry!

J: Wrong! am very hungry

R: Wrong! I meant ur hunger has such a long breath that stretches from before hunger

J: Is there a difference Donk between hunger and greed?

The messages below began as an exchange on the complexity of Arabic grammar, and then as was often the case the

conversation meandered between the fields of Quincy and streets of Jerusalem.

R: Now u understand cause of Arab defeat. At birth at death defeated by language

J: Oui words as fixed contours? Are they in other languages canoes?

R: Arabic spoken can be a dolphin. Written is walking in bog canal with concrete shoes

J: And the dolphins leap?

R: Definitely but need a sea

J: Drinking spray and eyes shut like horizons

R: Hope ur talking about dolphins otherwise image of u as fallen water skier

J: I fell watching the 2 dolphins this afternoon in hay – u are eating a pear?

R: Not pear am searching 4 white mulberries. Seems Jerusalem chopped them all down

J: White 4 white silk! ...Shall I send u blackcurrants? Their leaves a paradise 4 white snails

R: Now I'm confused do I want the berries or the snails w/ garlic floating on bed spinach? Lunchtime

J: Donk – give shade am in scorching heat with hay. A shadow is simply an absence of brighter light but how desirable such an absence

R: found mulberries size of aboriginal grubs! Take head, lower into bucket of water don't retrieve til grubs gone

J: 1 cart to go. Grubs everywhere

J: not 4 not 5 but 6 [carts] so I'm plus 1 hour to softest drink in world

R: old peasant strategy

J: old peasants dream

J: 6 carts. no softest drink. no women. no old peasant dream. no rage. no nothing. only flies

R: what is old peasant dream? Shiny new tractor? Rough and ready peasant girl? Smell of sea? Pot of rabbit w/beans? Zillions of soft drinks 4 the taking?

J: what a menu! Cold water to make one hour younger

J: Put both wrists in icy water & u don't need a knife for them

Parsing meaning is another constant.

J: Of all d roses endurance is the strongest? Can u smell

R: U pondering already! Endurance can be lack of imagination not just no choices. But 4 roses I prefer endurance with perfume over dazzle

J: Endurance not passive
 Is full of choices
 Perfume essential 4 endurance
 Defiant

R: Can we use stamina or 'sumud'/ steadfastness. Endurance 4 the girls can mean boring or a beating from mama

J: I prefer sumud + stamina

R: U are so manipulable with the girl stuff!

*

R: tell me difference between patience & endurance. I know difference between latter and stamina

J: Perhaps patience more passive and endurance biding her time 2 come back!

R: Patience wears slippers and endurance barefoot

J: Does barefoot endurance dream of being patience when old?

R: Probably. But perhaps still hopes to tango painted toes in slippers

Along with John's appetite for Arabic poetry and literature, he also closely follows the political coverage of Palestine/Israel. The degree of his attentiveness became clear to me when I'd be asked about this or that Palestinian political figure the international press corps had barely heard of. But with all things Berger, the close reading of detail was always the way to the big horizon.

J: Did u read Hanegbi and *Benvenisti*in [the Israeli leftist daily] *Haaretz*?

R: of course they correct 1 state the only practical vis geography and only ethical vis history... ironic its both a pipe dream & some version of an inevitability

J: Yes, Donk when u said ACCEPT DESTINY this is what it meant – the crazy bleeding inevitable

R: But why always so much blood before reaching the foreseen? Humans hopeless

J: Humans much given to giving power to those who should never have it

R: So if lemmings have leaders they'd be from human stock

J: No lemmings have nothing to lament, for they have no choice! We are lamenting some of our choices. Choice and lament go together. Price of god given liberty

J. Without it we can't love!

R: If only love was always a choice

J: no love never a choice but doesn't it engender a 100000000 choices

R: And what choices did u make last few days?

J: 1. Sit and write despite all 2. Do not enter where I can do nothing 3. Continue to talk to Donk 4. Laugh whenever forbidden 5. Trust absurd hunches

*

J: What do you think of [Israeli political writer]? Just read him

R: Right or Left Israeli discourse is constant drone of moralism. They all taught they were born on high ground

J: all moral high grounds are dung heaps – always

R: But remember donkeys are creators of heaps

J: Donks make droppings but only humans can make dung heaps piling shit on shit to make high moral ground.

Sometimes the exchanges were just what friends do.

J: Ur sad! I can tell – complain!

R: As u once said its all so simple and so difficult. More so in matters of heart and history

J: History is a dog that has always whined most nights

R: So what do you do – shoot it or unleash it?

J: Throw it a bone and go into another room next morning tail
 wagging it may lick u!

R: Did better – sent it a licentious muttess. Now its silent
 drooling poodle

 *

R: U weren't born to the poor so when did they invite u for a
 drink?

J: Not question of invitation but of a certain logic of my life

R: of course but decision even if felt natural, where to look, to
 fight, throw weight not necessarily lead to comfortable drink
 at table the poor which I see you doing all the time. Others
 defend from afar. No this is a gift from who or where?

J: Sometimes I think from another life that was a bit mine?

R. Yes those parts of ourselves that we can't name, that came
 out to catch something thrown at them

J: Came out to catch something thrown at them! So much
 begins there

 *

R: Two taxis to Ramallah. The 1st driver morose tells me: I've
 just started my life and there's nothing left. The second one
 I know, and ask him why happy? His reply: because there's
 nothing left to be upset about.

 *

J: God has always left! Omit the always! The always = our
 mortality!

R: am in strangest cemetery – protestant in west Jerusalem full
 of folks no one else would bury. Favorite epitaph: Johnny
 Shortlidge: 'we do what we gotta do then we go'

J: telepathy. My message was like to a cemetery!

R: I've walked by locked gate the cemetery for years – seems your message was a key! Here every 2nd word is god. He's implicated in a handshake/ cup of tea/ all goodness and badness/ happiness sadness. He's got a beeper fax and 5 mobile phones. Never closes for lunch, takes a holiday or catches the flu. He's relentless

R: And what makes no sense to me he's always around but never held responsible for this mess!

J: to mend the mess at this stage would mean re-beginning everything including his need to be recognised!

R: Snow! Here bigger event than the 2nd coming. Tomorrow the whole war of them and us will be buried under the most wonderful silliness. Whole families will go out to snowball passing cars with smiles. Wish you could see here like this

J: if only the whiteness erased the promises broken and kept making today the 1st day which for a few hours it was – wasn't it?

R: It fit the poetry your syntax – for a few hours what was, wasn't it. Such warm snow

John's visits to Palestine coincided with the demise of the Palestinians' iconic leader, Yasser Arafat. When John first visited in 2003, Arafat was under siege by the Israeli military in what remained of the Muqata'a (the Palestinian Authority's compound) in Ramallah. The following year, the Israelis allowed him to be helicoptered out of the compound to France

for emergency treatment of a mysterious medical condition that killed him a few weeks later. In November 2004 his body was returned to the Muqata'a for his funeral and burial.

On Arafat's departure to France:

R: even when he shuffled off in slippers and pajamas was still master of his game – the spoiler of spoilers! He fucked Sharon in flannel while making Donk (& I bet Said in his grave) pang 4 that past the bastard exemplified while destroying it. Our schizophrenia. We lost so much we even cling on to our losers

J. A politic hero can never be judged by sum total of his actions but by his fidelity to a cause. He came back from everything as himself

J: He came back from everything including death as himself and that self helped many others to be themselves

Arafat's funeral:

J: Those hands! Those hands! Forest of hands how they loved him!

R: So you saw it. Chaos a roar of the sincere mess that we are

J: The day of the mountain!

R: Don't know if it was love exactly but he was theirs all each of theirs intimately. The sea that bore the mountain – but the tears were real John and dry thus true

*

J: I'm drawing an ear of barley called prophets ear

J: Is there slight color difference between sweet and bitter almonds?

R: Yes it's in the blossom: sweet pure white earlier. Bitter later slightly pink

J: you're the prophet's ear!

*

J: Ever had a tomato sorbet?

R: No but imagine its like slightly sweaty raspberry?

J: Turns roof of the mouth into bronze gone a bit greenish with basilic

R: Anything except soft drinks that colors mouth is kiddie food!

J: Black and blue berries exception to any rule

J: Lick bronze and it tastes a little of yellow tomato – its not coloring but tasting Donk! That's why buds are called buds from which colors come!

R: [In Italy] looking for a bronze Garibaldi to lick.

*

R: what's difference between optimism and hope?

J: optimism= an insurance policy. Hope = the quick of the soul – no?

R: yes and yes and what's left in their absence is your enduring endurance

J: the time-table is like that but its not forever Donk

*

J: Between rage and empathy – what?

R: between rage and empathy only exhaustion

*

J: In deep Polish forest and talking to St Jerome about death

R: So what did he tell you?

J: He told me {and u} that we never know in this life the best that we do and that's why we live in such shit!

R: We must be content knowing that we have sometimes spilt on others a little perfume lent them our clogs or offered them our last shred of newspaper

J: Donk! Okri – the oppressed always live with death. They die in life. suffering drenches them in mystery. intense experience accelerates them again and they mature more strangely and more deeply than their oppressors

*

R. Did you know swallows keep soaring in pouring rain?

J: Yes swallows fly high in rain and we try to follow

NOTES

[1] Boullata, K. (1990) *Faithful Witnesses: Palestinian Children Recreate Their World*, London and New York: Olive Branch Press.
[2] Elia also came on that first trip – or, more precisely, was a very welcome gatecrasher. Maria Nadotti was a constant companion on every trip.
[3] Berger, Y. (2009) *Destinez-moi la Palestine*, Jerusalem: Dar al-Feel Publications.
[4] Berger, J. (2011) *A to X: a story in letters*, translated by Tania Tamari Nasir and Fathieh Saudi, Beirut: Arab Scientific Publishers.
[5] Darwish, M. (2009) *Mural*, translated by J. Berger and R. Hammami, London: Verso. The book includes 'The Dice Player'.

FIRE

A GESTURE OF TIME

KATHRYN YUSOFF

A line is drawn … in the darkness, on a cave wall, in the recesses of the earth, in the night of prehistory. Animals are painted from the ground bones of other animals. The burnt offerings of animal fat draw out animal images from the darkness, like optical illusions they are there, and then they are gone; fully rendered, alive in their presence, and then they slip into the animal darkness as quickly as they have come. Light is the reader. Time, like light, is what is drawn. They are lines made by spitting, sculpting, dabbing, rubbing, touching, painting. Pigment is mixed and regurgitated, laid by tongue into the surfaces and folds of rock that gives its surface to suggestion.

> The Cro-Magnon reply … to the first and perennial human question, 'Where are we?' was different from ours. The nomads were acutely aware of being a minority overwhelmingly outnumbered by animals. They had been born, not on to a planet, but into animal life. They were not animal keepers: animals were the keepers of the world and of the universe around them, which never stopped.

Beyond every horizon were more animals. At the same
time, they were distinct from animals. They could make
fire and therefore had light in the darkness.[1]

The animals are remembered in the grinds of the bones
that carried them. The geology of life is remembered in the
inhuman materials that constitute the pigment that paints
the flanks, which takes up a different kind of life for a while.
As Anne Michaels suggests, the animal is already in the paint
before it is painted: 'We made our paints from the bones of
the animals we painted. No image forgets its origin'.[2] To this
mix of feldspar (aluminum silicates of potassium, sodium or
calcium), haematite (iron oxide – red), limonite (iron oxide
– yellow), charcoal (black), or manganese dioxide (blackish-
brown), spit and blood are added, from mouth to hand to rock,
with the fire of animal fat luring the animal bodies into being
across the surface of the hidden earth. Time, like light, is what
is drawn through the geologic. A force is pulled through the
darkness of prehistory to presuppose a future. The work of art
is that gesture of time given to the future. Across this dance of
animal exuberance and the secret of the underground, energy is
exchanged. Something private and possible is created that will
erupt into the world to give a new dimensions of thought, in a
geologic epoch distinct from our own.

John Berger said that the cave drawings in Chauvet were
made so that they might exist in the dark, so that what they
embodied might outlast everything on the surface.[3] He says:

Each line is as tense as a well-thrown rope, and the drawing has a double energy that is perfectly shared. The energy of the animal who has become present, and that of the man's [sic] arm and eye drawing it by torch light. These rock paintings were made where they were so that they might exist in the dark. They were for the dark. They were hidden in the dark so that what they embodied would outlast everything visible, and promise, perhaps, survival.[4]

The secrets of these dark underground places became known in 1940 just as everything visible on the surface was in darkness, illuminated only by the exploding field of destruction. In this ruptured landscape, a gift of such wealth arrives to suggest the potential of the universe to be otherwise. These caves with their prehistoric painting have the shape of a pocket: a pocket in time and in the imagination of time's being. It is a pocket that holds dear the possibility of survivals against the ravages of everything that erupts and constrains the surface. In the case of the cave drawings at Lascaux, it was a pocket in the earth that punctuated the confined, traitorous spaces of fascism, to tell another story of the possibility of an exuberance that expands the world rather than making it smaller and meaner. The 'discovery' of Lascaux in the context of the Second World War speaks to the possibility and promise of such survivals: the survival of coming into being; surviving through the epochs of geologic time; survivals that foresee the future in their power to exist as a possibility within meaning; and the fragile power and politics of persisting in time.

Lascaux was born into the world in concert with Auschwitz. Another figuration of life, overwhelmingly animal, was opened up in the underground to offer, at that very moment of violence, a gesture of friendship to the politics of the present. These two signs share a natal moment; respectively representing the annihilation of time and its possibility; of something exuberantly given to time and something exterminated from it. One is the beginning of language, the other its death. Not so much origins and ends, as an ontology of possibilities and potentialities within the gesture of time.

In the discovery of Lascaux we are given poetry. In Auschwitz we are given the struggle of language and the refusal of poetry (as the writer and philosopher Blanchot says, language is not destroyed by Auschwitz, but we become aware of the unbearable weight its silences must carry).[5] Both silences become a question of how absence speaks, and what traces writing leaves. Berger comments, 'the pocket in question is a small pocket of resistance. A pocket is formed when two or more people come together in agreement ... And unexpectedly, our exchanges strengthen each of us in our conviction ...'[6]

As a writer and a reader come together – a reader of drawings, a follower of lines in Palaeolithic caves – a solidarity flowers into a political connection across the drift of continents and epochal shifts. Private acts of solidarity with the future potentiate the political present. These marks, art made in the underground, are a way of offering solidarity, marking what the philosopher Elizabeth Grosz calls the 'nick of time',[7] and the possibility and potential of stretching out beyond one's

skin. Cosmic imponderables. The art of the underground is of the future. Exploring the forces that take us into the future also demands that we recognise the forces that vibrate through time, across the cosmos, through different climates, to be part of the humanity that we have become. This inheritance, which in part emerges through a capacity to embrace the uncertain forces of the universe and survive, endures in the art of the Pleistocene. It makes its passage through time to be vitally present at the very moment of engineered death.

When I was writing about Palaeolithic cave painting,[8] one of the things that struck me most while looking at the epic tomes of cave art and their grandiose claims on the evolution of human subjectivity, was the small footnotes in the major narrative of 'Man': the tucked-away, hardly mentioned fact that these were not caves that people lived in.

Overwhelmingly, the cave drawings were painted alone in the dark, often centuries apart, by those who frequently travelled for extensive distances through waterlogged subterranean complexes. That is, this cave art was painted for the dark, for the continuance of life in the most secret and inhuman of places. These were not, as commonly thought by anthropologists, big social statements of cave cinema to rally groups or mark a territorial acquisition. Art did not make property. Instead, they might be seen as an act of solidarity with the possibilities of the future; a different kind of hopeful territorialisation. Maurice Blanchot imagined that community was created in writing, and that writing itself was a kind of communist practice. Not of the sort that immediately launches political parties and dogma

into the world (although it may be a spark on the way to more institutional forms of sedimentation). Blanchot[9] thought that writing was a form of communist generosity that launched this exposure into the world. The generosity of writing was – like Aboriginal firing of the bush – a burning that ignited buried seeds, giving energy for something to crack open and spring into the world, and transform the landscape.

The exposure to a community yet to come, questions what is found in the present, in the immediacy of relations, and speaks to an intimacy and identification with strangers. The responsibility to the future, to the unseen and unspeakable, in its most generous moments holds open the possibility of a relationship across time and space. Images held fast to rocks, under the surface, across fourteen thousand years of continental drift. The responsibility of the writer, according to Blanchot, was to the trail of language: to both communicate and locate new modes of communication that launch freedom into the world. It was the work of solidarity, like a burning arrow or searchlight arched across the sea at night. Just like the work of the volunteers who watch over boats in the Mediterranean, listening for chatter on the networks, tracking the weather, trying to see through the waves and into the recesses of the night, to find what people see but refuse to acknowledge.

It is not easy to see this communion as one of the most necessary and vital forms of political work, but opening ourselves up to experiences that travel beyond our own can be a way to come back at the organisations of power in the present that deny this solidarity across difference. Its social marks

might land, like the bones of animals, ground into different epochs, but this uncertainty is the wager of the night. That this labour is done alone in the dark marks the conditions of a form of sociality that is open beyond its own horizons, and exposes a unity that outlives our bones.

When I was an undergraduate, making furniture and trying to understand some notion of freedom within the accounts of postmodernity (in all the naïve ways open to a student), I was struck most by John Berger's account of his exchanges with the Zapatistas. Their message, their hope, as Berger recounted it, was that their voices would be heard beyond the caves in which they hid. I remember, rightly or wrongly, the postscripts that insisted on the possibility of their struggle, and the strength that came from being able to exist in other places and times. Beyond the danger of that immediate claustrophobic confinement, it spoke to the need for a future and the persistent desire to find solidarity within it. What struck me at the time, and in John Berger's writing since, was the resistance towards any legacy project in the reproduction of power, but also the desire merely to exist, to persist in the possibility of another way of being that was denied by the violence of the day.

I saw this again recently, at an event in London's East End, where in a live transmission a theatre group in Gaza was shown performing a rehearsal of a stage adaptation of Tolstoy's *War and Peace* (a year after the war in Gaza), to raise money for a full production.[9] After the main event, the audiences in London and Gaza had a chance to speak with one another. At first, the amateur acting, the choice of play and

its connections to Europe's formation seemed strained and awkward, but then the strange fit of these roles came alive, despite and because of this dissonance. Afterwards, when the audiences talked, the message repeated in many different voices from Gaza was: we exist; we persist, despite everything, and every attempt to annihilate us. Existence was the very possibility of playing other roles, rehearsing another version of *War and Peace* to the lived version of the political present. Making overblown gestures of Napoleonic despotism took on a certain humour and power. Despite all attempts by the international community to turn away from the responsibility of recognition, the act of the play was like a historical echo that reverberated in the present circumstances. The appeal was warm and funny, made through the right to have theatre … the right to have light – using the backup generator to provide the conditions for people to meet and share a space of imagination to make the conditions of the world larger for a while. This 'interdisciplinary vision is necessary in order to connect the "fields" which are institutionally kept separate. Any such vision is bound to be (in the original sense of the word) political. The precondition for thinking politically on a global scale is to see the *unity* of unnecessary suffering taking place.'[10]

The promise of existence, of having a future, requires holding open the pocket of another kind of relation to the world than that which is imposed relentlessly by an occupier. Such acts, Tolstoy in Palestine, Palaeolithic cave drawings, bring the underground into view as a form of awareness in the world. They suggest that there are secret places held in the earth,

with a duration that exhausts the inequities of the present. These forces do not so much dwarf the present, but subtend its possibilities, offering a breath in the suffocation of fascism. Such pockets, in Elizabeth Grosz's words, 'enlarge the universe by enabling its potential to be otherwise'. These spaces in time are given as gifts, freely and without expectation of return, 'but in that addressing the future, among other things, we're also addressing the question of human hope'.[11] Time is *given* to carry with it a force. That which is given is not some preexisting structure of exchange, but the act of trying to force open a crack in the very temporalisation of the universe.

When I go back to the first article I read by John Berger, the words of the Zapatista Subcomandante Marcos written to Berger seem to me to serve as a fitting postscript to these pockets made in a gesture of time:

> What I'm telling you happened 15 years ago. Thirty years ago, a few people scratched history, and, knowing this, they began calling to many others so that, by dint of scribbling, scratching and scrawling, they would end up rending the veil of history, and so the light would finally be seen. That, and nothing else, is the struggle we are making. And so if you ask us what we want, we will unashamedly answer: 'To open a crack in history.'[13]

To open a crack in history is to awaken language. To make it live and strive towards forms of relation that have been evacuated in the present occupations. It is a gesture to the future, to expand

the underground, to stutter, and to struggle with scribbling gestures towards a making sensible of time.

NOTES

1 Berger, J. (2002) Past Present, *Guardian*, 12 October 2002, www.theguardian.com/artanddesign/2002/oct/12/art.artsfeatures3
2 Michaels, A. (2009) *The Winter Vault*, London: Bloomsbury Publishing, p. 1.
3 Berger, J. (2001) The Chauvet Cave, in Berger, *The Shape of a Pocket*, London: Bloomsbury, pp. 33–42.
4 Berger, Past Present.
5 Blanchot, M. (1971) *Friendship*, translated by E. Rottenberg, Stanford, CAS: Stanford University Press.
6 Yusoff, K. (2015) Geologic subjects: nonhuman origins, geomorphic aesthetics and the art of becoming inhuman, *Cultural Geographies* Vol.22, no.3, pp. 383–407.
7 Grosz, E. (2004) *The Nick of Time: Politics, Evolution and the Untimely*, Durham, NC: Duke University Press.
8 Yusoff, Geologic subjects
9 Blanchot, M. (1969) *The Infinite Conversation*. Minneapolis: University of Minnesota Press.
10 Theatre for Everybody (Gaza) and Az Theatre (London) are creating and producing a new Arabic version of Tolstoy's *War and Peace* in Gaza,www.aztheatre.org.uk/index.php?page=war-and-peace-gaza-london-2
11 Berger, J. (2007), *Hold Everything Dear: Dispatches on Survival and Resistance*, New York: Vintage, p. 44.
12 Grosz, E. (2005) *Time Travels: Feminism, Nature and Power*, Durham, NC: Duke University Press, p. 25.
13 Berger, J. (2001) Our Word Is Our Weapon by Subcomandante Marcos, *Guardian*, 3 March 2001, www.theguardian.com/books/2001/mar/03/extract

MILK

WORDS AND WORLDS

ANA AMÁLIA ALVES

Like many people, I have read and re-read John Berger's *Ways of Seeing*,[1] as well as his various essays. Somehow I didn't know of Berger's poetry until the publication of his *Collected Poems* in 2014.[2] A year earlier, I was forming a relationship with Amarjit Chandan's poetry, reading his works in their English translation. Compelled to translate Chandan's poems into Brazilian Portuguese, I began to think about and question the inferior place that is so often delegated to indirect translation and to the sensuality of words, and what Mariam Motamedi Fraser has called 'word-relations' – how we exist and become with words, how they feel in the mouth, how they appear, how they sound.[3] More than this, Motamedi Fraser contests the ancient Aristotelian notion of the 'proper sensible', suggesting that, 'sensory and sensual experiences of words do not necessarily attach themselves to corresponding sets of sense organs (eyes for vision, ears for hearing etc.)'.[4] Words then can be a space of intermingling senses. It is this realm of words that can be especially alive in poetry and which makes demands on translation.

It is significant that the first contact I had with Chandan's poetry was through his voice. I saw and heard him reading his poems from *Sonata for Four Hands*,[5] prefaced by John Berger, at its UK launch tour. It was the first time I was aware of hearing the Punjabi language. I felt the beauty of that moment of unintelligibility. These were magical, enigmatic, musical sounds. I was not able to grasp the meanings, yet somehow I was able to sense and follow something through the poet standing in front of us, the audience. Hearing the poet's mother tongue speaking directly to mine was a moment of human connection. I felt alive.

Then all of a sudden something changed. It happened when Chandan began reading the English translations of his poems. Although I come from a non-English-speaking country, because of all the years I have spent studying and teaching English, I was able to understand the meaning of the words. Later, reading the poems in English, I realised that with the English words I was thinking too much. The poetic and bodily sensations were being dulled. They were leaving me. I had learnt my first lesson about the powerful effects of the voice and the mother tongue, and this experience opened me to these core themes in Chandan's, and later Berger's, poetry.

At the behest of Antonio Moura, a Brazilian poet who particularly liked Chandan's poem 'Voices', I translated the poem into Brazilian Portuguese. In 2013 'Voices' was published in *Polichinello*, a Brazilian literary magazine. The same issue carried my translation of 'What Opens the Way Is Darkness' by the poet and journalist Bejan Matur,[6] the first person to announce her Kurdish origins in a Turkish TV broadcast.

After seeing the published poems I became aware that I was being brought into contact with cultures to which I would not have had access if I had not known English. Indirect translation has been consistently questioned and undervalued in comparison to direct word-for-word translation. In my case, it was my only way into these poets' worlds. If the poems had not been translated into English, there would have been no encounter. And because I could read their English translations, I was also able to 'read' Punjabi and Kurdish poetry for the first time. Now I have translated many poems from the *Sonata for Four Hands* into their first versions in Brazilian Portuguese – four already published at *Zunái*, a Brazilian literary magazine edited by the poet and critic Claudio Daniel in São Paulo: 'Roots', 'To Father', 'Wear Me' and 'Who Knows'.[7]

This work led me to a more long-term dialogue with Chandan. He sent me some of Berger's essays and then Berger's *Collected Poems*, which I immediately began translating into Brazilian Portuguese. Later in 2014, when I had the chance to meet Chandan again in London, to give him the *Polichinello* issue in which he appears for the first time in Brazil, he told me that the three poems he had written were inspired by John Berger ('To Father', 'Lasan Garlic' and 'John Berger Gives a Talk at the ICA on 15.09.95'). I had not known that Chandan's poem 'To Father' was inspired by Berger. I had chosen to translate this poem for its strength and beauty – and possibly because it speaks to a central theme in the Portuguese-speaking literary tradition: *saudade*, a state of nostalgia or longing for an absent something or someone.

I spent some months exploring the relationships between Chandan's and Berger's poetry. Reading them side by side allowed me to immerse myself quite unconsciously into a pool of overlapping themes and images, and also to enter each singular universe and the distinctions between them. Some of the shared aspects of the poems are mother tongue, voice and history, which are particularly present in 'Words 1', the first part of Berger's *Collected Poems,* and recur throughout Chandan's *Sonata for Four Hands.*

JOHN BERGER

WORDS I

Down the gorge
 ran
 people and blood

In the bracken
 beyond touch
 a dog howled

PALAVRAS I

Garganta abaixo
 desceram
 pessoas e sangue

No bosque
 todo solto
 um cão uivou

AMARJIT CHANDAN

Roots

Roots make me think of my forefather Dhareja –
 The root of my family tree.
His roots are flowing in my veins.
I am the seed of that root.
I fell into the womb of mother earth
Being born, to live for ages.

A letter just put down on paper
 knows its roots.

Raízes

Raízes me fazem pensar em meu ancestral Dhareja
 A raiz da minha árvore genealógica.
Suas raízes correm pelas minhas veias.
Eu sou a semente daquela raiz.
Eu caí no útero da mãe-terra.
Nascido, para viver por eras.

Uma letra recém marcada no papel
 sabe das suas raízes.

My translation of the poems into Brazilian Portuguese focused on keeping the musicality, rhythms and tones of the poets' voices alive as I heard and felt them speaking in their mother tongues. Berger has suggested that translation is a triangular

affair, between the poet's language, the translator's language and 'what lay behind the words of the original text before it was written'.[8] It's also true that the idea of a 'mother tongue' can easily be misunderstood to stand for a muscular purity of both language and lineage. But language is open, constantly impressed by other cultures. It is always in development, and there are no fixed interpretations. At the same time we all share a mother tongue: that same language that Berger and Chandan use to reach us. This is poetry, where we can feel our humanity and be at home.

My way into the translations of the two poems began with the imagery and emotions I experienced at a sensuous, unthinking level while reading Chandan's and Berger's poetry. This is what I wanted to express in Brazilian Portuguese. Berger says that experiencing what prompted the original words is 'a return to the pre-verbal' and that, 'within one mother tongue are all mother tongues'.[9] I hoped that my translations would bring Portuguese-speakers the sensations and gestural experiences of a mother tongue that Berger and Chandan invite us to hear and to speak – the universal language of poetry.

A sense of origins and sustenance is rendered by each poem, and is done so in relation to *words*. Words are our milk, and our roots. A coming into language (and perhaps another creation story) appears later in Berger's poem in the image of a baby breastfeeding – 'Her child sucks the long /white thread / of words to come'. There is also the evocation of a continuous heritage forged through notions of ancestral descent as in Chandan's 'Roots'. The poems are wonderfully sensuous, so I was concerned

with keeping and conveying what I felt when I first read them. As a second parameter, I also focused on trying to keep the shape and connotations of the words *within* their relationships in the poems, as well as of the words in and of themselves.

The challenges in Berger's 'Words I' came in the first and second stanzas. In the first stanza, the challenge was in the word 'gorge', which in English means a narrow ravine and is also a much older word for throat. *Gorge* gives the poem a vivid imagery of liquid flowing through a narrow passage. Berger plays with this idea, adding the word *blood*, suggestive of wars and violence, the very opposite of love! In Portuguese, I struggled to find a word that would bring an equivalent sensation of simultaneous constraint and flow, and convey the layered meanings within the word. I chose *garganta* (throat) instead of *barranco* or *desfiladeiro* (ravine) because it retained the bodily imagery and a similar acoustic (*gorge/garganta*).

The word *bracken*, which appears in the second stanza of Berger's poem, was just as demanding to translate. This kind of vegetation exists in the Brazilian landscape but unlike in the English language, we tend not to name it by relating it to the actual plant. I thought that *samambaias* or *campo de samambaias* ('bracken') would change the imagery created by the poet, since in Brazil bracken is more often known as a decorative plant in urban settings. Instead I chose the word *bosque*, which conveys the sense of a wild terrain in the same way that *bracken* does. Most important, it also keeps the *b* sound and the word length. What was lost with this word choice was the sense of space as open and unbordered.

In 'Roots', the difficulty was translating the sensual aspects of the poem while conveying the complexity of relationships and the ambivalent meanings that can circulate in the idea of descent. Roots, for Chandan, can stand as blood and love lines, as well as the family of exploited labour. The terms for family tree (árvore genealógica) and womb (útero) used by Chandan when translated into Portuguese flatten these multiple possibilities and introduce a more scientific, distancing vocabulary. This made me think about the westernisation of Brazil, a country not usually seen as part of the Western world but whose native academic scholars and intellectuals, perhaps in consequence of the influence of the European humanities and sciences, frequently classify themselves as Western.

As it turned out, the non-scientific words for *anatomy* and *ancestry* in the English translation of the poem suggest a path we might travel when reading both Chandan's and Berger's poetry. To enter their worlds we can leave behind certain western scientific reasoning. History, for instance, is not what passes through time but what is with us/in us from the beginning. History, as we read in 'Roots', is about the natural world and also non-linear time. Time can move in different directions, many times can coexist in the same moment. We are the seeds of those roots and we are our ancestors.

John Berger inspired Amarjit Chandan, and Chandan's poems acted on me. This chain of influence and emotion exists in poetry because in it languages and cultures are freer to merge and mix; time and place can be rearranged, and so can the meanings of belonging. Poetry is our humanisation, and

Berger and Chandan invite us to experience a shared existence in which regional and universal, past and present, are one.

Some of Chandan's poems now circulate in Brazil, bringing with them John Berger's poetic tradition and influences. We shall see where the growth of this root in the Portuguese-speaking world might take us.

NOTES

1 Berger, J. (1972) *Ways of Seeing*, London: British Broadcasting Corporation and Penguin Books.
2 Berger, J. (2014) *Collected Poems*, Middlesbrough: Smokestack Books.
3 Motamedi Fraser, M. (2015) *Word: Beyond Language, Beyond Image.* London: Rowman & Littlefield.
4 Ibid., p. xxxii.
5 Chandan, A (2010) *Sonata for Four Hands*, Todmorden: Arc Publications.
6 Bejan Matur is mentioned in John Berger's 'A Place Weeping', *Threepenny Review*, Summer 2009. www.threepennyreview.com/samples/berger_su09.html
7 'Raízes', 'Para meu pai', 'Vista-se de mim' and 'Quem sabe' are available at http://zunai.com.br/post/106405283453/torre-de-babel-7-amarjit-chandan
8 Berger, J. (2014) Writing is an offshoot of something deeper, *Guardian*, 12 December 2014, www.theguardian.com/books/2014/dec/12/john-berger-writing-is-an-off-shoot-of-something-deeper
9 Ibid.

BLOOD

A FORTUNATE MAN: A MASTERPIECE OF WITNESS

GAVIN FRANCIS

First published in 1967, *A Fortunate Man* is a masterpiece of witness: a moving meditation on humanity, society and the value of healing.[1] It's a collaborative work that blends John Berger's text with Jean Mohr's photographs in a series of superb analytical, sociological and philosophical reflections on the doctor's role, the roots of cultural and intellectual deprivation and the motivations that drive medical practice. The subject of the book, John Sassall, emerges as an individual deeply committed to inner reflection as well as to his vocation as a physician. When I was a newly qualified doctor it became my habit to give copies as gifts. For years it had been out of print and difficult to find; the habit was becoming expensive.

Early in 2014 I wrote to Berger because I was working on a book about medicine and the human body, and had been struck by the lucidity of his work *Cataract*,[2] an essay about the renaissance of vision he experienced through cataract surgery. I wanted to ask if he would let me quote some of his words in a chapter I was writing about the eye. I thought that maybe after

a few months I'd receive a reply from an assistant or, more likely, nothing at all, but within a couple of days of posting the request he called me. 'Of course you can quote from my books,' he said down the telephone, 'but of course!' His enthusiasm was catching, and we struck up a correspondence. I told him how I wished *A Fortunate Man* was back in print – it was a work considered deeply influential, and one that pioneered the fusion of text and images in photodocumentary – and asked if he'd mind me approaching some publishers to see if they loved it as much as I did. 'Of course!' came the reply. 'Carry on!'

When asked how to approach his work, Berger has often replied: 'I'm a storyteller.' 'Even when I was writing on art,' he said in 1984, 'it was really a way of storytelling – storytellers lose their identity and are open to the lives of other people.' When I asked him how he and Mohr came to write the book, he began by telling me a story. It started in London, in the early 1950s, when Berger was a commentator on art for the *New Statesman*. His essays and reviews were unconventional as well as controversial; he had to fight to keep his job. 'We received a marvellous piece from an Indian writer called Victor Anant,' he told me, 'called "An English Christmas". On the back of the envelope was the return address: "Left Luggage Office, Paddington Station". I jumped on my motorbike and drove over to meet him. He'd not long arrived from Bombay, and this was the first job he'd found.'

Anant, like Berger, distrusted established power. In India he had been imprisoned by the British. The two men became friends and, several years later, when Berger was living in rural

Gloucestershire, Anant and his Pakistani wife were drawn to live nearby. Sassall was the general practitioner who attended the two men at that time. 'I became friends with Sassall after going to him with some minor medical problem,' Berger explained. 'I used to meet regularly with him and with Anant to play bridge.' The two writers recognised in Sassall an outstanding physician as well as an enthusiast for an unfashionable ideal – the Renaissance dream of aspiring to universal knowledge and experience. As a doctor who sought daily to empathise with people of very different backgrounds and perspectives, Sassall, they perceived, came closer to attaining this ideal than most men or women ever could.

By the mid 1960s Berger had moved to Geneva, but both he and Anant were still in touch with Sassall. One day, Anant suggested that Berger write a book about their friend, his medical practice and his determined pursuit of the universal. Berger again: '"You know, this man is really remarkable," Anant told me, "but one day no one will know of him. His goodness will have consequences, of course, but unless you write about him, the specifics of his life and his attitude may not be preserved."'

Mohr was at that time also living in Geneva, a photo-journalist with the Red Cross and the United Nations who had done some of his finest work documenting the stateless experience of Palestinian refugees. 'Jean is one of the truly great photographers,' Berger told me, 'utterly invisible, blending into the background like a lamp-stand – the perfect man to sit in on medical consultations.' Sassall invited Berger and Mohr

to live with him and his family for six weeks and, with his patients' permission, join him night and day in the clinic and on emergency visits. Afterwards, the two men returned to Geneva and worked in isolation for just a month – Berger recalls the text flowing fairly quickly. 'When we got together again and compared what I'd written with the photographs Jean had chosen, we found we'd replicated one another's work entirely,' he says. 'They were tautologous – as if my text was a series of captions to his images. We had both tried to write the book on our own. That's not what we wanted at all, so we reworked it so that the words and pictures were like a conversation; building on, rather than mirroring, one another.' Sassall checked the manuscript and made some minor corrections – 'medical terminology, technical comments, that sort of thing' – but was otherwise happy with it. In April 1967 the book was published.

The *Guardian* carried an early review by Tom Maschler,[3] the celebrated editor at Jonathan Cape, placed between a photograph of a Vietnamese baby scarred by napalm and an advertisement for woollen minidresses. 'It is a beautiful book,' he wrote. 'John Berger writes with a passion, with an intensity that few writers could achieve.' He was particularly entranced by the way Sassall, as portrayed by Berger, has an insatiable appetite for human experience and imaginatively enters the minds of his patients. Philip Toynbee, writing in the *Observer* a few days later, called it 'a series of brilliant descriptive sketches … a genuine tour de force, and the admirable photographs of the local countryside and its inhabitants match and illuminate the text with an unusual degree of sympathetic understanding'.[4]

Toynbee felt particularly well qualified to comment on the accuracy of Berger's portrayal of the physician as the book's subject happened to be his own doctor. 'The Sassall who emerges from these pages – both from the text and from the photographs – is indeed the man that I myself have known, liked, and admired for several years. But he is more than the man I know, not because Berger has romanticised him or enlarged him, but because Berger knows him better than I do and has thought about him harder.'

A Fortunate Man is a memorial not just to this exceptional individual but to a way of practising medicine that has almost disappeared. Sassall's approach to his practice is all-consuming – in today's culture of working-time directives and the commercialisation of disease it would be almost impossible to sustain. Sassall has made a Faustian pact: he is rewarded with endless opportunities for experiencing the possibilities inherent in human lives, but at the cost of being subject to immense and, at times, unbearable pressures. These pressures manifest themselves as episodes of profound depression, during which he is overwhelmed by 'the suffering of his own patients and his own sense of inadequacy'.

The book opens with a series of 'case studies', though the term is too clinical and doesn't reflect either the emotional subtlety of Berger's word sketches or the versatility of Sassall's responsiveness to his patients. They are glimpses of the situations Sassall responds to every day, recognisable to any doctor, but they convey the extraordinary depth of Sassall's commitment to his patients. They also show how powerful

an influence the landscape exerts on the community and its stories. Berger writes in the opening pages: 'Sometimes a landscape seems to be less a setting for the life of its inhabitants than a curtain behind which their struggles, achievements and accidents take place.'[5] Within that landscape the community looks to Sassall as a 'clerk of records',[6] the figure to whom they tell their stories: 'He keeps the records so that, from time to time, they can consult them themselves.'[7]

Berger and Mohr follow Sassall through these parallel landscapes – the physical landscape of rural England and the metaphorical one of his patients' lives. The moral possibilities of medical practice are drawn out, without shying away from the risks that doctors such as Sassall run in identifying so closely with those in mental and physical pain. The myth of Faust, the life of Paracelsus, the works of Conrad and the dream of the universal are each examined for the ways in which they illuminate aspects of Sassall's motivation. He is compared to one of Conrad's Master Mariners, though as someone who sets out to compass not the globe but the totality of human experience.

Towards the end, Berger tries to make an assessment of Sassall's contribution to society, but finds that he cannot. A society that doesn't know how to value the lives of its people can't adequately account for the value of easing their suffering. 'What is the social value of a pain eased?' Berger asks. 'What is the value of a life saved? How does the cure of a serious illness compare in value with one of the better poems of a minor poet? How does making a correct but difficult diagnosis compare

with painting a great canvas?'[8] The absurdity of the questions reveals just how far we have to go in appreciating the value of not just art, but life.

In the years after publication, Berger moved to Haute-Savoie, a remote Alpine district in the south-east of France close to the Swiss and Italian borders, in order to live closely with people who worked the land. 'I didn't go to university,' he told me, 'the peasants were my university professors.' Like Sassall in rural Gloucestershire, Berger became a clerk of records for the people he lived among. He poured his reflections on their lives into his trilogy *Into Their Labours*,[9] as well as works such as *A Seventh Man*,[10] his exposition, again with Mohr, of Europe's exploitation of peasant migrant labour. As a storyteller, Berger wishes to lose his identity in that of his subject and his readers, just as Sassall sought to lose his in those of his patients. Berger's assessment of Sassall could stand for an assessment of his own life and work: 'Like an artist, or like anybody else who believes that his work justifies his life, Sassall – by our society's miserable standards – is a fortunate man.'[11]

In the late 1970s Sassall left the Gloucestershire practice and travelled for a while in China, learning the ways of the barefoot doctors who were then the main providers of medical care in rural China. In April 1981 his wife Betty died, at the age of 61. At the end of his *Observer* review, Toynbee confessed to a 'quarrel' with Berger for leaving Betty out of the narrative, though the book is dedicated in part to her: 'this racked and pain-haunted man would have collapsed long ago, and perhaps irretrievably, if it hadn't been for his wife', Toynbee wrote. 'Her

role is as archetypal as his.' Sassall's suicide a little over a year later in August 1982, only a couple of months after retiring from medical practice, deepens the enigma of his life. A careful reading of *A Fortunate Man* reveals its title to be a paradox: fitting for a study of a man whose very openness to experience – his gift to the world – was also his undoing.

A Fortunate Man is now fifty years old but remains fresh, urgent and relevant, a reminder for physicians and patients alike of the essence of medical practice, of the differences between healing and medicating. The patients Berger describes suffer from the same problems as those visiting my own GP clinic today – depression, cardiac problems, minor injuries – but the landscape of the NHS is utterly transformed from the one Sassall knew. The expansion and technical complexity of modern hospital specialities mean that although 90 per cent of patient contact in the UK occurs in general practice, it receives less than 9 per cent of NHS funding. Berger's book illustrates how good general practice saves the NHS a fortune by doing things hospitals cannot do – knowing patients well; caring for them in their own homes; managing uncertainty; gauging when and when not to push for a diagnosis. *A Fortunate Man* is a timely reminder of just how unique, and valuable, British general practice is.

There have been criticisms of the book: notably that it lacks humour, and that its portrayal of women in the case studies can, to today's eye, verge on paternalistic. In its defence I'd argue that medical practice can be a restorative, engaging and deeply affirming for both physician and patient, but rarely

funny, and that judged by the place and time in which the book was written, neither Berger nor Sassall hold sexist attitudes (it was written, remember, during the glory years of *Dr Finlay's Casebook*). One of the most widely read contemporary books on medical practice was Michael Balint's 1957 work *The Doctor, His Patient and the Illness* (note the 'his').[12] To give an example of prevalent attitudes, Balint dismissed the slippery problem of patient confidentiality with: 'A patient may recognise himself in the description of his case. This highly undesirable hazard is unfortunately inevitable … to miminise this risk we confined our selection to case histories of patients who were thought unlikely to read this book.'[13]

In trying to assess Sassall's qualities as a physician Berger wrote: 'He is acknowledged as a good doctor because he meets the deep but unformulated expectation of the sick for a sense of fraternity.'[14] This quest for recognition has rarely been articulated so beautifully. Back in 1967, Maschler concluded his *Guardian* review by saying simply: 'I am grateful for it.' I, too, am grateful: to Anant for suggesting the book in the first place, to Berger and Mohr for crafting such a masterpiece, and, of course, to Sassall, and his family, for permitting the intimate details of his life and attitudes to be set down.

NOTES

[1] Berger, J. and Mohr, J. (2015/1967) *A Fortunate Man: The Story of a Country Doctor*, Edinburgh and London: Canongate.
[2] Berger, J. with drawings by Demirel, S. (2011) *Cataract: Some Notes After Having a Cataract Removed*, London: Notting Hill Editions.

3 Maschler, T. (1967) A valuable life, *Guardian*, 28 April.

4 Toynbee, P. (1967) Review, *Observer*, 30 April.

5 Berger and Mohr, *A Fortunate Man*, pp. 19–21.

6 Ibid., p. 113.

7 Ibid., p. 111.

8 Ibid., p. 165.

9 Berger, J. (1991) *Into Their Labours: A Trilogy*, New York: Pantheon Books.

10 Berger, J. and Mohr, J. (2010/1975) *A Seventh Man,* London: Verso.

11 Berger and Mohr, *A Fortunate Man*, p. 146.

12 Balint, M. (1957) *The Doctor, His Patient and the Illness*, London: Pitman Medical Publishing Co.

13 Ibid., p. 6.

14 Berger and Mohr, *A Fortunate Man*, p. 79.

FOREST

THE COLOUR OF THE COSMOS: JOHN BERGER ON ART AND THE MYSTERY OF CREATIVITY

NIKOS PAPASTERGIADIS

In a 2011 review of an exhibition of Paul Cézanne's paintings at the Musée du Luxembourg, John Berger ends with this fabulous quotation: 'Colour is the place where our brain and the universe meet.'[1] Prior to this embrace with Cézanne's celestial speculation, Berger charts a movement in Cézanne's work from the revelation of the sensuousness in which the human body is bound, to the experimentation with the visible sensation of a circumambient landscape. Towards the end of his life Cézanne stated that the 'landscape thinks itself in me, and I am its consciousness.'[2]Through the distinctive use of the colour black, at both the earliest and in the final phase of his painting, Berger observed that Cézanne's quest for the connection between the perception of worldly impressions and the consciousness of emergent forms opened a path for seeing how all works of art are to some extent a creation of the world. Berger claims to glimpse this world via a 'black box'

that lurks in a corner of a painting such as *La Pendule Noire* (1869–71).

All of Berger's writing hits you in this way. It strikes deep in the most intimate space and simultaneously throws you out towards the widest spheres. This dual perspective towards the particular and the whole is a constitutive feature of his artistic and critical imagination. In this essay I will focus on the worldview that is invoked in John Berger's critical writings, examining the extent to which this worldview contains an implicit creation story. Some aspects of a creation story have appeared more explicitly in his recent essays, and I will consider whether these elements are pervasive or representative of a fundamental shift in outlook. In particular, I will reflect on the potential parallels between the overtly political texts and the more ontological ruminations, and ask whether both modes of address are related to a fundamental cosmology. Finally, a further link between creation stories and what I call the cosmopolitan imaginary will be posed through an exploration of the interplay between the political and the cosmological in Berger's writing.[3] I will proceed with a question that moves in a kind of helix motion. How does art offer an image of the world, and how does the imagination create a world?

The fascination with the transformative function of the imagination has never dropped from the centre of Berger's criticism. In the 1950s and 1960s, Berger was an outspoken advocate of social realism and had little patience with the formalist perspectives in art criticism.[4] Formal innovations are important for Berger but they are never seen in a vacuum.

They always come hand in hand with aspirations for social transformation. This axiomatic interweaving between the politics of art and the art of politics has never shifted from his writing. Berger's politics is, as he has reaffirmed, still Marxist, but I will argue that his outlook now also attends to the relationship between creativity and cosmology.[5]

This complex outlook is most evident in Berger's recent evocation, in *Bento's Sketchbook*,[6] of the places of belonging. Through the juxtaposition of stories in which strangers find momentary recognition of each other through small gestures of hospitality, to the meditations on the writing of the philosopher Baruch Spinoza, Berger provides an optic that oscillates between the banalities of everyday life and the widest horizons of the cosmos.[7] Belonging is not exclusively pinned to a singular point of origin in this world. It is not even tied to a transnational ideology. It is embedded in something that is wider and deeper. The horizons of view are open to the experience of the infinite and focused towards the production of a form that would in turn make it comprehensible. Aesthesis starts with this kind of sensory awareness of the world. Aesthetic imagination is now given the scope to embrace the whole.

To put it briefly, throughout Berger's writing we can trace the outline of a double claim on the historical modality of the aesthetic imagination. It produces images that come out of history, but they are not bound by or the sum of specific historical forces. Imagination has a double perspective towards the images in its own historical context; it simultaneously reassembles elements that exist in a given period and also reproduces them anew.

In the midst of Cold War–period debates on art and politics, Berger asserted that 'imagination is not, as it is sometimes thought, the ability to invent; it is the capacity to disclose that which exists'.[8] At this point in time, the revelatory function of the imagination was given a determinant role over all other dimensions. The duty of the artist was defined in terms of a pursuit of truth. Through this endeavour, solidarity and justice were also realised. Thus the virtue of art was understood in its capacity to deliver more virtuous forms of ethical conduct and express a transformative agenda of radical politics. Art was imbued with a strong corrective task: it was meant to clarify ambiguities, break out of restrictions, and overcome false hierarchies. Through art we could *see through* the distortions that blurred reality, blocked solidarity, and delayed justice.

Since the past decade, while these ethical commitments and political values have been reaffirmed, there has also been a stronger attention to aesthetics. Berger has neither retreated into an academic fascination with aesthetic theory, nor adopted a position of mystical detachment. His attempt to articulate the visions of the world that are created by other artists is also an approach that makes his own sensory awareness of the world more explicit. By focusing on the manner in which art is making a world even as it represents the world, Berger is extending his understanding of the function of the imagination beyond an evaluation of its political objectives and ethical sincerity. His observations of the social and political conditions that are represented in the artwork are now more directly linked to

ruminations on how a specific work of art is expressive of a general vision of the world.

This process of rumination gives greater credence to the use of sensory faculties for grasping the realm of what is possible in the world. From this perspective, art not only reveals an existing truth but also provides the means for exploring new connections and wider resonances. For instance, in the late paintings by Cézanne, Berger describes the 'complementarity between the equilibrium of the body and the inevitability of landscape' by comparing Cézanne's depiction of rocks in a forest to the intimacy of armpits.[9] Berger sees these paintings as prophetic expressions about creation. The creation of the world appears in the sense of expectancy that comes from the minute interplay between the animate and inanimate. The revelatory function of art is complemented by a connective and harmonic version of aesthetics.

Berger's account of how creative acts are interpreted has seemingly shifted from a form of strident and activist critique to a more poetic and open-ended process of engagement. In the early period, from the 1950s to the late 1970s, he defined the role of the critic in rather combative terms, fighting the evil that oppresses people: the task of the critic was to show how an artist's work can provide a deeper sense of human wholeness and an 'expanded awareness of our potentiality'.[10] In his most recent essays, while his attention to the political details of oppression has not lessened, there is an attempt to address them in a wider framework of understanding the broader whole. This is not an entirely new step but, rather, is a move

from ideological critique towards a genre that gives more space to sensory awareness of the actual world. This genre resembles the mode of writing that Taussig calls 'fabulation' and Latour calls 'poetic writing'.[11]

Reflecting on his own critical approach, Berger tells us that his attention is often captured by a 'living' detail and how this provides an entry point into the wider 'field' of the work.[12] However, in a later essay, he reflects on his approach in a more enigmatic manner. He recounts a dream in which he was standing before a swinging door, but then teases us by stating that he 'magically unremembered' how it opened.[13] These are tantalising comments. They invoke the tension between the boundless whole and the grounded particular that recurs in all of Berger's reflexive statements on art. The organising principle of creativity requires both human intimacy and a cosmic sweep. Berger does not shirk from this magnificent duty. In an essay on the double movement of creation, he concludes with the words of the Chinese painter Shitao: 'The brush is for saving things from chaos'.[14]

CREATION STORIES AS COMPANIONSHIP

A starting point for the exploration of creation can be found in Berger's famous phrase 'ways of seeing'. In the opening sentences of *Ways of Seeing*, Berger posited: 'Seeing comes before words. The child looks and recognises before it speaks.'[15] This highlights the priority of sensory awareness to *logos*– the articulation of thought into language. However, it

is the following passage that catapults us from the source of the senses to the widest frame, as he states that this aesthetic knowledge is the attempt 'to establish our place in the surrounding world'.[16] Most of *Ways of Seeing* is a trenchant polemic against the restrictions that 'normalise' the modes of perception in capitalist societies. However, it also provides an evocation of the inherent potential to revitalise and expand our consciousness of the indivisible experience of being surrounded by the world. Considerable attention has been given to the polemical aspect of Berger's writing.[17] What I will focus on is his poetic awareness of the cosmos.

The phrase 'ways of seeing' usually refers to a 'patterned' mode of perception that reflects a personal inclination, a cultural disposition or at best a global consciousness. Amongst artists this pattern is expressed in a specific aesthetic form. It provides a reference point that coils its way throughout their life's work. This process of aesthetic reiteration is usually addressed as a consequence of psychological drives or as a persistent response to intractable social issues. It is presumed that the artist returns to this *topos*, or persists with a specific *tropos*, because the psyche has been locked into an obsessive and compulsive mode. Or else there is the view that the structures of social conflict are of such indomitable force that the artist cannot but help to keep coming back to confront social tensions. These two models would restrict the function of creativity as if it were a consequence of the individual's psychic make-up, or the confrontation with the inevitable forces of social inequality. I will suggest that Berger's writing on art and

creativity can be explored from another perspective. The third way would consider whether a 'way of seeing' is also expressive of the link between the artistic imaginary and cosmology. It would turn to face the way the visible order carries within it multiple dimensions and is open to new formations.

> Our customary visible order is not the only one: it coexists with other orders. Stories of fairies, sprites, ogres were a human attempt to come to terms with this co-existence. Hunters are continually aware of it and so can read signs we do not see. Children feel it intuitively because they have the habit of hiding behind things. There they discover the interstices between different sets of the visible.[18]

In this passage from the 2001 collection of essays entitled *The Shape of a Pocket*, Berger teases out the keen sensitivities and wide-eyed sensibilities that allow artists to find connections that we would normally gloss over in everyday life. However, the point of this evocation of co-existent sets of the visible is neither simply a reconnaissance mission of missing signs, nor an excavation of the ruined symbols that would otherwise disappear from the field of vision, but a more ambiguous gesture of registration of multiple and more supple ways of seeing. How do we mark out the features of this 'creative' way of seeing, and how is it connected to a way of living with the world, and by this I mean not just the earth, but the cosmos as a whole?

Despite a lifetime of writing on artistic creativity and throughout his persistent reflections on the ontological bonds

that link a person to the world, there is no explicit creation story in Berger's work. In his meditative book *And Our Faces, As Brief as Photos*, he drew on Mircea Eliade's examination of the mythological accounts that posit a connection between a person, their ancestry, the home and the universe:

> Originally home meant the centre of the world – not in a geographical, but in an ontological sense. Mircea Eliade has demonstrated how home was the place from which the world could be *founded*. A home was established, as he says, 'at the heart of the real'. In traditional societies, everything that made sense of the world was real; the surrounding chaos existed and was threatening, but it was threatening because it was *unreal*. Without a home at the centre of the real, one was not only shelter-less, but also lost in nonbeing, in unreality. Without a home everything was fragmentation.

Home was the centre of the world because it was the place where a vertical line crossed with a horizontal one. The vertical line was a path leading upwards to the sky and downwards to the underworld. The horizontal line represented the traffic of the world, all the possible roads leading across the earth to other places. Thus, at home, one was nearest to the gods in the sky and to the dead of the underworld. This nearness promised access to both. And at the same time, one was at the starting point and, hopefully, the returning point of all terrestrial journeys.[19]

The intersection between the vertical and horizontal axes is for Berger the nexus at which meaning both arises and is secured (see also Thorpe's essay 'Fences', this volume). It is simultaneously a confirmation point and a platform for critical self-understanding.

This is a crucial meeting point. While Berger rejects the simplistic modern tales that equate individual freedom with leaving home, he is also not proclaiming that ancient cultural values are static. What is at stake is a more complex negotiation between the vicissitudes of an individual's life history and the wisdom that is condensed into cultural values. Rather than rejecting traditional cultures as being mired in superstition and bound by oppressive hierarchies, Berger is more concerned in exploring the ways in which they provide a source of knowledge that can furnish contemporary guidance and understanding. In the more recent collection of essays on art and the politics of resistance *Hold Everything Dear*, Berger recalls a gesture of consolation from the Islamic tradition.

A small brass bowl called a Fear Cup. Engraved with filigree geometric patterns and some verses from the Koran arranged in the form of a flower. Fill it with water and leave it outside under the stars for a night. Then drink the water whilst praying that it will alleviate the pain and cure you. For many sicknesses the Fear Cup is clearly less effective than a course of antibiotics. But a bowl of water which has reflected the time of the stars, the same water

from which every living thing was made, as is said in the Koran, may help resist the stranglehold.[20]

The strength of this sentimental gesture is that it establishes water as the conductor of the universe's life force. While antibiotics can cure by eliminating some harmful bacteria, it is water that is adopted as the medium that connects the individual with the universe. Berger claims that this symbolic act of union provides a sense of release from the crippling feeling of helplessness and insignificance. It takes away the pain of feeling isolated. Towards the end of the book he quotes from the Caribbean cultural theorist Edouard Glissant who argues that 'the way to resist globalization is … to imagine what is the first sum of all possible particularities and to get used to the idea that, as long as a single particularity is missing, globality will not be what it should be for us'.[21] Berger then adds quotations from Emily Dickinson, Spinoza, and contemporary resistance fighters that both express wonder at the ever-present manifestation of the eternal and compare the freedom gained from the overthrow of tyranny to the reclamation of the power to create the world anew.[22]

Some common elements and a recurring structure can be found in these stories. They contain a common pathway that moves from isolation to connection, and promote a political view on equality and freedom that includes the sense of wonder. Crosscutting these narratives of social solidarity and political emancipation is the work of imagination. From these stories we can see how the source and frame of creativity is presented

not just in terms of its outcomes, such as its capacity to give new form to the meaning of either an object or a relationship with others in the world, but it is also intimated that it is drawn from a desire for companionship.

Companionship is at the heart of Berger's evocation of creation. It is of note that when Berger turns to Michelangelo and acknowledges that he was a figure that 'assumed at the very last possible historical moment – the Renaissance role of the artist as supreme creator',[23] his focus is not on the majesty of formal compositions, for this would be akin to staring at the finger when God was pointing to the light, but on the perverse conjuring of the very act of creation. For Michelangelo, this creation story was itself a manifestation of a creation fantasy. Staring up at the Sistine Chapel Berger notices that this male artist assumed the ability to give birth:

> The whole ceiling is really about Creation and for him, in the last coil of his longing. Creation meant everything imaginable being born, thrusting and flying from between men's legs.[24]

The point of creation for Berger is not just the production of a pure idea that can acquire material form, or the discovery of a source from which growth proceeds, but is expressive of a desire for companionship. For the generation of art critics that preceded Berger, such as Herbert Read and Kenneth Clark, the idea of the artist as Promethean creator was a given. One of the primary functions of *Ways of Seeing* was to establish an

alternative frame for interpreting the 'mysterious forms' of art, and to provide a more grounded approach for evaluating the agency of the artist. Hence, in a later essay Berger makes explicit his rejection of the illusion that the artist stands above society, draws on mystical forces and creates new forms with divine authority.[25] Berger insists that there is no real autogenesis in art. He sees artists as 'receivers' and beneficiaries of signs being sent to them. Creation comes from the artist's ability to give form to what he has received. Hence, if creativity seeks companionship with the universe, then it begins in the process of collaboration.

To conclude, Berger's early work adopted an internationalist perspective on art and politics that was closely affiliated to the New Left. This robust cosmopolitan vision was embedded in an anti-colonial and transnational revolutionary ideology. However, Berger also confessed to being both a 'bad Marxist', in that he had an aversion to power, and a 'romantic' who upheld the capacity for subjective intuitions to keep him open to the mysteries of art, love and the universe.[26] The interplay between this overt political stance and implicit subjective union with others has taken new dimensions in his recent writings on art. It has led to a cosmopolitan imaginary that combines a celestial and terrestrial sense of unity. This perspective brings us to what I believe is the core question in Berger's work. In what ways do we belong to the world?

NOTES

1 Berger, J. (2011) Paint It Black, *Guardian*, 12 December, 2011, www. theguardian.com/artanddesign/2011/dec/12/cezanne-paint-it-black.

2 Merleau-Ponty, M. (1964) Cezanne's Doubt, in *Sense and Non-Sense*, translated by. H. L. Dreyfus and P. Allen Dreyfus, Evanston, IL: Northwestern University Press, p. 16.

3 On the 'cosmopolitan imaginary' see Papastergiadis, N. (2012) *Cosmopolitanism and Culture*, Cambridge: Polity Press, pp. 81–92.

4 Berger, J. (1960) *Permanent Red,* London: Methuen; (1969) *Art and Revolution*, London: Writers and Readers.

5 Berger, J. (2007) *Hold Everything Dear*, London: Verso, p. 121.

6 Berger, J. (2011) *Bento's Sketchbook*, London: Verso.

7 Ibid.

8 Berger, *Permanent Red*, p. 51.

9 Berger, Paint It Black.

10 Berger, J. and McQueen, H. (1983) Interviewing Berger, *Aspect*, 26–27, Winter, pp. 57–65.

11 Taussig, M. (1986) *Shamanism, Colonialism and the Wild Man*, Chicago: University of Chicago Press. Latour, B. (2004) Why Has Critique Run out of Steam? From Matters of Fact to Matters of Concern, *Critical Inquiry*, Vol. 30, No. 2, Winter, pp. 225–248.

12 Berger, J. (1980) *About Looking*, New York: Pantheon.

13 Berger, J. (2001) *The Shape of a Pocket*, London: Bloomsbury. p.13.

14 Ibid.

15 Berger, J. (1972) *Ways of Seeing*, London: British Broadcasting Corporation and Penguin Books, p. 7.

16 Ibid., p. 7.

17 MacIntyre, A. (1960) The Barricades of Art, *New Statesman*, 29 October 1960. Caute, D. (1974) *Collisions*, London: Quartet Books. Robbins, B. (1986) Feeling Global: John Berger and Experience, in J. Arac, ed., *Postmodern Politics*, Manchester University Press, pp. 145–161. Dyer, G. (1986) *Ways of Telling*, London: Pluto Press.

18 Berger, *The Shape of a Pocket*, p. 5.

19 Berger, J. (1984/2005) *And Our Faces, My Heart, Brief as Photos*, London: Bloomsbury, pp. 55–56.

20 Berger, *Hold Everything Dear*, p. 73.

21 Ibid., p. 117.

22 Berger, *The Shape of a Pocket*, p. 119.

23 Ibid., p. 98.

24 Ibid., p. 99.

25 Ibid., p. 18.

26 Berger, *And Our Faces*, pp. 37–38.

TOAST

'TO THE LIGHT IN CHARDIN'S JUG!'

MICHAEL BROUGHTON

Ta de panta oiakizei keraunos / Lightning steers all

<div align="right">HERACLITUS[1]</div>

Entering art school in the mid1990s with the illusions, pretensions and hopes, as well as the absolute certitude, of wanting to become a painter, I had (only marginally) less idea of what that then meant than I do today. I remember the intoxicated, giddy feeling – against the known context of a life thus far spent in school – of spending all day everyday, as far as I could see, making drawings and paintings. The last thing I wanted to sully my new utopian quarantine were books and words. Almost literally, at the door, I received the 'standard issue' copy of *Ways of Seeing*,[2]and having already assured myself of my own genius in a ceremony of my mind, I tossed the book to one side where it lived on a table of clutter in my studio. *Ways of Seeing*'s first entry into my life was as a visual object amongst others that made a brief cameo in some long-since-forgotten still life.

For me the first touchstones were primarily paintings, books and writings (especially those of John Berger); they were only later to become – intimacy wise – equidistant in shaping my thoughts. Was John Berger an influence after all? The answer is twofold. If influence and motivation are about being a first mover, in the way that I can think of Constable and Van Gogh, then John's writings had no impact on me at all. If, on the other hand, I discovered his shapely voice articulating something already, always underway, then it gave me comfort and a sense of brotherhood that ameliorated the isolation and self-doubt of a studio life. His influence was to continue.

In 2010 as I was preparing for a second solo show in London, I was asked, 'Who would you like to write a catalogue introduction?' I replied, 'Naturally… John Berger!' So I sent a winged message of hope and low expectation, only to receive a kind reply of sympathy which expressed the impossibility of writing about paintings which he hadn't actually seen in the flesh. 'No problem,' I wrote. 'I'll bring them all to your house.'

I managed to skid into snow-covered Quincy with a van full of paintings, shortly after the New Year of 2011. John's son Yves and I unloaded the paintings into the barn, and with his renowned hospitality, John escorted me to a nearby hotel owned by some friends. The next day we looked at the paintings.

The works were a selection from the previous three years which took their origins within two principal subjects: namely my own studio with its contents; and an adjacent disused room for playing snooker. The paintings were dealing with painting, which take their form as light, space and familiarity presented

as a live event of visual recall. For better or worse they are mere lived-out experiences in paint that try to describe a feeling for 'place' in a mode of drawing. Simple.

From the conversations we had around one particular painting, *Studio Interior I*, (see Figure 4) John drew out the unifying theme of 'time', and parallels were drawn between the church paintings of Pieter Saenredam (an undisclosed first-mover influence) and their intrinsic relation to time and light. The working title of 'Big Moments' was provisionally noted

4

Studio Interior I, 2011, oil on board 153.5 x 170cm, courtesy of Art Space Gallery London, Michael Richardson Contemporary Art

and all this immateriality was left parked in John's mind. We all left shortly after for an evening meal, and spoke of other things. Perhaps, as in all his writings, it has been this capacity that touches me most deeply – the negation of deep truth, negative in character, brought warmly into the light – never reductive but always bodily and always tender:

> The painted light in these works is not the light of Reason, nor is it the light of astrophysics. It is the light of intimacy. And intimacy has its own time-scale, distinct from the time of clocks or calendars: an irregular time-scale which slows down to make some moments big, and accelerates to make other moments irrelevant. This is why such light can play with the notion of the eternal. The eternal with a small e
>
> They don't capture an outside light, they await light. And slowly, dimly, the act of waiting becomes itself light, an interior light.
>
> Here the dual meaning of the word interior spells out the riddle. We are looking at paintings of interiors whose intimate space is inhabited by an interior light.[3]

As the time approached to return, we all took a small drink in John and Beverly's kitchen, a toast for the way home. 'Down the hatch!' someone said. John added, 'To the light in Chardin's jug!' It was something we already understood namelessly – the visible and the intelligible.

NOTES

1 Heidegger, M. and Fink, E (1993)*Heraclitus Seminar 1966/67*, translated by C. H. Seibert, Evanston, IL: North Western University Evanston Press, p. 4.
2 Berger, J. (1972) *Ways of Seeing*, London: British Broadcasting Corporation and Penguin Books.
3 Berger, J. (2011) Big Moments, in Michael Richardson, ed., *Michael Broughton – Big Moments: Paintings 2012,* London: Art Space Gallery, p. 4, www.artspacegallery.co.uk/BOOKS/Broughton2012/pageflip.html

OIL

ON A MOTORBIKE TO

TESSA MCWATT

For two centuries we've believed in history as a highway which was taking us to a future such as nobody had ever known before. We thought we were exempt. When we walked through the galleries of the old palaces and saw all those massacres and last rites and decapitated heads on platters, all painted and framed on the walls, we told ourselves we had come a long way – not so far that we couldn't still feel for them, of course, but far enough to know that we'd been spared. Now people live to be much older. There are anaesthetics. We've landed on the moon. There are no more slaves. We apply reason to everything. Even to Salome dancing. We forgave the past its terrors because they occurred in the Dark Ages. Now, suddenly we find ourselves far from any highway, perched like puffins on a cliff ledge in the dark.

This speech, from the taxi driver in John Berger's novel *To the Wedding*,[1] gives us Berger the man, the voice, the storyteller. Here we have the two key elements of his alchemy: the guidance of history; and the imperative of the ordinary. In one paragraph he guides our gaze to our past predicaments, through art, while

grounding us in an ordinary moment in a coach, as a group of people travel towards their individual futures. Zdena, to whom the taxi driver is speaking, responds like this:

I can't fly.

Well, nor can I. Perched like puffins on a cliff ledge in the dark – yes, I see us there. Now. But when I read Berger, I come as close as I ever might to feeling that I might be able one day to lift off. To see clearly. To hope. Even possibly to fly.

My relationship with Berger, the work and the man, began through *To the Wedding*. This single book and my ongoing endeavour to develop a film based on it are touchstones to his influence more broadly. Berger uncovers angles in the world that broaden it. He draws us not only to ways of seeing, but also to ways of being, by example. John is all about motion. His verbs: to listen, to see, to share. And specifically, in the case of *To the Wedding*: to journey.

'The most important thing to pay attention to', Berger has said about the title of the novel, 'is the preposition – to.' His commitment to action is manifest in that imperative. We are all travelling *to*– where we're going is of minor consequence. The journey is what counts. Action and motion: these make life bearable.

The motorbike with its headlights zigzags up the mountain. From time to time it disappears behind escarpments and rocks and all the while it is climbing and becoming smaller. Now its

*light is flickering like the flame of a small votive candle against an
immense face of stone.*

To the Wedding the film was sparked by *a coup de foudre* (a
phrase used by many to describe first encounters with Berger)
in 1995 when the book first appeared. I distinctly remember
reaching the end of the novel with the hairs rising up along my
neck in response to the image of Ninon standing before Gino
in her wedding dress, which is *soiled like a flag after a battle.*
This arrival would be enough in itself – a moment possible only
through Gino's persistent love for Ninon, who would soon die
of AIDS. But we arrive at the wedding already changed. Jean
and Zdena travel towards one another after many years, to the
wedding of their dying daughter, and it is this journey through
loss and reconciliation that has us agreeing with Zdena: *Let
these days never end, let them be long like centuries!* Through
fragments, voices, and a defiance of linearity, the story unfolds
like a secret. With the Berlin Wall down, the borders open, we
travel through more than just territories. The changed and
changing face of a continent is explored through encounters
with its inhabitants, and through the lens of a generation
of activists. Walls are down between the young and the old.
Between life and death. The final cadence is so elemental that
it's devastating: *Her skin glistens.* A simple gesture ends the
novel, as Gino undoes a single braid of Ninon's hair.

A rush of air. An overwhelming lightness. My fate was sealed.

Many years later, I, like the novel's blind narrator, still
cling to words or phrases which seem to ring true. The narrator

is a tamata seller whose wares give comfort to those in peril like Jean, who buys one for the daughter who is suffering *everywhere*. A tama provides that *in exchange for a promise made, people hope for a blessing or a deliverance.* My promise has been to the film adaptation, and the deliverance has been a deepening relationship to aesthetics and authenticity.

Up there in the sky there's no need for aesthetics. Here on earth people seek the beautiful because it vaguely reminds them of the good. This is the only reason for aesthetics. They're the reminder of something that has gone.

I first met John Berger in 2000. It had been his book that I had held up to my producer friend when he'd asked me if there were any stories I'd loved so much that I wanted them brought to a wider audience through film. 'This one,' I said, waving it, stealing Michael Ondaatje's back cover quote: 'Wherever I go in the world I will have this book with me.'

My friend gave me John's phone number the next day. 'Call him,' he said.

Spellbound by Berger the writer and the man, I didn't see how a cold call would be possible. I wrote to him, explained my intentions, described my passion, and a few days later he called me. His voice – with its unique, hybrid accent, its now familiar hesitations and qualifications that are the aperture to insight – told me that while he supported an adaptation, he wondered if one was necessary.

'The story exists,' he said. 'It is there, for anyone who wants it.' This angle on necessity levered open issues of commodification that have governed my approach to the adaptation. For John, only the possibility of a new work of art would make an adaptation necessary. Merely transcribing words from the page to images on the screen was not where art would reside. Adaptation, I would come to see, was not the same as translation. I assured him that the story would inspire the right artist. We arranged to meet the next time he was in London.

Lunch at a sleek, trendy restaurant was generously arranged by the film company. The food was good, the acoustics terrible. John kept looking up at the ceiling, as though to something lost, as we tried to talk over the din. His thinking seemed disturbed in a venue that had neglected the vastness of its guests. We declined dessert, and he led us to a nearby pub on a street next to the one where he grew up. Here the atmosphere allowed conversation. He talked of European filmmakers and artists with both delicate respect and criticism, framing shared themes, pointing out minuscule effects like the choice of a character's socks. I held tight to my awe, and soon realised he wanted none of that. When he asked me to send him the novel I was writing, I felt like I'd betrayed my mission. I wondered what audacity I might have revealed that led to this offering. I would in time learn that this is another element of his alchemy. His critical and artistic practices are not separated from his social engagement. They are all part of the dialogue of his storytelling. His feedback on my manuscript would turn out to be just the beginning of his generosity. I regularly consult with him over the phone

about ideas and drafts, and he supports me at all stages. Before we hang up he sometimes says, 'Now, I put my hand on your shoulder and turn you back to your work.'

The feeling of wings.

We discussed the novel's relevance to the new millennium. I raised concerns about how a contemporary audience might engage with a story about AIDS now that life-sustaining drugs are available in rich countries, but inaccessible to many in African countries. I wanted to somehow acknowledge the non-European experience of HIV and AIDS and the devastation that was taking place in other parts of the world. He thought for a long time about this, as he does about everything put to him. His hesitations were audible. His agreement with my concerns was palpable, and his response had that feeling of a Polaroid image revealed. It would happen in an organic way through our consciousness of it, he said. Without forcing it, and by focusing on the truth in the story at hand, we would respect the parallel truth of stories outside of it.

And the thrush sings like a survivor – like a swimmer who swam for it through the water and made it to the safe side of the night and flew into the tree to shake the drops from his back and announce: I'm here!

Over the next few months, we exchanged ideas about film-makers. He never forced an opinion. Soon in our exchanges

it became clear that the key blueprint to our shared principles for the film would be the screenplay. And as it had been so far my passion alone that had driven the project, John said, 'Tessa, why don't you write the script?'

You've never flown, even in dream?
Perhaps.
It's a question of belief.

I am not a screenwriter by training or by inclination, but from him I took the suggestion seriously. That feeling of wings: a new vantage point that art makes possible. I considered his proposal. I knew that if I were to take the story on I would have to go to my own body. The only way I could imagine Ninon's isolation and feeling of being outcast in Italy was to make her mixed-race, like me, to have her sense of belonging threatened not only by her diagnosis but by an intersectionality in a Europe that hadn't yet – and arguably still hasn't – come to terms with its colonial past. In order to make the script mine I would need Ninon's journey to be one of greater displacement. That meant for me that Jean would have to be black, while Zdena would remain Caucasian of Slovakian origin.

Writing Ninon as mixed-race now meant that the characters' predicaments, and the resonance around her contracting AIDS, would be more profound on the symbolic levels of genetics and hybridity. The border crossing in the story would now have reverberations that are even more compelling today than when I began. My projection of Jean, as he travels across

France and Italy on his motorbike – a black man in an altered Europe, where borders are open but where he is a visible reminder to Europeans of further change, indeed of the Africa I had been concerned about representing – brought unexpected ripples towards deeper interpretations of some of the passages in the novel.

In the hut on the riverbank where Jean Ferrero is sleeping, the Po is audible: it makes a noise like lips being licked because the mouth is too dry. Yet rivers never speak and their indifference is proverbial. The Alamana, the Po, the Rhine, the Danube, the Dnieper, the Sava, the Elbe, the Koca, where some lost soldiers of Alexander the Great fought stragglers of the Persian army in a skirmish of which there is no record – there's not a great river anywhere for which men have not died in battle, their blood washed away in a few minutes. And at night after the battles, the massacres begin.

Through this projection of race I had arrived at a new way of thinking about what authenticity was, how a story can adapt to the personal preoccupations of any given artist, how a single story will never speak only to a single experience. From that opening came greater challenges: how to adapt the language of prose to the language of film. How would a film be true to the novel's politics as well as its emotions? Authenticity is a tough master to serve.

I am a novelist who deals with the themes of belonging and displacement, but the challenge of the screenplay, as a woman from a complex diasporic background (when people ask, I

ream off a list of 'bloodlines' and ethnicities: Scottish, African, English, Amerindian, French, Indian, Portuguese, Chinese, the order for which is suggested only in the context of British colonialism), became one that was vital to my development.

The central image of the story for me became the virus. Not as something pernicious, but as an instrument of change. Viruses engage in border crossing. Their survival demands it. A treacherous journey is involved. The destination 'host' becomes altered. Change is lasting.

The scene in which Jean meets the hackers also gained more resonance. These young, vibrant men are emblematic of the disenfranchised youth of the early internet, whose hero, Captain Crunch, was breaking into systems. Berger reminds us that the internet has its roots in resistance, in rebellion, in freedom.

We hack to stay alive! says Lunatic, we hack to stay on the planet.
And to show them they can't keep us out and never will …

The hackers have *invented a virus too*, and Berger foreshadows groups like Hactivisimo, Cult of the Dead Cow and Anonymous – hackers who have taken their radical activism into cyberspace.

Within the frame of change and resistance, the wedding itself becomes a border crossing: the passage that pernicious despair makes towards hope. The story's border crossings involve countries, the past to the present, a generation of Europeans from behind a wall, and each of these is embodied in the characters. Sex transmits the HIV virus, and as such the

body becomes the site of ultimate danger and change. But Gino is not afraid, and it is his passion in the face of death that drives the narrative, his refusal to be separated from love. So the virus paradoxically leads to the healing of wounds.

I was pushing, says Gino, pushing and pushing with my feet against the planks – his laughter was all mixed up with the sunlight and with what he was saying – to lift you up and up and up and the wall of the house fell down!

Being mixed-race signifies many borders already crossed. The losses implicit in the crossings, along with the explicit newness that needs a voice – a chorus of voices – will be, in the film, the aesthetic shorthand to Berger's prescience of the changes that were underway in 1990 and are culminating with urgency today.

'As soon as we use the terms "us" and "them",' I once heard John say in an interview, 'there is the potential for barbarism.' His insistence on a social 'we' is underscored by the wedding. The celebration, the healing, the ordinary joy: the wedding scene is an affirmation of shared spirit.

It's hard, he says. We're living on the brink and it's hard because we've lost the habit.

A script is only a map. The next crucial bridge to a film became finding the right director. Now, a couple of years into the process, the original producers were no longer

involved and I had no money to develop the project myself. The Canadian production company Screen Sirens contacted me independently, spurred by the passion of Helen du Toit, who, like me, had experienced a *coup de foudre* on first reading the novel. They attached the gifted director Keith Behrman to collaborate with me. The team worked in development for several years, until various circumstances changed and the project was stalled. Even so, the issues that arose in conversations between creative and financial partners brought more light to the complexities of an authentic portrayal. As the years passed, it became clear that we were now dealing with a period film and the challenges of representing a complex moment in history. Visual choices would produce different emotions. Making an adaptation was another border crossing, after all, and it was key in my evolution as an artist. Throughout all of this, John was humble, trusting, grateful. I learned patience and faith in art. I also learned about the restrictions of co-productions, the tyranny of commercialism, and the fickleness of passions, but these only served to strengthen my conviction that this slow road to making art might be the only reason to do anything.

We've lost the habit.
Of flying?
No, of living on a ledge.

Helen du Toit and I eventually decided to go it alone. We have a director, Andrea Pallaoro, whose response to the novel

matches ours. An Italian who is intimately familiar with the River Po, where *the waters change all the while and stay the same only on the map*, he has taken on the script to infuse it with the language of cinema and his own vision. The screenplay is no longer mine, but as a creative producer I am learning a different side of collective art making.

I dream of a film.

I dream of showing it to John. The barbarism of 'us' and 'them' dialogues proliferate around us.

You have to be frightened, he says.
Frightened I am.
Then you'll fly.

At the end of the novel, the blind narrator slips into the future tense. He imagines rather than recounts the wedding, and this verb tense bears the pearl of Berger's offering:

They will sit side by side at the large table, surrounded by thirty people, and she will notice everything which is happening. Nothing will escape her. Wedding feasts are the happiest because something new is beginning, and with the newness comes a reminder of appetite, even to the oldest guests.

And *here is where we meet* (to borrow another Berger title):[2] at the intersection of our bodies, our countries, and our losses. Ninon's foreshadowed death reminds us that the dead are among us and that their spirit is unifying. If we forget them,

we forget ourselves. The eternal border crossing is from now towards the future, and the future is all about possibility.

This long journey towards a film adaptation feels like the slowness of awareness, of awakening – an evolution towards a collective authenticity. The years feel like nothing. And the novel is the perfect tama.

What shall we do before eternity?
Take our time.

NOTES

[1] Berger, J. (1995) *To the Wedding*, London: Bloomsbury. All italicised passages in my essay are taken from this novel.
[2] Berger, J. (2005) *Here Is Where We Meet*, London: Bloomsbury.

THE TREES ARE IN THEIR PLACE

FENCES

A TRACTOR-COLOURED APPLE

NICK THORPE

> To live and die amongst foreigners may seem less
> absurd than to live persecuted tortured by one's fellow
> countrymen ... But to emigrate is always to dismantle the
> centre of the world, and so to move into a lost, disoriented
> one of fragments.[1]

I carry these words of John Berger close to my heart as I trudge
the sandy labyrinth of tracks which riddle the Hungarian-
Serbian border, on the trail of yet another group of asylum
seekers from the zones of war and hunger which abut so closely
on our own comfortable world. Or as I stand on the shore at
Piraeus, watching families walk down the gangway of the Blue
Star ferry from the Greek islands, wrapped in grey, UN-issue
blankets. Or as I trawl the kaleidoscope of Facebook images,
in search of the young men and women from Congo, Syria,
Afghanistan or Iran I've met in the borderlands, on their way to
seek safety and happiness in Europe.

Berger's writings place the new refugee crisis in the
context of our common experience of dislocation. We are all

economic migrants now, he reminds us. And the slave trade of the sixteenth and seventeenth and eighteenth centuries, the no-man's-land of the First World War, the concentration camps of the Second, and the disappearance of the peasantry of Europe are all part of that trend of ripping out our roots, at our own peril. Perhaps he also points out a space, up ahead, where we can all sit together and reach something like a consensus. And he offers a theme about which we might actually agree – the need all us migrants feel, deep down, for a sense of home.

I ask the refugees I meet the same questions. Who are you? What do you want? How long do you plan to stay? Why did you leave? Why now? Who and what did you leave behind? And do you think you will ever go back?

Hanna was from Eritrea. I met her at the roadside in Asotthalom, on the Hungarian-Serbian border, in early August 2015. By then, the Hungarian government had already started building a razor-wire fence along the whole length of that border, to keep people like her out. It was built by prison inmates, and rolled out and hammered in by soldiers and men and women on government work schemes. It was controversial in Hungary, among other reasons because it bore more than a passing resemblance to the Iron Curtain, torn down twenty-six years earlier. Also because half a million Hungarians have emigrated to western Europe in recent years, and are known as 'migrants' in countries like Britain. How could they now refuse to provide temporary shelter to others?

'Have you heard about the fence?' I asked Hanna.

'I saw it ...' she whispered. Would it have stopped her? 'Nothing will stop us now,' she said. The astonishing determination of the refugees, to just keep going, come hell or high water, struck many observers.

Her husband was from Burundi. He had lived in a refugee camp in Greece for thirteen years. Hanna was in the same place for seven. They met there, had two children, but never got the papers that would have allowed them to work or make a home in Greece. So when they saw the new wave of refugees passing through, they tagged along. The mystery of the large numbers coming to Europe can be partly explained by this copycat effect. The growing violence and insecurity in many countries, and the greed of the smugglers for ever-bigger profits, are other causes.

As we stood talking by the road, her eighteen-month-old daughter tugged her by one arm, her five-year-old son by the other. The boy had a small blue wind-up torch – a treasure in the past night, a plaything since dawn.

Then a man driving a red tractor slowed down, and handed Hanna a shiny, tractor-coloured apple. She took it graciously, with a murmur of thanks in her own language.

'We do not know who these people are,' the Hungarian prime minister Viktor Orban argued, in justifying his decision to build the fence. So why don't you come down here and ask them? I wanted to ask him.

*

Asotthalom is a relatively poor, rural community. Many people here had grown weary of the constant stream of migrants, night after night, knocking on their doors, asking for food or water, or setting their dogs barking. The mayor, from the far-right Jobbik party, went so far as to record a video message to all migrants, to steer clear of his village. But they kept coming until the fence was finished, and local people, the police, and volunteers from all over the country and beyond kept helping them, whatever the politicians said.

One of the reasons Hanna fled Eritrea in her late teens, she explained, was that she had been subjected to female genital mutilation. Even now, when she makes love with her husband, the pain is bad, she said.

Why was this stranger telling me the most intimate facts of her life? The media stand accused of peddling emotion, of blackmailing the public into accepting hundreds of thousands of people like Hanna into Europe. I see our work rather as an act of witness. We stand as messengers on the border, facing both ways. Replying to questions as well as posing them. Recording the huge diversity of the new arrivals. Each story is different.

What do you say to all those in Europe who fear you, who resent your arrival? I asked a man from Gao in Mali. *Je ne demande que ta pitié,* he answered. I want nothing more than your pity.

A man came down the railway track at Roszke, dressed in suit and tie, stained dark with sweat, limping heavily, supported on both sides by his relatives. He had walked from Damascus, he said. But who are you? I asked. That railway

track, in August and September 2015, became the main point of entry into Hungary for thousands of people each day from Serbia. Each dawn I stood there, interviewing the newcomers. As he paused before replying, I noticed how tall he was. 'I am, sir, a sovereign man.' And in this Europe of sovereign nations, scrambling to defend their borders, I was suddenly pleased to meet a sovereign man.

Another morning at the same spot a Syrian man asked me to approach on his behalf two young police officers, whose patrol car was parked right across the track. His wife and daughter were hiding in the reeds on the Serbian side. What would the police do if the three of them tried to cross the border? The policemen explained that they would do nothing to stop them. The man seemed unconvinced. Upset by the thought that they might seem fearsome, the policemen got into their car and drove away. And three more souls entered the European Union, with a lighter heart.

For a time, the focus of the refugee story shifted to Budapest. The government couldn't stop them coming in until the fence was ready, but it tried to stop them travelling on – the only country in Europe, the government explained, trying to keep the rules of the Schengen zone. The newly restored square in front of the East Station, and the subways below, quickly filled up with little tents, and hundreds of people sleeping rough, beside or inside them. The Budapest police chief rang Zsuzsanna Zsohar, one of the organisers of the hundreds of volunteers trying to care for the migrants, to ask what help she needed. Some Hungarians cursed, but many helped. Others

just gaped. A red-nosed clown entertained the children. A boy drew a new map for me of his own country. Blue, white and green horizontal lines, with three hearts in the middle, specked with blue dots. The tears, Alam Hamdal explained, 'of the Syrian people'

Children blew bubbles, which billowed over the heads of the crowd. I met a distraught seventeen- year-old boy, looking for his thirteen-year-old brother. Each kept ringing their mother in Kabul, who had no idea of the geography of Budapest. I produced a map. It turned out his brother was at the West station, while he was at the East.

Upstairs, riot police in full body armour and maroon caps clustered along the main steps like hornets, denying access to the platforms. In Forget-Me-Not street nearby, every single plug in each fast-food restaurant overflowed with the travellers' mobile phones. An elderly German tourist from Bavaria approached me in despair. He had been trying in vain for hours to find somewhere to recharge his phone, in order to track down other members of his group. I took him into the reception area of a hotel, found him a spare plug and a seat, and ordered him a beer. After a while he burst into tears. 'I feel so sorry for these poor people,' he explained. He had been a refugee himself, after the Second World War.

The days got shorter and the fences longer. I watched a rabbit, at dawn, hop up to the razorwire out of the destroyed undergrowth, then hop forlornly back. Ten kilometres from the Hungarian-Croatian border, at Illocska, we found a lone railway carriage wrapped in razor wire like Christmas tinsel,

waiting to plug the railway line here too, when the government decided to close the border. And decorated it with the large white empty snail shells we found lying between the sleepers.

No more migrants came through Hungary. They were diverted westwards, through Croatia and Slovenia instead. Someone from Frontex, the European border agency, explained to me that migration is like a balloon. You squeeze it in one place, it gets bigger somewhere else. On a European level, Hungary's fence was useless. And when other countries began building them, the migrants just got stuck behind the latest barrier. Or the smugglers' rates went up. 'Only public transport', a Syrian acquaintance explained to me in Bosnia, 'makes the smugglers redundant.'

One night in Slovenia I asked a man from Aleppo what he thought of the fact that the Russians had started bombing his country. 'Everyone bombs us now,' he said. 'And each explains that they are doing it to help us.'

Another time in Slovenia, I stood in front of the camera in the refugee camp in Lendava, in my little puddle of technology, one cable protruding from my ear, another from my collar, as small, shy crowds gathered around us. They wanted to borrow our phones. Some got through, most didn't. For the rest of the day, the phones rang, returning missed calls. Someone's brother from the United Arab Emirates. Someone's father from Kandahar. A woman who lost track of her father in the mud and rain in Croatia. A man desperate to find his pregnant wife and children. There were calls from Iran and Iraq in Farsi or Arabic. We replied in our incomprehensible English. My

colleague Orsi went back to the camp in the evening with a photo, sent on a phone from a refugee camp in Austria. She went from one group of Afghans to another. No one recognised the faces. Then she heard running footsteps, and was pulled into a huddle of women beside a long blue tent, and hugged and thanked. Another family reunited.

In the same camp I met Elyssa, from Afghanistan. At the age of eleven, he had fled with his family to Iran. At the age of fifteen, he was working in a factory when the Revolutionary Guard arrived, to press-gang Afghan migrants into fighting in Iranian units for the Assad regime in Syria. If he didn't go, he and his family would be kicked out of Iran, he was told. After three weeks' military training, he found himself on the front line. Before going into battle, they were given morphine. He fought out of his mind, he said. After three months he was allowed home on leave, for a religious holiday. He fled to Turkey. Traumatised by his experience of war, when I left him he was sitting in the sunshine outside a dark green tent, his eyes tight shut.

In another part of the camp, the boys played football. Syria 4 – Afghanistan 3. Or the other way round. Noone was counting. The goalposts were rubber tyres. A high-scoring game. The goalkeepers were reluctant to dive on the hard tarmac, after travelling so far, and risking life and limb, shot at by Iranian border guards, bitten by Bulgarian police dogs, or robbed at knifepoint by smugglers.

Aristote from Congo reached Brussels with his pregnant wife after hiding under the seats of railways carriages all the

way from Budapest. They had tickets, but the police turned them off so many times – in Hungary, Austria, and Germany. By the time they got to Belgium, they had exhausted all their funds. After a week living on the street, a family invited them in. Their baby girl was born the following January, in Brussels.

Just before Christmas 2015 I was in Athens. By then the Balkan countries had announced that they would only allow refugees from Syria, Iraq and Afghanistan to proceed. It was as if the right to asylum had been nationalised. All others would be turned back.

Tariq was from Morocco. What would you be doing, this Saturday evening, if you were not drinking beer with me in Athens, waiting to pay fifteen hundred euros to a trafficker? He shrugged. 'Drinking beer in my own town. Going to the disco.' He had already reached Macedonia once since the border fence was built. He and his friends crossed illegally and walked for six days through the forest. On the first day, he fed a precious scrap of food to a three-legged dog. He showed me a photograph of it on his phone. From then on, the dog followed him everywhere. Until they were caught by the Macedonian police, just short of the Serbian border. And sent all the way back to Greece. He last saw that dog, standing on the railway platform, looking after his retreating train.

Tariq was an economic migrant. He was not fleeing war or persecution. Like many migrants he did not tell his family he was leaving. He was escaping poverty, he said. He just wanted a 'normal' life. The next day he sent me a photograph of himself

and his friend on a bus, bound for the Macedonian border again. He was supposed to walk through the mountains, then a car was supposed to pick up him and several other Moroccans and drive them to Belgrade, where they would receive false Syrian papers. And continue their journey to Germany. Two days later he was back in Athens. Their car had been stopped by Macedonian police, again near the Serbian border. He was determined to try again. The money he paid was still safe, he hoped, in the drawer of an Athenian 'travel agent'. Only when he reaches the safety of Austria will he ring the man who knows the combination for the lock.

A million refugees paid smugglers around four thousand dollars each to reach western Europe. $4 billion. The smugglers were Afghans, Syrians, Turks, Bulgarians, Romanians, Serbs, Romanians, or Hungarians. For a time in August and September 2015, the petrol stations at Roszke were taken over by bulky Roma 'businessmen' from Borsod county in eastern Hungary. Twelve to a van, $250 apiece, for the two-hour journey to Budapest. The same journey would have cost $10 by train. But there was no information. No interpreters at the border. The government did not want to help them. There were only three portable toilets for a thousand people.

Nearby, on the motorway, a million Turkish guestworkers passed on the same route, returning to Germany after their holidays. The Hungarian police were nonplussed by so many Muslims at once, some picnicking beside their Mercedes, some tramping up the highway.

Then there were the volunteers, idealists from western or central Europe, anarchists trying to rescue the reputation of Christian Europe for kindness. They painted *No Borders* on their vans and tents, and served hot food or tea all night to the migrants as they crossed. They quarrelled with the Red Cross, or Christian agencies such as Caritas, who enjoyed privileged relations with the disaster management teams in each country. Some volunteers traipsed for months from border to border. 'I consider it my duty to help,' said Martin, a travelling baker from Mainz, brushing off the thanks of another early-morning migrant on the Bulgarian-Serbian border.

What has made the influx so frightening for many Europeans is the apparent finality of it all. What if all these people stay forever? What if they invite their relatives to join them? How can all those who speak no European language hope to integrate? Will the new ghettos where they gravitate become breeding grounds for terrorism?

The drunken attacks on women and girls at the railway station in Cologne on New Year's Eve 2015 by men of mostly North African or Arabic background became a graphic example of what can go wrong, by design or accident. 'This has nothing to do with Islam,' one of the victims, an Afghan woman who had lived in Germany for two years, told the local newspaper. 'Religion is irrelevant for most of these men. What they lack is respect for women.'

'Home was the centre of the world because it was the place where a vertical line crossed with a horizontal one,' Berger wrote.

The vertical line was a path leading upwards to the sky and downwards to the underworld. The horizontal line represented the traffic of the world, all the possible roads leading across the earth to other places. Thus, at home, one was nearest to the gods in the sky and to the dead in the underworld. This nearness promised access to both. And at the same time, one was at the starting point and, hopefully, the returning point of all terrestrial journeys.[2]

It is easier to destroy the vertical lines than the horizontal ones (see also 'Forest' by Papastergiadis, this volume). The survivors limp out of the ruins of Sinjar or Aleppo, and eventually reach Turkey's west coast.

New vertical lines, new buildings, new trees grow out of the plain. 'There is nothing that they can destroy,' the Croatian architect Radovan Ivančević said of the ruined Ottoman bridge in Mostar, 'that we fanatics will not rebuild.'

In the Roma ghetto on the edge of Jilava in Romania, a family waits for the return of the children's mother from the care home where she works in Denmark, with enough money to build a second room for their shack.

And in the borderlands of central Europe, Hanna carefully hands her new apple to her daughter, who delights in its touch and texture, so alike and unlike her brother's blue torch.

NOTES

[1] Berger, J. (1984) *And Our Faces, My Heart, Brief as Photos*, London: Bloomsbury, p. 57.
[2] Ibid., p. 56.

METHOD

WAYS OF SEEING MIGRATION, WAYS OF NARRATING...THE WORLD

IAIN CHAMBERS

History, political theory, sociology can help one to understand that 'the normal' is only normative. Unfortunately these disciplines are usually used to do the opposite: to serve tradition by asking questions in such a way that the answers sanctify the norms as absolutes.[1]

Seeing comes before words.[2]

John Berger's writings have always acquired an artistic autonomy. Yet I have also been consistently struck by the manner in which his critical montage of words and images carries us through the poetical to a further understanding of the political. The language is never neutral nor does it seek the illusory transparency of the social sciences or an empirical culture. The words are like weights, constantly threatening to leave holes in the page. The eye is irresistibly drawn in. His books are albums of late modernity. In them the persistence of

photographs pushes us beyond the reach of words. The photographs introduce us to another, non-verbal, grammar: another way of telling.

Berger himself renders this procedure clear in some pages in *Another Way of Telling*.[3] I will initially look at this work as I feel that it renders explicit the narrative strategies adopted in his earlier collaboration with the Swiss photographer Jean Mohr in *A Seventh Man*.[4] In *Another Way of Telling*, also realised with Jean Mohr, he elaborates on the difference between painting and photography (which is also the passage from individual to potential mass representations of the world) as the distinction between translation and the trace. If the painting seeks to reproduce, hence configure and control, authorise and authenticate, appearances, the photograph quote them. If the former seeks to translate appearances, that is, to work up the world into a coherent medium of expression via paint or pencil, the latter proposes a trace of light. The photograph is a cultural construction sustained by the immediacy of a world external to its mechanisms.

So the photograph provides more than a picture. It taps into the ambiguity of vision. It draws us into a world not fully of our making. If the painting encloses time in its execution and eventual presentation, the photograph can only contain an isolated instance, ultimately sustained by non-human agency. The painting is ultimately autonomous, the photograph an accessory. Berger argues that it is precisely this subordination to the rules and reflection of light that robs photography of a language while at the same time freeing it from closure in our

experience and understanding. As he notes, Roland Barthes in *Image– Music–Text* referred to photography as a message without a code that inaugurates 'a decisive mutation of informational economics'.[5]

Clearly, this discussion does not simply serve to reference a semiotic precision, or to mark a distinction between diverse modalities of representation. There is here an altogether deeper question of epistemological, even ontological, importance.

In 'Bursts of Meaning',[6] a 1982 review essay on *Another Way of Telling,* Edward Said expresses both his admiration for Berger while simultaneously letting slip a certain intellectual anxiety about the ambiguity of his methods. Said, noting its interdisciplinary, even eclectic, character, characterises Berger's analytical approach as a stone thrown into water. It generates concentric circles of meaning that move in multiple directions, breaking the flow of sequential narrative to puncture the consensual surface of the present. Said called these circles' constellations of experiences'. At the same time, we can note a certain discomfort in the Ivy League–trained professor of comparative literature dealing with Berger's un- or anti-disciplinary approach to his arguments. While Said recognises the importance of the disruption of linear order – both historical and explanatory – in Berger's work, he feels that the ensuing ambiguity leads to political liability. He concludes with the stark admonition that Berger fails to acknowledge the power of ideology in setting the field for photographic activity, and that ultimately he fails to connect his 'aesthetics with action'.[7]

In an altogether more recent essay,[8] John Hawley notes that a year after writing this review Said began working with Berger's longtime collaborator Jean Mohr on the project that would become *After the Last Sky: Palestinian Lives*.[9] Whereas in *Another Way of Telling* the photographs carried no captions (although they were clearly embedded in a particular discursive regime carefully laid out in texts by both Mohr and Berger), in *After the Last Sky* Said felt impelled to translate the images into words, to give them a voice that explained the Palestinian condition. The photographs are directed towards a meaning, they seek political recognition and a historical verdict. As Said recognised, and ultimately criticised, Berger instead insisted on the photograph as a 'quotation' that was ultimately untranslatable. Its ambiguity, precisely as ambiguity, sustains truth – not necessarily as an identifiable semantic unit, but rather as an experiential opening towards something that escapes the closure of any singular telling of time and place.

This, in the widest sense of the term, poses a political question. For what it touches upon is precisely the critical disposition relayed in a way of telling. As a narrative of history and space, it seems to me that Berger's 'method' raises a deliberate challenge to the academic and disciplinary configurations of time and place. For the question is not reserved to the field of photography or the history of the visual arts: it launches a critique of the disciplinary protocols and pretences of the historiographical operation. Disquieting questions about the political consequences of continuing to respect a particular manner of narration and explanation are

rendered explicit. Even 'minor' and countervailing linearities from below – what Said was seeking to establish in *After the Last Sky* – perhaps, and precisely in their structured subordination, also feed the circuits of hegemonic narratives secured in the same implacable logic. Here scholarship, often simply the synonym for academic liberalism and the disturbing historical archive upon which it draws in elaborating understandings of balance, distance and neutrality, can come unstuck. The critical power of Edward Said's own unrelenting exploration of the question is perhaps the most eloquent testimony to this state of affairs. I will return to this aspect in a moment.

What Berger invites us to see are not isolated objects but a material spectrum which proposes a perspective, a manner of seeing that breaks away from consensual understanding. For if photographs are 'possible contributions to history' they can also 'be used to break the monopoly which history today has over time'.[11]What precisely does that mean? Exploring the space between the photographic image and the printed word we can consider time as an unfolding series of temporalities. These exceed and flee their particular framing in an institutional chronology that is oblivious to their patterns and hostile to their voices. For photographs 'do not translate from appearances. They quote from them.'[11] Here Berger rightly invites us to break the links between positivism, the camera and sociology.[12] So accustomed are we to treating image technology as a direct and neutral window on the world – no matter how mediated are the means of representation via chemicals, light, celluloid and pixels –that we assume that the

'shot', the 'take', the 'cut', captures naked reality rather than proposes a trace[13]. The unilateral aggression evoked by these terms is by no means incidental. That's the way it is, and so the existing order in all its inequalities, cruelties and differences is reconfirmed. Realism and the political order become one. To return to the historical construction of the perspective, the technological elaboration of the frame, the cultural investment in the image, is precisely to open up this critical space between the linear violence of a unique history and its monopoly over the narration of time. It is to splinter it into coeval but multiple shards of telling and understanding.

> The migrant is not on the margin of modern experience; he [sic] is absolutely central to it.[14]

> The subject is European, its meaning is global. Its theme is unfreedom.[15]

The shift from the seasonal migrant labour force of guest-workers in the 1950s, 1960s and 1970s to settlement and the creation of immigrant communities within the Occidental metropolis is, above all, the shift from cultural and historical anonymity to the daily immediacies of the city becoming a site of historical transit and constant cultural transformation and translation. (Of course, there are histories and tempos involved in this planetary reality: in contemporary China the lodgings and life described in *A Seventh Man* are still very much the case for the migrant workers from rural areas, living and sleeping

on site while building the metropolis). The city is no longer simply mine or ours. In its immediacies it, far more than the abstract space of the nation-state, becomes the fulcrum of historical negotiations that tests and transforms democracy into a process still to come.

Temporality is sliced up into different rhythms. Identities are multiplied. The once-faceless worker who came to the metropolis to sell his labour power now brings all the means of his and her social reproduction – culturally referenced from the kitchen to music, clothes and religious affiliation – into the homelands of the capitalist intellect. The colonial logistics that previously rendered differences distinct and distant are annulled and reassembled in the urgent proximities of today's postcolonial metropolitan mix. Here the infernal costs of our 'progress' and democracy – slavery, colonialism, genocide, poverty, child labour, war, and then more war – return. That past does not pass. It accumulates. And the battle against acknowledging that history, and taking responsibility for the planetary conditions it has produced, is augmented and extended on all fronts. The world is drawn ever tighter into being rendered accountable only to its language and logic, to its unilateral power. That might be a definition of neoliberalism and its mantra of 'there is no alternative'.

In his 2010 Preface to the new edition of *A Seventh Man*, Berger bluntly refers us to the present-day 'global economic order, known as neoliberalism – or, more accurately, "economic fascism"'.[16] The authoritarian gaze, rendering the world reducible to a unilateral field of vision, was also, of

course, the deep subtext of the television series and subsequent book *Ways of Seeing*,[17] produced in the early 1970s. In both instances, the multiple histories inscribed on different bodies of experiences and lives –marked by race and sexualities, age and class, location and gender – are cancelled in the supposedly objective neutrality of the universal gaze whose power endorses knowledge of the world.

We are all objects of someone else's dream. To wake up from this dream is to initiate confronting a seemingly uncontrollable nightmare. For no one is this truer than the modern migrant. Reduced to a legal and political object, rendered illegal, suspended between hospitality and hostility, the migrant's condition exposes all of the nightmarish limits of the liberal dream. In this precise sense the political economy of modern migration, and here we can stretch the time frame back over five hundred years, is the political economy of modernity. The freedom to move and constantly confirm our subjectivity in the world is based precisely on the unfreedom that forbids others to move and to assert their rights to subjectivity. As John Berger puts it in the very first page of *A Seventh Man*, to consider contemporary migration, in all of its worldly, political and cultural consequences, is to promote this waking process and 'grasp more surely the political reality of the world at this moment'.[18] This, just to remind ourselves, is a book first published in 1975. And if our understandings of borders, confines and the racial hierarchies that profile and police the world have undoubtedly grown in sophistication, the brutal truth of Berger's observations remains unaltered. How are we

to wake up from this dream and snap out of our submission to its language? How can we open our eyes to the present state of affairs when our success and subjectivity depends upon the dream?

Out on the edges of our vision, the modern destitute migrant is still restricted to the marginal categories of so-called Third World poverty, underdevelopment and the refugee. The violence implied in the creation of these categories is rarely related back to the Western making over of the world in its interests. To seek to better one's daily life is apparently permitted only to the Occidental few. Of course, everyday life in the modern metropolis proposes an altogether more flexible history. Here the fluidity, proximity and overlapping of confines renders it increasingly impossible to refer to a separate, external world, or to sharply set off one set of cultural combinations from another.

This, of course, is not to deny the ongoing work of governing political and cultural apparatuses – from state government to the mass media – continuing to propose the opposite, and thereby ensure their authority to patrol and confirm the categories. To challenge and undo the latter would not simply be to expose the hypocrisies of Occidental humanism preaching universal values while slaughtering non-Europeans in every corner of the globe. It would also mean dismantling the very scaffolding of a precise political economy where the violent imposition of the juridical rights of individual property have consistently sanctioned the order of European liberalism. It is the colonial gestation and production of this polity – what

we today live in a further turning of the screw as neoliberalism – that renders explicit the racial and racist hierarchisation of the peoples of the planet. This was not an unfortunate and incidental chapter in its history, but was, and is, central to its apparatuses of power and management.

In this precise sense, the cultural and historical mix of the modern metropolis and the migrant are coterminous cyphers that do not simply mark a historical conjuncture: the multiculturalism of the postcolonial city. They also pose and practise a radical realignment of the polity. No longer present in the earlier form of transit labour and guest workers (the subject of *A Seventh Man*), the existence of today's migrants and refugees folds the historical present back upon itself. Although we may choose to look away, at the end of the day he or she reveals the colonial formation of liberal modernity and our selves. In a profound sense the archive is broken. It can no longer secure a unique telling of time, place and belonging. Its contents spill over the map, ready to be assembled into other narrations.

Is it possible to see through the opaqueness of the world?[19]

Of course there are other lessons we can draw upon here. The whole history of the Black Atlantic, of its diasporic poetics and politics, is one. There the very apparatus of seeing, so central to the ocular hegemony of Occidental reason, is further subverted by unauthorised systems of sound transforming time and space

into unsuspected modalities of belonging. History is rerouted through another set of referents: unauthorised, suspended in the dense currents of bass cultures rising to the surface of modernity from far below. To fold time in this manner and render the past proximate is to crack the rigid scales of a numbing chronology. It is to muddy the transparency of a violent rationality that has already decreed the conditions of what we are supposed to see and understand as 'home' and the way of the world. Contrary to this conclusive theology, sounds are able to sustain the uncharted spaces of other histories. History can be dubbed. The technologies of truth – textbooks, peer-reviewed journals, research exercises, the institutional accounting of time and labour, the apparatuses of knowledge and power – can be interrupted, crossed by other rhythms, broken up into another mix.

On another occasion I have discussed how the contemporary performance by the Iraqi musician Naseer Shamma of the music of the ninth-century Muslim musician and dandy Abu I-Hasan 'Ali Ibn Nafi, better known as Zíryáb, produces folds in history and opens up holes in time.[20] The chronological rigidity of the institutional archive that authorises the present state of comprehension is here sounded out, crossed by slivers of the past that punctuate its annexation of the present. These other histories are the traces of other maps. The microtonalities of the Arab *oud* not only draw Arab and Islamic culture back into the picture of the Euro–African–Asian formation of Spain and modern Europe. They also resonant in dissemination across the Atlantic, via the black diaspora induced by the

racist slave trade, to reverberate in the blue notes of subaltern cultures and their music making in the Americas.

This is to travel with John Berger and perhaps take his considerations further. There is no cancellation implied; simply a reassembling of critical resources seeking to respond to a world in which the question of migration has radically disturbed the ground beneath our feet. With migration no longer simply referencing a socio-economic phenomenon – cheap, transit labour brought in to service the needs of the Occidental metropolis – we are now invited to consider the source of a profound and irreparable interruption of modernity itself.

NOTES

1 Berger, J. and Mohr, J. (2010/1975) *A Seventh Man*, London: Verso, p. 104.
2 Berger, J. (1972) *Ways of Seeing*, London: British Broadcasting Corporation and Penguin Books, p. 7.
3 Berger, J. and Mohr, J. (1982) *Another Way of Telling*, New York: Vintage.
4 Berger and Mohr, *A Seventh Man*.
5 Barthes, R. (1977) *Image–Music–Text*, edited and translated by S. Heath, New York: Hill and Wang, quoted in Berger and Mohr, *A Seventh Man*, p. 96.
6 Said, E. W. (1982) Bursts of Meaning, reprinted in Said, E. W. (2010) *Reflections on Exile And Other Literary and Cultural Essays*, London: Granta Books.
7 Ibid., p. 152.
8 Hawley, J. C. (2006) Edward Said, John Berger, Jean Mohr: Seeking an Other Optic, in S. Nagy-Zegmi, ed., *Paradoxical Citizenship: Edward Said*, Lanham, MD: Lexington Books.
9 Said, E. W. (1986) *After the Last Sky: Palestinian Lives*, photographs by Jean Mohr, New York: Pantheon.

10 Berger and Mohr, *A Seventh Man*, p.109.
11 Berger and Mohr, *Another Way of Telling*, p. 96.
12 Ibid., p. 99.
13 Ibid., p. 93.
14 Berger, J. and Mohr, J. (1975) *A Seventh Man*, London: Penguin Books, back cover.
15 Ibid., p. 11.
16 Berger and Mohr, *A Seventh Man* (2010), p. 7.
17 Berger, *Ways of Seeing*.
18 Berger and Mohr, *A Seventh Man* (2010), p. 11.
19 Ibid., p.122.
20 The music can be heard on *Maqamat Zíryáb: Desde el Eúfrates al Guada-laquivir*, CD by Naseer Shamma (2003). Pneuma PN-480.

LIFE

REMEMBERING ABDELATEEF MOHAMED BASHIR

GLENN JORDAN

And then, later, they found the photos he took and gave them were a kind of company – like the melodies of tunes they knew and might sing when together.

JOHN BERGER[1]

Photography for Berger was always a specific act of sharing, and it is this notion of photography as a form of social exchange that has dominated his photographic theory and distinguished it from much of the semiotic-deconstructive writing that overlapped with his own interests in the mid to late 1970s.

JOHN ROBERTS[2]

Since the 1980s I have been working as an ethnographer, photographer and curator, with immigrant, refugee and ethnic minority communities in Wales – helping to build an archive of marginalised images and voices, seeking through research and creative practice to break down barriers between peoples from

different backgrounds. Much of this work has been done via the Butetown History and Arts Centre, a gallery, archive and educational centre in Cardiff that I co-founded and directed for nearly twenty years. My usual practice is to work on projects in collaboration with people from various local immigrant, ethnic minority and religious communities.

I have written about some of these initiatives elsewhere.[3] Here, I simply want to point out that while I have done hundreds of hours of oral history interviews and taken thousands of photographs of people who are defined as racially or culturally Other, my most vivid recollection is of my encounters with one person, an elderly activist-intellectual from the Sudan.

I met Abdelateef Mohamed Bashir on two occasions. This piece contains memories and photographs from both of these occasions – as a personal tribute to an extraordinary man and, I will suggest, an example of a Bergeresque intervention.

In the afternoon of Sunday, 3 March 2012, I visited Abdelateef Bashir at his home in the Roath area of Cardiff. I knew that he was a founding member of the Sudanese Communist Party (in the 1940s) and that he had made an important contribution to politics and anti-colonial struggle in the Sudan.

I had been told a few days earlier that he was very ill – that if I wanted to interview and photograph him, I needed to go to his house soon. I was taken by Abdel Wahab Himmat, a Sudanese journalist and political activist, who was working with me on a doctoral thesis on the Communist Party in the Sudan.

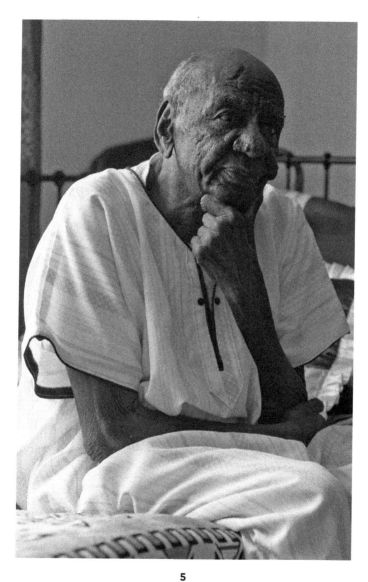

5
Abdelateef Mohamed Bashir at home in Cardiff, March 2012,
photograph by Glenn Jordon

The family had placed his bed in the living room so he could engage with the public. I thought of how, in the West, the dying are so often placed in isolation. This was very different.

I stayed there for a few hours. Perhaps a dozen people from the local Sudanese community visited when I was there. Abdelateef would talk awhile – engaging in animated conversation and laughter with his guests. I was struck by his strength, his humour, his knowledge. And by how he was loved and cared for by members of family and his community.

He invited me to ask questions. I asked about his life and about political struggle in the Sudan, but I wanted most to photograph him. I was mesmerised by his face – his eyes, his smile, his expressions – and by his body language. He was so full of life. Yet he was dying, and he knew it.

Three months later, on 9 June 2012, I met Abdelateef Bashir – his friends called him 'Comrade' – again. I went to the graveyard on the occasion of his funeral. I photographed as they carried his coffin aloft. Rays of the sun shone through the clouds like streams of a rainbow. Look closely, perhaps you can see them.

I photographed as younger men from the community lovingly threw shovelloads of soil into the grave. They continued until the grave was full and the tribute was complete.

I photographed as his daughter prayed and cried. I recalled how deeply I was affected by the death of my own father almost thirty years previously, although it still seems to have been much more recent.

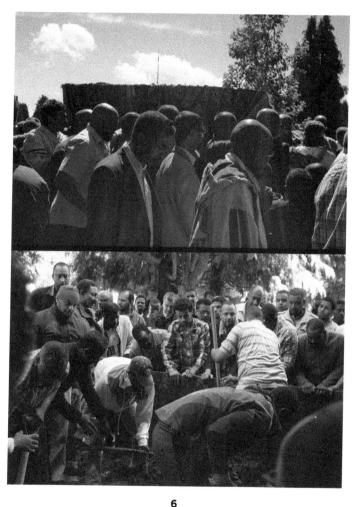

6

Funeral of Abdelateef Mohamed Bashir, Cardiff, June 2012,
photographs by Glenn Jordon

The imam who gave the sermon was an old friend of mine. I was happy to see him. We hugged and exchanged greetings. But it was not him that I photographed.

REFLECTIONS

Every large family in the Alpine village where I live has its own collection of Mohr photos. Sometimes, there's one framed on the mantelpiece; others are in a box that is brought out when people begin to reminisce. Frequently, these are photos they have asked him to take at a wedding, a village gathering, a dance.[4]

Since I photographed Abdelateef Bashir, I have often thought about how I would like to live and die. When I think about that, I see his face – his smile, his eyes – and I sometimes recall how my father had a similar will to keep on living as death was knocking at his door. A few days before he died, my father, Whitney Jordan Sr, told me that he was trying to stay awake at night – trying to keep his eyes wide open – so that death would not catch him offguard. It is that kind of will to live that one can sense in the photographic portraits I took of Abdelateef Bashir.

I also sometimes think about the fact that although he and I came from different continents and religions, we were able to establish a connection – one that continues between me and members of his family and community. In a world of violent confrontations between people of different cultures and faiths

– between Them and Us – such experiences help to rescue me from the brink of despair.

Within months of me taking the photos, ownership of Abdelateef's portraits and the funeral scenes had shifted from me to members of the Sudanese community in Wales. At a memorial service one year after Comrade Abdelateef's death, a selection from the dozens of photographs that I took were digitally projected, accompanied by solemn Arabic music. Three years after his death, Salah Suliman Barkeit, a Sudanese artist who fled to Europe after being tortured at home for his political views, appropriated one of my photographs to make a beautiful drawing of Abdelateef Bashir.

7
Comrade, 2015, chalk on paper, Salah Suliman Bakheit

In the past forty years, John Berger has often reflected on the social uses of photographs – in particular, on the difference between 'private photographs' and 'public photographs' (see also the essays 'Hope' by de Alwis, 'Trauma' by Salomone and 'Memory' by Vrana in this volume). In 1978, in an essay in *Camerawork,* a UK-based photographic magazine, Berger says:

> Now there are two distinct uses of photography: the private and the public. The private, that is to say the photographs one has of the people one loves, one's friends, the class one was in at school, etc.; in private use a photograph is read in a context which is continuous with that from which it was taken …
>
> Private photographs are nearly always of something which you have known. By contrast public photographs are usually images of the unknown or, at best, they are images of things which are known only through other photographs. The public photograph has been severed from life when it was taken, and it remains, as an isolated image, separate from your experience. The public photograph is like the memory of a total stranger, a total stranger who has shouted 'Look' at the event recorded.[5]

When I took the photographs in Abdelateef Bashir's house, he was a stranger to me. I imagined that the photographs would be used, sometime later, in a gallery setting – perhaps in an exhibition of portraits and life stories of refugees in Wales,

including recent refugees and Holocaust survivors who I had photographed earlier for the *Hineni* exhibition and book.[6] But before the images could be used in the public way that I had intended, they were appropriated by the community.

Like many of Jean Mohr's photographs of members of the rural agricultural community where John Berger lives,[7] my portraits of Abdelateef Bashir and my photographs of his funeral have now come to function like 'private' photographs in a photo album or on a family wall. The local Sudanese community have made my photographs their own. I think this is the kind of photographic practice that John Berger and Jean Mohr have long encouraged.

Here, the camera is not a weapon.[8] Rather, it is used as a way of remembering, an act of caring that ensures that death does not get the final word.[9] In *Another Way of Telling*, which he co-authored with John Berger, Jean Mohr recalls an instance when the local woodcutter's spouse solicited his assistance:

> One day the woodcutter's wife stopped in the village and said, 'I'd like to ask you a favour. Would you take a photo of my husband? I don't have one, and if he's killed in the forest I won't have a picture to remember him by.[10]

The woodcutter's spouse makes a pre-emptive move: she takes out an insurance policy against the finality of death. Jean Mohr makes a close-up, head-and-shoulders portrait, which Gaston's wife frames and puts on her mantelpiece.[11] Mohr's portrait

of Gaston, like mine of Abdelateef Bashir, belongs to both public and private worlds. But it is in the private that these two portraits have most meaning.

NOTES

1 Berger, J. (1999) Jean Mohr: A Sketch for a Portrait, in J. Mohr and J. Berger, *At the Edge of the World*, Reaktion Books, pp. 6–15, p. 10.

2 Roberts, J. (1998) John Berger and Jean Mohr: The Return to Community, in J. Roberts ed., *The Art of Interruption: Realism, Photography and Everyday Life*. Manchester University Press, pp. 128–143, p. 128.

3 Jordan, G. (2008) An African Presence in Europe: Portraits of Somali Elders, *Cultural Studies*, Vol. 22, No. 2: 328–353. Jordan, G. (2012) Photography that Cares: Portraits of the Marginalised, the Invisible and the Stereotyped, in G. Jordan with C. Heyman, E. Lavine, C. Parry-Jones, D. Soffa and C. Weedon (2012) *Hineni: Life Portraits from a Jewish Community*, Cardiff: Butetown History and Arts Centre in collaboration with Cardiff Reform Synagogue, pp. 18–24. Jordan, G. (photographer and editor) with A. Ahmed and A. Arwo (2004) *Somali Elders: Portraits from Wales / Odeyada Soomaalida: Muuqaalo ka yimid Welishka* (in English and Somali), Cardiff: Butetown History and Arts Centre. Jordan, G. and Weedon, C. (2015) Changing the Archive: History and Memory as Cultural Politics in Multi-ethnic Wales, in C. Williams, N. Evans and P. O'Leary, eds, *Tolerant Nation? Exploring Ethnic Diversity in a Devolved Wales*, Cardiff: University of Wales Press, pp. 175–205.

4 Berger, A Sketch for a Portrait, p. 10.

5 Berger, J. (1997/1978) Ways of Remembering, in J. Evans ed., *The Camerawork Essays: Context and Meaning in Photography*, London: Rivers Oram Press, pp. 38–51, p. 44.

6 See Jordan et. al. *Hineni*.

7 Berger, J. and Mohr, J. (1995) *Another Way of Telling*, London: Vintage.

8 Sontag, S. (1977) *On Photography*, London: Penguin.

9 Death is a recurring theme in John Berger's writing – in his essays on photography and writing, in his fiction and in his interviews. With regard to death and photography, the most notable writings by Berger are these: various essays with discussion of W. Eugene Smith's photograph *Spanish Wake*, 1951 (see Berger, J. (2013) *The Big Book*, Vol. 3,

Austin: University of Texas Press); an essay entitled 'Image of Imperialism' on the ideological use of Che Guevara's body; 'Christ of the Peasants' (see Berger, J. (2013) *Understanding a Photograph*, ed., G. Dyer, London: Penguin Classics); and a discussion in *Pilgrims* (1983), a book of extraordinary photographs of religious practices, including death rituals, in peasant communities by the Czech photographer Markéta Luskacová (see www.marketaluskacova.com/publications/02-pilgrims-small-catalogue-arts-council).

10 Berger and Mohr, *Another Way of Telling*, p. 59.
11 Ibid., p. 70.

MEETINGS

JOHN BERGER
IN THE LIBRARY

NIRMAL PUWAR

We are never just looking at one thing, we are always
looking at the relationship between things and ourselves.
Our vision is continually active, continually moving,
continually holding things in a circle around itself,
constituting what is present to us as we are.

JOHN BERGER, *WAYS OF SEEING*, P. 9

On the shelves under the small section of the local library
labelled 'Sociology', I found John Berger's book *Ways of Seeing*.[1]
The book foregrounds how the relationship between what we
see and what we know is never settled. I was then, in my teens,
trying to decide if I wanted to study the rather unknown subject
called Sociology at A level. Stoke library, in Coventry, was a
familiar space. My family were regular visitors. We lived a
minute's walk away. As children we frequented it at least three
or four times a week. Within this fan-shaped building there
were different zones. The children's room consisted of fiction
as well as the important general-knowledge and reference-

based encyclopaedic tombs used for homework. This room led off from the more adult room carrying general knowledge and reference books, as well as fiction in several languages, including Urdu, Punjabi and Gujarati.

The neighbourhood and the city of Coventry became a work mecca for arrivants from the British ex-colonies in the period between the two world wars and especially the post-1945 period. It was considered a boomtown for employment and training in engineering and the car industry. Reflecting some of the interests of the arrivants – who were, before they even knew it, settling into the city as 'home' – the library started stocking a 'multicultural' collection, including a large selection of Asian vinyl records and cassettes. In time, following on from changes in music technologies, this collection shifted to CDs and DVDs. In the zone leading off from the central room, which carried these items as well as local reference materials and fiction, one walked into a space with further adult books, sitting under authoritative labels such as 'History'. Though the shelf space was much smaller, nevertheless the subject 'Sociology' was granted the recognition of a heading, reassuring a teenager that sociology was becoming a proper subject to study.

Finding John Berger's *Ways of Seeing* in this section added to the intrigue of a somewhat esoteric subject with an 'ology' attached to it. The only other ology I knew of then was biology. While the classifications in biology of the human and plant world appealed to me, I knew I was not heading towards a scientific specialism. Interestingly, the books in our home, in a room which became a study with shelves, consisted of

scientific works, on chemistry, physics, maths, technical drawing. This was the (male) educational tradition in the family. As I held John Berger's *Ways of Seeing* in my hands, I doubt if I understood much of it. I still remember, though, that what impressed me was the form. The compilation of the book from words, paintings, advertisements and statements was fascinating. The very emphasis in the title on *ways of seeing* spoke to me more than the commentary on specific historic paintings. Little did I know then that this kind of compilation was a million miles away from what was considered proper or authoritative sociology. Neither did I know then that I would never actually be taught Berger.

Within the fan-shaped library, in the same room as the section for Sociology, are to be found broadsheet and tabloid newspapers, as well as magazines. A number of non-European papers and magazines have been regularly stocked for some years. On a table close to the racks for papers and magazines, regulars arrive to place their spectacles on and off the table as they browse and become pulled in closer to the news-sheets by the contents of the words and images: news from here, there and everywhere, from the 'home' they left fifty or so years ago, as well gossip and titbits, alongside adverts.

If Berger were to sit down at the roundtable, among these newspapers and magazines, with the library's regular visitors, one can imagine how Chapter 7 of *Ways of Seeing* might have been written differently. Of course the contrast between the poor and rich noted by Berger from gleaning English publications could also be found on the pages of the Urdu and

Hindi press. As could the viewing postures of women inviting further viewing. Here readers shuffle their hands between papers in different languages. Shaking the creases out of Punjabi and English pages. The allure of consumption and lifestyles includes products to be realised in, and objects the readers themselves might have laboured over. Cars – from the high-status Jaguar to the more commonplace, but still sought-after, Ford and Peugeot have all been produced on the assembly lines in Coventry and neighbouring cities such as Leamington Spa. At the table in this section of the library, Berger would also have found readers taking in reportage of state violence and counter-violence movements in Kashmir or the Punjab. A different compilation of images, geopolitical situations, stories and languages would have had to be considered for the assemblage of Berger's ways of seeing. His visit might even have coincided with one of the heated debates that occasionally spontaneously erupted, though most of these vexed conversations took place in the much larger two-storey central branch of Coventry City Library located in the city centre, a mile away from Stoke library. At any time of the day, here you could find at least a handful of men from India and Pakistan gathered, switching between discussing international news and the price of fish in the local market, and reciting poetry at and to each other. These were overwhelmingly social gatherings of older men, most of whom had retired from working long day or night shifts on assembly lines within different industrial lines located across and slightly beyond the city. Dunlop, Ford, GEC, Courtaulds were regular workplaces for men and women.

Unusually for the time, in the 1970s, Berger and Mohr were drawn to highlight the condition and contributions of migrancy in northern Europe. This was well before migration became a hot academic topic, as it is now.[2] The work of John Berger has been translated into several non-European languages, including Farsi, Arabic, Korean, Turkish and Punjabi. This was especially so for *A Seventh Man*,[3] which was published in various languages in the 1970s and has journeyed to perhaps the most unexpected places. Berger himself was surprised when he found the book on a makeshift shelf in a shanty town in Istanbul. He notes that it was no longer a sociological treatise. Rather it had 'an intimate address', as 'a book of life stories, a sequence of lived moments', akin to a 'family photo album'.[4] Car production, assembly lines, hot and heavy foundry work, as well as the hard labour of digging tunnels all feature in the words and images collected in *A Seventh Man* as a result of the conversations with the migrant men, Berger and his long-time photographic collaborator Jean Mohr encountered.

The important themes of arrival, work and return featured as overbearing threads in the lives of migrants looking for work in northern Europe. As noted by Berger, the book does not directly feature men or women from the former colonies then living in northern Europe. Nevertheless, there are still parallels to be found. Not only are there similarities in the conditions of hard industrial labour; the hopes for the future and the pain of longing for home, as well as the comfort of recognised words and music, were also present in the lives of men and women who migrated from the colonies to the mother country in

Britain. Like the figures in *A Seventh Man*, they also planned for the glory moment of undertaking the journey home – with the status of accrued material possession – whilst enduring the nights of labour as well as the hateful looks bestowed on an unwanted stranger. Indeed these elements continue with the bodies that move from different locations and contexts across the globe today. Looking back to the 1975 publication of *A Seventh Man* in 2010, when the book was republished, Berger writes: 'It can happen that a book, unlike its authors, grows younger as the years pass. And this I believe is what may have happened to 'A Seventh Man'.[5]

Even though Berger has a global readership and many international collaborators, the authoritative commentators remain a largely European fraternity. Critics and reviewers have an impact on how legacies are defined. Time and death are reccurring concerns in Berger's works. He has, for instance, spent much time with Rembrandt's paintings, characterising him as a painter of ageing. Berger has often featured people in his stories after their death. In these commentaries he has mentioned how (he) the storyteller becomes Death's Secretary. In *Here Is Where We Meet*,[6]for instance, in Lisbon the male narrator recognises the gait of a elderly woman walking towards him. As she comes closer, he notes that it is his mother, who has been dead fifteen years. She declares that the dead do not stay where they are buried. Berger's work often brings the dead into imaginative, playful meetings. For him, more often than not, the dead are always with us. On the last page of *And Our Faces, My Heart, Brief as Photos*, he

speaks of the peace derived from having his bones strewn on the ground next to his beloved. Wherein it is enough to be phosphate of calcium together. Where do we place the dead when they are gone?

A lifetime's work ages very differently, especially when a person goes. Receptions wax and wane. In *The Sense of An Interior*,[7] Diane Fuss surveys the locations, items and furniture of noted writers such as Freud and Proust. Proust is well known for making snuff out of his parent's stuff. Once they had died he filled his apartment to the brink with their stuff. For the 100th anniversary of the philosopher Adorno's birth, in 2003, the city of Frankfurt commissioned the Russian artist Vadim Zakharov to build a monument for Theodor W. Adorno-Platz. In a re-creation, Adorno's chair and desk are enclosed in a large cube of safety glass; an open copy of Adorno's work *Negative Dialektik* is placed on the desk,[8] along with a lamp that switches on at night; the base of the cube is surrounded by black and white granite tiles engraved with quotes from Adorno. Robert Hullot-Kentor has described the events of the jubilee as 'a lugubrious display', noting how the 'jubilee successfully portrayed the life of the man as if a single strand carried him from birth to garlanded tomb'.[9] Tensions, movements, expulsions and frustrations often get flattened out in monumental memorialisation. Monuments can transpose conflict into consensus.[10] The chair and desk stand in to encase the ghost of Adorno. Yet in Frankfurt University itself it is a struggle to find Adorno or the rest of the Frankfurt School on the university curriculum.

Interiors of learning don't have to become museumified. Libraries are very specific domains where the private thoughts and interaction with a range of reading materials occurs in public. They are public-private rooms of research as well as writing. For years, scholars, researchers and writers continued to visit the same circular room of the British Library in London, just as Karl Marx had done when he penned his own writing tomes. The public library in Manchester carries on this tradition too. Thus these public-private rooms of research and reading continue to be forms of heritage which are in Stuart Hall's terminology 'living archives' – archives which breath, grow and invite engagement.[11]

It is in the tradition of the living archive that I would like to return to the fan-shaped library in Coventry. If Berger had visited and sat at the circular table with the newspapers and magazines from different countries, he would have found a tall elderly Asian man, with a full head of hair, pulling newspapers up close to him, while setting his glasses on and off, between nose and table. Depending on which year Berger visited the library, he would have found either just his coat hanging on the chair, or one walking stick, or two walking sticks, or a zimmer frame nearby, or a wheelchair. Each of these aids characterised his ageing as well as the resurgence of injuries endured during wartime in Burma in his younger years in the Second World War as a recruit to the Indian British Army.

Herein, I have become, in Berger's sense, Death's Secretary. I am referring to my father, Sawarn Singh. He started visiting

the local library several times a day after he retired. He actually retired twice, first in the seventies when he left the night shift on the Ford assembly line and then again in the mid eighties from his job as an attendant at the Herbert Art Gallery and Museum. In contrast to his time at Ford, in the museum he walked the much grander, and cleaner, corridors across several floors. As nighttime security guards, he and his co-worker took tea together while sharing the hourly walk through the gallery as a security check throughout the night. Sculptures by Barbara Hepworth and penny-farthing bicycles as well as halls of transport items filled the large space they kept guard over. Six-foot canvases of Lady Godiva naked on horseback, painted by John Collier (in 1898), craned the necks of viewers walking up the grand staircases.

If Berger had sat at the table in the library my father visited he would have found a collage of materials that contributed to my father's ways of seeing. His own compilation of *Ways of Seeing* would have been a bit different from the one Berger assembled. He kept company with an eclectic mix of reading materials. He read the *Daily Jang* Urdu newspaper, the weekly Punjabi *Des Pardes*, as well as the tabloid *Mirror*. In fact, at times he cut out from the English papers to share with his family advertisements for products –possible items to buy – which promised an easier life. These might be slip-on shoes, elasticated trousers or a Ford car, on which he was entitled to get a discount as a former employee. His routine consisted of regularly checking out Urdu novels from the library to read

at home, especially before bedtime. Romantic and adventure stories comprised the ever-changing books in his bedside drawer. Not wanting to feel the weight of material items in his care, he usually limited himself to taking out two to three books at a time. Towards the very last years of his life he would continually throw items away, avoiding what he perceived as the stress of having to look after stuff. In contrast to Proust he was not into making snuff out of stuff.

When he passed away in 2013 (aged 94) the library staff, a good number of whom were South Asian, sent a message saying that they would miss his presence: for them he had become a part of the furniture for at least twenty years. Rather like the long-gone mother who appears in Lisbon in Berger's *Here Is Where we Meet*, the staff might look up from their counter only to see Sawarn Singh's large frame walking in, leaning in on his zimmer frame, with his greeting smile – the outline of his trace bearing a ghostly presence and reminder of his loss. The architectural emplacement of the body in the built environment like all architectures gives way to the play of time. Should Berger also come back on this occasion to Stoke library, he might trace a line drawing of Sawarn Singh, offering us a portraiture. He has often painted to shed light on the labour and life of welders, steelworkers, fisherman and performers.

If Berger had come to the table in Stoke library he would not only have met Sawarn Singh reading and holding in his hands very different materials to those Berger sifted through to make *Ways of Seeing*. He would have also have met a man

handling pen and paper, as a person who wrote, somebody who *made* sentences with words without being a formal writer like Berger; a common relationship to pen, paper and word of working-class men and women. In the library, letters were penned on sky-blue airmail paper for 'home'. Now and again my father would lend a writing hand to those fellow travellers to the mother country in need of a letter 'home'. Sitting at the table in the library he occasionally wrote *shayari* (poetry in Urdu), to be later recited among other older Asian men who met weekly with food and drink in a local school annexe. Since his death, I have been told by some of his poet friends (Prem Sharma and Ram Krishan Prashar) that he wrote – in Urdu, the language of his schooling – his life story, something akin to a memoir or autobiographical notes. As a family we are yet to stumble across them. Herein we are quite literally tasked with being Death's Secretary. Such is the stuff that meetings with people and their materials are made of.

NOTES

1 Berger, J. (1972) *Ways of Seeing*, London: British Broadcasting Corporation and Penguin Books.
2 Anderson, R. (2014) *Illegality, Inc.: Clandestine Migration and the Business of Bordering Europe*, Oakland: University of California Press.
3 Berger, J. and Mohr, J. (2010/1975) *A Seventh Man*, London: Verso.
4 Ibid., p. 8.
5 Ibid., p. 7.
6 Berger, J. (2005) *Here Is Where We Meet*, London: Bloomsbury.
7 Fuss, D. (2004) *The Sense of an Interior: Four Rooms and the Writers That Shaped Them*, London: Routledge.
8 Adorno, T.W. (1966) *Negative Dialektik*, Frankfurt: *Suhrkamp*.

9 Hullot-Kentor, R. (2008) *Things Beyond Resemblance: Collected Essays on Theodor W. Adorno*, Colombia: Columbia University Press, p. 95.
10 Lefebvre, H. (1991/1974) *The Production of Space*, Oxford: Blackwell Publishers.
11 Hall, S. (2001) Constituting An Archive, *Third Text*, Vol. 15:54, pp. 89–92.

PAIN

ISABEL COIXET FILMS WITH JOHN BERGER: *THE SECRET LIFE OF WORDS*

FRANCISCO-J. HERNÁNDEZ ADRIÁN

I want to say at least something about the pain existing in
the world today.

JOHN BERGER[1]

AN AREA OF PAIN

In John Berger's career as a novelist, poet, art critic and
thinker, pain figures centrally as a category of the political, of
human relations and solidarity, and of consciousness (a deep,
painstaking awareness of the here and now) that permeates
both reality and fiction, informing our perceptions of the
world in written and visual texts alike. 'It has never been easy to
relieve pain', he writes. 'But it has never been difficult to locate
the causes of pain: hunger, illness, cold, deprivation … It has
always been, in principle, simpler to relieve pain than to give
pleasure or make happy. An area of pain is more easily located.'[2]
In the following pages I explore how Isabel Coixet has read,

heard and interpreted Berger's ethico-political preoccupations in her own work as a filmmaker. Coixet's 2005 film *The Secret Life of Words* tells the story of the fortuitous encounter on a North Atlantic offshore platform between Hanna (Sarah Polley), an exiled nurse and survivor of rape and torture during the Yugoslav wars, and Josef (Tim Robbins), a burns patient who risked his life trying to stop a workmate from committing suicide during an oil rig fire. Covered in serious burn injuries, Josef remains on the platform, where drilling was stopped after the accident.

Some fifteen minutes into the film, Hanna travels by helicopter above the cliffs and beaches of Northern Ireland's littoral and onto the open sea, landing on an oil platform immersed in bright silver light. On two sides of the towering structure a large board displays a single word: GENEFKE. An even larger version of this gigantic sign is visible across the base of the rig's derrick. As Hanna unpacks her personal belongings in the medical ward inside the rig, she piles up rectangular soap bars on a desk – the same bars she uses to wash her hands compulsively in her apartment. Next to the soap we notice a small pile of books. John Berger's *Ways of Seeing* appears clearly on top.[3]

These references to Inge Genefke (a world-renowned pioneer in medical and humanitarian work with torture survivors) and John Berger are not just appreciative gestures. Instead, they express the director's desire to locate her visual narrative, and its complex ethical and political stakes, at the intersection of two critically demanding voices whose

life's works speak differently and eloquently about pain and politics in our contemporary world. At the end of the film, Coixet includes two separate dedications: 'For Inge Genefke, for IRCT' and 'For John Berger, for teaching me new ways of seeing the world'.

In an interview published in the medical journal *The Lancet* in 2004, Stephen Pincock writes about Genefke: 'In 1981, she founded the Rehabilitation and Research Centre for Torture Victims (RCT). From 1985 to 1996 she was the Medical Director of the International Rehabilitation Council for Torture Victims (IRCT), which grew out of RCT, and she is now its ambassador.'[4] By placing Genefke's name so prominently on the film's main location, Coixet encourages us to reflect on the potential relationship between the extractive practices associated with North Atlantic offshore drilling and Hanna's experiences on the platform as a torture survivor.

Coixet has voiced her admiration and friendship for Berger on many occasions, noting that he has taught her about 'ways of seeing the world' and that 'mirar es encontrar' ('seeing is finding'),[5]As we shall see, intimate secrets and traumas (of torture, betrayal and loss) are told in *The Secret Life of Words* through an oblique and empathic exploration of the sensuous dimensions of clinical care, and through a parallel study of the ways of seeing and feeling required by the difficulties of survival, recovery, and healing. I want to suggest that the film can be seen as a cinematic exploration of the struggle to share and overcome the memory of unspeakable trauma among those who survived it.[6]

ISLANDED LIVES

The film opens with a brief panoramic view of colourful reflections projected on a rippling seascape. The haptic suggestiveness of the image is heightened by the quietly dynamic sound of the sea surface. A fade-to-black transition reveals a brightly lit oil platform towering above the vast ocean – a melancholy sight immersed in a jazz melody. New fade-to-black editing structures increasingly distant shots of the rig, then a sequence of sepia images narrating a tumultuous incident – a fire on the platform. A series of alarming bodily movements, facial expressions, and distorted cries culminates in a shaky long shot of the smoky oil platform in the distance, its bright copper reflections cascading down the water's surface. From this fragmentary flashback, *The Secret Life of Words* builds a plot where a series of traumatic events and secrets embedded in two different life stories intersect and embrace through a deceptively simple romantic storyline.

Hanna works in a plastic processing plant, packing what looks like endless polythene sheeting rolls. She is so hardworking and efficient that she has not missed a single day's work, gone on holiday, or taken time off in four years. After her manager summons her to his office and explains this to her with some annoyance, Hanna decides to follow his advice – advice that feels more like an ultimatum – and goes on holiday to a bleak seaside resort on the coast of Northern Ireland. In the course of their brief conversation, the manager says:

You know, there are some beautiful heavenly places to go in the world ... places with palm trees and lounges on the beach, and waiters serving *piña colada* and that drink with the smoke in it, and aerobics in the swimming pool ... What's the matter? Don't you like palm trees?

Living a life of asocial efficiency and anonymity, Hanna stands for a *figure* of contemporary industrial modernity. As Thomas Nail writes, 'The figure of the migrant produced by the elasticity of economic expansion by expulsion is *the proletariat*.'[7] Like the anonymous characters in other North Atlantic films – Baltasar Kormákur's *The Sea* (2002) comes to mind – Hanna can be seen as a figuration of transnational, expelled and displaced labour communities across northern and western Europe. Indeed, hers and myriad other lives represent a kind of precarious surplus that is embodied in this figure of the migrant as 'that part of the spectrum of the proletariat that is currently economically expelled as a mobile social surplus'.[8] Yet these precarious lives are not the main focus here. Their stories have been told more or less indirectly in such acclaimed films as Lars von Trier's *Breaking the Waves* (1996) and *Dancer in the Dark* (2000), and Alejandro González Iñárritu's *Biutiful* (2010). What makes Coixet's film particularly intriguing is that the figure of the displaced and generally troubled worker is compounded by a bewildering number of sensory symptoms.[9]

Hanna's perceived efficiency and quiet non-alignment with more or less functional, normalised working activities carries

within it an oblique reference to the breakup of the former Yugoslavia – a country that, since its constitution as a Socialist Federal Republic in the early 1960s, had held a unique place as one of the most progressive states in Eastern Europe and as a defector from the Socialist Bloc under President Tito. Yet the politics of memory at stake in Coixet's film is only indirectly derived from the multiple conflicts and forces that unfolded at the end of the Cold War. The film stands instead as an ethical exploration of silence and trauma, emotional survival, and sensory recovery. With Berger, it reflects on a 'past seen from a possible future' in the sense that it foregrounds individual resilience and hope above historical contingency.[10] In the film, the main characters' pasts remain painfully hidden, but are told and heard – shared through narrative and sensory exchanges – as they search for a precarious opening onto the future. The location of their differing quests is both allegorically and materially displaced onto the accidentally arrested structure of an offshore oil rig.

Before she leaves for her holiday, we see a close-up of Hanna's hands holding an embroidery hoop. On a coarse white piece of fabric, she composes what looks like the shape of a northern cardinal(a North American migratory bird). Sitting alone in her sparsely furnished apartment, she works attentively by a bright lamplight, appearing to be lost in thought (she reminds us of a Vermeer subject). In the bus to the seaside resort, we see Hanna is embroidering again. As she steps out at the end of the ride, she hesitates for a few seconds before she

throws the embroidered fabric – the object of long moments of quiet introspection – into a rubbish bin.

Sitting alone again on a bench in a desolate place by the water, Hanna looks at an object beyond the cold grey sea and overcast skies. It is the tiny silhouette of an offshore oil rig standing much taller than the small ship some distance to the right. A dark cloud of smoke leaves the platform diagonally. In the next scene she is seated yet again, now having lunch at a Chinese restaurant. A man at the next table speaks on a mobile phone. Hanna overhears the words 'emergency' and 'Where do I find a nurse?' She boldly approaches the man and declares: 'I'm a nurse.'

Deciding to speak up across her restaurant table, Hanna is propelled into what we might call a *clinical* adventure (from the Greek *klinikē*, bedside) – into a space where 'the secret life of words' takes on an explicit meaning through her relationship with an unknown burns victim. Her journey, taking her by bus to the seaside resort, then by car to a heliport, and finally by helicopter to the platform, is an instance of the 'journey to the origins' often found in written and visual island narratives, from Jules Verne and Paul Gauguin to Ingmar Bergman's *Through A Glass Darkly* (1961). For Hanna, the journey traces an ironic progression from the ceaselessly operative plastic processing plant, and the efficiently plastic-wrapped food she eats at work, to the stillness of the oil rig.

A Dr Sulitzer (Steven Mackintosh) instructs Hanna on the patient's needs and then abandons the platform in a helicopter. An aerial view provides a new opportunity to appreciate how

the film constructs the rig as a remote and isolated space on the verge of collapse. The massive structure – a 'burns victim' itself – appears fragile, its main functions and industrial capacities momentarily and perhaps fatally suspended after the tragic accident. Yet the sight is also surprisingly vibrant with the innuendo of untold personal stories and arrested life journeys. On the island-platform Hanna meets her patient, Josef. She also meets other men who have found themselves islanded on the rig. The melancholy community includes Dimitri the platform captain (Sverre Anker Ousdal), Simon the cook (Javier Cámara), Abdul (Emmanuel Idowu), who is in charge of cleaning, Scott and Liam (Danny Cunningham and Dean Lennox Kelly), the closeted lovers who work in the engine room, a basketball-playing oceanographer called Martin (Daniel Mays), and Lisa the free-range goose. This 'community of those who have nothing in common'[11] is surrounded by the relentless sea, islanded in the momentary meaninglessness of a paralysed oil platform.

PARALYSED STRUCTURES

A disruption of the sensorium cuts through the film's otherwise conventional cinematic fabric, as if Coixet had chosen to address Laura Mark's reflection in her 2000 book *The Skin of the Film*: 'There has been increasing interest in the past several years among film- and videomakers and "visual" artists to supplement vision with the experiences of hearing, touch, smell, taste, and kinesthesis.'[12] Hanna's character seems

besieged by a range of symptoms, yet these are just aspects of a broader field of disruptive presences, interferences and supplements. She wears a hearing aid; we hear a child's voice-over that speaks *about* Hanna; and Josef, the man under her charge in the improvised burns clinic, remains blind for two weeks. Unable to move easily, he has suffered damage in an arm and leg and severe burns to various parts of his body. His – and our – ways of seeing are unavoidably conjectural, yet supplemented by an expanding perceptiveness that seems to transcend, rather than frustrate, Josef's own immobility as the subject of clinical care.

Imre Szeman writes perceptively: 'Oil is not just energy. Oil is history, a source of cheap energy without which the past century and a half would have been utterly different. And oil is also an ontology, the structuring "Real" of our contemporary socio-political imaginary ...'[13] The paralysed oil rig is also a sensory device. It extracts and absorbs a mixture of elements, including seawater and fossil fuels – 'millions and millions of tons of water, rocks and gas', declares the disturbing voice-over at the beginning of the film – from the depths of the ocean floor. In a casual conversation Martin, the oceanographer, asks Hanna an enigmatic question:

– Do you know how many waves this oil rig has weathered since it was built?
– Five million?
– Not bad. Twenty-five.

He goes on to explain that since drilling stopped, and as a result of the water temperature dropping by 10 degrees, 'whole colonies of mussels which were stuck to the rig legs have been lost, tropical mussels brought by some current that I haven't been able to identify yet'. He then hands a closed mussel shell to Hanna, who holds and touches it with both hands, studying it intently. The dialogue continues:

– If we didn't know the amount of waves this place can weather we couldn't keep it standing.
– Do you think it would be much of a loss?

They stand uneasily, staring at each other in silence, and he takes back the mussel shell. As Cathy Caruth observes: 'The story of trauma, then, as the narrative of a belated experience, far from telling of an escape from reality – the escape from a death, or from its referential force – rather attests to its endless impact on a life.'[14] In this brief interaction, Martin presents Hanna with a tactile, living argument for not escaping reality, and for the importance of counting the losses echoing through one's abysmal post-traumatic reverberations.

Hanna's clinical work with Josef is occasionally interrupted by panoramic views of the oil platform at different times of the day, from bright pastel sunsets to duller or softer compositions, sometimes evoking picturesque studies of skies and waves structured around the rig's oxidised railings. These visual asides suggest a pictorial sense of temporal variation, reminding us of the constrained industrial structure where the

reciprocal therapeutic relationship unfolds. Berger's charac-
teristically precise observation about Courbet's childhood
landscape comes to mind: 'It is a place where the visible is
discontinuous.'[15] These intense atmospheric interludes signal
a series of peripheral encounters and conversations, when
Hanna meets other members of the small island-platform
community. In one of these sequences, after a fade-to-black
transition, a low-angle view of the platform building depicts it
as a massive monumental site reminiscent of a photograph by
Thomas Struth.[16]

There is something of the still photograph's iterative force
in Coixet's visual approaches to the rig. Changing and evolving
like wounds, burns and scars, this sinister structure (a structure
on the verge of obsolescence and decay) appears in the film
as an object of a meticulous visual study. In her provocative
book on the still photograph in film as an instance of the
death drive, Laura Mulvey suggests that cinematic narrative
reveals 'a secret stillness': 'Just as the cinema offers a literal
representation of narrative's movement out of an initial inertia,
with its return to stasis narrative offers the cinema a means
through which its secret stillness can emerge in a medium-
specific form.'[17] Mulvey's reflection is particularly interesting
for us because of the discontinuous cinematic panoramic that
(perhaps unconsciously) she delineates, drawing examples
from the films of, among others, Roberto Rossellini and Abbas
Kiarostami. By extending the useful gesture of an establishing
shot into a nuanced grammar of sensory variations, Coixet
suggests that the island-platform is the subject of an effort in

portraiture as much as an industrial landscape or – like a small island in the North Atlantic – as an aspect of a much larger and fast-decaying extractive rationality.

SENSORIUM AT WORK

Unlike the paralysed structures I just considered, two different kinds of sensory structures do function efficiently in *The Secret Life of Words*. We might call the first a 'structure of hearing'. Although Hanna is 'hard of hearing' and perceived as isolated and asocial, she nonetheless *overhears* and listens attentively. Before she leaves for her seaside holiday, Hannah telephones a woman named Inge, yet she does not speak, leaving Inge to speculate whether or not she is indeed speaking to Hanna. The mobile phone conversation Hanna overhears at the Chinese restaurant prompts her to escape from her enforced holiday and to reclaim an aspect of her previous life as a young nurse trainee in Dubrovnik. Hearing in this instance is not necessarily linked to labour in an economic sense, but to emotional action and intimate recovery. At the clinic, Hanna listens to a recorded voice message on Josef's mobile phone that is linked to a guilt-ridden secret from his recent past. Listening into others' intimate messages, she intercepts their affects, desires and secrets.

The second kind of functioning sensory structure applies to the recovery of gustatory and tactile experiences. Marks writes that '[t]he cinema of cultural displacement often focuses on loss: of language, of custom, of one's place in a

community. However, a discourse of loss alone cannot explain the transformations and new productions of culture and consciousness that occur in diaspora.'[18] By rediscovering, relishing and sharing the intimate experiences of gustatory and olfactory sensation, and by touching and being touched by Josef, Hanna regains emotional consciousness and enjoys some of the 'piña colada' pleasures naïvely prescribed by her boss at the beginning of the film. Hearing and feeling (tasting, touching and being touched), as much as seeing, are linked to sensory rediscovery and potential healing.

For Josef, however, the sensory experiences associated with Hanna elicit sexual desire as well as scopic frustration. For Josef, multiple instances of talking with and listening to, smelling, touching and kissing Hanna appear to be intertwined with the changing modulations of memory, intimate disclosure and persistent blindness within the clinical context. He must also confront his own fantasy of Hanna (and his own scopic desires) just before the end of the story. Coixet locates this final displacement in the film's transnational and diasporic flights in the symbolically charged space of an archive containing written and visual records of torture survivors. A recovered Josef – his burn scars still visible across his face – travels to Copenhagen seeking to meet Hanna's former therapist, Inge. A direct reference to Inge Genefke, this character speaks for Hanna, but tightens, rather than loosens, the knot in Josef's curiosity.

Inge initially challenges Joseph: 'Do you want a photograph of her to see if she is as beautiful as her voice?' But she also guides him through the archive, presumably at the International

Rehabilitation Council for Torture Victims (IRCT), and offers him the possibility of watching a video of Hanna. Josef's refusal to watch the videotaped material perhaps expresses his decision not to listen further and deeper into Hanna's past, but to contemplate instead a possible future with her. One can speculate that Josef relinquishes his narcissistic need to see, engaging unwittingly with a decisive passage in *Ways of Seeing*, when Berger writes: 'Women are depicted in a quite different way from men – not because the feminine is different from the masculine – but because the 'ideal' spectator is always assumed to be male and the image of the woman is designed to flatter him.'[19] Relying on Inge's words as sufficient reassurance that Hanna's imageless story is somehow complete, or a complete enough representation of her survival and resistance, Josef now turns to the living Hanna. Leaving the archive – the site of originary pain, shame and indelible evidence – he refuses to probe further into the secret life of Hanna's words. Hanna's and Josef's momentarily islanded lives are no longer bound by the decaying structure of the paralysed oil rig, but transcend that location through the sensory structures still at work beyond their clinical encounter.

A discontinuous and secret genealogy connects – like the tropical currents that Martin, the oceanographer, has not yet been able to identify – Walter Benjamin's 1936 essay 'The Work of Art in the Age of Mechanical Reproduction', with Berger's *Ways of Seeing* and Coixet's film.[20] As Berger writes, 'The only justification for criticism is that it allows us to see more clearly.'[21] And Susan Buck-Morss illustrates this

further when she notes: 'Even we mere mortals who are no Benjamin-type geniuses can learn from him a visual method of theorising. That's what method is, a set of tools that can be used by other people.'[22] We, no less than Isabel Coixet, owe John Berger a great deal for the enormous gift of his still fresh and challenging *Ways of Seeing*, and for the many other facets of his visual, ethical and political engagements that challenge *us* 'to see more clearly'.

FILMOGRAPHY

Before the Rain (dir. Milcho Manchevski, Macedonia and UK, 1994).
Biutiful (dir. Alejandro González Iñárritu, Spain, 2010).
Breaking the Waves (dir. Lars von Trier, Denmark, 1996).
Dancer in the Dark (dir. Lars von Trier, Denmark, 2000).
From I to J (dir. Isabel Coixet, Spain, 2009).
Nobody Wants the Night (dir. Isabel Coixet, Spain, France, Bulgaria, 2015).
The Deep (dir. Baltasar Kormákur, Iceland, 2012).
The Sea (dir. Baltasar Kormákur, Iceland, 2002).
The Secret Life of Words (dir. Isabel Coixet, Spain and Ireland, 2005).
Through A Glass Darkly (dir. Ingmar Bergman, Sweden, 1961).

NOTES

[1] Berger, J. (2008) Where Are We?, in his *Hold Everything Dear: Dispatches on Survival and Resistance*, London and New York: Verso, p. 35.
[2] Berger, J. (1984) *And Our Faces, My Heart, Brief as Photos*, New York: Pantheon, p. 70.
[3] Berger, J. (1972) *Ways of Seeing*, London: British Broadcasting Corporation and Penguin Books.
[4] Pincock, S. (2004) Inge Genefke, *The Lancet* 363, 5 June, p. 1914.

5 Huete Machado, L. (2006) La mirada Coixet (interview with Isabel Coixet), *El País Semanal* 1.531, 29 January, p. 50. See also Isabel Coixet and John Berger, *From I to J*, exhibition catalogue and DVD, Barcelona: Arts Santa Mònica and Actar Barcelona/New York, 2009.

6 Victoria Rivera-Cordero writes that 'The Secret Life is a film about two wounded people that chance brings together and who connect through their suffering and trauma'. Rivera-Cordero, V. (2013) Rebuilding the Wounded Self: Impairment and Trauma in Isabel Coixet's *The Secret Life of Words* and Pedro Almodóvar's *Los abrazos rotos*, *Arizona Journal of Hispanic Cultural Studies* 17, p. 231.

7 Nail, T. (2015) *The Figure of the Migrant*, Stanford University Press, p. 85.

8 Ibid., p. 88.

9 Three other examples come to mind: Coixet's most ambitious and in many ways most psychologically and pictorially driven film to date, *Nobody Wants the Night* (2015); Baltasar Kormákur's study of resilience and survival, *The Deep* (2012); and Milcho Manchevski's extraordinarily compelling story of the Bosnian War, *Before the Rain* (1994).

10 Berger, J. (2001) Past Seen from a Possible Future, in his *Selected Essays*, edited by G. Dyer, London: Bloomsbury, pp. 238–245, p. 238.

11 Lingis, A. (1994) *The Community of Those Who Have Nothing in Common*, Bloomington: Indiana University Press.

12 Marks, L. U. (2000) *The Skin of the Film: Intercultural Cinema, Embodiment, and the Senses*, Durham, NC, and London: Duke University Press, p. 194.

13 Imre Szeman (2010) The Cultural Politics of Oil: On *Lessons of Darkness* and *Black Sea Files*, *Polygraph* 22, pp. 33–45, p. 34.

14 Caruth, C. (1996) *Unclaimed Experience: Trauma, Narrative, and History*, Baltimore and London: Johns Hopkins University Press, p. 7.

15 Berger, J. (1980) Courbet and the Jura, in *About Looking*, New York: Pantheon, pp. 141–148, p. 142.

16 Thomas Struth, *Semi Submersible Rig, DSME Shipyard, Geoje Island, South Korea*, http://publicdelivery.org/tag/south-korea/

17 Mulvey, L. (2006) *Death 24x a Second: Stillness and the Moving Image*, London: Reaktion Books, p. 79.

18 Marks, *Skin of the Film*, p. 195. In an essay on Coixet's unique status as a transnational or, rather, emphatically non-national and sometimes non-European filmmaker, Núria Triana Toribio writes: 'In the words and work of Coixet we discern ambivalence towards nation, language and the European mode of filmmaking and the ways in which they can pigeon-hole a filmmaker within his or her own national cultures'.

Triana Toribio, N. (2006) Anyplace North America: On the Trans-national Road with Isabel Coixet, *Studies in Hispanic Cinemas* 3(1), pp. 47–64, p. 62.

19 Berger, *Ways of Seeing*, p. 64.

20 Ibid., p. 34; Benjamin, W. (2007) The Work of Art in the Age of Mechanical Reproduction, in his *Illuminations*, edited by H. Arendt, translated by Harry Zohn, New York: Schocken Books, pp. 217–251.

21 Berger, Courbet and the Jura, p. 141.

22 Buck-Morss, S. (2002) (in conversation with Laura Mulvey and Marquard Smith), Globalization, Cosmopolitanism, Politics, and the Citizen, *Journal of Visual Culture* 1(3), pp. 325–350, p. 328.

SECRETS

UNDERCOVER SEEING: REPORTING ON THE WORKING LIVES OF MIGRANT WORKERS

HSIAO-HUNG PAI

When I discovered *A Seventh Man* in a bookshop and read it for the first time some fifteen years ago, I couldn't put it down.[1] Its language and imagery mirrored those in my mind, not least because I was also a new migrant and an outsider. I felt an affinity to those characters emerging from Berger's pen. I read through the pages, over and over again, as if seeking reassurance. The story of Turkish migrants, in Berger's portrait, was told in their journey from 'Departure', to 'Work' and then 'Return', an embodiment that could be taken from any migrant worker's diary.

'Every migrant worker is in transit. He [*sic*] remembers the past: he anticipates the future: his aims and his recollections make his thoughts a train between the two,'[2] writes Berger. In *A Seventh Man*, Jean Mohr's photography was the means to tell that story of transient existence. Among the limited belongings of Turkish migrants were photographs of home. For Berger,

'All photographs are a form of transport and an expression of absence.'[3]

The form of transport has evolved over the decades. Zhang Guohua, a rural migrant from China journeying to Britain, brought with him not only printed photographs but also a mobile phone in his suitcase.[4] As China has opened up to the market economy, peasants have found themselves unable to compete with agricultural production from the West. As the rural economy declined, many left their land to find work in the cities and abroad. Zhang was one of tens of thousands of migrants. His mobile phone was the means by which he was able to maintain some contact with his family in China. The phone was all that he had to fill his absence.

On arrival in Britain, Zhang was given a fake name and a fake ID by a London agency, and he was immediately sent to work in an electronics assembly factory in the northern town of Hartlepool. There, he worked double shifts over a long period of time, until he was literally worked to death. He was not even allowed a break during his last shift, stamping logos onto microwaves. When he died, no one knew his real name. They only found out he was called Zhang Guohua when they looked through his mobile phone. The factory, which denied any responsibility for his death, was manufacturing for the multinational corporation Samsung. Samsung had produced the same mobile phone that Zhang relied upon for maintaining contact with his family in China.

Those who survive migration and manage to achieve their aims have had to endure long periods of separation from their

families. Many Chinese migrants have given the best years of their life to the British economy in order to secure a future for their children – and the price they pay is not being there to see their children grow up. Xiao Lin is one of these migrant parents.[5] During his fifteen years in Britain, he could only see his children on Skype in an internet café. He was unable to return home for a visit because he had been working without papers.

Xiao Lin came from a village in Fujian, southern China where a large amount of land was taken over by developers, with little compensation to the villagers. Xiao Lin took part in the protest against the land grab, but had to give up when the protests fell on deaf ears. One by one, the villagers left their homes to seek their livelihood abroad. They all borrowed heavily to be smuggled to the USA or Europe. There were no alternatives for them. After six months of journeying through Europe, Xiao Lin finally arrived in Britain. He chose to join others to pick cockles in Morecambe Bay, in order to avoid the high risks of getting caught as a restaurant worker and deported. He considered himself lucky. It was by pure chance that he had not chosen to join the team of cockle pickers who drowned in 2004.[6]

It is these everyday catastrophes of migration that motivated me to find out more about the working lives of migrant workers. Technologies have transformed the medium by which we document and portray working lives. Given widespread media misrepresentation, I have wanted to present realism in writing about the working lives of migrant workers. For me, realism means the least possible distance between

myself and the people I'm writing about. In this respect, I found traditional journalistic methods limiting.

During the initial finding-out stages of my research, the words of a Chinese migrant kitchen worker remained in my mind. He had told me, 'If you don't live the life of a migrant worker, how are you going to really understand it?' His words confirmed the idea that I needed not only to get close to the people whose lives I wanted to know about, but that I should also become one of them. I wanted to be an active participant not just an interviewer or a distant 'objective observer'. This undercover method was going to change my way of seeing their working lives.

In the years that followed, I started to adopt a participatory approach by going undercover and posing as a migrant worker, working alongside other migrants in factories and farms. From then on, I was no longer a reporter and outsider. I was on the inside.

Being inside doesn't mean that you go and do the manual work in the daytime and return home to relax with a glass of wine in the evening. Being inside means you adopt a migrant worker's identity and live her life. You do the work they do; you eat the food they eat; you sleep on mattresses with them. You are one of them. At least temporarily.

This unconventional way of telling, as I pose as a migrant worker, presents the 'story' of migrant workers as the story of you and I. By becoming 'them' and inhabiting 'their' story, the nameless and faceless workers, who have always been

represented as statistics in mainstream media, have had their stories told, via me, from their own perspectives.

But this way of telling has its own difficulties and dilemmas. Some argue that it is breaking the rules of objectivity and breaching the rational distances of conventional journalism. Working undercover as a journalist, i.e. using subterfuge, risks partiality. From the preliminary research I did prior to the undercover work, I was sure that the idea of 'objectivity' is the necessary price to pay in order to achieve a realistic representation. It sounds paradoxical, but it can't be more true. As the journalist Gunter Walraff has put it, 'deception can be used to expose social deception'.[7]

Prior to my undercover work, I also confronted the argument that the practice of subterfuge would risk the invasion of migrant workers' privacy and, in some cases, might risk violating their rights to privacy. The only justification for subterfuge is the public interest: I must continually struggle to prove in each case that it is in the public interest to have the information gathered from an undercover assignment and that subterfuge is the only way to attain this information.

It was clear in my mind when I started my first undercover assignment that the task was to expose wrongdoing, i.e. the systematic exploitation of migrant workers in British industries, and to represent as truthfully as I could the struggle of these workers. Before setting out on the assignment, I had done some basic finding-out about migrant labour in the region (Norfolk) and found sources that could tell me about the scale of the exploitation involved. The undercover assignment was not a

'fishing expedition' but confirmation of previous research and the only method through which I could gather the often hidden evidence of exploitation that I was looking for. It was this sense of a 'mission' that sustained me during difficult interactions with the labour recruiters and through the hard manual labour that I did in the meat-processing factory.

After leaving the assignment, I phoned several workers with whom I had shared a room, told them about my true identity and explained the reasons why I had gone undercover. The relationship – respectful and lasting friendships – between my former co-workers and myself that was built up since then has made me see the value of the approach I had taken.

In the aftermath of the assignment, questions about ethics were inevitably asked. Ironically, at this point, they came from one of the corporations exposed in the exploitation of migrant workers. As revealed to me by my co-workers, one of the corporations resorted to putting my real name and photo outside on the factory walls, telling workers that I had betrayed them. Everyone saw through the tactic and no one took the side of the company. Since then, several workers have contacted me often to inform and update me about their situation. For the majority of them, although discovering my true identity was a surprise, they came to understand the purpose of the subterfuge and wanted to offer further help in exposing poor labour practices.

Following the same path, I went on my second piece of undercover work in the Midlands.[8] The starting point was Birmingham, where thousands of workers of many nationalities

were being recruited to work at below the National Minimum Wage and in appalling conditions on farms and factories across the region. I remember having to put on thick gloves to harvest leeks as fast as I could, in order to earn enough for the day. Everyone has a family to feed back home, but these workers were rarely self-centred and often lent me a helping hand with my slow leek cutting. Solidarity was one of the most precious things that I experienced working undercover.

During this assignment, I shared a room with a Chinese woman who told me all about her high-risk work during the winter off-peak season when there was no farm work to do. She would travel to Cardiff to work as a maid in a brothel. Later, she would introduce me to the world of migrant labour in the sex industry.

Post-assignment, once again, I saw how willing former co-workers were to share their stories further. It was almost liberating, this woman said, to have someone 'outside' (outside of her underground world of work) to communicate and entrust her thoughts to. Britain's sex trade, as she showed me, is a hugely exploitative working environment. The nature of migrant sex work is determined by structural inequalities of gender, ethnicity and class. Since then, I have conducted extensive research with migrant sex workers across the UK, some working from place to place, region to region, including many Chinese sex workers, whose job mobility is high yet whose in-work freedom of movement is restricted. Others tend to work in several premises across one city, at least for a period of time, such as many Romanian and eastern European sex

workers. I followed the working-life story of a couple of women for a period of four to five years, while interviewing many who have taken up different roles in the trade, from madams and pimps to maids.

Out of the eighty thousand sex workers in the UK, more than twenty thousand are migrants.[9] Yet little has been written about them and much of what is written is negative and demonising.

Over several years, my project looked at the process through which women leave their home countries and how their work-seeking journey is portrayed as they enter Britain.[10] I looked at their employment experiences, their eventual decision to enter the sex trade, their exploitative working conditions as sex workers, and their industrial relations. As important, I looked at migrant women workers' responses to these conditions and how they dealt with them, not merely as victims of exploitation, but as parents and children needing to make the best decisions possible in difficult circumstances in order to make a living for their families. From their perspectives, I looked at how they adjust to, accept, reconcile with or resist poor working conditions.

A NEW WAY OF REPRESENTING REALITY

Later, when discussing research in the sex industry with documentary filmmaker Nick Broomfield, the idea of working undercover emerged once again – only this time it presented further ethical as well as technological challenges. This wasn't the first time I had considered the idea of filming inside the sex

industry, but the medium was new: I would have to wear a pair of glasses that had a camera in the middle and film the daily life around me. This was my first time of taking subterfuge further in a new way of representing reality – a new way of telling.

Prior to the undercover work, I've had to have discussions about ethics of subterfuge once again. As expected, numerous questions were asked and debated prior to the assignment: Do the ends justify the means? Does a realist approach in portraying wrongdoing and suffering give us the right to go into someone's space and film it? These were the questions that I thought about repeatedly. Each time it was clear to me that subterfuge was the only way of investigating and confirming the thesis: exploitation and a lack of protection are central to the working lives of migrant sex workers in an unregulated industry. Ultimately, it is the system (or the lack of it), rather than the individual traffickers (upon whom state policies have focused), that accounts for the abuse of basic rights in the sex industry. Therefore, it was clear to me that the public needs to be shown the reality of the everyday working lives of migrant sex workers. Thus, the ends justified the means.

Inside the brothels, my secret camera glasses became my new means to represent the lives of the women I was working with. Posing as a Chinese migrant searching for housekeeping work, I went from an upmarket massage parlour in St John's Wood to a shabby terraced-house brothel in Stratford where I worked for two weeks, for half the agreed pay. I ended up in Finchley, north London, working as a maid for a well-connected madam who owned two premises hiring Chinese

and Romanian sex workers. As long as the battery of my camera glasses was charged (I had several charged-up pairs of glasses but they each ran out within an hour and I always had to find a socket to recharge them), I filmed whenever possible, without selecting scenes or structuring the daily events. Each day, the filming only finished when I was allowed to go to bed, at around 2a.m. There were over two hundred hours of footage, which was eventually edited into just 63 minutes of film.

I filmed the madams and the punters face to face. The technology means that any wrongdoing has no place to hide. It also creates a sense of intimacy for those watching – viewers encounter and witness misery and suffering close-up. When a migrant woman talked to me about how she was deceived into not using contraception when serving customers and how her health and safety were put at great risk for months on the job, she was looking straight at the viewers, via the camera. There's no escaping from feeling the misery she was trying to convey. Other migrant women, most of them mothers, who must work to provide for their families, tell the viewers, via the camera, how they were made to please customers in every way possible and at their own expense. They speak of the sacrifice that they're making in order to make ends meet. There's no escaping that voice of sorrow and anger at their entrapment and the sense of hope that they felt for the future of their loved ones, which kept them going.

The closing up of distance means that these migrant women's lives are no longer just another story. This way of telling has proved a challenge to stereotypical imagery (in the

media migrant workers are often patronised or demonised) and has changed perceptions. I truly hope that this work will become a piece of evidence in the on-going debates about the decriminalisation of sex workers and the regularisation of Britain's sex industry.

For me personally, the two months' filming took the participatory approach to a new level. Not only did I witness exploitation in the workplace, I myself became the receiver of daily verbal and emotional abuse and intimidation from the brothel employer. And there was no escape: it was a live-in job. It affected me so much that in the later part of the undercover job I couldn't do the filming properly. Several times I wanted to quit the job. I knew that I could just run away, get a cab and go home to my normal life. But my adopted persona, a single mother called Xiao Yun, couldn't walk away.

To earn for her family, she had borrowed money. Like everyone else who worked in the brothel, she hadn't paid off her debt yet. She had to keep on working, accept the employer's demands, keep her head down and carry on. In a couple of years, she would have paid off the debt – this would take much longer if she were working in a restaurant kitchen or cleaning hotel rooms or looking after someone's child. It was through taking on the identity of Xiao Yun that I felt and understood what it must be like to be in those situations and the choiceless choices migrant women are making in a system that fails them.

NOTES

1 Berger, J. and Mohr, J. (1989/1975) *A Seventh Man: The Story of a Migrant Worker in Europe*, Cambridge: Granta Books.

2 Ibid., p. 64.

3 Ibid., p. 13.

4 See Chapter 1 of Pai, H.-H. (2008) *Chinese Whispers: The True Story Behind Britain's Hidden Army of Labour*, London: Penguin.

5 See Chapter 8 of Pai, H-H. (2012) *Scattered Sand: The Story of China's Rural Migrants,* London: Verso.

6 See https://en.wikipedia.org/wiki/2004_Morecambe_Bay_cockling_disaster.

7 Günter Wallraff described his methods as an undercover journalist on RTL Television thus: 'You have to disguise yourself in order to unmask society; have to deceive and dissemble to find out the truth.'

8 Pai, *Chinese Whispers.*

9 This figure is given by the UK Network of Sex Work Projects, www.uknswp.org/.

10 Pai, H.-H. (2013) *Invisible: Britain's Migrant Sex Workers*, London: Westbourne Press.

ONCE
THROUGH
A LENS

MEMORY

PUBLICITY AND LOSS IN THE AGE OF MECHANICAL REPRODUCTION

HEATHER VRANA

What if, despite John Berger's warning in *Ways of Seeing*, one was to argue for making the images of art 'ephemeral, ubiquitous, insubstantial, available, valueless, and free'?[1] The photographs of the Guatemalan Mauro Calanchina and their infinite appropriations by graffiti artists, graphic designers, and stencilmakers will show why this must be so. For only once an image has become public is it 'possible to begin to use photographs according to a practice addressed to an alternative future … if we are to maintain a struggle, a resistance, against the societies and cultures of capitalism'.[2] While Berger denounces publicity as the ruin of the image(see also the essays by de Alwis, Jordon, and Salomone in this volume), he also sees that in some way, photography could call forth a future against capitalism. I am struck that this tension in Berger's thinking remains implicit, as the stakes of the devaluation of a too-precious original are so changeable and yet so high. An image rendered unto the public or publicity – not in the sense

of advertising and business, but rather in the sense of making something known to the public – can be vital (see also the chapters by Bell, de Alwis, Jordon and Salomone).[3]

Through the words and images that make up *Ways of Seeing*, Berger warns readers that the original meaning of an image has been destroyed by the camera, by the potential for multiple ways of seeing, and by the infinite perspectives offered by the camera lens. He laments, 'For the first time ever, images of art have become ephemeral, ubiquitous, insubstantial, available, valueless, free.'[4] It is as if the painting has lost its value because the painter's intention is lost when the image is seen out of context, all of which is occasioned by the advent of popular photography. Thereafter, an image may fall victim to the vicissitudes of any willing reproducer. The image, whether photographed or painted, is impossibly devoid of context. Berger makes this point at length in a 1972 essay on the work of the photographer Don McCullin, entitled 'Photographs of Agony'. Without context, he writes, there is no empathy. Paging through McCullin's war photographs, the viewer may find herself 'arrested' by horror or disgust, but she always reads on after an all-too brief moment of encounter. McCullin's photographs are 'photographs of agony' not only because of their subject, but because it is agonising to see these photographs. Our response is hopelessly inadequate.[5]

And yet Berger detects an opportunity in his reading of Susan Sontag's classic essay *On Photography*.[6] In his response to *On Photography*, Berger first argues against the society of the spectacle that has been occasioned by the rise of some types

of photography, particularly commercial photography, under capitalism. And yet he goes on to write:

> If the living take that past upon themselves, if the past becomes an integral part of the process of people making their own history, then all photographs would re-acquire a living context, they would continue to exist in time, instead of being arrested moments.

In fact, the past that Berger refers to here is one that is not past at all. He goes on to say, 'It is just possible that photography is the prophecy of a human memory yet to be socially and politically achieved.'[7] So much seems to hinge on that word *just*. What future is ours that can be remembered from the past? What explains this apparent paradox? And what if we were to push a little more and ask Berger of the potential of documentary photography to create a different sort of value through mimicry and diffusion rather than originality? What if we were to further trouble the languages of visual reproduction?

It is significant that in 'Photographs of Agony' and 'Uses of Photography' Berger differentiates at least two types of photography: one we might call *multiplicative photography*, and the other we could name as *documentary photography*. Multiplicative photography excerpts and proliferates an image or a portion of an image, deliberately obscuring intentionality and origin. It is a tool of capitalist publicity. Documentary photography may resist capitalist publicity in order to capture a moment of agony, but it also falls short in its failure to elicit

action from a necessarily disconnected viewer. The task for a new type of photography, outlined across both essays, is to connect the viewer to the photograph and through the photograph to the photographer and the photograph's subject.

At the time Berger was responding to the growing popularity of a new type of photography that questioned the meanings of documentary photography, social realism, identity, object, and landscape. Advances in technology put more cameras into the hands of amateur photographers. Luck, opportunity, and the snapshot aesthetic – now an almost mundane part of the romance of popular and street photography – were then still novel. The period also saw the proliferation of a style that we might think of as witness photography, inspired by the earlier work of Jacob Riis, and later Paul Strand, Weegee, and Walker Evans. From the late 1960s, photographers like McCullin, Sebastião Salgado, Garry Winogrand, Lee Friedlander, and Mauro Calanchina brought something different to the medium. Their black-and-white work focused on familiar themes such as war and poverty. They sought out scenes of suffering rather than portraiture in order to document 'the social landscape' worldwide.[8]

One of these men, Calanchina, is practically unknown outside Guatemala, although he was the single most important photographer of university student protestors who, with the guerrilla, urban workers, and rural *campesinos*, took on the murderous Guatemalan state in the 1970s and 1980s. Calanchina was not yet twenty years old when he began to shoot the marches, meetings, demonstrations, and daily lives

of his classmates. Although few of his photographs have been shown outside of some small and infrequent exhibitions held in Guatemala, his oeuvre is remarkable in its simplicity. It is a startlingly matter-of-fact and intimate perspective on the small opposition movement that was taking on a massive military and paramilitary machine backed by the United States government.[9] Calanchina was a close friend of the leaders of the student party FRENTE that dominated student politics at the university throughout the mid and late1970s. The Guatemalan Communist Party (Partido Guatemalteco de Trabajo [PGT]) and its youth branch, the JPT, had close ties to FRENTE. Its rival was the FERG (Frente Estudiantil Robin García), whose members lived in semi-secrecy and began to abandon university-based actions. FRENTE continued to organise marches openly and remained involved in university politics. There was great risk involved in this choice, but many FRENTE members believed that public attention could help ensure their safety. Hiding their identities would make them seem guilty, like hoodlums. In 1978, perhaps not long before or after Salgado took a remarkable photograph of a young girl carrying a tray of snacks for sale on the outskirts of Guatemala, Calanchina photographed the FRENTE-led board of the Association of University Students (AEU), the most powerful student union in the nation. The Secretary General of the group, a young economics student named Oliverio Castañeda de León, stood out for his bold and unswerving rejection of the government's use of intimidation and force against the city's popular sector.

On 20 October 1978, AEU Secretary General Castañeda de León was gunned down by a group of men in broad daylight, just blocks from the National Palace, for his part in organising a march in protest at a bus fare hike that would have made public transportation unaffordable for the capital city's large working poor population. After his assassination, the photographs of Castañeda de León taken by Calanchina provided vital visual motifs of the students' martyrdom. Through the repetition of his name and his image, Oliverio Castañeda de León became simply 'Oliverio'. His glasses, the three-quarters profile, wide lapel shirts and matching sweaters, and finally the red carnations of Oliverio's funeral procession have come to signify the sacrifices of the honourable students in their struggle against a murderous state.[10] Calanchina's photography has been part of the conditions that made it possible to secure Oliverio's place in popular memory. They are also war photographs, but unlike McCullin and Salgado, Calanchina usually leaves the act of violence out of the frame.[11]

The photographs of agony – in Berger's case, the photo-graphs of bombings in Vietnam – are 'arresting'. 'Despair' and 'indignation' overcome us. In the work of McCullin and Salgado, blood is spilled 'on camera'. The agonistic moment is isolated in a single frame. As Berger writes, 'Such moments, whether photographed or not, are discontinuous with all other moments. They exist by themselves. But the reader who has been arrested by the photograph may tend to feel this continuity as his own personal moral inadequacy.'[12] Perhaps it is the subject of the photograph, as Berger suggests, or perhaps

it is the photographer's attitude toward the act of isolation and dispersal. He concludes with the following:

> Confrontation with a photographed moment of agony can mask a far more extensive and urgent confrontation … In the political systems as they exist, we have no legal opportunity of effectively influencing the conduct of wars waged on our name. To realise this and to act accordingly is the only effective way of responding to what the photograph shows. Yet the double violence of the photographed moment actually works against this realisation. That is why they can be published with impunity.[13]

Yet Calanchina's photographs are invoked to call attention to impunity. And there is no agony in the face of the studious Oliverio, dressed in a wide-collared polyester shirt, bent over a piece of paper – maybe a speech – with a pen in hand.

Berger's 'Uses of Photography' was written in the same year that Oliverio was assassinated. Therein he argues how technical innovations in photography have impacted on how we perceive truth, witness, and memory. But, if in *Ways of Seeing* and 'Photographs of Agony', Berger critiques documentary photography for its readiness to conceal or morph what is originary – the painter's meaning or the fleeting moment of the photograph – in 'Uses of Photography' he opens up the possibility that a community of memory might be constructed by radically changing photographic practice. The key to this

practice is a distinction made by Berger between the public and private uses of photography. The public photograph 'is torn from its context, and becomes a dead object'. The private photograph permits 'the context of the instant recorded [to be] preserved … the photograph lives in an ongoing continuity'.[14]

Having established this difference, however, Berger goes on call for the distinction between public and private photography to be transcended. In this way, a more universal and integral, inclusive history could be created. Yet unswayed by his own utopian musings, Berger insists, 'We live today in the world as it is.'[15] Thus invited into Berger's community of the present, we are urged to rethink the relationship between the photographer, the types of photographs taken, and the ends to which they are used. For his part, the photographer must approach the photographic event 'as a record for those involved in the events photographed', rather than as a reporter to the outside world.[16] Yet the photographer, the individual record-maker, remains at the centre of Berger's thought.

Calanchina, on the other hand, has withdrawn, and by his withdrawal opens up the possibility for the community of memory that Berger so desires. His photographs have been excerpted, photocopied, reprinted, and adapted in commemorative publications and graffiti, and on websites, posters and banners. If photography is a medium of memory, then Calanchina's photographs are more than mere memory aids. Commemorative publications and newspaper special editions disaggregated the student into his name, his glasses, his profile, his silhouette, and ultimately, the red carnation held aloft during

his funeral procession. The red carnation had recently become a symbol of assassinated students and so it, too, indexed the students' righteousness and the state's dishonour.

Calanchina and his many facsimiles have created a visual lexicon for the peoples' suffering against the erasures of a murderous state. This is the power of Calanchina's work. And his are not the only photographs that have become part of a language of loss in Guatemala. As early as the 1975–1976 school year, students in the AEU Committee for Family Members of Disappeared People circulated reproductions of state and university-issue identification card photographs in order to help identify individuals who had been arrested and possibly assassinated by the government. These images were accompanied by information about the individual's arrest, their family, and their job or course of study. When formal writs of habeas corpus filed with the government proved ineffective, the images served as a type of popular writ.

In 1999, three years after the civil war officially ended, members of the group Sons and Daughters for Identity and Justice Against Forgetting and Silence (HIJOS) began reprinting the images as 8.5- by 11-inch posters. The HIJOS campaigns for public memory against forgetting have consistently referred back to these haunting images for nearly two decades. These days, the images are scanned and used to create more posters with information about the individual's life and detention. They are pasted onto the exterior walls of stores and homes throughout downtown. These same identification photographs are also printed and transferred onto thick

card stock, so that graffiti artists and protestors can cut out inexpensive but reusable stencils for nighttime graffiti strikes.

A single photograph became a photocopy, which became a stencil, which has in turn become one of many memorials painted on a particular wall. With each repetition the singular moment of the photograph and the importance of the individual photographer-as-witness is lost. Remembrance is collectivised and made active, wily and unpredictable, subject to the vicissitudes of new generations. Calanchina as photographer recedes before these new iterations. With each new medium, a new texture is gained, a new place is marked. There is a productive tension where the figures of youth, newness, and generation become bearers of the past. HIJOS concentrates these protest art projects on and around Sixth Avenue, which has been the historical and commercial centre of the city since the eighteenth century, and the University City. Of course, HIJOS is not unique. This publicity practice has been crucial to human rights movements throughout Latin America where these so-called *desaparecidos* photographs are a familiar genre of memory politics.[17]

This memory practice may be understood as a sort of alternate publicity, one that runs counter to the capitalist publicity that Berger so detests in what I have called multiplicative photography. In *Ways of Seeing*, he contends:

Capitalism survives by forcing the majority, whom it exploits, to define their own interest as narrowly as possible. This was once achieved by extensive

deprivation. Today in the developed countries it is being achieved by imposing a false standard of what is and what is not desirable.[18]

In 1970s Guatemala, capitalism survived by simultaneous processes of deprivation, desire, neo-colonialism, and war. Calanchina photographed three murals by Arnoldo ('El Tecolote') Ramírez Amaya that made such a critique. The young artist and a friend painted several enormous murals on the classroom buildings of the Economics, Law, and Humanities faculties, which formed the Plaza Rogelia Cruz, a commemorative space that honoured a female student who had been disappeared and tortured in 1968. A large multi-storey image of Cruz, painted from a headshot, covered one wall, while other murals denounced Coca-Cola and the national Gallo beer company, owned by a notoriously wealthy and cruel family.

Today most of Ramírez Amaya's murals survive and a robust mural culture prospers on USAC campuses nationwide. Many classroom buildings are covered in murals that feature

8

A mural on the CUNOC campus of the University of San Carlos, CPR Urbana BlogSpot

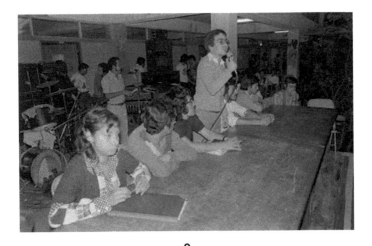

9

Oliverio speaking while joined by other FRENTE members,
photograph by Mauro Calanchina

images of student and faculty martyrs, reproduced from
Calanchina's photographs, identification photographs, or
versions of these original photographs rendered in commem-
orative publications. This alternate publicity permits the
circulation of images in a democratised form. And how the
images proliferate! There is the original photographic film, the
photographic print, the scanned and digitalised image available
online, the laser print in a commemorative publication, the
dot-matrix rendering in a 1970s student newspaper, the
photocopied poster on a building or storefront, the stencil on
a street corner, a digital image on a researcher's camera, and
finally the image reproduced in these pages. Does it matter
whether the authenticity of the original has been lost? Yes,

because precisely the reproducibility of Calanchina's work, its ready extraction, has permitted memory's endurance in the collectivity.[19]

In a recent essay in the *New York Times* Magazine, the acclaimed essayist and author Teju Cole writes, 'Photography is inescapably a memorial art. It selects, out of the flow of time, a moment to be preserved, with the moments before and after falling away like sheer cliffs.'[20] John Berger might see this selection as a violent and irrecoverable extraction. In the world of digital reproduction about which Cole writes, the infinite moments of extraction have rendered the photograph banal. On the saturation of the documentation of life, Cole notes, 'the effect of this incessant visual notation becomes difficult to distinguish from surveillance'. Both Berger and Cole – great popularisers of the arts of diaspora and exile – seem to imagine only an oppressive end for the proliferation of photographs. Calanchina and the thousands of young Guatemalans who copy, stencil, cut, reprint, and spray-paint variations of his images show us otherwise.

Walter Benjamin says as much in the second section of his text 'The Work of Art in the Age of Mechanical Reproduction', which so influenced Berger. Benjamin writes,

> technical reproduction can put the copy of the original into situations which would be out of reach for the original itself. Above all, it enables the original to meet the beholder halfway, be it in the form of a photograph or a phonograph record. The cathedral leaves its locale

to be received in the studio of a lover of art; the choral production, performed in an auditorium or in the open air, resounds in the drawing room.[21]

While Berger laments that reproduction has made an image 'ephemeral, ubiquitous, insubstantial, available, valueless, free,' this subversive publicity is the very condition of possibility of the remembrance of Oliverio, Rogelia, Mario, Robin, and thousands of others. From posters on Sixth Avenue, stencilled graffiti on campus, and digital photographs, their voices ring out that they may be returned to the people.

NOTES

I wish to express my gratitude to David Kazanjian and E. Cram for comments on an early draft of this essay.

1 Berger, J. (1972) *Ways of Seeing*, London: British Broadcasting Corporation and Penguin Books, p. 32.
2 Berger, J. (1980) *About Looking*, New York: Pantheon Books, p. 58.
3 This definition of publicity seems to date to the 1820s; see *The Chambers Dictionary*, Delhi: Allied Publishers, 1998. Jeremy Bentham was particularly fond of this use of the word in the realm of justice; see Bentham (1838) *Works*, Edinburgh: W. Tait; see also Immanuel Kant (1996) What is Enlightenment? in *Immanuel Kant: Practical Philosophy*, Cambridge: Cambridge University Press, pp. 11–22.
4 Berger, *Ways of Seeing*, pp. 32–34.
5 Berger, *About Looking*, p. 38.
6 Sontag, S. (1973) *On Photography*, New York: Farrar, Straus, Giroux.
7 Berger, 'Uses of Photography', in his *About Looking*, p. 57.
8 Lyons, N. (1966) *Contemporary Photographers Toward a Social Landscape*, New York: Horizon Press.
9 Some excellent books on the period include J.T. Way (2012) *The Mayan in the Mall* Durham, NC: Duke University Press, Deborah Levenson (1994) *Trade Unionists Against Terror*, Chapel Hill: University of North

Carolina Press, and Greg Grandin (2004) *The Last Colonial Massacre* (University of Chicago Press; for an overview of Guatemalan history, see Grandin, L., and Oglesby, E. (2011) *The Guatemala Reader*, Durham, NC: Duke University Press.

10 Vrana, H. (forthcoming) *Do Not Mess with Us!: Guatemalan Students versus the State, 1944–1996*, University of California Press.

11 Of course Salgado's work changes over time in this respect, especially after *Africa* (2007). Several interviews with Salgado in Wim Wenders' and Juliano Ribeiro Salgado's film *The Salt of the Earth* address this shift.

12 Berger, *About Looking*, pp. 39–40.

13 Ibid., p. 40.

14 Ibid., p. 56.

15 Ibid., p. 58.

16 Ibid.

17 On photography and the politics of memory and mourning in the Americas, amongst many others, see Diana Taylor (2002) 'You Are Here': The DNA of Performance, *TDR* Vol. 46, No. 1 (Spring), pp. 149–169; Andreas Huyssen (2003) *Present Pasts: Urban Palimpsests and the Politics of Memory*, Stanford University Press; Allison Landsberg (2004) *Prosthetic Memory: The Transformation of American Remembrance in the Age of Mass Culture*, New York: Columbia University Press; and Jean Franco (2013) *Cruel Modernity*, Durham, NC: Duke University Press). See also *Latin American Perspectives*, Vol. 36, No. 5, special issue: Memory and Politics (September).

18 Berger, *Ways of Seeing*, p. 154.

19 Perhaps reproducibility in photography is akin to Jacques Derrida's concept of iterability in language advanced in 'Signature Event Context' (in Derrida (1988) *Limited Inc.*, edited by G. Graff, translated by J. Mehlman and S. Webber, Evanston: Northwestern University Press. Thanks to David Kazanjian for suggesting this reading.

20 Teju Cole, Memories of Things Unseen, *New York Times* Magazine, 14 October 2015, p. MM22.

21 Benjamin, W. (1968) The Work of Art in the Age of Mechanical Reproduction, in his *Illuminations*, New York: Schocken Books, pp. 220–221.

STARS

'A PRESENT MOMENT, MORE PRESENT': JOHN BERGER'S POLITICS OF INTENSITY

VIKKI BELL

I

> We are both storytellers. Lying on our backs, we look up at
> the night sky … Those who first invented and then named
> the constellations were storytellers. Tracing an imaginary
> line between a cluster of stars gave them an image and an
> identity. The stars threaded on that line were like events
> threaded on a narrative.[1]

In conversation with Michael Ondaatje, John Berger remarked
that the capabilities of cinematographic editing have been
influential on his writing.[2] He identified cinema's ability to
move from expansive vistas to close-up shots as that to which
he most related and aspired. Certainly Berger's work is infused
with a sensitivity to how long views, the narratives of History,
breathe only with the addition of 'close-up' stories of human
relationships, that tell the story again but from a different

angle, like different tracings of the same constellation. Indeed, it is not only that different lines might be traced between the stars, but also that a different story altogether can be told when one begins with the lovers lying on the ground gazing up. And let us let them be lovers, although Berger does not exactly say so, if only because it is his forte to weave stories of love into the movements of human and natural history. Ondaatje is his soulmate in this respect, envisioning the intimate complexities of, for example, the lives of the labourers constructing the Bloor Street Viaduct in *In the Skin of a Lion*, who spread the tar so that the smell of it 'seeps through the porous body of their clothes' and the black of it is 'permanent under their nails'.[3] Those who constitute the infrastructures of urban life the world over, in other words, who burrow and climb and hammer out the systems upon which we all rely; these are the lives depicted in Diego Rivera's murals that Ondaatje says he thought of often in the writing of his novel, and that lend a 'furious democracy' (in Ondaatje's words) to both men's writing, even at its most tender.

The character in *In the Skin* to whom Ondaatje gave the name Caravaggio was partly inspired, he tells us, by Berger's essay on the painter. There, Berger writes of a feeling of 'complicity' with Caravaggio, the 'painter of life' who does not 'depict the world for others: his vision is one that he shares with it'.[4] If Caravaggio banished daylight in order to intensify his focus – for 'the chiaroscuro reveals violence, suffering, longing, mortality, but at least it reveals them intimately. What has been banished ... are distance and solitude'[5] – one might

say that Berger's writerly inclinations and sensitivities echo the resultant 'overall intensity, the lack of proper distance'[6] for which Caravaggio was so criticised, and which Berger so admires. This intensity is not a simple theatricality, nor a search for something truer to life, but is a philosophical stance that concerns political equality, akin to some extent to Jacques Rancière's thesis. Rancière challenges the way that aesthetic sensibilities are thought to be unevenly distributed. Thus he argues that the aesthetic sensibility of the squatter in a poor suburb of Lisbon, as portrayed in Pedro Costas's film *In Vanda's Room*, who wishes to clean the table in his home despite the imminent destruction of the whole suburb scheduled for bulldozing, approaches the heart of the matter better than righteous attempts to employ artistic intervention to explain economic inequality or attempts to mobilise audiences through making them aware of unjust structures of domination or pitiful experiences of subordination.[7] As he scrubs at the table, the man quietly demonstrates his aesthetic sensibility, his equality. Berger, too, sees in the smallest of gestures something important and urgent. 'Getting close' is for him, as for Robert Capa, the way to get a better picture. But it is not for the sake of the picture that he seeks such proximity. If the 'underworld' was a world of tension and theatre, he comments in relation to Caravaggio's paintings, it is in part because in these small gestures – even in a glance – one can sense a whole 'life's desire'.[8] It is this desire, the yearnings that are not necessarily articulated as such, that draws Berger's attentions; oftentimes, these are political demands, they bespeak political inequities.

Elsewhere, Rancière has discussed an attention to minutiae through James Agee and Walker Evan's (1941) *Now Let Us Praise Famous Men.*[9] There, Rancière finds a focus on the quality of each sensible event as aspiring to spur the 'recognition of an art of living' in the 'handiwork of the poor',[10] describing it as a Proustian poetics that is committed to unfolding 'the truth of one hour imprisoned in the triviality of a utensil or a fabric'.[11] Agee's struggle with journalism as a task was due not least to its insistence on the selection of details, whereas he – borrowing from Proust, and like Whitman, Woolf, Joyce – found *every* moment in every life vertiginous with interconnections, and so every detail bursting with an inexhaustible totality.[12] If Agee struggled with forms of representation emerging around him at that time, such as John Ford's novel *The Grapes of Wrath*,[13] he was himself understood as part of a swathe of intellectuals motivated by a kind of cultural democracy based in a Whitmanian art 'attuned to the vibrations of universal life', and which came to be famously critiqued by Clement Greenberg and others espousing a Marxist approach. These critics sought a more structural, less 'indulgent' analysis based on the scrutiny of capitalist relations.[14]

Read against this older debate, one staged between those who became nevertheless understood as different guises of a unity – 'modernism'[15]– Berger's writing is intriguing, blending a Marxist sensibility with an attention to gestures, scenes and personal stories that manages to avoid a sense of self-indulgence. The intensity of Berger's work, in contrast to Agee's writing, hesitates to allow the creation of intensity

to slide into an easy discourse of the ethical. In his discussion of Caravaggio, Berger is explicit about this avoidance. In the incomprehension of Caravaggio's Matthew who answers Christ's pointing finger with his own 'Who me?' or in Judith's face as she beheads Holofernes, Berger sees a facial expression peculiar to the painter's work: 'an expression of closed concentration and openness, of force and vulnerability, of determination and pity. *Yet all these words are too ethical.* I have seen a not dissimilar expression on the face of animals – before mating and before a kill.'[16]

II

The flower in the heart's
Wallet, the force
Of what lives us
Outliving the mountain.[17]

At the cemetery in Santiago, at the monument to the detained-disappeared and the 'politically murdered' from the period of military dictatorship, I take dozens of photographs. The main wall of names has a message carved across the top that precisely links human love to geological time: 'Todo mi amor está aquí y se ha quedado pegado a las rocas al mar a las montanas' (All my love is here and remains within the rocks, the sea and the mountains). I must step back to capture the full length of the monument.

The whole cemetery is vast; it is an enclosed area of eighty-six hectares, built in 1821 by order of Bernard O'Higgins.

Alexander Wilde has commented that if it is a site of social and personal memory 'it is also a repository of Chile's *political* memory, including the seventeen-year military dictatorship of Augusto Pinochet and Chile's prolonged "transitional democracy" since 1990', to which, like a huge open air museum, it bears 'mute witness'.[18] In the years of the dictatorship, the cemetery became a site for the expression of resistance and solidarity, with annual marches that ended at Patio 29 towards the far side of the cemetery, where many killed for their political beliefs were buried in unmarked graves.[19] Key funerals taking place in the cemetery, such as that of the student Rodrigo Rojas Denegri who was murdered by police in 1986, continued to gather dissent from across the social and political spectrum.[20] Here, Allende was reburied in 1990. The monument I photograph is becoming somewhat less a focus of social resistance, becoming 'incorporated into national history' as the Pinochet years are becoming part of a longer narrative.[21]

Many of the photographs I take are of the niches of what are in effect open mausoleums on either side of the wall of names.[22] Loved ones have left flowers – some real, most synthetic – as well as many photographs and even notes. Some messages are carved in stone, while others are written in biro on scraps of paper, like notes left on the kitchen table: 'Nelson, Hoy 2 de octubre se cumplan 41 anos de tu asesinato y todavia no se hace justicia tus asesinos – andan sueltos. Esposa y hijos.' (Nelson, Today, 2 October, is 41 years since your murder and still your murderers have not been brought to justice – they walk free. Your wife and children.)

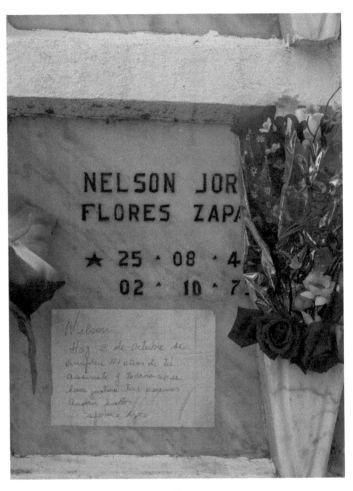

10

Santiago Cemetery, photograph by Vikki Bell

Reading this note, I recall Berger's own wanderings in a cemetery on the small Hebridean island of Gigha as noted in *And Our Faces, My Heart, Brief as Photos*. Of the simple carvings on the gravestones, the names and the precision of the dates of birth and of death, he wrote that these were surely not addressed to the living, who would recall these simple facts, but to the already deceased. They are 'letters of recommendation to the dead, concerning the newly departed, written in the hope that they, who have left, will not need to be renamed'.[23] But the note in Santiago – a small supplement to the marble name and dates – to whom is it addressed? It speaks of a personal story, of the passage of time endured, a wish to be able to convey different news across an impossible divide. 'Our stories are not read by the dead.'[24]

At another niche, a photographic portrait has been mounted onto the marble. It has been joined by two recent colour photographs of young children, tucked into the rim – grand-children perhaps – as if being shown to the deceased. Elsewhere a black-and-white photocopy of a wedding portrait has been taped up, two happy faces smiling happily out from the back of a car. The weather and the passage of time have the faces in many of the photographs fading away; some mourners have taken measures against the natural elements, laminating their messages, or covering them with plastic. Some have disappeared completely, leaving abstractions I find somehow just as moving as the preserved images. 'Our faces, my heart, brief as photos.'

On several occasions Berger takes pains to differentiate how photographs of loved ones figure depending on our

relationship to the one portrayed there. In *A Seventh Man*, he put it simply: 'A photograph of a boy in the rain, a boy unknown to you or me. Seen in the dark-room when making the print or seen in this book when reading it, the image conjures up the vivid presence of the unknown boy. To his father it would define the boy's absence.'[25] Currently, my research often takes me to spaces where I am explicitly or implicitly prompted to wonder about lives cut short. Like Berger when he visited Ramallah and stood before the posters showing faces of those who had died in the Second Intifada,[26] I have stood in front of walls of faces transforming public structures into something as intimate as a wallet of private papers and pictures, reading their stories, wondering about their lives. 'What we mourn for the dead is the loss of their hopes,' Berger wrote.[27] That my wonderings are of a different order from those intimately related to these faces I have no doubt.

The *desaparecidos* and murdered are made present for me in such photographs, their stories are told and the photographs 'illustrate' those stories in various ways (see also the essays by de Alwis, Salomone and Vrana in this volume). But for those who mourn them, it is surely true that it is their absence that is felt. (And I myself choose never to carry photographs of my own children when I travel such distances, for I know how painfully their unknowing images can flood the loneliness, exacerbating the slowing of time and the depth of the nights I spend apart from them.) Back at home, the photographs I have taken of these faces line up on my computer, meeting each other and mingling with pictures of my own family captured

in celebrations and holiday snapshots, often disturbingly similar to those images that the families of the disappeared or murdered display at demonstrations, in spaces of memory or, indeed, tucked into the niches at the cemetery.

III

> This small corner of the landscape – which I had never particularly noticed before – caught my eye and pleased me. Pleased me like a particular face one may see passing in the street, unknown, even unremarkable, but for some reason pleasing because of what it suggests of a life being lived.[28]

Writing about a small hillock on which stood three neglected pear trees, John Berger describes his pleasure at noticing this vista, before moving on to describe a dramatic sense of being watched himself, of the landscape watching, even tracking, him. It is as if the life of the land, the branches and leaves of the ailing trees, the valley beyond, the harvested fields, the vegetation and the movements of the weather, become fully present, and Berger himself becomes interconnected with each of the complex systems moving around him. Walter Benjamin, jotting his thoughts on a scrap of paper, described his understanding of 'aura' with just such a sequence, one in which a normal human reaction to being watched, that is, to glance up or back at the direction of the gaze, is extended to Nature:

> To experience the aura of an appearance or a being means becoming aware of its ability [to pitch] to respond with a glance. This ability is full of poetry. When a person, an animal or something inanimate returns our glance with its own, we are drawn initially into the distance; its glance is dreaming, draws us after its dream.[29]

In his experience of becoming-landscape, Berger is so 'drawn': 'I was aware of an inequality. I was less present than the corner of the landscape which was watching me.' And later: 'I was everywhere, as much in the forest across the valley as in the dead pear tree, as much on the face of the mountain as in the field where I was raking hay.'[30] He writes in a way reminiscent of Deleuzean philosophy,[31] with no separation between what is contemplated and the 'contemplative soul', as motions of particles and sensations mingle and pass through sensibilities, such that they may cause little spasms, contractions, in a process Deleuze terms 'passive synthesis'. Contractions are impersonal; they are not moments to be actively gathered or deployed.[32] They point only 'to the primary sensibility that we are. We are made of contracted water, earth, light and air – not merely prior to the recognition or representation of these, but prior to their being sensed.'[33] Each of us is, then, a bundle of contractions, arising improbably from an impersonal swirl of life forever in movement, forever risking or flirting, if you prefer, with non-individuated existence. Reading Berger, it seems that he somehow attunes himself to this swirl and even awaits it, training his attentions to the movements and contours that may

at any moment offer a sense of an extended participation, an intensity that gathers one up while simultaneously dispersing one's very sense of the here and now into a broader ecology of movements and relations.

IV

> Our words seem to resonate in a present moment more present than those we normally live. Comparable with moments of making love, of facing imminent danger, of taking an irrevocable decision, of dancing a tango. It's not in the arena of the eternal that our words of mourning resonate, but it could be that they are in some small gallery of that arena.[34]

Another hillock, this time in Ramallah. In his introduction to the translation of Mahmoud Darwish's poem *Mural*, John Berger speaks about his visit to the grave of the Palestinian poet (see also 'Courage' by Yakhlef, in this volume). After the death or murder of a loved one, he writes, words resonate differently, existing in 'a present more present' than usual. Again, Berger speaks of an intensity that arises because we exist only with others, sustained because of and for others. When we feel that connection, and not only through the experience of death but also in love, with joy, there is also an intensification of time, an intensification that makes time momentarily 'stand still'. This is a politics of intensity close to Benjamin's, who was so formative in Berger's thinking.

The context of the Palestinian struggle makes this 'present more present' deeply resonant with Benjamin's description in the 16th and 17th theses of the 'Theses on the Philosophy of History', where Benjamin writes of a present in which 'time stands still and has come to a stop'.[35] Thinking, writes Benjamin, involves a flow of ideas and their arrest, a 'crystallisation', a 'messianic cessation' which by another name is a 'revolutionary chance in the fight for an oppressed past', that may be taken in order to 'blast a specific life out of the era or a specific work out of the lifework'.[36] Where such a chance can be grasped, there is a mode of recognition that halts the dissolution of all events into a homogeneous History. Remembrance of the work of the poet Darwish is also recognition of the Palestinian struggle; it is a lifework that speaks of an oppressed past that is thereby given a chance of being remembered. Not to allow that oppressed past to be covered over by a History: this requires an ongoing task for those in each present, to continue to listen out for the past's relevance to present configurations.

It is intriguing – if typical of him – that Berger, more idiosyncratic than most, would add 'dancing a tango' to his list of 'more present than the present' moments. Elsewhere, in *The Shape of a Pocket*,[37] Berger mentions the work of the celebrated Argentine poet Juan Gelman, whose poetry he also links with the experience of a present 'full of tension', a present where the pain of mourning means 'there is only the present, only the immense modesty of the present'.[37] Knowing Gelman's story, that his son and pregnant daughter-in-law were among the *desaparecidos*, Berger cites the poem 'Cherries (to Elizabeth)'

in which a woman 'is washing furiously / with blood / with oblivion / to ignite her is like putting a Gardel record on the phonograph'.[38] Gardel, the great tango legend, is on the gramophone, and Berger imagines a dance taking place; he writes that Gelman's is a poetry 'in which the martyred come back to share the pain of those bereaving them. Its time is outside time, in a place where pains meet and dance … Future and past are excluded there as absurd.'[39]

Berger may well not have known at the time he wrote this essay that Gelman's search for his granddaughter finally ended in 2000, when she was located in Uruguay, having been taken from her mother and given away to be brought up without knowledge of her true parents' identities. He was able to reconnect with her during the years before his death in 2014. When Gelman was searching, he wrote a poem about not being deluded by grief, about maintaining hope. Berger quotes some lines from it.[40]

Berger's own hope breathes life into his essays, despite their attention to the global operations of power, the contemporary 'prison' in which 'we' live.[41] Against the lament that often pervades his writing, he still finds a 'small cargo of hope' (as he comments in the conversation with Ondaatje). He finds that hope, above all, in human communication that reaches out despite all that mounts up against its possibility. In Ramallah, he laughs with the young boy who, watercan in hand, wants to show Berger his plot of fruit and vegetables: 'We are both – God knows why – living at the same moment'.[42]

As Rancière says of the letter in Pedro Costa's film *Colossal Youth*, which is an amalgam of letters from Cape Verdean immigrants and a letter sent by Robert Desnos to his lover from a Nazi camp, and which returns like a refrain throughout the film, Berger's essays belong to a wider circulation. They are letters from the world, offered back in an intimate form that makes it available to 'us' anew 'like a song they can enjoy, like a love letter whose words and sentences they can borrow for their own love lives'.[43] But like cinema, Berger knows that essays in books have their limitations. He knows they will not in and of themselves be sufficient to rebalance the inequities of the present. Yet he writes for a future-to-come, for the contours of a configuration that is present, if only virtually, that may yet come about. As A'ida writes in *From A to X: A Story in Letters*, to her imprisoned lover: 'The future that they fear, will come. And in it, what will remain of us, is the confidence we maintained in the dark.'[44]

NOTES

1 Berger, J. (2005/1984) *And Our Faces, My Heart, Brief as Photos*, London: Bloomsbury, p. 8.
2 2010 Lannan Foundation, John Berger in Conversation with Michael Ondaatje, vimeo.com, https://vimeo.com/11089692
3 Ondaatje, M. (1987) *In the Skin of a Lion*, London: Picador, p. 29.
4 Berger, *And Our Faces*, pp. 79–80.
5 Ibid., p. 81.
6 Ibid., p.83.
7 Rancière, J. (2009) *The Emancipated Spectator*, translated by G. Elliott, London: Verso, first published in French 2008, p. 80.
8 Berger, *And Our Faces*, p. 83.
9 Rancière, J. (2013) *Aisthesis: Scenes from the Aesthetic Regime of Art*, London: Verso, pp. 254–5.

10 Ibid., p. 255.

11 Ibid.

12 Ibid.

13 Ibid., p. 259. John Steinbeck's novel *The Grapes of Wrath* was made into a film by John Ford in 1940, a year after its publication. Agee considered its 'unreality' insulting to the people whose lives its portrayed.

14 Rancière, *Aisthesis*, p. 262.

15 Ibid.

16 Berger, *And Our Faces*, p. 85.

17 Ibid., p. 5.

18 Wilde, A. (2008) Avenues of Memory: Santiago's General Cemetery and Chile's Recent Political History, *A Contra Corriente: A Journal on Social History and Literature in Latin America*, Vol. 5, No.3, pp. 134–169, p. 145.

19 Streeter P. B. and Leiva, M. I. (2015) The Chilean Medical Forensic Service, in Douglas H. Ubelaker, ed., *The Global Practice of Forensic Science*, Oxford: Wiley Blackwell, pp. 39–48, p. 42.

20 Stern, S. (2006) *Battling for Hearts and Minds: Memory Struggles in Pinochet's Chile 1973–1988*, Durham, NC: Duke University Press, p. 281.

21 Wilde, Avenues of Memory, p. 165.

22 There are two mausoleums on either side of the wall, one for the *detenidos-desaparecidos* and one for the *ejecutados-políticos* with many fewer niches than there are names on the wall, but with fewer still occupied.

23 Berger, *And Our Faces*, p. 44.

24 Ibid.

25 Berger, J. and Mohr, J. (2010/1975) *A Seventh Man*, London: Verso. p. 21.

26 Berger, J. (2007) *Hold Everything Dear: Dispatches on Survival and Resistance*, London: Verso, p. 59.

27 Berger, *And Our Faces*, p. 33.

28 Ibid., p. 29.

29 Benjamin, W., in U. Marx, G. Schwarz, M. Schwarz and E. Wizisla, eds (2007) *Walter Benjamin's Archive*, translated by E. Leslie, London: Verso; first published in German. Fig 2.7, n.p., translated by E. Leslie.

30 Berger, *And Our Faces*, p. 29.

31 I'm thinking here especially of Deleuze, G. (1994) *Difference and Repetition*, translated by P. Patton, New York: Columbia University Press.

32 As described by Branka Arsić, Active Habits and Passive Events or Bartleby, in Patton, P. and J. Protevi, eds. (2003) *Between Deleuze and Derrida*, London: Continuum, pp. 135–157.

33 Deleuze, *Difference and Repetition*, p. 73.

34 Berger, J., Introduction to Darwish, M. (2009) *Mural*, translated by R. Hammami and J. Berger, London: Verso, p. 2.

35 In Benjamin, W. (1992) *Illuminations*, translated by H. Zohn, London: Fontana Press. First published in German 1955, p. 254.

36 Ibid., p. 254.

37 Berger, J. (2001) *The Shape of a Pocket*, London: Bloomsbury, p. 164.

38 Ibid., p. 161.

39 Ibid.

40 Ibid., p. 164.

41 2014 GRID *Times of Crisis: John Berger and Noam Chomsky*, https://www.youtube.com/watch?v=2qCaW1_4LBQ

42 Berger, *Hold Everything Dear*, p. 65.

43 Rancière, *The Emancipated Spectator*, p. 81.

44 Berger, J. (2008) *From A to X: A Story in Letters*, London: Verso, p. 81.

CONSCIENCE

TELLING TALES: BEARING WITNESS WITH JOHN BERGER AND JEAN MOHR

RAM RAHMAN

1984 DELHI

The first indication I had that something was badly wrong in Delhi after Indira Gandhi's assassination was when I saw an elderly Sikh on the Defence Colony flyover with his turban unwound and trailing on the ground. I was in an auto and as I reached the top of the flyover, I saw wisps of black smoke rising from different parts of south Delhi. It was the day after her killing by her Sikh bodyguards, and by that evening the news had gone around that violence had exploded across the city. The information network then was the landline telephone, and people were calling friends about the panic that was spreading area by area. Friends in the press had more information than the general public and my flat in Civil Lines became a dormitory for stranded press friends from outside Delhi. The photographer Raghubir Singh arrived late at night from Simla, and we had to scramble to collect enough food for all as everything was

shutting down. A wild rumour had been spread that the water supply had been poisoned.

In the next few days as the extent of the violence became clear, I joined a group of friends in a spontaneous relief effort. Many citizen initiatives had sprung up to provide relief to the victims, and ours was just a small effort. Patwant Singh, Leila Kabir Fernandes, Pramila Dandawate and others had somehow come together in two Ambassador cars and we drove across the river to Kalyanpuri with blankets, medicines and food supplies, not knowing what we would find.

What we did find shocked us deeply. I had two rolls of Tri-X film and my Pentax. I realised right away that I had to document what we saw. Only two adult males were left alive in this one gali (an alley\lane) in sector 13 where 22 had been burnt alive. No help had reached these people yet. They were wandering

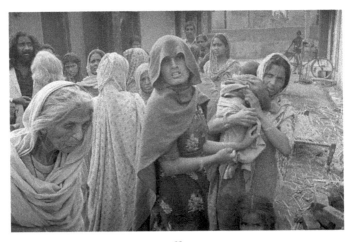

11
Delhi, 1984 in Kayanpuri, sector 13, photograph by Ram Rahman

stunned in the shells of their burned-out homes, showing us the burned autos their menfolk had driven to earn a living.

I noted down Gagan Singh's name when I photographed his widow holding his finger, chopped off by someone in order to steal his gold ring. That photograph was prominently displayed on the truck that carried the travelling exhibition on its journey from Jallianwala Bagh in Amritsar to Delhi, over a two-week period in 2012. Justice Phoolka, who has been fighting for justice for the victims for the last twenty-eight years, identified her as Nanki Kaur. All those years later, I found out her name. There has been no justice for the survivors till now.

My parents had told me of the Great Killings in Calcutta in 1946, when my father had taken his young new bride back to his home. They drove in a tonga through streets strewn with dead bodies being eaten by vultures. My mother, pregnant with my sister, never forgot those days, and it was one reason I was given the name I have. I never thought I would see anything similar in my lifetime. How wrong I was. After 1984 there was the Ayodhya mosque demolition (1992) and then the Gujarat massacres of Muslims in 2002.

My friend and comrade Safdar Hashmi led his street theatre group in a performance in Sahibabad on the outskirts of Delhi on 1 January 1989. They were attacked by goons connected to a local Congress party politician. Safdar and a factory worker were killed. His funeral saw an unprecedented crowd in a march through the city as a sign of the shock and revulsion people felt at this murder of an actor. His killers were caught and, after a long trial, were sentenced to life imprisonment.

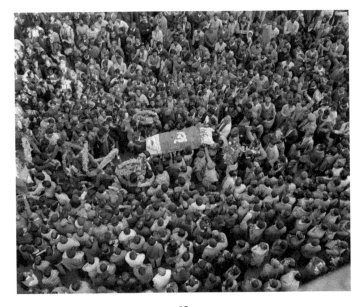

12

Funeral of Safdar Hashmi, January 1989, photograph by Ram Rahman

In Gujarat in early 2002, then under the leadership of Narendra Modi (he became the prime minister of India in 2014), a planned pogrom of the Muslim community ensued, supposedly in reaction to deaths in a train filled with Hindutva activists in Godhra Station. I photographed some of the survivors in 2006 when we worked in support of the activist Teesta Setalvad, who has been fighting in the Indian courts for justice for the survivors for many years. The ruins of the Gulberg Society were photographed in 2012 in Ahmedabad before the tenth anniversary of the killings. Zakia Jafri, who witnessed her husband Ehsan Jafri being dismembered alive

before her home was set ablaze, is still fighting for justice through the Gujarat courts, and has named Narendra Modi, the current prime minister at the time of writing, as the prime accused. In one of the massacres (Naroda Patiya), some of the accused were convicted and given life sentences, including a former minister in the Narendra Modi government, a first in the history of India.

The portraits were hung in the ruins of Gulberg in 2012 on the tenth anniversary of the killings.

These are some photographs that bear witness to the violence in Indian politics, which has only increased on a big scale since 1984. India is a society where photographs still have the power to serve as moral markers of conscience.

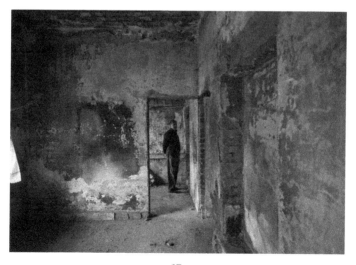

13

Salim Sandhi, Ahmedabad, in the room where his son was killed, 2012,
photograph by Ram Rahman

PERFORMANCE

THE IMAGE(S) BETWEEN US: PERFORMING DEATH IN A POST-9/11 WORLD

DOA ALY

> History no longer pays its respect to the
> dead: the dead are simply what it has passed through.
>
> JOHN BERGER[1]

Since the medieval order of the Assassins (*hashshashin*), terrorism has been able to shift the struggle into the symbolic sphere, by its willingness to sacrifice its own in the bid for power, through *isteshhad* (the act of martyrdom). After 9/11, such an interruption has been most pronounced in the gruesome images produced by the Islamic State of Iraq and Syria (ISIS). Relying mostly on online social platforms, the militia's extreme propaganda videos are elaborate, concise, and highly aestheticised. ISIS's imagery represents an interruption to the increasing homogeneity of the internet, enacted with clear intentions: to stage death horrifically, through art direction, scenography, scripted performances, and technical savvy. Because the camera does not have a language of its own,

the deep violence of these public images comes from both the brutality of what is recorded and how this selective quoting from appearances fuels other appetites.[2]

Death on camera introduces a dramatic categorical shift that is isolated from and irreconcilable with historical context – an impasse precipitating the production of more desire, and with it renewed hopes for transcendence. Because the image of death never shows a real death, it constantly transfers to other spheres, ensuring the continuation of a narrative that transcends the reality of death for the sake of its symbolic impact on those who are forced to witness it. Image and counter-image become the new political order administered by a logic seeking to avenge images. Killing is made at once unreal (an image) and necessary (for the production of more images). And as we sit behind our screens, radiation collecting in our eyes and in our bodies, we are the growing repositories of state and terrorist waste: the new paradigm of the blind narcissus. It is within this paradigm that this essay attempts the impossible task of responding to *seeing* death, and even to momentarily indulge in the moral debate with regards to images.

WAYS OF SEEING DEATH

In October 2004, Al-Jazeera broadcasted excerpts from a tape showing Osama Bin Laden accepting responsibility for the 11 September 2001 attacks, while condemning and threatening the Bush administration with further attacks. The Bin Laden video, placed in conjunction with the iconic images

of the airplanes crashing into the World Trade Centers, and the footage from the war in Iraq and Afghanistan, concludes the triangulation of offence, defence, and psychological warfare presented in this very public showdown between terrorism, global powers and the media. The world became divided into antagonists, protagonists and parasites. In this ménage, Islamist terrorism gained the upper hand; propaganda videos exhibited intelligence, murderous stamina, extreme faith, and a fluency pertaining to the technological tools of the western world. Above all, it presented a clear adeptness at constructing narratives for the purposes of propaganda, using the same techniques the states of the western world have often used for their own purposes.

In *The Spirit of Terrorism*, Jean Baudrillard addresses the role of images in conveying the reality of terrorist acts as ambiguous at best ('The image consumes the event, in the sense that it absorbs it and offers it for consumption') and at worse misleading ('rather than the violence of the real being there first, and the frisson of the image being added to it, the image is there first, and the frisson of the real is added').[3] The image, which has absorbed the event, regurgitates the event as fiction. The gruesome ISIS video depicting the immolation of the Jordanian pilot Moath Al-Kasesbeh in February 2015, for example, is the product of an act of fragmentation and magnification. The iconic scene, which depicts Al-Kasesbeh caged and set on fire, made headlines all over the world, turning the ubiquitous image of his death into a montage of sorts. It is the expression of total intentionality on the part of ISIS – they

burned that pilot alive because he was part of the coalition against ISIS that bombed civilian targets who were burned alive. The narrative of revenge is also a kind of staging in this respect. When the image of the punishment is presented on screen, it becomes difficult to differentiate between the reality and fiction behind the event, since the image itself is by default a fabrication, or a staging, and the pilot himself becomes but a figure in a much larger narrative.

To this end, you might say that an image of death is not a real death, but rather a spatial and temporal interruption that suspends the very moment of killing. The actual murder happens once, at a moment in chronological time that will never be repeated. Yet the real moment is forever lost (and forgotten); captured as a mock-moment returning not from the past but from the future to serve as an automated apocalypse. The sheer absurdity of the brutality we bear witness to throws us off in four directions; this unstoppable death, so close, keeps popping up on our screens uninvited – how exactly should we react to it?

Take the online performances of ISIS, which are generative, contagious and viral. We cannot approach the gruesome performances of ISIS, and our responses to them, without looking at the transformations brought about by the advent of the digital age and algorithmic abstraction. The flexibility and speed characteristic of digital technologies put certainty and crisis on an even keel, creating a state of permanent instability that is the norm. Automation, so to speak, mimics the state of exception, while remaining inaccessible to it. Both the

Islamic State (ISIS) and the despotic state allegedly fighting terror transfer hierarchical forms of governance to the digital platform, attempting to institute a state of emergency as an interruption. It naturally fails, since automation in and of itself is a perpetual limit situation upon which the real is modelled, and not vice versa. This outpacing of knowledge means that all existing interpretive models used physically on the ground become obsolete. Violence becomes the only way to compete with this outpacing.

In this, we find ISIS propaganda videos real enough for governments to take action, and not real enough for people to take action. Of course, while ISIS claim to address people in their communiqués, their messages are designed for politicians, not for populations, since we are actually left incapable of taking further action in response to such senseless violence once we have witnessed it. On the other hand, those in power, who have tanks and weapons and can mobilise armies, can take action and do so right away, without thinking. Meanwhile, those of us perceiving the conflict are left to distinguish the religious or ethical folk registers that instantly transmute such violent and visual interventions into acts of subjugation. Through the circulation of these deathly images, categories are blurred as fact mixes with fiction. The challenge for the witnesses of online violence, therefore, is precisely the reclamation of agency in the face of such interruptions as those produced by ISIS propaganda.

But what does it mean to witness the absurd death of another? *Shaheed* (Arabic for 'martyr'), and *shahid* ('witness'),

share the same root: *shahad*, which means 'to see'. The martyr is the one who sees God in paradise and lives for eternity in his presence. The witness and the martyr can never meet in reality, for the existence of one means the demise of the other. On the ground, in the aftermath of a terrorist or state-organised massacre, the photographer is a witness. The witness believes it her duty to document and testify to the violation.[4] Their relationship is stratified from the onset. The witness obviously has power over the martyr. She has complete power over the martyr's body and the martyr's body's image. This imbalance of power, for the briefest of moments, prolongs the condition of violation. On the internet, as we rapidly process the stream of images, we are all witnesses to something that is impossible to testify to. The screen is like a revolving door, across which the positions of witness and martyr are interchangeable on any day. What becomes impossible with this fluidity is the very act of *seeing*, at the core of either status. No matter how many times we look at it, death in the image remains unseen. The image, at once the evidence of violence and the evidence of the violated martyrdom, brings two incompatible paradigms to a deadlock. Most important, it becomes difficult to address each death as what it is, a unique event.

In Egypt – since the revolution – the word *martyr* has been deployed to exert political and juridical pressure. The recurring phrase *Haq al shohada* (often accompanied by images of dead victims) refers to the martyrs' posthumous right to a fair trial of their killers. On 8 February 2015, twenty-five soccer fans from the Ultras White Knight were killed in a stampede outside an

army-owned soccer stadium, caused by the police's excessive use of tear gas. Security forces 'panicked', showering tear gas on crowds crammed in a cage-like passageway. Immediately after the event, images of the dead bodies, scattered on the pavement and at the morgue, were published on social media platforms. The photographs were taken and uploaded in haste, often without credentials. Once online, they were endlessly reprocessed: edited, rearranged in grids, inscribed with commentary, scripture, or questions. All victims were dubbed martyrs of the police's alleged planned liquidation of the Ultras. Facebook and online journals were littered with eyewitness statements; they started with an oath and ended with a prayer like sworn testimonies. It was obvious that survivors saw it as their responsibility to relate the truth of what had happened. Meanwhile, as testimonies, comments and opinions were shared, the victim in the picture was reduced to a virtual presence, silent, unreal and sublime.

Any language originating from the Manichaean struggle between good and evil (the goodness of a martyr's death against the corruption of their killers) will not bring about justice when it comes to how we look at the images of terror circulating online. On the contrary, the violence of the images and the despotic bestiality and debasement they express through the language of ideology, will inevitably cause a logical logjam.

Fiercer than ever, like the ultimate pornographic nightmare, slicker than any fiction, the final threshold of horror is the image of a defenceless civilian being decapitated for the camera by an anonymous masked criminal. The

irreversible cruelty is at once visible (as an act) and invisible (through the actor). The terrorist introduces himself from behind a mask through a shocking murder on camera: an act that is attributed to the group, as a unanimous performance. He could be anyone, or every one. His appearance is simultaneously a disappearance. The entire performance is symbolic, and the players are readily exchangeable with any others. Thus, as much as the victims become fragmented, so do the perpetrators. Yet we, too, undergo a process of abstraction, becoming open targets for both terrorist and state violence alike – 'life exposed to death'[5] – as much as we ironically re-enact the symbolic gesture of the invisible terrorist as witnesses to atrocities we cannot help but see.

In *The Remnants of Auschwitz: The Witness and the Archive*, Giorgio Agamben calls into question the very meaning of the witness, or rather, the 'complete witness' – one who exists at the disjunction between two impossibilities in which the notion of testimony contains within it an inherent lacuna. 'The language of testimony is a language that no longer signifies and that, in not signifying, advances into what is without language, to the point of taking on a different insignificance – that of the complete witness,' Agamben explains: 'he who by definition cannot bear witness.'[6] This insignificance stems from the impossibility of bearing witness, since the act can only produce a flawed, hollowed language. The lacuna formed by the language of testimony, the impossibility of bearing witness, is filled with the image, which is meant to act as the evidence of killing. Yet the image opens up into another irresolvable void:

a finality that renders all action and speech redundant, coupled with a transience that negates finality.

This is the image's life cycle – from appearance to viral peak to oblivion, predicated on a relentless repetition. Yet, as much as these images circulate, seemingly *ad infinitum*, death does not become any less irrevocable – we are only pulled deeper into the drama the image perpetuates. Is it possible to imagine that the truest triumph of the terrorist act resides in the image of thousands marching through the streets of Paris for *Charlie Hebdo*? That with this good gesture of solidarity and resistance not only terrorism triumphs, but globalisation and neoliberal despotism as well? When we accept, in principle, possible immolation – we accept that any death is exchangeable with another. Death reproduced symbolically by populations is reproduced practically by the universal 'system of generalized exchange', as Baudrillard calls it.[7]

RE-ENACTING VIOLENCE

On 3 March 2015, exactly a month after the immolation of the Jordanian pilot Moath Al-Kasesbeh, a video of a couple getting married was uploaded to YouTube. The bride and groom and their friends restaged fragments of the Kasasbeh video. The cage in which Kasesbeh was burnt was reconstructed, and the bride and groom were escorted into the cage in a frenzy of dance and play with fake swords.

Re-enactments are fascinating. Between the potency of terrorism and the neutered War on Terror, they have emerged

as a hybrid response to terror that is saturated with influences from both sides of the supposed war: globalisation and terrorism. Laughing hysterically in the face of death is in effect a communion with damaging universal forces, a token of loyalty to the post-death superstructures that control our lives through a constant, rapid and infinite proliferation of information and images. Re-enactments are indeed a form of resistance, a resistance to the interruption caused by the image itself: a resistance of resistance.

In this way re-enactments betray a sense of loyalty to the status quo, resisting the introduction of new variables while offering a sense of being already partially lost to death. They signal, in a way, the failure of ISIS's online campaign to produce the rupture it intended. At the same time, by posing as activism's *enfant terrible*, they expose the naïveté of the revolutionary imagination. The image of beheading is unique, and a unique image has no place in the world of automatic understanding and generalised exchange.

What does this say about how we might relate to the regime of violence that exerts itself through the images disseminated through various networks that shape our perceptions and experiences of the world around us?

In the case of the wedding video, we see a further fragmentation of a violent, mediated event. It takes one detail and displaces and decontextualises it so that it becomes ambiguous: it could mean anything. It could refer to the original event, but it doesn't necessarily have the same meaning or implications. Consider the fragmenting of the Egyptian revolution from

2011 onwards through the highlighting of certain key moments of celebration or violence through mediation, both via informal social networks and via news outlets. When you take one aspect out of the context of a complex series of events, you attempt to change history through it. Yet, while the intention in the ISIS video is clear, it is much harder finding the logic behind why these people decided to celebrate in a cage. But there are points of overlap between death and celebration: the ritualistic aspect of both ceremonies – beheading and betrothal. This brings us back to the irreconcilability of images of death produced in support of a terrorist cause.

The Islamic State is a phenomenon existing on two separate but interdependent planes of reality. The first is a physical existence on the ground that is structured and calculated. The second, as noted earlier, is an online existence that is generative, viral and uncontrollable, since it absolutely depends on the effects digital technology has on the experience of an image of death. As Bernard Stiegler writes: 'Digital technology greatly expands the power of understanding. Kant said understanding was necessary, but without reason it may be unreasonable. And that's exactly what happens: we have created an automatic understanding but there is no reason to steer it.'[8] In other words, there is at once reason and unreason, both human and automated. Reason and unreason are completely compatible, not only in the events we are witnessing today, but also in our contemporary life in general. The wedding video that re-enacts the execution of a soldier is at once unfathomable and wholly understandable. Eventually a beheading video equals

a wedding video. Thus, how we reconcile the contemporary compatibility of good and evil is the greatest challenge we face today, in a world that seems too attached to binary oppositions to think of something beyond the horror we currently face.

Since the 11 September 2001 attacks, our increasingly secularised existence has made it impossible to reconcile the mauled corpse with the eschatological ideal of martyrdom. It's unfathomable that such brutality is entirely pointless and followed by eternal nothingness, yet the idea of a battered body in heaven offers no further relief. That is the most damaging way in which the image of death cheats us. It jams together incompatible systems of meaning causing a conceptual blockage. The image is a call for action: it wants us to react and seek justice, replicating itself with urgency. This economy, primarily based on a visual exchange of violence and transgression, is a form of highly effective terrorist propaganda that is willing a future made up of two things: violence and re-enactment. After all, when the political is transmuted to the visual realm, everything is accelerated through self-replicating images that feed off our deepest fears and desires. That is the lesson terrorism learned from 9/11, and a lesson ISIS is teaching us now.

NOTES

A longer version of this chapter was published in Ibraaz, 009_05, 30 November 2015, www.ibraaz.org/essays/138, edited by Stephanie Bailey.

1 J. Berger, in Berger, J. and Mohr, J. (1995/1982) *Another Way of Telling*, New York: Vintage, p. 107.

2 Berger, J. (2013) *Understanding a Photograph*, London: Penguin.
3 Baudrillard, J. (2002) *The Spirit of Terrorism*, London and New York: Verso, p. 29.
4 See Agamben, G. (1999) The Witness, in his *The Remnants of Auschwitz: The Witness and the Archive,* translated by D. Heller-Roazen, New York: Zone Books, pp. 15–40.
5 See Agamben, G. (1998) *Homo Sacer: Sovereign Power and Bare Life*, translated by D. Heller-Roazen, Stanford University Press, p. 89.
6 Agamben, *The Remnants of Auschwitz*, p. 39.
7 Baudrillard, *The Spirit of Terrorism*, p. 9.
8 Stiegler, B. (2015) System and Technics, interview by Helene Finidori, *Spanda Journal* VI, 1/2015.

A MIRROR

BOUND BY THE LOOK

RASHMI DURAISWAMY

Rather than carry the baggage of a psychoanalytic theory of the gaze, Berger focuses on the history of the look. These histories of looking are part of a very British variant of Marxism that never lost sight of the empirical. In fact, Berger interweaves the historical very delicately with the experiential. This sensuousness binds, turning subjects into objects and objects into subjects in the business of looking and seeing:

> To draw is not only to measure and put down, it is also to receive. When the intensity of looking reaches a certain degree, one becomes aware of an equally intense energy coming towards one, through the appearance of whatever it is one is scrutinizing.[1]

The 'other' in its psychoanalytic, existential, phenomenological and other variants is, therefore, not of much concern in his works, for it is the moment of being bound that reigns. As a Britisher who feels and thinks 'continental' and lives in Europe,

he is particularly sensitive to this moment of the insider-outsider, of otherness-become-own.

HISTORY, POWER AND THE LOOK

Berger shares with Bakhtin the idea of dialogism. What interests him is the looking back of the subject/object and the having-been-seen-ness. Bakhtin is interested in the 'mirror-image' and the look at oneself, which he says is always intercepted by the evaluations of others and the subject's own response to those evaluations.[2] This mediated look in the mirror is different from the way we look at the world and the world looks at us. What is also important for Bakhtin is the micro-dialogues of the sideward glance and the responses to the as yet unarticulated but anticipated response. Berger is interested instead, in the act of looking and the history of the power equations that marginalises one of the 'looks'.

His 'Why Look at Animals' exemplifies this.[3] Moving from an anthropomorphism during the times when humans and animals lived 'together' fulfilling useful functions, animals gradually lost their centrality from the eighteenth century onwards. They became the object of romantic nostalgia. With industrialisation, the growth of cities and the shrinking of the countryside, there was a growing commercial exploitation of animals. They were also reduced to being pets, spectacles at the zoo, or were imaged as toys. Zoos, according to Berger, belong to the same register of modernity – that of enforced margin-alisation – as 'ghettos, shanty towns, prisons, madhouses,

concentration camps'.[4] This leads Berger to the grim view that the 'look between animal and man, which may have played a crucial role in the development of human society and with which, in any case, all men had always lived until less than a century ago, has been extinguished'.[5]

How does Berger approach the modern look? He is not so much concerned with the collective aspects of literary or metaphoric surveillance; of the collective spectacle; of the new technologies of being envisioned by inanimate or simulated unrealities that *are* the new realities. What concerns him is the classical problematic of the real and its representation and the moments of interface between the two. Berger is classical in his thinking about the modern in that while he never loses sight of social classes and modes of production, his focus is on the individual caught up in larger social processes and the individual cogito going about the business of looking and being-looked-at.

Berger, like his contemporaries Roland Barthes and Susan Sontag, is fascinated by the photograph. In *The Seventh Man*, Jean Mohr's photographs of migrants do not 'supplement' Berger's text. They are a collaborative effort to document the journey of the migrant. Berger imagines these photographs as a form of transport: 'Did you come by photograph or train?'[6] What is path-breaking about this book is that it proposes a counter album to the genre of the family album: Wedding, Birth of Child, Birthdays, Relatives Visiting as opposed to Departure, Journey, The Shock and Rituals of Arrival, The Constricted Living Quarters, The Dream of the Return Home

or The Invitation to Those Back Home to Come and Join. The photographs document the typical and the specifically individual situations migrants go through, alienated from a context that is not their own. Berger writes of the 'looks' they have on their faces: 'The expression on many faces is reminiscent of another situation: the expression of a father waiting outside while his child is being born. Here he awaits his own new life.'[7]

The text is also interesting in the way in which transitions occur from the first person to third person; from theory to the actual acts of migration; from the particular to the general; from documents, facts, events, to fiction and poetry; from politics and economics to the cultural and the social. It is a collage and more than a collage: it is cubist writing that shows us migrations from many perspectives. Berger approvingly uses the term coined by the Cubans: 'to underdevelop': a verb that signifies the power equations of the world system in which certain states under the hegemony of others were not allowed to develop, or whose development was interfered with, to ensure their subordinate status. Berger points out astutely that with each migrant worker who arrives, an underdeveloped economy is subsidising a developed economy.

PEASANTS IN HISTORY

Berger focuses on peasants as much as he focuses on migrants, and his writings on both have not lost their relevance more than forty years later. The peasants are survivors and their

toil constitutes an autonomous economy within an economy, outlasting the changes in the modes of production in the larger sphere. A sense of timelessness, which can be also understood as a certain kind of conservatism among the peasantry, ensues from this. Berger makes an important point about the difference between the workers and the peasants and why their views on the world will always differ: 'Any transformation of which the peasant dreams involves his re-becoming "the peasant" he once was. The worker's political dream is to transform everything which now has condemned him to be a worker.'[8] Our attention is drawn to the fact that for the first time in history, this class of survivors may not survive, since the world economic system of which they are a part has little use for them. Berger critiques the undervaluation of the peasantry as a class in the Marxist worldview and the fallacy of believing that the peasant economy was not strong enough to deal with the onslaught of capitalist enterprise.

Berger's essay on peasants prefaces the documentary-fiction narratives in *Pig Earth*.[9] This introduction is one of his most important from a political and sociological perspective. The stories that follow demonstrate his familiarity with the daily life of the peasant: the slaughtering of animals, the mating of animals, the digging to look for a water source, the just-born calf whose tongue has not found its way out of its mouth, the hard life of the countryside. The stories are remarkable for their attention to the detail that is part of the routine lived-experience of the people whose stories are being told.

THE LOOK AFTER DEATH

One would imagine that the look has to do with life and the living, but Berger also thinks about the look after death. He is fascinated by the death of animals in the abattoir and in homes as part of the everyday of peasant life, so finely tuned that it resembles machinic activity. There is no need for speech, each person knows exactly which portion to chop off, in what sequence, and where and how to store or dispose of the part that has been cut off:

> Then through the cut hide, just as the tree is transformed into timber, the son axes the breast bone ... This is similar to the last axing of the tree before it falls, for from that moment onwards, the cow, no longer an animal, is transformed into meat, just as the tree is transformed into timber.[10]

Berger recognises that there is a limit to analogy in the description of this life. The slaughter of the cow lets loose a stream of blood: 'The son cuts by the throat and the blood floods out on to the floor. For a moment it takes the form of an enormous velvet skirt, whose tiny waist band is the lip of the wound. Then it flows on and resembles nothing.'[11]

In the description of the abattoir he focuses on the preparation for the animal's death: 'A mask at an execution renders the victim more passive and protects the executioners from the last look of the victim's eyes', and later, 'Her eye is

staring unseeing, and her tongue is falling out of the side of her mouth.'[12]

Death, for Berger, is an after-life in which the processes of life continue. It is rarely depicted as an end-of-the-road, finalising event. This is most evident in his descriptions of the slaughter of animals. Even when it is the 'end', Berger emphasises its 'form-giving' capacity to the life that had been lived. Writing of Walter Benjamin's suicide, he states that the German writer consciously chose to bequeath form to his life by his death. Drawing his dead father on a rectangular piece of paper, Berger sees death as a series of departures. No one would mistake these drawings, he says, for those of a man sleeping. Gradually, memories infuse the lines being drawn with their weight turning them into a site of 'arrivals: The drawing was no longer deserted but inhabited ... My father came back to give the image of his death mask a kind of life.'[13]

Berger raises an interesting point about the religious look of submission/supplication, of closing one's eyes in front of the image of God and the open eyes of the viewer in front of a realistic representation of God, in a secular context. 'Did Holbein so shock Dostoevsky because it was the opposite of an icon? The icon redeems by the prayers it encourages with closed eyes. Is it possible that the courage not to shut one's eyes can offer another kind of redemption?'[14] he asks.

Dostoevsky is said to have been so disturbed on viewing Holbein's *The Body of the Dead Christ in the Tomb* that he almost had an epileptic fit. The painting has an important place in the novel he wrote in this period when he was in Europe, *The Idiot*;

Prince Myshkin believes that the painting has the power to make the viewer lose his faith. In response to Berger, I would say that Dostoevsky was not just struck by the difference between the image of Christ in icons and Christ in the Holbein painting. Both the artist and the viewer were bound to look upon that suffering *and* keep faith. In the novel, Myshkin keeps faith, Rogozhin loses it and Ippolit, in his confession, goes further in his evaluation of the realistic portrayal of the body of the Saviour and states that Christ himself might not have wanted to be crucified had he seen the painting. Dostoevsky contrasts this with execution by the guillotine, a product of the age of Enlightenment that swiftly did away with the condemned. Myshkin refers to it three times, in rapid succession, each time from a different point of view: the anguish the condemned man will go through in knowing he will be dead soon; the internal living out of the few minutes before death, and the look of the crowd on the condemned man, and the man looking back at the crowd. Dostoevsky seems to be setting up a kind of parallel between two kinds of death and suffering: while talking to Yepanchin's valet of philosophical subjects in a typical carnivalesque situation, Myshkin explains that the torture of the efficient guillotine is far greater than that of the nailing of Christ to the cross.[15]

THE LOOK CALLED FORTH

Berger writes of the dialogue of energies between the viewer and the object viewed. 'What is this energy? Might one call it

the will of the visible that sight should exist? Meister Eckardt talked about the same reciprocity when he wrote: "The eye with which I see God is the same eye with which he sees me."'[16] Berger and Eckardt seem to grant a primacy to the viewed, which calls forth sight and subsequently places human sight on a par with that of God. One wonders if there is a parity of vision, for does not the eye of God have panoptic and panoramic vision? Eisenstein's *Ivan the Terrible*, a film in which the director weaves a complex double allegory of equating Stalin with Tsar Ivan and also simultaneously offers a critique of it, has several interesting examples of this unequal relationship with the 'eye of God'. Take, for instance, the well-known image of Ivan looking down upon his people in his self-exile. The panoramic eye-view of the King, the hawklike profile and the expression on his face, do not bode too well for the common folk, even though they have trudged long and far in the harsh landscape to beseech him to return to his throne in Moscow. The image is 'overlaid' by an extreme disjunction in scale compositionally between the king and his people: he and the power he wields over them are clearly immense.

LEISURE AND PLEASURE

Berger has written extensively and offered deep insights into the modern period and the modernists. Among his insights is the linking of the look to pleasure and leisure, paradoxically as subversive moments within capitalism[17]. If production, circulation and consumption are important in a capitalist

economy, then leisure could be subversive. He writes of Matisse, 'In an ideological climate of anguish and nostalgia an artist who frankly and supremely celebrated pleasure, and whose works are an assurance that the best things of in life are immediate and free, is likely to be thought not serious enough.'[18] Of Renoir he states, 'Pleasure for him was not for the *taking*: it had to be ubiquitous and omnipresent.'[19] He notes that in Renoir's nudes the pleasure was not of possessive 'owning': 'The women he depicts are never naked; they and everything around them are clothed, covered, by the act of painting. He made hundreds of nudes and they are the least present, the most chaste in European art.'[20]

Berger sees the act of framing as important to perception. A visual field becomes important only when it is framed by an act of looking that is itself contextualised. A closed level crossing that forces him to look at a field offers him a view he does not get when he walks around in the same field. Being forced to look at a space yields far more: 'It is as though these minutes fill a certain area of time which exactly fits the area of the field. Space and time conjoin.'[21]

In the television series *Ways of Seeing*, Berger elaborates on the linkages between perspective, oil painting and capitalist enterprise. In his discussion of the tradition of female nude painting in western art he examines issues of voyeurism, reception, and gender bias. Although there are references to other, non-European styles of painting, there is no systematic appraisal of the other trajectories of the modern, unleashed for instance by colonialism. Re-reading his works today, one

wonders how he would, for instance, read the Russian painter Vasily Vereschagin's 1870 painting *Sale of a Child Slave* and its influence on his teacher, the French painter Jean-Leon Gerome's 1880 *The Snake Charmer*, which was in turn reproduced, a century later, on the cover of Edward Said's *Orientalism*. This is a nudity that is not 'masked'. The charms of the child are put on display through an interplay of looks. What is made *frontal* are the looks of the old men looking at the young child, whose backside is the focal point of the composition. How do we critically locate our own position/s in viewing paintings such as these, and how does the being-looked-at-ness manifest itself here through the prism of Orientalist othering?

A TRIBUTE

In his letter to Rosa Luxemburg, written in 2015 (see also 'Verbs' by Ali Smith in this volume), he traverses a century framed by the date of her murder, revisiting all the things and ideas dear to him: socialism and its everyday histories intertwined with grand historical time.[22]This tribute to Rosa is woven around a phillumenist box, bought by Janine, a Polish woman of modest means, on a whim in a Moscow street in the 1970s. The box has travelled from Poland to France through her son, a plumber and builder, whom Berger knows. This is the gift he wishes to send to Rosa, to the example she set, recalling her theoretical writings, her critiques of socialism and Bolshevism, as also her love of birds. This wonderful letter is quintessentially Berger, bringing together so many

diverse threads of thought into a weave of the particular, the sensuous. If one had to choose only one article that would 'sum up' a lifetime of Berger's concerns, this would be it: migration, the travel of people, things and ideas, the shadow economy of socialism, the 'windfall' of profit through which an existence is eked out and the parallel but embedded life of pots, plants and the *pictures* of birds that were so dear to Janine, the ordinary woman of socialism, bound to Rosa, the extraordinary woman of socialism. This binding of two women, distant in time and historical destiny, and the vision of this arc are what epitomise Berger's writings.

The modern as Berger conceives it is situated in a specific historical conjuncture. It is the modern inaugurated by capitalism. It is the modernity of the twentieth century with its development and underdevelopment. Berger never loses sight of this underbelly of the modern. He does not venture into the postmodern, but focuses his attention on the connections between the hierarchical inequities of the modern. One of the important features of his work is his robust internationalism.

Berger's theoretical legacy is in situating the look in the context of political otherness. He overcomes binaries of the subject/object by going into sensuous detail. What strikes a chord is his attention to the sense of time lived by people and classes; of seasons; of the time of day; of the relation with the past and future, deeply felt. He emphasises the dialogic moment of looking and receiving a look in return, of being bound by the look. He has charted histories of looking at animals, at people, at paintings, at social relations, and has carved a niche of his

own among thinkers who have thought about the look and its power equations in modernity.

NOTES

1 Berger, J. (2001) A Professional Secret, in his *Selected Essays*, edited by G. Dyer, London: Bloomsbury, pp. 536–540, p. 539.

2 'In actual fact, our position in front of the mirror is always somewhat false: since we do not have an attitude to ourselves from outside, so we adopt the position of a possible other, with the help of which we try to find an evaluative position towards our own selves ... this is what leads to that very distinctive, unnatural expression of our face which we see in the mirror, which we do not have in actuality.' Mikhail Bakhtin (1979), *Estetika Slovesnovo Tvorchestvo*, Moscow: Iskusstvo, p. 31. In his discussion of the expression of women in the history of nudes in European oil painting in the television serial *Ways of Seeing*, Berger discusses the nuances of the look of the women being painted.

3 Berger, J. (1980) Why Look at Animals?, in *About Looking*, New York: Pantheon Books.

4 Berger, J. (2001) Why Look at Animals?, in his *Selected Essays*, edited by G. Dyer, London: Bloomsbury, pp. 259–273, p. 272.

5 Ibid., p. 273.

6 Berger, J. and Mohr, J. (2010/1975) *A Seventh Man*, London: Verso, p. 17.

7 Ibid., p. 91.

8 Berger, J. (1992) *Pig Earth*, New York: Vintage International, New York, p. xx.

9 Ibid.

10 Ibid., p. 5.

11 Ibid., p. 4.

12 Ibid., p. 3.

13 Berger, J. (2001) Drawn to That Moment, in his *Selected Essays*, pp. 419–423, p. 420.

14 Berger, A Professional Secret, p. 538.

15 For a detailed discussion on this see my article (1994) Idiocy and Civilisation: A Study of Dostoevsky's *The Idiot*, in G. Sen, ed., *The Russian Enigma*, Madhavan Palat, New Delhi: UBS Publications.

16 Berger, A Professional Secret, p. 540.

17 Berger, J. (2001) The Production of the World, in his *Selected Essays*, pp. 459–463, p. 463.

18 Berger, J. (2001) Henri Matisse, in his *Selected Essays*, pp. 35–37, p. 35.

19 Berger, J. (2001) The Opposite of Naked, in his *Selected Essays*, pp. 550–553, pp. 550–551.

20 Ibid., p. 552.

21 Berger, J. (2001) Field, in his *Selected Essays*, pp. 354–357, p. 355.

22 A letter to Rosa Luxemburg, *New Statesman*, 18 September 2015, www.newstatesman.com/2015/09/letter-rosa-luxemburg-0

UNDEFEATED
DESPAIR

TRAUMA

WITHIN AND BEYOND TRAUMA: MEMORY IMAGES OF POST-DICTATORIAL CULTURE IN CHILE

ALICIA SALOMONE

The whole incredible problem begins with the need to reinsert those events [...] back into living consciousness.[1]

In his essay on the Hiroshima disaster,[2] John Berger refers to the weight of this historical landmark and to its original interpretation as a monstrous and irrefutable experience – 'Never Again' became a worldwide slogan. Berger contrasts Hiroshima's transcendent impact with its progressive deactivation through a slow and systematic process of suppression and elimination: an elimination that is both physical and moral. At the same time, Berger reflects on a series of drawings created by Hiroshima's survivors, highlighting how these fragile images allow us to see beyond the mask of innocence used by evil to naturalise horror. For Berger, the concept of evil implies the presence of forces against which we must be in constant struggle, impeding their ability to triumph over life and destroy

it. For this reason he argues that the memory and imaging of Hiroshima should always be present. This is why the citizens of Hiroshima began to compose their drawings: the presence of the images serves to revive the essential energy needed to oppose evil and sustain struggle.[3]

It is remarkable how this British critic's words resonate with contemporary Chilean society, a space so distant from the post-nuclear Japanese hecatomb. On a different scale in terms of the number of victims and the origin of tragedy, the 1973 coup d'état also represented a social catastrophe, affecting hundreds of thousands of people, shocking national and international communities. Two images that made headlines around the world synthesise this tragedy: the photograph of the presidential palace La Moneda, where President Salvador Allende was resisting even as the building was bombed and consumed in flames. And a second image which registered the inscrutable faces of the military junta that took control of the country on that fateful 11 September– a photo that was soon recognised as one of the paradigmatic images announcing the imposition of state terrorism not only in Chile but also in a large part of South America.

More than forty years after the military coup, this collective trauma is far from being processed or resolved. It is a phenomenon not unrelated to the transition that took place in March 1990, when President Patricio Aylwin's inauguration appeared to have left behind two decades of a vicious dictatorship. However, much like in Spain after the death of Francisco Franco in 1975, the transitional pact in Chile did

not imply a radical rupture with the previous regime: on the contrary, it allowed for a negotiated exit that bestowed on the ex-dictator and his allies a wide area of power within the new political regime.[4]

The agreed-upon transition put limits on the demands of the citizens, who sought the truth regarding the more than three thousand detained-disappeared and political executions, and demanded justice for them and the thousands of victims of human rights abuses.[5]As the Chilean sociologist Tomas Moulián believes, this explains why the first decade of the Chilean transition was dominated by compulsory forgetting and a silencing of crimes committed by the state with the purpose of ensuring political and economic stability.[6]

As the different spheres of state power imposed consensus, only a few dissident voices, especially from the artistic field, expressed their discontent and distress regarding a reality that seemed to betray the democratic expectations encouraged during many years of resistance. Among these artists was the poet Elvira Hernandez, whose 1992 book *Santiago Waria (1541–1991)*describes the capital city, a synecdoche for the country, through antithetical and ironic images.[7] Her work confronts the success-obsessed and amnesiac vision of a triumphant neoliberalism, denouncing its shameful contrasts from her own perspective.

[Santiago]
Alto contraste
estilo callampero y bursátil

[…]
robótica y mendicante

[Santiago]
High contrast
Shantytown and stock exchange style
[…]
Robotic and begging

In her tour of the city, the poet casts her incisive gaze over the urban landscape. She discovers within the walls of this transformed, palimpsest-like city, the ghostly prints of violently suppressed figures. In her errant, solitary and melancholy trajectory, she is confronted with the faces of indigenous people from the past – alluded to in the bilingual title of the book[8] – and with the more recently assassinated, reintroducing into the urban imaginary the counter face of an ethically degraded world:

El barrio turco vive de su última liquidación
Viven los cara dura viven los cara'e palo
¡Jécar Vive!

The Turkish neighbourhood makes a living from its
latest sale
The unashamed live, the unabashed live
Jécar lives![9]

Another artist who installed a critical vision within this tense environment was the documentary maker Patricio Guzmán, whose film *La batalla de Chile* (The Battle of Chile) gave testimony to the crisis of the 1970s Popular Unity government led by Salvador Allende.[10] In 1997 Guzmán returned to the topic of social memory through a documentary, *La memoria obstinada* (Chile, Obstinate Memory).[11] In this piece, he filmed the reactions of people who were exposed to images of the past in order to analyse how different social layers had processed the social and political conflict of the 1970s.

Guzmán involved a range of people, including followers of the military regime and those who had been affected by the dictatorship. In particular, his film addresses the effects and reflections of the latter, among them left-wing militants, survivors of military repression, working-class youth marginalised by repressive neoliberal policies, and the family members of human rights victims. By drawing on the memories evoked by the narrator, the documentary registers not only what they remember but also their lapses, absences, and erasures of memory: memory loss that is the natural product of the passing of time, and that which is provoked by trauma.

In the film there are recurring scenes of an elderly uncle, who unsuccessfully tries to play fragments of a Beethoven sonata on a piano. The figure of the uncle is rendered a perfect leitmotiv of this double dimension and resonance of forgetting. It signifies the inevitable bodily processes of ageing that should be accompanied and responded to with love and care. It also becomes a subjective imprint of a perverse politics that feeds

trauma and undermines individual and collective resilience. It is this perverse politics of forgetting that must be denounced and subverted. This is what the film suggests when including the testimony of Carmen Vivanco, a close relative of five detained-disappeared persons. Vivanco's memory loss impedes her from recognising herself in the ghostly images of the past shown to her by the narrator. As the close-up view of her face suggests, this is not the result of her ageing but rather of the trauma she experienced – a trauma exacerbated by the lack of state recognition and reparation during the opaque years of the first transitional decade.

WITHIN AND BEYOND TRAUMA: MEMORIES OF A NEW GENERATION

In the later part of the 1990s and the early 2000s, the Chilean landscape began to change, opening up for the first time to the possibility of modifying the established political scene. Trials for crimes against humanity were initiated in Spain, resulting in the imprisonment of the ex-dictator Pinochet in London in 1998. Human rights violation cases were also reopened in Chile. These events triggered a number of 'memory outbreaks' and incited a wider debate about the recent past and the imposed limits of the transitional justice of the time.

A number of other events contributed to this process: the thirtieth and fortieth anniversary of the military coup; media reports relating to memory; and even the presence of social movements that struggled to add new issues to the

democratic agenda, including matters of gender and sexual identity, the recognition of indigenous rights, and the demands of environmental organisations. In 2011, energies converged when an active student movement took to the streets to legitimatise their struggle to transform the education system – a crisis that the students linked to the imposed neoliberal privatisation of education during the dictatorship.

This new social climate found a shared narrative in the artistic-cultural scene, where there was a proliferation of literature, theatre and audio-visual production focused on the aesthetics of memory. Such developments showcased the presence of a new generation of artists. These were the children and grandchildren of activists from the 1970s and 1980s, who sought to inscribe the cultural field with their own accounts and visions of what had happened in the past. In this receptive environment, their creations began to be seen as a corpus distinct from the styles and productions of preceding generations.

The question, then, has to do with the new images of memory that emerge in their work, and, most important, their subjectivities, formal articulations, and ideological-political positions. In relation to subjectivity, the primacy bestowed on the child's enunciation and point of view is notably present in the ambivalent feelings expressed towards previous generations. Their aesthetic options are sustained in languages that hybridise different genres, blurring the lines between fact and fiction as they search for their own voice and tone of expression. A distinctive feature is the tension towards the

narratives defended by their parents' generation: tensions that are also observed within their community of peers, expressing affinities and differences.

It has become clear that we are faced with a series of aesthetic productions that employ different formats and perspectives and establish a clear generational mark. This mark is the result of complex transgenerational experiences of trauma and the need to confront emptiness and ruptures alongside the continuities of memory.[12] Moreover, as these artists are faced with ethical, political and ideological dilemmas associated with an ever-present past, they are compelled to take a position regarding the past *in the present*, negotiating the challenge of representation through the languages of art.

These challenges are embodied in numerous current pieces, but they are particularly captured in many documentaries produced in the twenty-first century by artists who were children or adolescents during or after the beginning of the dictatorship. Among them is Macarena Aguiló's 2010 documentary *El edificio de los chilenos* (The Chilean Building), in which the author narrates her story as the daughter of MIR (Movement of the Revolutionary Left) militants and as a victim of the repressive state system.[13] Kidnapped at the age of three by the state intelligence police, who sought to pressure her parents, she remained a detained-disappeared person until she was freed and sent into exile (an exile which would last more than fifteen years). The time that passed between her exile and her return to Chile constitutes the backbone of her narrative, centring on her residence in Cuba at the Project Homes

(Proyecto Hogares). She spent her childhood there under the care of 'social parents' (*padres sociales*) and 'socialsiblings' (*hermanos sociales*) when her mother returned to Chile from France to join the struggle against Pinochet.

Aguiló's narrative is channelled through a personal voice, interwoven with other testimonial voices. It is hybridised as it intersects with other materials in the film – visual elements, literary references, phonic registers and moving images that complete and bring tension to her narrative. The materials include her family photos, childhood drawings, and parents' letters, all of which were kept in a box by the narrator as encrypted relics to be explored in the narrative present. At the same time, the inclusion of the animation drawings of Gerardo – one of the narrator's social siblings – is noteworthy. They represent the painful feelings of her uprooted childhood precisely at the moment when, following the closing of the Project Homes, the children had to be separated, leaving Cuba to return to Chile or other countries. This is especially apparent in the sequence of the sinking of the Chilean Building in the Caribbean Sea, showing the children's flight in different directions.

The film is sustained by the intersection between narrative, multiple voices and diverse materials that express the contradictory effects on the narrator's subjectivity. The ambivalent emotions she felt – and still feels – towards parental figures coexist with her joyful and empathic childhood memories of her social siblings. Using a tone that is more sad than ironic (although irony is not absent from her narrative), Aguiló names her oscillating feelings: from the justification and

understanding of her parents' ideals, to the resentment of being abandoned, to memories of danger and the elusive search for a sense of security.

Alongside these difficult emotions, the narrator expresses loving sentiments towards her peer group as well as her social father, an adult who becomes an important figure by taking on the formative and protective role of her own absent parents. He bestows the narrator with basic life skills that ensure her survival. And it is precisely this same figure, appearing many years later in the present enunciatory context of the film, who once again accompanies the narrator in the process of looking back and reinterpreting her history with new eyes.

LIVING WITH THE PAST

As Berger's opening quote suggests, a key concern surrounding traumatic social situations is how to avoid their deactivation within the political reality, whether they are the product of a programmed politics of forgetting or other operations that gloss over their disruptive edges (see also the essays by Bell, Vrana, and de Alwis in this volume). The problem resides in how we reinstall these events within a living consciousness and break down the naturalisation and justification of horrors suffered in the past. As such, certain images, that embody a particular 'way of seeing',[14] can be a crucial contradictory (counter-hegemonic) element in the unmasking of the false innocence with which evil presents itself, emerging at the same time as a reservoir of energy that is needed to confront it.

In a society like Chile that has suffered from impaired memory and struggled to articulate the trauma lived during the dictatorship, certain photographic, literary and visual images evoke what was absent. They contribute to the naming of an experience that was just beginning to find representation in language, although not without difficulty. How do we refer to the permanent state of mourning when faced with the disappearance of a family member, the brutality of torture, or the helplessness of a child surrounded by terror? The political circumstances of the transitional post-dictatorship period did little to facilitate these expressions. Finally, after three decades, there appears to be more interest in transforming inherited power relations; pushing the limits of the possible and imaginable beyond the system established by the 1980 authoritarian constitution.

In this context, the images offered by these writers and artists bring to the foreground the different ways in which visual storytelling expresses what is happening in Chile. It is a work that is difficult to categorise. It is a work in progress both for those who were key players during the 1970s and 1980s and for those who observed and experienced this period from a child's perspective. In any event, given that both generations coexist in the present, their respective experiences and contrasting positions allow us to deepen and complicate the social reconstruction and aesthetic representations of one of the most complex periods of our history. In this way, they present the possibility of imagining a different future.[15]

NOTES

This essay has been translated by Elsa Maxwell. The author would like to acknowledge financial support from the Fondecyt Project 1160379.

1 Berger, J. (1993) Hiroshima, in L. Spencer, ed., *The Sense of Sight. Writings by John Berger*, New York: Vintage International, p. 286.
2 Ibid., pp. 291–292.
3 Ibid., p. 294.
4 Enzo Traverso argues that Spain also opted for an amnesic transition, resulting in the prolongation of official repression for more than a generation. Thus, the memory of the Civil War could only emerge in the 1990s (cited in Sánchez, A. (2010) *Instrucciones para la derrota. Narrativas éticas y políticas de perdedores*, Barcelona: Anthropos, p. 17, n.3).
5 The mission of the National Commission for Truth and Reconciliation (Comisión Rettig), created in 1990, was to seek the truth in relation to the human rights violations committed during the dictatorship. Twenty years later, the National Commission on Political Prison and Torture (Comisión Valech), produced a new report that officially recognised the existence of 9,795 torture victims and political prisoners between 1973 and 1990. Neither of the reports contains information on the perpetrators of these crimes.
6 Moulián, T. (1997) *Chile. Anatomía de un mito*, Santiago de Chile: LOM, p. 31.
7 Hernández, E. (1992) *Santiago Waria (1541–1991)*, Santiago de Chile: Cuarto Propio, n.p.
8 The title brings together two syntagms: Santiago and *waria*, the name the Mapuches gave to the town settled by the Spanish after the conquest. By including the year of the city's founding (1541) and the beginning of the democratic transition (1991), a narrative tracing the historical continuity of the social domination deployed from and upon this metropolis becomes plausible.
9 This verse refers to Jécar Neghme, the last militant executed by the Chilean dictatorship, killed on 4 September 1989.
10 *La Batalla de Chile, La insurrección de la burguesía*, film, directed by Patricio Guzmán (1975). Havana, Instituto Cubano del Arte e Industria Cinematográficos.
11 *La memoria obstinada*, film, directed by Patricio Guzmán (1997). Santiago de Chile, Patricio Guzmán Producciones.

12 The harm produced by the traumatic experiences of the military dictatorship was multigenerational, intergenerational (creating conflicts between generations) and transgenerational (it is inherited and its effects emerge in future generations). See Centro de Salud Mental y Derechos Humanos-CINTRAS (2009) *Daño transgeneracional: consecuencias de la represión política en el Cono, Sur*. Santiago de Chile: CINTRAS-CHILE, www.cintras.org/textos/libros/librodanotrans. pdf, p. 51.

13 *El edificio de los chilenos*, film, directed by Macarena Aguiló (2010). Santiago de Chile.

14 Berger, J. (1972) *Ways of Seeing*, London: British Broadcasting Corporation and Penguin Books.

15 Ibid., p. 10.

JEST

THE DANGER OF *WAYS OF SEEING* IN PAKISTAN

SALIMA HASHMI

The year was 1982. The military regime of the Islamic Republic of Pakistan's General Ziaul-Haq was in full bloom. Newspapers, radio and the sole state-run television channel were strictly monitored. The pervasive 'press-advice' emanated with regularity from the Ministry of Information and Broadcasting, keeping all public expression on a tight leash. The 'advice', a misnomer if ever there was one, ensured a ban on political discussion or comment on the regime's performance. Vigilantes roamed free, identifying 'un-Islamic' practice at large. These transgressions could range from a five-year-old copy of *Playboy* magazine, spotted on a dusty shelf in a bookshop, to the attractiveness of a female TV anchor who smiled too often, and deserved to be reigned in. Students found that enjoying the company of the opposite sex in a college cafeteria or a concert in a hotel ran the risk of sudden, violent targeting.

Fear seeped into our lives almost unnoticed. Like a shadow it accompanied us at work, in mundane daily tasks, in shops, restaurants, and markets. Imperceptibly we compromised.

Opinions were guarded. Letters were discreetly composed, telephone conversations negotiated with care. Oblique references and prudent codes were developed when talking about people, events, and unfolding circumstances. Rumours flowed like rivers through our lives.

From this landscape of silence emerged great ribaldry, and the General was the butt of all wisecracks. His decrees on religious practices and his overarching desire to constrain and control personal space were met with satirical riposte in the private domain. The jokes travelled at the speed of lightning. The punchlines were rendered in all the region's languages, assimilating the nuances of each, adding local idioms. It may have been the instinctive resentment brewing in the collective innards of people, or a makeshift courage, but witticism and jests were maliciously gratifying.

Yet this was not enough to combat the insidious rise of hypocrisy in public life. The unashamed display of self-conscious piety, the vying for approval of religiosity, sermonising on the most trivial of matters, all became the norm. For those who could disengage themselves from the business of survival, there grew a sensation of being surrounded by inescapable ugliness.

Poets, writers, artists, performers, burdened by edicts, injunctions and expurgations, yearned to resist, but there were alluring opportunities for the pliable. Monetary benefits, subtle moves to win approbation and recognition were undisguised and available.

In such times, modest autonomous acts of pedagogical investigation could threaten a culture of comfortable compliance.

As an artist and art educator at the prestigious and arguably the only independent art and design institution in Pakistan, one struggled to contest the stifling environment. Videos and the internet were still in the distant future. One cast around to devise lively projects for students, not unmindful of the context we inhabited. We relied on our students' observations, on books, on the occasional magazine which had slipped past the eagle eye of the censor. Bookshops importing art books had to bribe officials not to deface images of Greek statuary or robust Rubens ladies. The volumes in the library were witnesses to the fact that there had been a life before General Zia.

The British Council Library in Lahore, an established friend of academics and students since the early part of the twentieth century, had acquired the BBC series *Ways of Seeing* on 16mm film in 1982. This was an unexpected and welcome bit of news. The National College of Arts (once the Mayo School of Arts) owned a 16mm projector and a 16mm Bolex camera, presented by the United States Information Services in the 1960s, in the heyday of US efforts to woo Pakistan's educational institutions. Technically, screening the films without a censor's certificate was not allowed, unless it was on a premises with diplomatic immunity. The US Center, the British Council and the Goethe Institute enjoyed this privilege. Due to a bureaucratic oversight, the films were dispatched to the college, where I organised screenings for the students of the Department of Fine Art. As their teacher I took responsibility for the content of what was shown, and the ensuing discussions.

I introduced *Ways of Seeing* as an important new way of looking at western art history, familiar to art students only through books and reproductions. Gardner's well-worn *Art through the Ages* was a familiar text.[1] Howard Read was a known commodity, as were Gombrich and Peter Fuller. Safe in the written word, there was no danger of being challenged on that turf.

Nevertheless, one was aware that the moving image, even when it focused on the still image of a painting, could be considered a stealthy way of encouraging immorality and obscenity in the student body. I was especially wary of the episode that dealt with the nude, a subject brimming with sexualised connotations and controversy. But, as a teacher, for me the questions being raised by Berger, about appearances, 'what we see', and 'how we see it' were even more critical for the community. The students were largely oblivious to Berger's (and by extension, mine) nefarious designs. They enjoyed the series and raised many questions about the teaching of western art history and its relevance to them in Lahore. They were largely conversant with the paintings in the series; however, their interest was deepened by the group discussions of the films.

Berger's references to 'false religiosity' and manipulations of images struck a deep chord with the students. They were being subjected to daily broadcasts about what was acceptable in a morally pristine society and what were the temptations to be identified and avoided. From a pluralistic culture, they were being nudged towards uniform interpretations of 'knowing'.

Women students in particular dwelt privately on matters of the 'body' and the obsession of the Pakistani state with women's appearances and veiling. There, the matter should have ended, or so I thought.

A couple of months later, there was a fracas in the student body. The student members of the right-wing Jamaat-e-Islami confronted a student whose comic strips, displayed on the noticeboard, were pinpointed as being blasphemous and anti-Islamic. The fight snowballed with attacks by vigilantes sent from outside the college. Among the many consequences was the setting up of an inquiry by the board of governors. They examined the accusations made against some of the faculty members who were deemed to be propagating profane ideas through their lectures and studio projects. My name was among them.

My list of trespasses, among several others, was the screening of *Ways of Seeing*, including the episode on 'The Nude'. The said episode, it was stated, had exposed vulnerable young eyes and minds to obscene images and ideas. The board was headed by a retired Chief Justice of the Punjab High Court, pompous and not known for standing up to the powers that be. He did, however, consider himself to be a man of letters. My defence, I decided, would be on the basis of pedagogy and not of morality. I therefore took a pile of books with me into the hearing. The film screening was the last of my transgressions to be probed. I had already made my case about the teaching of human anatomy, as a component of the curriculum approved by the government.

'Berger's nude' was up next. Library books, marked with the images shown in the film, were placed carefully in full view of the committee. I began my presentation on *Ways of Seeing*. After barely sixty seconds I was cut short by His Lordship. 'Did you say this series was made available by the British Council?' 'Yes, sir, they have it in their film library.' Looks were exchanged between the members of the committee. His Lordship signalled me to stop my learned account of John Berger's unique contribution to the teaching of art history and the 'receiving' of images. I was apparently in the clear because the British Council, as a responsible extension of Her Majesty's Government, could not possibly be involved in any disingenuous educational activity which could lead young people astray. I made my exit relieved, yet somewhat annoyed that I had been deprived of my chance to educate the committee and to share with them the subversive nature of *Ways of Seeing*.

NOTE

1 Gardner, H. (2001) *Art through the Ages,* 11th edn, edited by F. S. Kleiner, C. J. Mamiya and R. G. Tansey, Fort Worth, TX, and London: Harcourt College Publishers.

HATE

MUSTAFA DIKEÇ

People want us to demonstrate. Very well, but tomorrow
what do we do? They point their finger at us with a nasty
look on their face? I don't want to be part of this France
for a single afternoon, but every single day.

<div align="right">YOUSSOUF FROM THE BONDY BANLIEUE[1]</div>

In the immediate aftermath of the horrors of 7 January 2015,
emotions ran high, seesawing between the urgent need to do
something, and a feeling of resignation, that everything seems
futile. For what can we do against such reckless hate? On
this day – almost a month after the release of the US Senate's
report on the gruesome CIA torture programme, and three
weeks after the deadliest terrorist attack in Pakistan, the
Peshawar school massacre in which145 people, 132 of them
schoolchildren, were killed – a minibus full of explosives went
off in Sana'a, killing at least 37 people and wounding 66. This
became yet another news item added to the long list of terrorist
killings, without anyone organising rallies or identifying
themselves with the tortured or murdered victims of the terror.
No one even wiggled a pen in the air.

But the horrors of 7 January were not limited to Yemen's capital city. For three days, the French capital was caught up in murderous events. Parisians had a taste of what it might be like to live with terror, experienced on a daily basis in other parts of the world. Unlike the terror in those other places, however, Parisians do not live under the constant threat of established armies, private mercenaries, or drones operated from the Nevada desert. They might also take some relief that the perpetrators of the crimes of 7 January were identified and hunted down by legitimated authorities, which is rarely the case in regions destabilised by constant terror, induced by military interventions and other forms of violence.

In a sign of solidarity, millions of French citizens stood up against terror, to show the world that they were 'a united people'. The gatherings were massive, emotional and, in a way, encouraging – encouraging in that despite everything that happened, the citizens of this country, one would think, were able to publicly manifest their solidarity and unity. But the murderers of 7 January were French citizens too, born and raised in France. The details of their lives that started to emerge suggested that they all went through a radicalisation. They were not born with an inclination or bred from childhood to plan and kill journalists, police, or Jews in their country of birth and residence. This raises the possibility that their indoctrination and radicalisation into murderers could not have happened in the absence of long-standing and deeply entrenched grievances. It is the hate stemming from such grievances that the ideologues of terrorism mobilise, which is why the deprived and

disenfranchised neighbourhoods in the peripheral areas of cities
–*banlieues*, slums – where unemployment hits as many as half the
youth population, are targeted as potential recruiting grounds.
But what could cause grief to a French citizen, in this cradle of
human rights, united under the 'one and indivisible Republic'?

Let me make it clear that I am categorical in my condem-
nation of what happened. There is no theoretical, theological
or sociological justification for these murders. But if we are
troubled by the events, troubled enough to take a hard look
at them, rather than falling in love with ourselves, then it is
important to inquire about the conditions that made such a
deployment of hate possible. In the highly emotional aftermath
of the events, it was hard not to feel moved by the extraordinary
mobilisation of citizens. Newspapers were full of commentary
about how proud French citizens should be, how united and
solidaristic we are as a people, how the spirit of May 1968
continues despite the attack on its inheritors, how we French
value equality and freedom of expression. If all was nice and
dandy, what made the radicalisation of these three French-
born-and-raised citizens possible? Why, a decade ago in 2005,
did three hundred French towns go up in flames for two weeks,
and what has been done since? How is it that the extreme right
has become the second major political force in this land of
freedom, equality and fraternity? Marine Le Pen, the leader
of the extreme right party, had already topped the presidential
polls before the events, in September and November 2014, and
extreme right leaders are now having a field day in France and
also the rest of Europe.

This is not to suggest that the murderers' actions can be justified by the circumstances. Rather it is to warn that despite the timely and admirable display of unity under an alleged one and indivisible republic, French society is deeply divided. It is divided because of its long history of racism and an increasing hostility towards immigrants. It is a poisonous mix of xenophobia and Islamophobia that several French politicians, endowed with the authority of the state, have unashamedly mobilised for their political ends. Muslims are the most stigmatised groups in France. They are spared neither by satire nor by political discourse and action. We are living in a society where discrimination against Arabs, blacks and Muslims no longer shocks anyone, where political power is concentrated in the hands of a homogeneous political elite, despite token appointments.

The perpetrators of the hideous crimes of 7 January had the somatic features and names that could easily have made life a nightmare in France. It is no secret that France has a solid track record of discrimination against its Arab and black citizens, extending from the job and housing markets to a heavy-handedness in identity checks by the police. Now of course the police are more popular than before. This is not surprising – even François Hollande's popularity went up in the polls after the events. The police are cherished, and rightly so. They risked – and some lost – their lives trying to protect citizens. But this fact does not overshadow and should not let us forget the deep-seated tensions between disenfranchised French Arab and black youth and the police, fed by a long history of police

harassment and violence, the perceived immunity of the police, and the colonial history of France. As Abdel, from a *banlieue* of Lyon, once told me of the tensions between *banlieue* youth and the police, 'The Algerian war is not over in France.'[2] The mutual hostility between the two groups is played out on an uneven terrain. The former is demeaned and delegitimised by official statements, while the latter are typically spared much criticism, even when their use of force exceeds legitimate limits and turns into violence disproportionately visited upon the former group.

Following the death of a young demonstrator at the Sivens Dam site in October 2014 (killed by a flashbang grenade thrown by a gendarme), Prime Minister Valls told the National Assembly that he 'would not accept for the police and the gendarme to be accused [*mis en cause*]'[3]. The demonstrator was not part of the *banlieue* youth, yet the unequivocal response of the prime minister shows the extent of the 'untouchability' of the forces of order. There is even more to be concerned about. The flashbang grenade that killed the protestor was the same kind used in the Special Forces operations to neutralise the terrorists on 9 January 2015. What does this tell us about state responses to protest, if the same arsenal of weapons is deployed to disperse environmental and ecological demonstrators as to neutralise murderous terrorists?

There were ample signs of the growing tension between the police and Arab and black youth, and the other hardships that the latter group suffer, most spectacularly in the recurrent revolts of *banlieues*, revolts that have continued to increase

both in geographical extent and in intensity over the years (five large-scale revolts in the 1980s, forty-eight in the 1990s, while the revolts of 2005 touched some three hundred communes). The majority of these revolts followed deaths of residents that implicated the police. Yet no police officer has ever been sanctioned in any significant way, if indeed any have been sanctioned at all.[4] Furthermore, the political significance of such revolts – political in that they brought into sharp relief the faultlines and geographies of grievance in French society –was increasingly undermined by official statements.

But not all revolts received the same hostile response. Exemplary here is Nicolas Sarkozy's response to the 2007 Lorient revolts staged by Breton fishermen:

> Fishermen don't cheat. When people here demonstrate, when they use violence, it's not to have fun, it's never to harm anybody, it's because they're desperate, because they no longer have any option, and they feel condemned to economic and social death.[5]

The fisherman's grievances, it seems, are legitimate. But when the *banlieue* youth were revolting in 2005, the same Sarkozy characterised them as 'barbarians, murderers, or, in the best of cases, delinquents', or they were 'thugs' and 'scum' to be cleaned up by power hoses.[6] Demonising language like this only aggravated resentment. This was even acknowledged by a senior official of the French Intelligence Service:

Riots, according to my observation, riots occur in neighbourhoods with a large population of immigrant origin, so they primarily reflect a difficulty of integration, and resentment, so, a resentment very strongly felt by young people of the second generation, and even the third generation too [...] one is in touch with other cultures, while also integrated in French culture, but with the feeling of being rejected by French society, you see? That's it. Now, incidents that trigger riots, that's another issue completely, you see, there's the triggering incident, and there's the background that's going to make it, because incidents triggering riots are like the spark that sets fire to a stock of gunpowder, but that's what the gunpowder is. It's that resentment.[7]

The sense of rejection and what I have elsewhere called 'the paradox of actually existing republicanism', which, despite an alleged commitment to equality, institutes a division between white and darker citizens of the republic in its everyday workings, was powerfully articulated by Abdel from the Lyon *banlieue* of Vaulx-en-Velin, one of the poorest and most notorious in France.[8] When I asked him why he did not want to acquire French citizenship even if he had the right to, he said:

Well right now, I don't see, I don't see the point, no ... because whether you're French or not makes no difference ... except you're eligible to vote, and to have a job as a civil servant, but apart from that ... I don't see it [...] whatever

your ID says, for them, we are, well, we're Arabs, what, we're, we're sons of immigrants ... and even our kids will be told they're children of immigrants, and ... well, I don't know, I ... it's as though they don't want us to even exist in this country ... exist as we are, what, we're French we're French, there are white French people, there are Black French people, there are yellow French people, there are grey French people, there are French ... there's all sorts! But we, we are always reminded of our origins, we keep being told, but you're the son of, of ... immigrants, son of ... why keep telling us that? We know, we don't need to be reminded! You too, you're the son of, I don't know, Spaniards, I don't know, son of ... real French people, if there are any left, there can't be many, can there! French is a mixture, well, you know ... but with us in particular, you really feel it with the, well, with the Arabs, they're always, always ... oh well.[9]

It is the interrelations between everyday hardship, racism and symbolic violence that create the conditions that turn resentment into hate, hate into radicalisation. The appeal of fundamentalist discourse resides in its potential to turn a feeling of powerlessness into one of being all too powerful, guided by a divine source and a heavenly objective. If there is an element of truth in this observation, if the fundamentalists do indeed capitalise on the imposed inferiority of downtrodden youth and provide them with doctrines and forums designed to make them feel more powerful, then the French state has been

doing exactly the opposite. And not just in terms of concrete policies, but also through the deployment of stigmatising language by its high-ranking officials that went unsanctioned. Successive French governments have failed to address the problems that have led to growing discontent. They flamed the fire of resentment by tolerating inflammatory language that combinesd xenophobia and Islamophobia.

Between 2009 and 2011, we had in office a Minister of the Interior, Brice Hortefeux, condemned for racist insults during his term. He said of a young militant of Arab origin, who – surprise! – 'eats pork and drinks alcohol', that he did not 'fit the prototype at all!'. He added: 'There always has to be one. One is all right. It is when there are many of them that there are problems.'[10] In 2009, during a debate on national identity, the Secretary of State, Nadine Morano, declared that what she wants 'from a young Muslim, when he is French, is for him to love his country, for him to find a job, for him not to speak slang, for him not to wear his cap backwards'.[11] In 2014, the same politician posted a photo of a veiled woman on a beach on her Facebook account next to an image of a young Brigitte Bardot in a bikini. Morano commented that while Bardot conveys an image of France 'proud of the freedom of its women' (forgetting its rampant sexism), the covered woman insults French culture. 'When one chooses to come to France,' she wrote, neglecting the possibility that the Muslim woman might have been born there, 'it is imperative to respect our culture and the freedom of women. If not, one should leave!'[12] A couple of months later, coming across a woman wearing a

niqab (outlawed since 2011), and with a suitcase in the Gare de l'Est, she told the woman to uncover her face. She then went to the police and asked them to intervene.[13] On Facebook, she later wrote: 'It has to be reasserted that it is a real public security issue. Who is under this dress? What is there in the suitcase … suspicion is warranted when a person is hidden.'[14] Known for her racist and Islamophobic remarks, Morano served first as Secretary of State between 2008 and 2012, then as minister. She is now a European deputy. The insidious danger to such racist ranting is that it can lend shape and legitimacy to bigotry. After Morano's remarks about the veiled woman on the beach, Harlem Désir, former president of SOS Racisme (which is basically a Socialist Party satellite), former head of the Socialist Party, and member of the current government, said that he 'understood her reaction', and that women wearing veils on the beach had always seemed 'aberrant' to him.[15]

I am not trying to suggest that these French state officials caused the *Charlie Hebdo* attacks. The point is that several governments faced with increasing signs of a rising discontent have been too coy about addressing, or have simply chosen to neglect, the root causes of the grievances of deprived and disenfranchised groups. They have also, with their provocative speech acts, contributed to these groups' further stigmatisation and demonisation. As the authors of an official report on the political participation of *banlieue* inhabitants observed, the unprecedented revolts of 2005 only served to give rise to a state of emergency, more repressive policies, and a top-down urban renovation programme that had little regard for the

residents concerned.[16] Their proposals for giving political voice to those living in popular neighbourhoods, outlined in a 2013 report commissioned by the Secretary of State for Urban Policy, were ignored. The five reports on 'integration' that were subsequently submitted to the prime minister went straight into the bin, in part because they were critical of the notion. All of these reports were unequivocal in their insistence on the importance and urgency of fighting against increasing racist discrimination. No concrete measures were taken.

In light of the emerging accounts from the survivors of the 2015 massacre, it turns out that this issue of 'what the French state has done for *banlieue* youth' was a point of contention within *Charlie Hebdo* itself, some arguing on the side of 'nothing' and others of 'plenty'.[17] Of course this sounds like a very French take on things that asks too much from the state. Perhaps one could ask: What has the French state done to prevent the disenfranchisement and vilification of the *banlieue* citizens? Has it developed effective policies to curb unemployment? Has it sought effective policies to end discrimination in the job and housing markets? Has it done anything, rather than covering up and justifying police harassment and violence? Has it sanctioned government ministers for their public racist and Islamophobic comments? Has it not itself, through its policies and through the public discourses of its officials, including its president, contributed to the further demonisation of this group?

It was ironic to see that Marine Le Pen was not invited to the *Charlie Hebdo* rally, but Sarkozy was. Now relegated to the second rank in the protocol, Sarkozy seemed more intent

on pushing his way into the first rank of the rally to appear in a photo shoot. It was also ironic to see Ahmet Davutoğlu at this rally for freedom of speech. He is the prime minister of a country that Reporters Without Borders identified in its 2013 Press Freedom Index as 'the world's biggest prison for journalists' when Turkey stepped ahead of China in the tally of jailed journalists. The invited political leaders made it to the first pages of newspapers, and the rally achieved its pragmatic political purpose for them.

The ironies of the rally also brought back memories of an earlier tension in *Charlie Hebdo* regarding freedom of speech. Nobody went out to demonstrate for freedom of speech in 2008 when Siné was fired from *Charlie Hebdo* after one of his cartoons, which took issue with the engagement of President Sarkozy's son to a Jewish woman, was judged anti-Semitic. Arguably it was no more anti-Semitic than many cartoons published over the years were anti-Muslim. The apparent double standard and the relentless degrading of the already deeply stigmatised and politically most disenfranchised of Muslims did not go unnoticed by even the least committed of these religious groups. What kind of message does this send to Muslim communities whose discontent over caricatures mocking their religion is silenced in the name of freedom of speech?

It is one thing to criticise powerful and dominant elites in a society, another to constantly take the piss out of its most stigmatised groups by mocking their dearly held religious beliefs. The misdemeanours of Islamists and the abuses of Islam in order to mobilise hatred and violence are already

widely criticised in the Muslim world. Even without the help of the French inheritors of May 1968, many courageous people in Muslim countries are themselves capable of criticising, and with mockery, the aberrations made in the name of Islam. And without recourse to what one journalist called, with reference to *Charlie Hebdo*'s Islamophobic cartoons, the 'repeated pornographic humiliation' of this religion, its prophet and followers.[18]*Charlie Hebdo* was right to practise and insist on freedom of speech, but it was far from even-handed in its attack on organised religions.[19] Especially after 9/11. As a former *Charlie Hebdo* journalist wrote in 2013, an 'Islamophobic neurosis gradually took hold' in the journal.[20] If the whole point of satire, vulgar or not, is to criticise the uses and abuses of power, just what a cartoon depicting a naked Muslim prophet asking 'Do you like my butt?' achieves remains obscure.[21]

It is one thing to feel resentment against systematic discrimination and symbolic violence, another to kill people. The path from one to the other is neither short nor straightforward. But a war-mongering response similar to Bush's after 9/11, which Prime Minister Manuel Valls chose to adopt in his immediate response to the attacks, will only aggravate the tensions and grievances, while providing a platform for 'a war between two fanaticisms', as John Berger observed regarding Bush's 'so-called war against terror'.[22] There are already many reported assaults on mosques. Muslim women who wear signs of their religious affiliation through dress once again seem to be disproportionately victimised. It is also likely that Arab and black young men will suffer a backlash that will do little

to improve their already precarious position in the job and housing markets, and their experiences of police harassment. It is the hate arising from such everyday injuries and grievances that the fundamentalists will seek to mobilise in recruiting future terrorists. The rally and its political theatre are over now.

Very well, but tomorrow what do we do?

NOTES

This is a slightly revised version of an essay that was originally written after the *Charlie Hebdo* attacks for *Society and Space* open site (http://societyandspace.com/material/commentaries/mustafa-dikec-hate/). I am grateful to Claire Hancock for her comments and suggestions, to Natalie Oswin for her invitation to contribute this piece to the open site, and for permission to use it here, and to Yasmin Gunaratnam for including it in this collection.

[1] Un rassemblement qui ne marche pas de soi, *Libération*, 11 January 2015.

[2] Dikeç, M. (2007) *Badlands of the Republic: Space, Politics and Urban Policy*, London: Blackwell, p. 144.

[3] Intouchables gendarmes, *Libération*, 7 November 2014.

[4] Amnesty International (2009) *Public Outrage: Police Officers Above the Law in France*, London: Amnesty International.

[5] Parfois, la violence a du bon…, *Le Canard enchaîné*, 11 April 2007, p. 8.

[6] Nicolas Sarkozy cóntinue de vilipender 'racailles et voyous', *Le Monde*, 11 November 2005; Sarkozy, à droite dans ses bottes, *Libération*, 21 November 2005.

[7] Dikeç, *Badlands of the Republic*, pp. 158–59.

[8] Ibid., p. 177.

[9] This interview was conducted in Vaulx-en-Velin on 23 May 2002.

[10] See www.youtube.com/watch?v=RcgtqhIwKRU.

[11] http://tempsreel.nouvelobs.com/contre-debat-sur-l-identite-natio-nale/20091215.OBS0722/nadine-morano-veut-que-les-jeunes-mu-sulmans-ne-parlent-pas-verlan.html.

[12] Morano offusquée par une femme voilée à la plage, *Libération*, 18 August 2014.

13　The law was voted on in 2010 and came into effect the following year. During the discussion of the law, the French Jewish Union for Peace co-signed a letter arguing against it on the basis that it was racist and stigmatising. See www.ujfp.org/spip.php?article71. For more on the debates around this law, and the contradictions of French citizenship in relation to femininity and women's dress, see Hancock, C. (2015) 'The Republic is lived with an uncovered face' (and a skirt): (un)dressing French citizens, *Gender, Place andCulture*, 22(7): 1023–40.

14　Morano: Faire du buzz sur la burqa? N'importe quoi, *Libération*, 14 October 2014.

15　Femme voilée: Harlem Désir dit 'comprendre la réaction' de Nadine Morano, *Libération*, 19 August 2014.

16　Pourquoi en sommes-nous arrivés là?*Libération*, 12 January 2015.

17　J'allais partir quand les tueurs sont entrés…, *Libération*, 13 January 2015.

18　Laughing in the face of danger: the state of satire in the Muslim world, *Guardian*, 12 January 2015; Paris is a warning: there is no insulation from our wars, *Guardian*, 15 January 2015.

19　This imbalance even led some commentators to argue that 'the journalists and cartoonists of Charlie Hebdo were racists'. See http://lmsi.net/De-quoi-Charlie-est-il-le-nom

20　www.article11.info/?Charlie-Hebdo-pas-raciste-Si-vous

21　See *Charlie Hebdo*, 19 September 2012.

22　Berger, J. (2007) *Hold Everything Dear: Dispatches on Survival and Resistance*, London: Verso, p. 104.

HOPE

BRIEF AS PHOTOS

MALATHI DE ALWIS

I first came across John Berger in a second-hand bookstore in Colombo, Sri Lanka. *Ways of Seeing* transformed the way I viewed the excellent reproductions of paintings by Vermeer, da Vinci, Rembrandt, Constable, Raphael and Dali that adorned my parental home and which until then I had not taken much note of.[1] I returned to Berger many, many years later when I stood in another second-hand bookstore, on a snow-blanketed day in New York City. I read the opening poem of *And Our Faces, My Heart, Brief as Photos* through a film of tears.[2] The poem begins with the moving lines

> When I open my wallet
> to show my papers
> pay money
> or check the time of a train
> I look at your face

and the poem ends:

The flower in the heart's
wallet, the force
of what lives us
outliving the mountain.

And our faces, my heart, brief as photos.

Berger's poem of loss and longing resonated with my poetic rendering, and translation into English, of a mother's lament in Sinhala for her 'disappeared' son:[3]

Upon mountain ranges, across scorching plains
Amidst twining lianas, in gurgling streams
Along highways and byways
In all my comings and goings
I trace your beloved face
Always.

In the article in which this poem first appeared,[4] I was striving to explore a particular unfolding of *dis*placement: bodies out of place, dispersed, and '*mis*placed' through the practice of 'disappearance', one of the most insidious forms of violence, which seeks to obliterate the body and forestalls closure. The lack of an identifiable body of evidence confounds the investigations of those who seek the 'disappeared', thwarting accountability (see also the essays by Bell, Chandan, Salomone, and Vrana in this volume). It also makes 'chronic mourners' of those left behind.[5]My concern was with how

such mourners 'reinhabit the world' in the face of the continual deferral of loss, and what might be its political outcome(s).[6] A central preoccupation of most families of the 'disappeared' was the constant tracing of traces given the ambiguity of the 'disappeared's' status of absence, and thus presence.[7]

Berger has observed that '[p]oetry can repair no loss but it defies the space which separates ... by its continual labor of reassembling what has been scattered'.[8] The 'disappeared' in the Sri Lankan mother's lament is reassembled and bodied forth through all the familiar landscapes that she traverses in much the same way that Berger's absent beloved is a constant presence in his everyday life: the pollen that 'lives us outliving the mountains'.[9] Berger's absent love is also embodied within landscapes when, in another context, he speaks of how 'your person becomes a place, your contours horizons. I live in you then like living in a country. You are everywhere. Yet in that country I can never meet you face-to-face'.[10]

The fascination with the convergence of lived time and space in settings of loss and death is epitomised in Berger's suggestion that poetry 'equates the reach of a feeling with the reach of the universe'.[11] His recourse to the renowned Russian poet Anna Akhmatova is thus especially apt:

> You and I are a mountain of grief.
> You and I will never meet on this earth.
> If only you could send me at midnight
> a greeting through the stars.[12]

In the same way that an absence defines a presence, the present can be known as the present only through the evidence of a past that once was a present.[13] The temporalities of living on in the wake of 'disappearance' are similarly convoluted. '[T]he families' emotional retelling of the disappearance of a spouse or child gave the impression that their loved one had disappeared 15 days earlier rather than 15 years earlier,' observed a member of the Asian Human Rights Commission who had documented stories of the families of the 'disappeared' in Sri Lanka, in 2003. The statement continued:

> Their pain had not subsided and will probably never do so. This impression of a tragedy that has freshly taken place is reinforced by the families' recollections of dates, times, places, suspected perpetrators and other details of their loved one's disappearance … those responsible for the disappearances painfully touched the past, present and future of these families.[14]

Indeed, the mother's lament while evoking her endless tracings and re-tracings in her quest for her 'disappeared' speaks of a subtle layering of temporalities through his traces – his face – which appears to her wherever she goes, in whatever she looks at. It is as if this very absent presence/present absence of the 'disappeared' is what holds death in check. He is every-where. Always.

Most poignantly, absent-presence/present-absence for both Berger and the grief-stricken mother reappears as 'face'.[15]

Berger's reflections on the (incriminating, thus unpublished) photograph of 5 DISK (Left confederation of trade unions) members who, along with thousands of other activists, had been declared illegal after the *coup d'état* in Turkey, in September 1980, follows a similar trajectory: 'The five heads whose eyes pierce me, have declared their bodies, not only resistant, but militant'.[16]

Berger has commented that '[u]nlike any other visual image, a photograph is not a rendering, an imitation or an interpretation of its subject, but actually a trace of it'.[17] Of all mementos, the photograph still remains the quintessential abject object for it takes its shape and poignancy from death and loss and absence. Its unique ability is to simultaneously encompass both presence and absence. It signifies absence yet keeps absence at bay by producing a simulacrum of presence. The effects of this absent presence were most palpable when I visited the homes of the families of the 'disappeared', whether in northern, eastern or southern Sri Lanka. No conversation would be complete without the invocation of the 'disappeared', an almost imperceptible tilting of the head or a casting up of the eyes towards a photograph of their loved one, given pride of place on the sitting room wall or the single glass cabinet, the repository of prized crockery and knick-knacks. In her Tamil poem 'Paled East',[18] translated into English by Shriganesan, Vijeyaluxmy Segarupan captures this tragic ubiquity of the absent presence within homes in the Eastern Province. She writes of how:

Photographs
hang in all houses
amidst joss stick smoke
and floral offerings
of village youth
eclipsing the portraits
of the gods.

While photographs of the 'disappeared' played an almost sacred role in the everyday life of those who mourned their absence, their significance outside the home was equally crucial. Like the mothers, wives and sisters of the 'disappeared' in Latin America, Sri Lankan women always marched with photographs of their loved ones at rallies and demonstrations. In these contexts, they collapsed the distinction Berger has drawn between private and public photographs. For Berger, a private photograph 'is appreciated and read in a context *which is continuous with that from which the camera removed it*' (see also the essays by Jordon, Salomone and Vrana in this volume).[19] It is 'a memento from a life being lived'.[20] In contrast, a public photograph is a 'seized set of appearances' that is 'severed from all lived experience'.[21] It is a 'dead object' that 'lends itself to any arbitrary use'.[22] In Sri Lanka, both in the south and in the north, the very bodiliness of massed women holding photographs of their 'disappeared' in public spaces viscerally highlighted the very absence of bodies in the discourses of the state. The state was denying that its armed forces and paramilitaries were abducting young men. Local police

stations were refusing to record entries regarding abductions. The sites of incarceration were unknown. Bodies were missing or so mutilated that they were unidentifiable. Often the sole photograph of the 'disappeared' possessed by his family was the primary document that authenticated an existence. This person was flesh and blood. He lived and breathed. There he stands sweating in his Sunday best at the local studio. Here he is accepting a gold medal for athletics, receiving his degree, getting married, holding his first child ... he was there!

It is the women's bodies that caption the photographs they carry of their kin as 'disappeared'.[23] This implication of doubled authenticity, as it were, gives credibility to the 'realness' of the 'disappeared'. It also asserts the mother's bodily relationship to her son by echoing a previous emplacement of the 'disappeared' *within* her body – a crucial link in the structuring of sentiment and the engendering of a critique of a repressive state.[24] Such public/collective usages of private photographs could perhaps be what Berger envisaged when he called for an alternative photography that could 'incorporate photography into social and political memory, instead of using it as a substitute which encourages the atrophy of any such memory'.[25]

The movement of the image from the private into the public is necessarily politically fraught and ambivalent. In Sri Lanka, the precious, much-caressed and much-embraced photograph of the 'disappeared' could also bear the 'signature of the state';[25] the photographs carried by some of the mothers were reproductions or a photocopy of the image that appeared on their loved one's National Identity card. The card is a

document that all Sri Lankans carried, during several decades of civil war, in order to negotiate everyday life, especially checkpoints. It is this 'evidential force' of the photograph, evoking 'the past and the real',[26] that bears testimony to time rather than the object.

It is such echoes that can also produce a *punctum*, a wounding or piercing that the French philosopher Roland Barthes describes so eloquently as being effected by certain photographs.[27] A further gift, 'the grace of the *punctum*', Barthes notes, is that of 'additional vision', the 'power of expansion',[28]enabling us to see beyond the photograph to '*what is nonetheless already there*'.[29]This 'subtle *beyond*' of the *punctum* is present in the lament of seventy-year-old Sumanawathi: '*Aney*, it is not I who should be carrying this picture [of her son] … It is my son who should be carrying pictures at my funeral.'[30] A similar untimeliness of loss was present in the wedding photographs that several women carried around their necks – frequently the only photographic record they possessed of their recently betrothed 'disappeared'.

Barthes has written movingly of the 'umbilical' connection between a photograph, its referent and its viewer: 'From a real body, which was there, proceed radiations which ultimately touch me … light, though impalpable, is here a carnal medium, a skin I share with anyone who has been photographed'.[32] For the families of the 'disappeared', this palpable, umbilical connection was crucial to their survival and re-inhabiting of the world. Such connections could also be channelled by those who sought to locate the 'disappeared'. Family members

spoke of Catholic priests they had consulted who had placed a cross on their husband's or son's photograph and predicted that he was still alive. Similarly, a maulavi (Muslim priest), had inserted a photograph of Ameena's husband in the Koran, and then divined that he was alive.[33]

Those who had no photographs of their 'disappeared' relatives were those who most feared the lapse of time and the fading of memory. Anula's house had been burnt down by a vengeful army commander because her husband – a People's Liberation Front activist – had been rescued by his comrades in a daring jailbreak. He had then gone underground and was subsequently recaptured and 'disappeared'. Anula had managed to piece together her husband's photograph from three burnt fragments of his laminated National Identity card so that 'at least his two children can have a picture of the father they never knew'. Jeeva was not as fortunate. She was five years old in 1990 when her father was 'disappeared'. In the same year that their house was burnt by a mob from a neighbouring village, she had lost all of his clothes, photographs and documents pertaining to his 'disappearance'. The rest of his photographs and papers were destroyed when the tsunami of 24 December 2004 flattened their home. She now has difficulty recalling what he looked like:

> When my mother was alive, she would be able to describe him to me or tell me stories about him. When she died in 2008, it was like my father also died with her because there was no one to keep his memory alive. My two sisters are younger to me so they have no recollection of

my father. My own daughters tease me for not having a photograph of their grandfather … I tried to locate the studio where he once had a photo taken but the owner of that place had also been 'disappeared' so it had been closed down. I then tried to see whether our relatives had a photo but to no avail. If you can find a photograph of him for me that would mean the world to me.[34]

Referring to the 'visual experience of absence whereby we no longer see what we saw', Berger says that we 'face a *dis*appearance. And a struggle ensues to prevent what has disappeared, what has become invisible, falling into the negation of the unseen, defying our existence.'[35] This is not merely a struggle against loss and absence. It is a struggle *for* presence. There is both terror and a promise in Berger's message to those of us who pursue the visible: 'The visible brings the world to us. But at the same time it reminds us ceaselessly that it is a world in which we risk to be lost.'[36]

Brief as photos.

NOTES

1 Berger, J. (1972) *Ways of Seeing*, London: British Broadcasting Corporation and Penguin Books.
2 Berger, J. (1984) *And Our Faces, My Heart, Brief as Photos*, New York: Pantheon, p. 5.
3 I am placing the word 'disappeared' in quotation marks to call attention to the inadequacy of the term given the violent circumstances within which disappearance has taken place, and to refuse the project of censoring memory by making unavailable the violated body as evidence.
4 de Alwis, M. (2007) 'Disappearance' and 'Displacement' in Sri Lanka,

Journal of Refugee Studies, Vol. 22, No. 3, pp. 378–391, p. 378.

5 On 'chronic mourners' see Schirmer, J. (1989) Those Who Die for Life
 Cannot be Called Dead: Women and Human Rights Protest in Latin
 America, *Feminist Review*, 32, p. 256.
6 Das, V. (2000) The Act of Witnessing: Violence, Poisonous Knowl-
 edge, and Subjectivity, in V. Das et al., eds.,*Violence and Subjectivity*,
 Berkeley: University of California Press, p. 223.
7 Derrida's theorisation of the trace – with its multiple registers of
 mark, wake, track, spoor, footprint, imprint – as an undecidable that
 is neither fully present nor fully absent, was invaluable here, though I
 remained steeped in a nostalgia for lost presence (bodies that matter)
 that was decidedly un-Derridian. See Translator's Preface to Derrida,
 J. (1974) *Of Grammatology*, translated by G.C. Spivak, Baltimore:
 Johns Hopkins University Press, pp. ix–xc, p. xvi.
8 Berger, *And Our Faces*, p. 96.
9 Ibid., p. 5.
10 Ibid., p. 78.
11 Ibid., p. 97.
12 Ibid.
13 Similarly, Derrida, in the course of extrapolating on the idea of articu-
 lation, remarks that the trace 'does not lend itself to be summed up in
 the simplicity of a present'. Derrida, *Of Grammatology*, p. 66.
14 Van Voorhies, B. (2004) The Pain Has Not Disappeared, in *An Excep-
 tional Collapse of the Rule of Law: Told through Stories by Families of the
 Disappeared in Sri Lanka*, Hong Kong/Katunayaka: ALRC, AHRC and
 Families of the Disappeared, p. 128.
15 The face here recalls Derrida's evocative commentary on the philoso-
 pher Levinas's formulation of desire, sight, sound, and the face of the
 other, 'Violence, then, would be the solitude of a mute glance, of a face
 without speech, the *abstraction* of seeing.' Derrida J. (1978) *Writing
 and Difference*, translated by A. Bass, University of Chicago Press, p.
 90, emphasis in original.
16 Berger, *And Our Faces*, p. 17.
17 Ibid., p. 50.
18 Segarupan, V. (2013), 'Paled East', translated by Shriganesan, in M.
 de Alwis, Laments from a Lacerated Terrain, *Journal of Postcolonial
 Cultures and Societies*, Vol. 4, No. 2, pp. 143–4.
19 Berger, J. (1980), Uses of Photography, in his *About Looking*, London:
 Bloomsbury, pp. 52–67, p. 55, emphasis in original.
20 Ibid., p. 56.
21 Ibid.

22 Ibid.

23 In the same way, for Walter Benjamin, the photographic caption 'liter-
 arizes the relationships of life'. Benjamin, W. (1972/1931) A Short
 History of Photography, *Screen*, Vol. 13, No. 1, p. 25.

24 de Alwis, M. (2000) The 'Language of the Organs': The Political
 Purchase of Tears in Sri Lanka, in W. Hesford and W. Kozol, eds.,
 Haunting Violations: Feminist Criticisms and the Crisis of the 'Real',
 Champagne: University of Illinois Press, pp. 195–216.

25 Berger, *And Our Faces*, p. 58.

26 Das, V. (2004) The Signature of the State: The Paradox of Illegibility,
 in V. Das and D. Poole, eds., *Anthropology in the Margins of the State*,
 New Mexico: School of American Research Press, pp. 225–252.

27 Barthes, R. (1981) *Camera Lucida: Reflections on Photography*, trans-
 lated by R. Howard. New York: Farrar, Straus and Giroux, p. 87.

28 Ibid., pp. 26–7.

29 Ibid., p. 45.

30 Ibid., pp. 55–9, emphasis in original.

31 'Aney!' is a common Sinhala exclamation of despair somewhat akin to
 'alas!'

32 Barthes, *Camera Lucida*, p. 59, emphasis in original.

33 Nonetheless, two maulavis I interviewed were emphatic that this
 kind of practice was prohibited within Islam as 'only Allah knows our
 future'.

34 Quoted in de Alwis, 'Disappearance' and 'Displacement', p. 384.

35 Berger, *And Our Faces*, p. 50, emphasis in original.

36 Ibid., p. 50.

SPIRIT

YOU CAME AND NEVER LEFT: A TRIBUTE TO JOHN BERGER FROM PALESTINE

TANIA TAMARI NASIR,
BIRZEIT, OCTOBER 2015

Dear John,

It has been a long time since I have written although you are often in my thoughts. I am always grateful to get news of you from my occasional email exchange with Yves and Sandra. Thank God you are in good health and spirits. How wonderful it is that you are writing again. There must have been a terrible period of stillness after Beverly's loss. How you must miss her. I miss her too. Just this morning I thought of her as I was watering the geraniums on our balcony. It is a cold autumn day and I remembered that this would be the time when Beverly would bring in her beloved geraniums for the winter. Quincy winters are not good for them. Ours are out in all seasons, though they suffer a bit when the odd snowfall visits us.

What prompts me to write today ya John is not only that I have missed writing to you, but also that I have decided to finish an unsent letter that I had started months ago, and that I

found yesterday as I was clearing my desk. It was dated March 2, 2015 and was written in Gaza.

Yes, I was there, on a rare visit after years of absence. As you know, we West Bank residents are banned from connecting with our sister landscape by the sea. I was lucky to be given a permit by the Israelis to accompany my husband who had to travel there for official business. Being in Gaza was a gift. I saw family and friends I have not seen for years. I listened to stories of suffering and loss, of fear, of hopelessness, and of war. I saw destruction beyond anything I could imagine. And I saw the sea, the one thing I was longing to see. Because I knew how deeply you care about Gaza, I decided to write you a letter from there, sharing my experience, planning to send it upon my return to Birzeit. I did jot down a few notes then, but as things have a way of getting mislaid and forgotten, the letter remained unfinished, unsent, until I found it patiently waiting to be sent to its destination. It was an invitation right then and there for me to finish it, an opportunity as well to connect with you again and to share other news – news of Palestine now, as we seem to be witnessing another major crisis in our struggle.

But first things first, let me go back to Gaza and to the notes that I had started writing while sitting on the balcony of our hotel room: 'I sit on a chair from where I can see the sea, the fishermen's boats, the seagulls, and the tender waves as they break, on not so clean a shore. The sights promise freedom and flight, yet one knows when in Gaza, the horizon is another prison wall … There is a man on a raft. The raft is dancing in tune with the waves while seagulls circling above dip down

gracefully to embrace the man and the raft, oblivious to the eyes of an Israeli naval ship looming in the distance ...'

This is where the Gaza notes stop. I'll pick up from here and continue from Birzeit.

Dear John,

Today Gaza and the whole of Palestine are engaged in an uprising, described by many as a Third Intifada. Once again we find ourselves battling with despair as we face a future dark and bleak. I know we have been in similar situations before. The struggle for the liberation of Palestine is an ongoing saga for us. With the passing of time, the unresolved issues, the unrealised dreams for justice and freedom seem suffocating, and the frustrations turn into a heavy burden almost impossible to carry any more. I recall a poem, 'The Earth is Closing In on Us', by our beloved mutual friend Mahmoud Darwish, published in 1984, which I translated sometime later.[1] I want to share some lines from my translation so that together we can listen to his voice again:

> The land cannot contain us anymore. It crams us in the
> last passageway, and
> we dismember ourselves to pass.
>
> The land squeezes us. I wish we were its wheat, to die, to
> live,
> and I wish she was our mother and unto us can be
> merciful. I wish we were images of the rocks,
> mirrored by our dreams.

Dear John,

I wish you were around for us to talk, to share, although I know it is a time in Palestine that will bring you anguish and anger. I would like to think of you far away, happy in Fayance, drawing fruits and flowers (a few days ago Yves sent me some of those exquisite drawings, a rose, a petunia). Somehow imagining you in an intimate loving conversation with petals and colours lessens my sadness. I sigh and smile. Even from faraway, you have a way of comforting ya John.

You have been comforting ever since you first came to Palestine. Your unwavering concern for the plight of humanity has led you to us, to the land ironically known to the world as the land of the prophets; prophets who were never able to bring us lasting peace. Prophets whose message of love remains unfulfilled, barely touching the hearts and the minds of the people of the land where violence and death have become a mantra!

You came to Palestine. Your presence seemed to buttress a deep and strong belief I have in yet another source for salvation and redemption and where humankind might find a *raison d'être*– in the sublimity of the arts, in the simple beauty of things; and in an unwavering commitment to truth.

We rejoiced in your presence then. Our experience became your experience and you did not hesitate in putting into words what you saw, what you felt. I had always longed for your words to find a home in Palestine, and for your words to 'Tell' what you 'Saw' and 'Felt'. And they did just that. 'A Moment In Ramallah' was the essay you wrote soon after your first visit to Palestine.[2] I go back to it now and read:

Today there is not a wall in the town centre of Ramallah, which has become the capital of the Palestinian Authority, which is not covered with photographs of the dead, taken when alive, and now reprinted as small posters. The dead are the martyrs of the Second Intifada which began in September 2000. The martyrs include all those killed by the Israeli army and settlers, and those who decided to sacrifice themselves in suicidal counter attacks. These faces transform the desultory street walls into something as intimate as a wallet of private papers and pictures …

Today, dear John, the number of martyrs multiplies by the day. Once again, posters of their young faces adorn the walls and streets of Palestine. They might be the children or the now grown-up younger brothers and sisters of those you saw back then in Ramallah. It is strange how the eyes of a dead person's portrait carry an eternal message from the world of the living. It does not matter that the person is now dead. This portrait was taken when his tomorrow was around the bend and so we look at them, and murmur a prayer, and a hope that they might not have died in vain.

John,

This one-way correspondence is growing by the hour, but I am happy for the nostalgia. Drinking my cup of coffee, I sit here, in our family room, in the old family house in Birzeit, more than a hundred years old. I remembered how we gathered here ten years ago with Beverly, Yves, Sandra and Melina. It was as if

you had always been there. I can't help but think that having your family with you gave your presence special meaning – a sort of seal of approval for being in Palestine. You trusted your family to Palestine.

You gave me your new book, *Here Is Where We Meet*.[3] The title fitted beautifully. You encouraged me to write a story about our family room – and your presence in it sparked the first words. I wrote an essay, 'A Family Room',[4] and dedicated it to you. It was a story close to my heart. The story of our family's home where a small elementary school for girls was established in 1924 by a woman, Nabiha Nasir, in her father's home. Nabiha was my husband's aunt. The school slowly grew until in 1972 it became Birzeit University, the first university in Palestine.

We were in that home where it all started and I was so proud to show you around. The vaulted ceiling rejoiced that day. During that visit you and Yves organised drawing and printing workshops for children, some in the Palestinian refugee camp, where boys and girls pushed and shoved to take part. Some of the workshops were at a photography lab at Birzeit University. After the workshops, you were asked about your experience. 'It struck me how swiftly the ideas were applied in the discussions. There is such an immediacy and energy here among young artists – an urgency you do not find elsewhere. The intensity of questioning, the ability to raise the questions that don't often get asked but need to be.'[5]

Soon after this trip you wrote a poignant essay, 'Undefeated Despair'[6]. You describe what you saw:

Despair without fear, without resignation, without a sense of defeat, makes for a stance towards the world here, such as I have never seen before. It may be expressed in one way by a young man joining the Islamic Jihad, in another by an old woman remembering and murmuring through the gaps between her few teeth, and in yet another by a smiling eleven year old girl who wraps up a promise to hide it in the despair …

'Undefeated Despair'. Those words haunt us still dear John. I long for them to be erased from the lexicon and the annals of Palestinian history. I long for you to write a text of joy and celebration; the victory of Hope in Palestine, not despair – regardless of in what garb. Saying that, realising the impossibility of such a wish coming true in the near future, I feel it is almost cruel, sacrilegious, to even imagine this happening in my lifetime.

Dear John,

We are halfway into October. On this chilly evening, I decided to stop listening to the news that advertises human brutality and suffering all across our globe. I once again turn to your words to find coherence and equanimity.

After your last visit to Palestine in 2009, in your essay aptly titled 'A Place Weeping' you quoted from the Kurdish poet Bejan Matur: 'A place weeping enters our sleep, a place weeping enters our sleep and never leaves.'[7]

Sadly, Palestine is weeping still. We've had our few years of tears dried, of parched eyes, of 'undefeated despair', of crazy hope. We waited and struggled on all fronts, locally and internationally, pursuing the implementation of international human rights conventions and United Nations resolutions to achieve justice and peace in Palestine. Yet the brutal reality of the status quo, the decades-long Israeli occupation and colonisation of our county is reigning still! And so today, our eyes can hold no more. The once-dry springs have erupted again. Free spirits can no longer be stifled. We revolt again. We weep again. In a few weeks, more than one hundred people were dead. Many more were injured and imprisoned. Palestine has become an arena of violence, death, anger, fear; of stabbings and execution-style shootings. Where are we heading? Have we reached rock bottom? There is a permeating feeling of utter helplessness, a terrible fear that a state of anarchy might go on for years. Why? I wonder how you would explain this, you who have been a bulwark of strength and wisdom? What shall we do, John? We cannot weep forever. We need miracles to go on.

And as if you have heard my questioning heart, you answered, by way of a short text you sent this morning to your friends in Palestine, assuring us of your support, telling us: I am with you. I am with those young people at the checkpoints, resisting, defying the might of the occupiers; those freedom fighters facing death, seeking freedom from the shackles of Israeli occupation, seeking freedom for their imprisoned homeland, usurped daily by the Israeli settlers and the government representing them. You have been here, John, you

have seen, you have felt and now, on October 18, 2015, you write these poignant lines:[8]

> Beethoven's Piano Concerto No. 5 summons up a happiness that is almost boundless and which, for that very reason, neither he nor we can possess. The Concerto was nicknamed the Emperor. It carries us to a horizon of happiness we cannot cross.
>
> I send it today to the Palestinian students demonstrating at the BethEl checkpoint at the entrance to Ramallah. They too are inspired by a vision of happiness they cannot know in their lives. I send the concerto as an arm to be used in their struggle against the Israelis who occupy and colonize their homeland. Beethoven approves. He cares deeply about politics. His Symphony No. 3, the Eroica, was inspired by Napoleon when he was still a freedom fighter and before he became a tyrant. Let's rename the Emperor for a day: Piano Concerto No. 5, the Intifada.

Powerful words and imagery that brought tears, tears of gratitude for your friendship and love. Oh yes, those young men and women can use an extra arm or two. I had to smile, for I could see you, together with Beethoven, two tall, dashing giants, marching with the youth of Palestine, arms raised, voices resounding, calling for the end of occupation, an end to the colonisation of Palestine. A stance for freedom and for liberation? What do you say John?

You have never left us John – you are one of those 'faithful witnesses' who never leave once they have seen, once they have felt. You continue to tell from thousands of miles away. For this and for so much more, we are grateful. We are blessed!

With love,

Tania

NOTES

1 This was my own unpublished translation of the poem 'The World Is Closing In on Us'. The poem, in Arabic with an English translation, can be found in M. Darwish and S. al-Qasim, eds, (1984) *Victims of a Map*, translated by Abdullah al-Udhari, London: Al Saqi Books, p. 13.

2 Berger, J. (2003) A Moment in Ramallah, *London Review of Books*, Vol. 25, No.14, 24 July 2003, pp. 20–22.

3 Berger, J. (2005) *Here Is Where We Meet*, London: Bloomsbury.

4 Tamari-Nasir, T. (2008) Notre Salle De Séjour, in A. Laïdi-Hanieh, ed., *Palestine: rien ne nous manque ici*, Brussels: Revue de l'Université de Bruxelles, pp. 125–147.

5 Hammami, R. and Sherwell, T. (2005) John Berger and Family in Palestine: Annals of a Visit, *This Week in Palestine*, No. 92, December 2005, http://archive.thisweekinpalestine.com/details.php?id=1526&edid=109

6 Berger, J. (2006) Undefeated Despair, *Open Democracy*, 13 January 2006, www.opendemocracy.net/conflict-vision_reflections/palestine_3176.jsp

7 Berger, J. (2009) A Place Weeping, *Threepenny Review*, Summer 2009, www.threepennyreview.com/samples/berger_su09.html. Matur, B. (2002) Time Trapped in the Stone, *Index on Censorship*, Vol. 31, No. 3, p. 141.

8 Berger, J. (2015) Letter from John Berger to the Palestinian Resistance, *Verso Blog*, 20 October 2015, emphasis in original, www.versobooks.com/blogs/2295-letter-from-john-berger-to-the-palestinian-resistance

PROPAGANDA

BY DEED: PROVOCATION, PRIMITIVISM, AND POLITICS IN JOHN BERGER'S WRITING

ROCHELLE SIMMONS

'Propaganda by deed.'[1] John Berger's use of this anarchist phrase in *The Success and Failure of Picasso* to describe Pablo Picasso's *Les Demoiselles d'Avignon* (1907) reveals what Berger perceives to be the intentions underlying Picasso's painting.[2] It also aptly portrays the principal protagonist's behaviour at the Stadttheater ball in Berger's Booker Prize-winning novel *G.*[3] The speech Berger gave when he shared his prize money with the British Black Panthers could be seen as propaganda by deed. Despite their dissimilarities, Berger's account of Picasso's painting, *G.*'s actions, and Berger's speech are all motivated by a revolutionary impulse, although Berger's affiliations are with Marxism rather than anarchism.[4]

These works also exhibit what Berger sees as the other cardinal characteristic of Picasso's *Les Demoiselles d'Avignon*: they are all aligned with various forms of primitivism or Negritude. If we add to these Berger's analysis of the drop curtain that Picasso designed for Sergei Diaghilev's ballet

Parade (1917),[5] discussions in Berger's novel between the boy G. and his father Umberto concerning Pietro Tacca's figures of *Il Quattro Mori(The Four Moors)* (1623–1626),[6] and the 1969 translation by Berger and Anna Bostock of the Martiniquan poet Aimé Césaire's *Return to My Native Land*,[7] then we have a basis for considering Berger's statements about Black Liberation as a form of revolutionary freedom. But before I engage in this discussion, I should state that I am not concerned with Picasso and his paintings as historical entities, but with Berger's interpretation of them in his art criticism and fiction.

PRIMITIVISM AND NEGRITUDE

In relation to *Les Demoiselles d'Avignon*, I am using 'primitive' in a non-pejorative, art historical sense, to designate the archaic (Iberian) and ethnographic (African) traditions from which Picasso drew some of his pictorial vocabulary. The word carried different connotations for Picasso himself. In *Success and Failure,* Berger invokes Ortega y Gasset's concept of the vertical invader to describe how Picasso defined himself when he moved from Spain to Paris in 1904. 'The European who is beginning to predominate … must then be, in relation to the complex civilization into which he has been born, a primitive man, a barbarian appearing on the stage through the trap-door, a vertical invader.'[8] As an outsider, Picasso was made to confront modern urban misery. He responded by idealising 'simpler, more primitive ways of life',[9] and by portraying himself as a 'noble savage',[10] in order to condemn this misery.

Berger also declares that Picasso's primitivism inspired his identity as a bourgeois 'revolutionary'. Césaire invented the term '*négritude*', which denotes a celebration of blackness.

PROVOCATION

In *Les Demoiselles d'Avignon*, Picasso 'uses his sense of the primitive to violate and shock the civilized'.[11] Berger writes, 'Blunted by the insolence of so much recent art, we probably tend to underestimate the brutality of *Les Demoiselles d'Avignon*'.[12] The man with the skull purportedly embodies Picasso's own fears about having contracted venereal disease and the depiction of five naked prostitutes is 'far more violent'[13] than his earlier work. Picasso's manner of portraying women 'like the palings of a stockade through which eyes look out as at death' is shocking.[14] Picasso shocks, too, through his unprecedented inclusion of primitive African references within a high-art Western tradition. 'He is concerned with challenging civilization. The dislocations in this picture are the result of aggression, not aesthetics; it is the nearest you can get in a painting to an outrage.'[15] Indeed, Berger states, 'By painting *Les Demoiselles d'Avignon*, Picasso *provoked* Cubism. It was the spontaneous and, as always, primitive insurrection out of which, for good historical reasons, the revolution of Cubism developed.'[16]

The other relevant work is Picasso's drop curtain. Berger writes that, following the First World War, the 'relationship between art and reality shifted'.[17] Whereas before the war

the Cubists 'had been ahead of events', after the war '[r]eality outstripped them [. . .] The age of essential politics had begun. What was revolutionary was now inevitably political.'[18] For Berger, the drop curtain is sentimental. It is 'a long way from the violence of the *Demoiselles d'Avignon*, a long way from the austerity of the Cubist still-lives, and a very long way from the Western Front in the third year of the World War".[19] The ballet itself was avant-garde. On opening night there was an uproar: '[t]he highly distinguished audience was outraged and suspected that the ballet had been designed to make them look ridiculous'.[20] Berger condemns *Parade*, not so much for its disregard of the war but because–despite its Cubist stylistic elements–it claimed to be realistic, which 'shocked in such a way as to distract people from the truth [. . .] The madness of the world, they could say, was the invention of artists!'[21]

G.'S BEHAVIOUR

Like Picasso, G. is horrified by modern society. Incensed by Wolfgang von Hartmann's belief that he could regulate his wife's passions, by arranging for Marika and G. to have a short-lived affair, G. wreaks revenge on von Hartmann and his ilk. Berger writes of how he wanted to express the revulsion he felt for every guest at the Stadttheater ball in 1914 Trieste. As a Hapsburg city, Trieste resembles '[an island] in an ocean of barbarism'.[22] G.'s action of taking a Slovene village girl to the ball sets him apart from the conventions and proprieties of the Austro-Hungarian establishment. Such an act could be called

primitive, in that it deliberately offends so-called civilised manners. It also causes the Austrians to reflect on 'how long it would take them to civilize these parts'.[23] Thus, G. uses his sense of the primitive to violate and shock the civilised by committing an act of aggression.

If the ballet audience was outraged, so, too, was von Hartmann filled with rage by G.'s behaviour. '*Parade* was very much a *public* manifestation.'[24] Similarly, G.'s 'insult, which was a public one, amounted to declaring: after a plate-licker, your wife'.[25] In his desire to shock, G.'s behaviour has much in common with Picasso, although he proceeds by affronting class prejudices. He dresses Nusa, the village girl, in a gown with a turban and a train, made of muslin, pearls, and Indian-style embroidered silk, so that she looks regal and commanding, like Sheba. The majestic dress, the exotic features of which recall the plight of other peoples subjugated by imperial rule, elevates a Slav peasant to the level of the Austrian and Italian ruling class, just as Picasso elevated archaic and ethnographic sculpture to the level of high art in *Les Demoiselles d'Avignon*. The reference to Sheba also recalls the influence of primitive, African masks on Picasso's painting. By reversing the accepted social order in Trieste, where the Italian word for Slavs (*Schiavi*) puns on the word for slaves (*sc'iavi*), G. insults not only von Hartmann, the wealthy and powerful director of the Kreditanstalt Bank, but also all of the imperialists who waltzed while the war–for which their values were responsible–raged on the Western Front. Berger's description of the ball and its circumstances is similar to his depiction of *Parade*. Once again,

the relationship between art and reality shifted, since, when the orchestra, which had come from the Eastern front, played Viennese dance music, 'The players no longer believed, as they had before, in the time of the waltzes.'[26] Berger places the ball in the context of the fighting in order to show how frivolous it was. In *Success and Failure*, he describes how, at the battle of Auvers Ridge, 'men were milling round like slow dancers, with dead or bleeding partners in their arms'.[27] This simile makes apparent the waltzing imperialists' responsibility for the war and the implied comparison with Picasso.

G.'s action suffers the same fate as *Parade*. When von Hartmann attempts to have G. arrested as he leaves the ball, the Chief of Police pronounces G. 'a little mad'.[28] Just as the audience attributes the madness to artistic invention, rather than to the war, the Chief of Police denies the social thrust of G.'s criticism, labelling his behaviour a personal aberration. In suggesting that G. may be plotting to overthrow the empire, von Hartmann acknowledges his revolutionary potential. However, von Hartmann's objection is overruled by the Chief of Police, who says to the departing von Hartmann, 'do not worry, everything will still be the same when you return'.[29]

In *Success and Failure,* Berger encourages us to judge Picasso's uniqueness. He does the same with G. As a proto-revolutionary, G. attempts, if not to overthrow the empire by reversing the accepted social order, then at least symbolically to attack the class system. G.'s behaviour is misinterpreted, since its subversiveness operates on a personal, not a political, level. He is outstripped by reality because '[t]he

age of essential politics had begun'.[30] As Berger writes in his essay 'The Moment of Cubism', 'No revolution is simply the result of personal originality. The maximum that such originality can achieve is madness: madness is revolutionary freedom confined to the self'.[31] Hence we see that Berger's view of Picasso forms the basis for his fictional character. G.'s behaviour at the Stadttheater ball reflects the provocative and primitive aspects of Picasso's *Les Demoiselles d'Avignon* and the ball itself is modelled on Picasso's drop curtain design for, and the audience reception of, Diaghilev's *Parade*. Although primitivism is variously defined in Berger's novel, in his art criticism it derives partly from African art, and it therefore alludes to a black artistic tradition.

NEGRITUDE

Unlike the oblique references to primitivism, Negritude is dealt with directly in G. Umberto's comments about *Il Quattro Mori*– the slaves Tacca added to the pedestal of Giovanni Bandini's Livornese sculpture of Ferdinand I de' Medici (1617) –are overt in their celebration of blackness, since he sees the bronze figures as strong and beautiful. Berger has called this statue 'the most important single image of the book'.[32] As naked African slaves chained to an imperious monument of the Grand Duke of Tuscany, the figures are an obvious symbol of slavery and domination–and, by extension, white oppression–and they are linked with the themes of madness, revolution, and freedom.[33] For example, Umberto sees madness in the four cursing

Moors, believing that 'Madness is native to the town,' but that
'it breaks out only spasmodically. Each time reminds him the
first time, in 1848 when he was ten.'[34] This reference to the
Revolution of 1848 presages the 1898 mass demonstration in
Milan, which G. witnesses when he is eleven, and which marks
the inception of his revolutionary consciousness. Whereas
G. is subsequently able to see 'the promise of mankind' in
the revolutionary crowd, Umberto 'fears it absolutely'.[35] For
Umberto, madness both signifies that which 'threatens the
social structure guaranteeing his privileges' and 'represents
freedom from the social structure which hems him in'.[36]

Berger's interest in 'the nature of freedom'[37] in G. can
be seen as an expression of his existentialist and Marxist
humanist allegiances, which emphasise revolutionary freedom,
alienation and the writings of Hegel and the young Marx. His
Booker Prize acceptance speech likewise conveys a vision of
Black Liberation as revolutionary freedom. In justifying his
decision to give half his prize money to the Black Panthers,
Berger traces the source of Booker McConnell's wealth back to
West Indian workers in the Caribbean:

> The industrial revolution and the inventions and culture
> which accompanied it and which created modern Europe
> was initially financed by the profits from the slave trade.
> And the fundamental nature of the relationship between
> Europe and the rest of the world, between black and
> white, has not changed.[38]

Referring explicitly to Hegel's Master–Slave dialectic,[39] Berger writes of how, instead of being 'divided between potential slaves and potential slavemasters', 'the oppressed are breaking through the wall of silence', and how, 'in their [common] struggle against exploitation and neo-colonialism', 'it is possible for the descendants of the slave and the slavemaster to approach each other again with the amazed hope of potential equals'.[40] He thereby proffers a Hegelian vision of intersubjective recognition between self and other, slave and master, and black and white that represents an end to oppression.

Berger chose to share his prize with the Black Panthers because of their connections with the Caribbean and their resistance 'both as black people and workers [to] the further exploitation of the oppressed'.[41] Yet although he claimed in a 1972 television interview that as an activist writer he and the Black Panthers shared the same aims,[42] the limits of this identification are obvious. As Max Silverman has written of Frantz Fanon's *Black Skin, White Masks*, published in 1952, ideas from Hegel, psychoanalysis and phenomenology have proved valuable tools in analysing the operations of white oppression, yet they have also been 'exposed as false universalisms when confronted with the specificities of "the lived experience of the black man"'.[43]

This Hegelian vision also connects Berger with what the philosopher Charles Taylor sees as 'the politics of recognition' that has been crucial to nationalist movements.[44] Nationalism and identity politics are present throughout *G.*, as when Berger describes the effect that Garibaldi's campaign for national

self-determination had upon the Italian people. 'He inspired the nation to become itself: to anticipate its own identity.'[45] Garibaldi's revolutionary activities serve as a model for other oppressed groups, such as Nusa's brother Bojan and the Young Bosnians, the workers in the 1898 Milan Demonstration, and the naked African slaves. Likewise, the novel is dedicated to 'Anya [Anna Bostock] and ... her sisters in Women's Liberation'.[46]

CÉSAIRE'S 'UNIQUE PEOPLE'

As already mentioned, Negritude is evident in Césaire's *Return to My Native Land*. In their Translators' Note, written soon after May 1968 and imbued with some of its spirit, Berger and Bostock state: 'The poem is important because of its thinking content. The thinking is both political and poetic. Politically it is a poem of revolutionary passion and irony. Poetically its images have a physical and often sexual resonance.'[47] Aside from the reference to irony, this statement could serve equally well as a description of *G*. In *Return to My Native Land*, Césaire asserts the primacy of African (not Martiniquan) nature over European culture: 'my negritude is neither tower nor cathedral/ it plunges into the red flesh of the soil/ it plunges into the blazing flesh of the sky',[48] although the poem's French Surrealist elements should not be overlooked. Notwithstanding Berger's conception of the Picasso of *Les Demoiselles d'Avignon* as a bourgeois revolutionary, when Picasso is compared with Césaire in *Success and Failure* it is

to Picasso's detriment, because Berger believes '[h]e needs to identify himself with others'.[49] If Picasso lacks subjects, as poet and French Deputy Césaire speaks on behalf of his 'unique people',[50] and 'the theme of his poetry is urgent and political', concerning 'the struggle of all Negro peoples everywhere for equal rights–economically, politically, and culturally'.[51]

It is as if the revolutionary impulse that impelled Picasso's primitivism in *Les Demoiselles d'Avignon* has found full expression in the Negritude of Césaire's *Return to My Native Land*. Inherent in this development is a move from personal originality to politics. By associating himself with Black Liberation in his Booker Prize acceptance speech, Berger sought to achieve praxis between what he referred to in the aforementioned television interview as his revolutionary writing and participation in a revolutionary political process,[52] for Berger described his art and his politics as one activity.

NOTES

[1] Berger, J. (1980) *The Success and Failure of Picasso* (1965), Harmondsworth: Penguin, p. 73.

[2] Picasso, P. (1907) *Les Demoiselles d'Avignon*, painting, New York: Museum of Modern Art.

[3] Berger, J. (1972) *G.*, London: Weidenfeld & Nicolson.

[4] Berger defines the Cubist revolution in art historical and political terms. Similarly, *G.*, which is a Literary Cubist novel, is set during 'The Moment of Cubism', to cite the name of a relevant 1969 essay by Berger (The Moment of Cubism, in *Selected Essays* (2001), edited by G. Dyer , New York: Pantheon). G. is based upon Picasso, whom Berger considered a 'Don Juan in relation to art'; cited in Dyer, G. (1986) *Ways of Telling: The Work of John Berger*, London, Pluto Press, p. 90. See also Simmons, R. (2010) John Berger's Revolutionary Narratives, in L.

Forster and S. Harper, eds, *British Culture and Society in the 1970s: The Lost Decade*, Newcastle upon Tyne: Cambridge Scholars Publishing, pp. 14–23.

5 Picasso, P. (1917) Drop Curtain for *Parade*, painting, Paris: Pompidou Centre.

6 Tacca, Pietro. *Il Quattro Mori* (1623–26), sculpture, Piazzo Guiseppe Micheli, Livorno.

7 Césaire, A. (1969/1939) *Return to My Native Land*, Translated by J. Berger and A. Bostock, Introduction by M. Kunene, Harmondsworth: Penguin.

8 Berger, *Success and Failure*, p. 40.

9 Ibid., p. 47.

10 Ibid., p. 129.

11 Ibid., p.72.

12 Ibid.

13 Ibid.

14 Ibid.

15 Ibid., p. 73.

16 Ibid., p. 75.

17 Ibid., p. 83.

18 Ibid.

19 Ibid., p. 85.

20 Ibid.

21 Ibid., p. 89.

22 Berger, *G.*, p. 260.

23 Ibid., p. 293.

24 Berger, *Success and Failure*, p. 88, emphasis in original.

25 Berger, *G.*, p. 291.

26 Ibid., p. 288.

27 Berger, *Success and Failure*, p. 255.

28 Berger, *G.*, p. 292.

29 Ibid., p. 293.

30 Berger, *Success and Failure*, p. 83.

31 Berger, The Moment of Cubism, p. 72.

32 Berger, J. (1972) Speech on Accepting the Booker Prize for Fiction at the Café Royale in London on 23 November 1972, in *Selected Essays*, pp. 253–255, p. 254.

33 As Tom Overton writes, 'Berger constantly connects the oppression of slavery and colonialism with that of industrial workers and soldiers, and his gift to the Black Panthers emerges as a logical consequence'; Overton, T. (2015) 'As if it were the only one': The Story of John Berger's

Booker Prize for *G*, In R. Hertel and D. Malcolm, eds, *On John Berger: Telling Stories*, Leiden: Brill, pp. 189–210. (digital edition), p. 200.

34 Berger, *G.*, p. 9.

35 Ibid., p. 10.

36 Ibid., p. 11.

37 Cited in Richmond, T. (1971) Berger's Bet on Freedom, *Guardian*, 5 October, p. 11.

38 Berger, Speech on Accepting the Booker Prize, p. 254.

39 Hegel, G. W. F. (1977/1807) *Phenomenology of Spirit*, Translated by A. V. Miller, Oxford: Clarendon Press.

40 Berger, Speech on Accepting the Booker Prize, p. 255.

41 Ibid.

42 John Berger Interview, in *Midweek*, 1972, with N. Harman. BBC (audio-visual)

43 Silverman, M. (2005) ed., *Frantz Fanon's* Black Skin, White Masks: *New Interdisciplinary Essays*, Manchester University Press, p. 3.

44 Taylor, C. (1992) The Politics of Recognition, in A. Gutmann, ed., *Multiculturalism and the Politics of Recognition: An Essay*, Princeton University Press, pp. 25–73, p. 25.

45 Berger, *G.*, p. 20.

46 *G.*'s relationship to feminism is contradictory, as this dedication and the main character's identity as a Don Juan figure would suggest. Although in this scene G. appears to exploit Nusa, elsewhere he treats her with consideration and respect.

47 Césaire, *Return to My Native Land*, n.p.

48 Ibid., p.75

49 Berger, *Success and Failure*, p. 136.

50 Ibid., p. 140.

51 Ibid., pp. 137–8.

52 John Berger Interview.

HERE IS WHERE WE MEET

NOTES

THE DISAPPEARANCE

AMARJIT CHANDAN

[Author's note: In 2004 Berger invited me to write with him about the Argentinian photographer Marcelo Brodsky's book *Buena Memoria*.[1] Having read my notes, Berger wrote back to me in July 2005, 'I love your pages and want to "talk" with them. But I've a stupid practical problem. I can't find a copy of 'Buena Memoria'! Did I send you mine by any chance? How has it disappeared? Stupid.' Although our essay did not materialise, this piece is written in the style of projecting the word as the image and vice versa.]

REAL HANDS

He who without explanation vanished one afternoon
(perhaps they carried him away) left on the kitchen table
his woollen gloves like two severed hands –
bloodless, improtesting, serener or rather
like his own hands, slightly swollen, robust,
with the lukewarm air of a very ancient forbearance.
There,

between the slack, woollen fingers
we place from time to time a slice of bread, a flower,
or the glass with our wine, reassured
that at least on gloves they cannot clasp handcuffs.

YANNIS RITSOS[2]

It is not only the photograph which marks the absence. It is marked by so many other objects – a pen, a letter, a comb, a shirt, a bicycle; or just a thought.

Three hundred and fifty bicycles are drawn on walls around Rosario to mark all those that disappeared – thirty-five thousand people from 1976 to 1983.

It is the wound. It hurts. The image in memory is never still like a photograph. The photograph fades with time; the black turns into sepia, silvery, mercurial. The film – the skin of the wound too raw to be touched even with the sight.

When the wound stops hurting, what hurts is the scar. – Brecht[3]

It is the scar.

The moment exposed on the surface of a film in total darkness; coating burnt by the focused light, washed away by the chemicals and the image becomes fixed and transparent. Turned into positive by the same process in reverse.

It burns. It is burnt.

It is the death mask.

> They acted and fought and struggled with love, a lot of love.
>
> <div align="right">TESTIMONY OF A STUDENT OF THE
COLEGIO NACIONAL DE BUENOS AIRES[4]</div>

Love embodies all – the struggle for justice, equality, freedom.

Against the backdrop of the large image, the faces of viewers and the viewed merge; they lean on each other in the reflection.

Faces from family albums come out in the public squares.
 The image is the defiance. Against tyranny; death, time.

Mothers chant carrying the photographs of their loved ones. Tears dried up. People join in the *carcerolazo* banging their pots. 'Where are they?' one banner asks.
 – Cut to –
Kissinger. Galtieri.
 – Cut to –
After WW2 Russian mothers running with their men's photos showing to the POWs returning home. There's no sound.

TRACES OF MEMORY

In an exhibition hall in Brixton
 names of the disappeared in Argentina so many years ago
 hang from the ceiling printed on a plastic sheet
 A strong focused light projects their shadows on the wall
 They move with the jostling of the viewers.
 Ever-changing fixtures of their eyes.
 Nothing stays still.
 The blurred contours of the alphabets touch the wall
 as you touch the book of Borges.

You close your eyes and take a deep breath –
 or is it a sigh –
 to vault the image in mind.[5]

Where are they?

Posing before the camera.
 Self-portrait.
 Seeing in the mirror?

Is the camera a friend, a stranger or unsure?
 What's in there? In that glass eye – blind and shining?

In *Buena Memoria* it is certainly a friend.

Passport photos – facing the future; towards the possibility of numerous journeys.

Police mugshots – Cheka/NKVD/KGB. Gestapo. Pol Pot.

ÍI O ÍI

Devoid of the past and future. Facing the monster in the present moment of time. Still.

Snaps – of dear ones kept in wallets. Lockets. Talismans. Keepsakes.

'A friend came to see me in a dream. From far away. And I asked him in the dream: "Did you come by photograph or train?" All photographs are a form of transport and an expression of absence.'[6]

The disappeared journey back on photographs (see also essays by Bell, deAlwis, Salomone, and Vrana in this volume). In *Buena Memoria* they arrive in groups. They are still together as they were when they posed for the school photograph. They haven't aged. They will never be.

They sit next to you. Your heart is on your tongue (Punjabi idiom). They listen to you and leave soon without a word. They are always in a rush. This time they disappear with their own wish. It is not a dream.

To relive the other person's experience is impossible, not to speak of one's own. Even those who re-enact Christ's crucifixion cannot relive his anguish and pain. Empathy, yes. Only the dead know death, you don't. You can only imagine.

NOTES

1 Brodsky, M. (2003) *Buena memoria*, Ostfildern: Hatje Cantz.
2 Ritsos, Y. (1973) Real Hands, translated by Minas Savvas, *New York Review*, 15 November 1973.
3 Bertolt Brecht (1976) *Poems, 1913–1956*, edited by J. Willett, R. Manheim, and E. Fried, translated by Frank Jones, London: Methuen, p. 148.
4 Brodsky, *Buena memoria,* p. 60.
5 Ibid., p. 61.
6 Poem by Amarjit Chandan (unpublished).
7 Berger, J. and Mohr, J. (1975) *A Seventh Man*, London: Penguin Books, p. 13.

VERBS

A GIFT FOR JOHN BERGER

ALI SMITH

There's a piece in a recent issue of the *New Statesman* in which John Berger, who is one of the world's most vital correspondents, talks, in a letter he writes, to Rosa Luxemburg, the long-dead (murdered in 1919) revolutionary socialist writer, Marxist activist and philosopher.[1] Yes, but he doesn't just talk to her, he talks *with* her, via some of the writing from letters she wrote herself, often when she was in prison. 'Freedom', Luxemburg tells him, and he reminds us, 'is always the freedom of the one who thinks differently.' In this piece, Berger writes a freedom for her. 'No single page and none of the prison cells they repeatedly put you in could ever contain you,' he writes. He also sends her a gift, a wooden box of painted birds, painted words – a box, it says on it, of birdsong. He tells her its history and he sends that history along with the box. 'I can send it to you by writing, in this dark time, these pages.'

Here's the gist of an email that came for me a couple of months ago: Dear Ali, can you write an 'appreciation' of John's writing, ideas and influence, about why his work truly matters, and can it be between five and eight minutes long?

How about forty years long? Because I could say that everything I've ever written or aspired to write has been in one way or another an appreciation of the work of John Berger. Berger, a force of unselfishness in a culture that encourages solipsism, an insister on open eyes, on the recalibration and re-energising of thinking, feeling, fiercely compassionate, fiercely uncompromising vision in a time that encourages looking away or looking only at the mirror images that create power and make money. Berger, who suggests that the aesthetic act, that art itself, is always collaborative, always in dialogue, or multilogue, a communal act, and one that involves questioning of form and of the given shape of things and forms. Berger, who can do anything with a text, but most of all will make it about the gift of engagement, correspondence – well, I can't give him anything but love, baby, it's the only thing I've plenty of, and that's what comes off all his work for me, fervent and warm and vital, an inclusive and procreative energy I can only call love.

My encounters with John Berger, whom I hadn't met until tonight, have always been vitally personal, *coup de foudre* then *coup de foudre* again, then the next time I read him, *coup de foudre*, struck by light, by enlightenment. I suspect many of his readers would recognise that sense of being literally struck, gifted something that makes you more than yourself – the thing that happens when the work you're reading or the art you're seeing actually demands of you that you engage, passes out of itself and takes up residence in the self, in correspondence with it.

This movement, which happens so often in the reading of Berger, concerns art and love and the political heft of both,

because in John Berger's work love and art and political and historical understanding are always in layered combination. There are many other writers and artists who work with this relation, but none with quite the transformatory fusion of his combining, which is a bit like encountering what clarity really is, what the word means, like looking through pure water and seeing things naturally magnified. He writes in *Portraits*– a new collection of his writing on art over his lifetime – about the working presence of the word 'art' in the word 'articulation', about how the two words share a root, 'to put together, to join, to fit … a question of a comparable flow of connections'.[2]

In this flow, things simply become apparent, or more apparent. 'The speed of a cinema film is 25 frames per second. God knows how many frames per second flicker past in our daily perception. But it is as if, at the brief moments I'm talking about, suddenly and disconcertingly we see between two frames. We come upon a part of the visible which wasn't destined for us. Perhaps it was destined for night-birds, reindeer, ferrets, eels, whales …' as he writes elsewhere.[3] Berger grants or creates something extrasensory by what he writes, and in the most natural possible way, as if nature and the human eye are already in their own liaison, and we have to catch up the knowing, get to where we'll begin to know what it is we're seeing. It's a democratic looking. Berger's take on invisibility is always about inclusion, has always been about the politically not-seen, the dispossessed, the people made to serve under so that there can be ruling classes, and via Berger the

ear acts with the eye to hear the otherwise drowned-out and inaudible – the voices of the invisible.

The act of going beyond ourselves is the art act. Writing about Cézanne, he calls it 'his love affair, his liaison, with the visible'.[4] Here he is on Rembrandt's *A Woman Bathing*: 'We are with her, inside the shift she is holding up. Not as voyeurs. Not lecherously, like the elders spying on Susanna. It is simply that we are led, by the tenderness of his love, to inhabit her body's space.'[5] He quotes Simone Weil: 'Love for our neighbour, being made of creative attention, is analogous to genius.'[6] Unsurprisingly then, but always electrifyingly, he is one of the great writers on the subject of love: 'A person loved is recognised not by attainments but by the verbs which can satisfy that person.'[7] And love is an art, and art is a matter of physical love and generation: 'At the best moments one draws with the whole body – genitals included,' he says in a piece on Maggi Hambling, in *Portraits*.[8]

One of the things I love in Berger's vision is his insistence on the artist not as creator but receiver, as a figure crucially open and receptive, since art's impetus is essentially collaborative or communal. Storytellers, he suggests, must 'lose their identities'. It's the only way to be 'open to the lives of other people'.[9] This open self-effacement is part of the act: as he says in *A Seventh Man*, his 1975 book on migrant workers in Europe, 'To try to understand the experience of another it is necessary to dismantle the world as seen from one's own place within it and to reassemble it as seen from his.'[10] Art as a natural border-crosser: 'If one thinks of appearances as a frontier, one

might say that painters search for messages which cross the frontier.'[11] And since we're talking frontiers and the crossing of them – if Cézanne said of Monet, 'Monet is only an eye, but my God, what an eye,' I'm going to say of Berger, Berger is only a man, but my God, the multitude of us, here, gone, and yet to come, that's in him.

What a fruition, what a seer of past and of futures, of the damage that 'the poverty of the new capitalism' would do to the multitude across all the frontiers, the people desperate right now to cross the frontiers as the only way to survive. What a gifting of voice to – and recognising and celebrating of, and fury at the injustices done to – the working classes, the underclasses and the people who have had to become migrants is in his work. What a clear vision of 'consumerist ideology ... the most powerful and invasive on the planet',[12] and of 'the innate paranoia of the politically powerful'[13] and of the narratives this paranoia inflicts on the world. 'Look', he says, 'at the power structure of the surrounding world and how its authority functions. Every tyranny finds and improvises its own set of controls. Which is why they are often, at first, not recognised as the vicious controls they are.'[14] What a foul improvisation millions of people are caught up in at this moment.

Meanwhile, what an energy and a pleasure and a humanity there is, he points out, against the odds, of the poor, and of the people called migrants, when it comes to that survival. That 'ingenuity of the dispossessed' is always up against a reductive power at every point, he says: 'There is no word in any traditional European language which does not either denigrate

or patronise the urban poor in its naming. That is power.'[15] Berger is clear about Power with a capital P, or what he calls in his letter to Rosa Luxemburg, 'power-shit'.[16]

'Today, to try to paint the existent is an act of resistance instigating hope.'[17] Yet 'To face History is to face the tragic.'[18] Despair is 'intrinsic to the practice of painting',[19] he says in a piece about Frans Hals; Goya's light is merciless for the cruelty it reveals; the Fayum painters 'worked from dark to light'.[20] And 'the self and the essential come together in darkness or blinding light'.[21] Everything in Berger's own art of describing to us, of picturing for us where it is we live right now, is an act of resistance and hope.

Portraits is full of references to darkness and light, the unifying properties of light, 'the attraction of the eye to light', but the attraction of the imagination to light, he says, is more complex, 'because it involves the mind as a whole … vision advances from light to light, like a figure walking on stepping stones'.[22] He quotes Pasolini: '*Disperazione senza un po' di speranza*: for we never have despair without some small hope.'[23] And here's Rosa Luxemburg, via Berger, from that recent letter to the past: '"To be a human being", you say, "is the main thing above all else. And that means to be firm and clear and cheerful … because howling is the business of the weak. To be a human being means to joyfully toss your entire life in the giant scales of fate if it must be so, and at the same time to rejoice in the brightness of every day and the beauty of every cloud."'[24]

So. A ten-year-old girl in the Scottish Highlands, way back in history, in 1972, is walking to school. It's an ordinary day,

and everything has changed, everything is new, and this has happened simply from a single phrase, a simple verbal act, having entered her consciousness. *So*, she is thinking, looking at the garage that she takes a short cut through, with the cars up on their raised platforms so that you can see, underneath, the part of them usually practically invisible, that's always closest to the road, looking at the mechanics covered in oil and grease with their heads lost in the bodies of the machines, *so*, she thinks as she walks through the school gates, stands in line with all the other kids, sits down in the given place in the church and looks at the Stations of the Cross on the walls, how they stick out dimensionally, are three-dimensional pictures, and the blue-painted statue of the Madonna up at the front, so there is more than just seeing, there are WAYS of seeing.

That was a start. And 'there's never a conclusion' is what Berger says in his preface to *Portraits*.[25] In a world capable of reversing the meanings of 'democracy, justice, human rights, terrorism' ('Each word', he has written, 'signifies the opposite of what it was once meant to signify')[26] we have a writer like Berger, who opens, reveals and reverses the given power relationships so that how we see changes. Way back, in *Ways of Seeing* (1972), he wrote warningly about how much we are led to 'accept the total system of publicity images as we accept an element of climate'.[27] He recognised a new nature, and Berger is, you might say, one of the most potent and authentic of our nature writers when it comes to the nature of the political structuring that gets called the world. He reveals and constantly reasserts the actual nature of things. 'Tyrants', he writes, 'have no knowledge of the

surrounding earth' from their 'guarded condominiums' and their cyberterritories.[28] He quotes Cézanne: 'The landscape thinks itself in me, and I am its consciousness.'[29]

From his piece on Jackson Pollock, here's his definition of genius: 'the genius is by definition a man who is in some way or another larger than the situation he inherits'.[30] Look at Berger in the world, and the world after him, then, now and to come. Not that I would characterise John Berger, whom I love, by his attainments, since, remember, a person loved is recognised not by attainments but by the verbs which can satisfy that person. Instead, in appreciation of him, I am and will be verbal: I see. I see in multiple ways. I veer towards that light in all the darknesses, real, historic, contemporary. And because of it, I will see. More, I will look. I will connect. I will co-respond. I will always know the life of dialogue. I will know the value of mystery, of not knowing. I will open. I will shout at the walls and the frontiers to break open. I will keep my nose open for the power-shit. If I despair, it'll be with hope. I will attempt to pay, at all times, not just attention, but creative attention. I will love. And I will pass on, both to the past and the future, what generosity and gifts and sight and insight have been passed on to me, with love.

NOTES

This is the text of a speech given on 18 September 2015 at the British Library, London, in honour of John Berger; www.newstatesman.com/culture/art-design/2015/10/gift-john-berger

1 Letter to Rosa Luxemburg, *New Statesman*, 18 September 2015, www.newstatesman.com/2015/09/letter-rosa-luxemburg-0

2 Berger, J. (2015) Martin Noel (1956–2008), in his *Portraits: John Berger on Artists*, edited by T. Overton, London: Verso, p. 479.

3 Berger, J. (2001) *The Shape of a Pocket*, London: Bloomsbury, p. 5.

4 Berger, Paul Cézanne (1839–1906), in his *Portraits*, p. 252.

5 Berger, Rembrandt (1606–69), in his *Portraits,* p. 147.

6 Berger, *The Shape of a Pocket*, p. 175.

7 Berger, J. (1980) Between Two Colmars, in *About Looking*, London: Bloomsbury, pp. 134–140, p. 137.

8 Berger, Maggi Hambling (1945–), in his *Portraits*, p. 443.

9 Dyer, G. (1984) Ways of Witnessing, *Marxism Today*, December 1984: 36–38, p. 38.

10 Berger, J. and Mohr, J. (1975) *A Seventh Man*, London: Penguin Books, p. 92.

11 Berger, J. (2001) A Professional Secret, in his *Selected Essays*, edited by G. Dyer, London: Bloomsbury, pp. 536–540, p. 359.

12 Berger, J. (2003) Written in the Night: The pain of living in the present world, *Le Monde diplomatique*, 18 February.

13 Berger, J. (2011) *Bento's Sketchbook*, London: Verso, p. 42.

14 Berger, J. (2011) Fellow Prisoners, *Guernica*, 15 July, http://www.guernicamag.com/features/john_berger_7_15_11/

15 Berger, Caravaggio (1571–1610), in his *Portraits*, p. 88.

16 Berger, Letter to Rosa Luxemburg.

17 Berger, *The Shape of a Pocket*, p. 22.

18 Berger, *Bento's Sketchbook*, p. 44.

19 Berger, Frans Hals (1582/3–1666), in his *Portraits*, p. 109.

20 Berger, The Fayum Portrait Painters (1st–3rd century), in his *Portraits*, p. 7.

21 Berger, *Selected Essays*, p. 149.

22 Berger, Matthias *Grünewald* (c. 1470–1528) in his *Portraits*, p. 54.

23 Berger, J. (2007) The Chorus In Our Heads or Pier Paolo Pasolini, in *Hold Everything Dear*, London: Verso, pp. 77–83, p. 77.

24 Berger, Letter to Rosa Luxemburg.

25 Berger, Preface, in *Portraits*, p. xii.

26 Berger, Written in the Night.

27 Berger, J. (1972) *Ways of Seeing*, London: British Broadcasting Corporation and Penguin Books, p. 130.

28 Berger, Fellow Prisoners.

29 Berger, J. (2011) Paint It Black, *Guardian*, 12 December 2011, www.theguardian.com/artanddesign/2011/dec/12/cezanne-paint-it-black

30 Berger, Jackson Pollock (1912–56), in *Portraits*, p. 361.

PLAY

INTERVIEW WITH THE
ARTIST PUSHPAMALA N.

N. RAJYALAKSHMI

NR Ms. Pushpamala, congratulations! You have been invited
to contribute to a celebratory volume to be brought out
for John Berger's ninetieth birthday. How did this come
about?

PN (smiles) Yes, I was surprised and flattered by the invitation.
I live in India and I have never met him personally though
I know him through his work. It could be through my
support of the international movement for the cultural
boycott of Israel of which Berger is a leading figure. I am
one of the convenors of InCACBI, or the Indian Campaign
for the Cultural and Academic Boycott of Israel. A few
years ago, we called for a boycott of the first big show of
contemporary Indian art, which was to be the inaugural
show of the prestigious new wing of the Tel Aviv Museum.
Though very few of the other invited artists actually joined
the boycott, there was a huge debate in the art world in
India around it, and the Palestinian and Israeli media
reported it widely. At that time a friend asked me to get

in touch with Amarjit Chandan, one of the editors of this volume, who is close to Berger. Perhaps he thought of me because of this.

NR That's interesting. Is Berger's work influential in India?

PN In the late 1970s and early 1980s when I was an art student in Baroda, *Ways of Seeing* was an iconic book.[1] I think TV had just come to India then and we had only the government channel, so I never saw the TV series. The Faculty of Fine Arts in Baroda was a lively and important intellectual centre. I think for us, Berger's analysis of the capitalist and imperialist underpinnings of Western post-Renaissance oil painting was very important. In India in the colonial period in the early twentieth century, there was a rejection of oil painting by the Bengal School of artists because they saw it as an imperialist imposition, and they dreamed of creating a Pan Asian art and culture based on our own art history, using Asian materials. It was part of the independence movement just as the Mexican muralists rejected oil painting. Many of the Bengal School ideas, which were indigenist, came to Baroda via the figure of K. G. Subramanyan, an important artist and teacher.

NR Did Berger's ideas affect the teaching in any way?

PN The Faculty of Fine Arts in Baroda was the first school created on the liberal arts model just after Independence in India, which gave degrees and emphasised theory and art history. Art history at the time was very Orientalist, coming from Indology, and the teaching was formal. I think *Ways of Seeing* showed us how to look at art politically.

It brought in an anthropological way of looking at art and popular culture. It was perhaps an introduction to cultural studies. But I think the book was most important in the way it deconstructed Western post-Renaissance oil painting from the inside, thereby questioning the authority of this powerful monolith which was so oppressive to us, as 'Third World' or postcolonial artists.

One of our very inspiring art history teachers at the time was the painter and poet Gulammohammed Sheikh, who was interested in Berger's ideas. He located Indian historical images in their time and place and talked about the history and process of making them. He was part

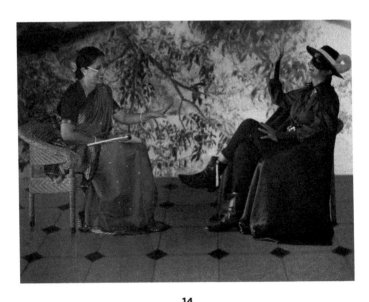

14
N. Rajyalakshmi interviewing the artist Pushpamala N.

of a group of artists and intellectuals who were political and critical of modernist abstract art and talked of a new 'narrative painting' to address the present. There was a lot of interest in the daily, the banal, and popular culture in the work of artists such as Bhupen Khakhar and Gieve Patel. Artists like Bhupen Khakhar were also questioning the mainstream cultures and looking at the subaltern cultures, or just unglamorous subjects, to paint. Geeta Kapur, India's pre-eminent art critic, who was closely involved with the group, has said that after Clement Greenberg and Harold Rosenberg, John Berger was the most influential art critic worldwide at the time.

NR How did his writing influence your own work?

PN *Ways of Seeing* was the first book I read by Berger. For a young art student in the early 1980s, the book presented a very exciting way of looking at historical art, and images in general. It made them less distant, less perfect, and connected them to our lives today. I was a sculpture student then, very interested in the project of creating an indigenous feminist language to talk of the contemporary, and looking at different kinds of sources from Indian sculpture traditions, folk art and popular art. But again, if I look at the photo-performance and video work I have been doing since the mid 1990s, it has had much to do with the deconstruction of familiar historical as well as contemporary images, foregrounding the power systems that shape them. I think Berger's book hasn't dated at all, and is still very important – a compulsory read I would say,

which should be read by every generation. I saw the TV
series on the web just now and it's still so illuminating!

NR You said you were trying to construct a feminist language
in sculpture – was Berger's writing on the nude and the
objectification of women important?

PN Berger's sharp critique of Kenneth Clark's book *The Nude:
A Study in Ideal Form*, which was a classic text, was very
important.[2] As a student, I made a series of sculptures
of women as we experience our bodies from the *inside*–
not as ideal bodies but looking somewhat awkward
and embarrassed – bodies seen 'affectionately' rather
than objectively. We were stout feminists in our teens in
Bangalore, reading Simone de Beauvoir, Germaine Greer,
Kate Millet and others, but we didn't know much about the
rising feminist art. The new feminist movement in India
grew in the 1980s with protests against 'dowry deaths'.
Later, the volumes on *Women Writing in India* by Susie
Tharu and K. Lalitha gave a history of women's practice
that one could connect to.[3] In India, the situation was
very different from the West which in some ways is far
more patriarchal, in the sense that here our independence
movement released many energies which brought women
into public life. For example, the Indian-Hungarian artist
Amrita Sher-Gil is seen as the first modernist painter in
India. A contemporary of Frida Kahlo, she was extremely
vocal and influential, though she died young. From the
1980s, I would say that women artists form the vanguard
of Indian art (even if most deny they are feminists!) and we

are a strong and influential presence here, making some of the most exciting art.

Talking about the 'male gaze' – the Indian male has suddenly come out of his languor and is attacking the gym to get six-pack abs. It seems that he wants to be an object of desire. All the recent TV ads show half-naked men spraying themselves with deodorant, assaulted by panting women.

NR (laughs) What do you think of John Berger's writings on photography?

PN (laughs) I think Berger would disapprove of my work. In his essay *Understanding a Photograph* he dismisses studio photography, which I am very interested in, and is much of what I do.[4] As I understand it, he thinks of documentary photography as truth, while I see it as a construction. I think it is still true that the public finds a photograph more accessible than a painting or sculpture, but all photographs are now part of fine art and seen as property. I'm afraid that this particular essay has become dated. Even bazaar photographs or family photographs are collected and institutionally archived, and you see forms such as live performance, which are supposed to be of the moment, patronised by museums and the art world. I would not take so contemptuous a line on museums either. In fact, in the non-Western world we are talking of more museums or better museums. I see the museum as a library of art, and in fact, artists constantly use things in the museum for their studies and as inspiration. Artists are also using the

idea of the museum as a form in their work. Museums can be dull because they are usually so bureaucratic, but even the dullest of museums are a fertile ground of reference for artists.

NR You say you have been recently thinking of Berger's writing on peasants and animals?

PN In *Why Look at Animals?*, Berger almost likens peasants to animals, the way they both have been marginalised by industrialisation and mass production.[5] His writings on peasants and animals are a trenchant critique of global economics, and our growing alienation from nature and the means of production. It's interesting that the latest issues being discussed in India today are the escalating farmer suicides and the crisis in agriculture, which are direct results of liberalised economic policies and the neglect of farming. The other raging controversies are around the Hindu fundamentalists demanding a beef ban, where recently a mob attacked and killed a poor Muslim in a village near Delhi, on the suspicion that he was storing cow meat. This led to a series of protests, with eminent writers returning their awards. It is now Cow versus Dog. While the cow is seen as a holy, pure animal and an object of worship, the dog is thought of as a dirty scavenger roaming about, an object of contempt. Shockingly, several politicians in a spate of recent paternalistic and foolish comments have likened the lower castes, Muslims and other marginal people to dogs and puppies, easily eliminated and of no value. If Berger wrote about the

ancient 'gaze' that bound animals and humans together, we seem to be creating a new kind of eugenics!

NOTES

[1] Berger, J. (1972) *Ways of Seeing*, London: British Broadcasting Corporation and Penguin Books.
[2] Clarke, K. (1956) *The Nude: A Study in Ideal Form*, New York: Pantheon Books.
[3] Tharu, S. and Lalita, K., eds (1993) *Women Writing in India: 600 BC to the Present*, 2 vols., New York: Feminist Press at CUNY.
[4] Berger, J. (2013) *Understanding a Photograph*, edited by G. Dyer, London: Penguin Modern Classics.
[5] Berger, J. (2009) *Why Look at Animals?* London: Penguin Books.

TENDERNESS

TRANSLATING JOHN BERGER: A PLUNGE INTO THE DEEP

CHRISTINA LINARDAKI

There is no doubt that some of John Berger's texts are unconventional. One such text is his essay on Charlie Chaplin 'Some Notes about the Art of Falling' which was originally published in the British Film Institute's *Sight and Sound* magazine.[1] I gladly took up its translation for the Greek magazine *Cinema,* only to find that trying to recreate the original's blend of strident political analysis and tender compassion was far from easy and involved much more than the right choice of words. That is often the way with translation.

Translation, more often than not, is a leap into the unknown. The translator sets off to what she believes is a planned destination, only to find herself soon in uncharted waters. This is a result of the text's varying complexity and opaqueness, and of the translator's related levels of visibility within it.[2] Berger's style is modern: he narrates different, seemingly unrelated stories and then weaves them together to produce unexpected conclusions. As Andy Merrifield has observed, Berger is 'a

stream-of-consciousness writer'.[3] In his 'Art of Falling', for example, Berger first discusses the stories of Charlie Chaplin (as a boy) and the painter Michael Quanne. He then moves on to the President of Bolivia, Evo Morales, followed by the story of four hundred migrants and refugees who were drowned in the sea around the Italian island of Lampedusa. And all the while as he stages these novel associations between very different people and events, he is really talking about how humankind can repeatedly fall, yet stand back up again. What Berger offers is a patchwork of individual stories that together add up to something bigger.

The translator, then, has a more limited visibility within the overall meaning and narrative of such a patchwork-like text and it is only at the end of the text that she can become illuminated. So she can't even begin to translate such a text unless she has first read through and understood its different and various meanings. She must also come up with a consistent translation of the phrases that recur throughout (for instance, in 'Art of Falling', the phrases 'words are missing to name or explain the daily run of trouble' and 'proverbial foreknowledge'), which could have been endowed with various interpretations at different points (see also the essay 'Milk' by Amália Alves, this volume). Consequently, she must render a single translation that can operate as a *passe-partout*. The translator is often forced to operate as an omniscient reader – a reader with foreknowledge of the conclusion or *dénouement* to which a text is leading. Inevitably, she translates the text not moving with the flow of the writing but rather from a retrospective point of view.

When writing, the author has an intention, whether consciously or not. However, the text delivered to the public is open to interpretation. It is open to what Arrojo sees as 'the infinite possibilities of *différance*,[4] which are potentially set in motion when a reader approaches a text'.[5] What this means is that when reading, the reader (and consequently the translator, who is a more informed type of reader) interferes with the author's meanings by projecting her own interpretations onto the text. Arrojo points to the 'incompleteness' of the text, which arises from its inability to constitute an entity of its own, that is, without the intentions and the interpretations of, in turn, the author, the reader and the translator. As a consequence, the author becomes 'a mere "limit", or a 'guest' that may, or may not, be invited to the reader's inventive reading act'.[6] When delivering a text to the public, the author, as Roland Barthes believed, undergoes a symbolic death.[7] As the author 'dies', someone else is born: the interpreter (that is, the reader or the translator), who is recognised as 'an active producer of meaning' and 'whose interference is not merely tolerable but inevitable'.[8]

Of course, such conclusions relate to texts that prove more resilient to translation than John Berger's. Although Berger's text structure is unconventional, he uses a simple, straightforward language that is difficult to misinterpret. His aphorisms, scattered throughout the text, are pithy, but direct. In 'Art of Falling', he writes: 'The clown is used to loss. Loss is his prologue,'[9] or 'Laughter is immortality's nick-name.'[10] A translator cannot go astray with such phrases. They operate as beacons within the text and their poetic quality does not render

them any more difficult to translate. This is because Berger allows words to 'slip back into the creature of their language', as opposed to a usage of words 'as mere labels', excised from the language they came from, which renders them abstracted and empty.[11] Berger's words are alive and full of meaning. They are straight-arrowed, therefore easy to translate.

This ease of translation defies views such as those held by George Steiner who, back in 1975, asserted that 'the perennial question whether translation is possible' is embedded in 'ancient religious and psychological doubts on whether there ought to be any passage from one tongue to another'.[12] These kinds of doubts have largely been abandoned nowadays, but questions still remain that reinforce a sense of the precariousness of translation. Even today, translation is often thought of as a form of falsification. Consequently, translation seems an impossible task since it implies an impasse: that of being faithful to the target language while 'nonetheless resurrecting a certain fidelity to the original'.[13]

The issue of fidelity is paramount. Should a translator 'remain faithful to the text and not to the words?'[14] as Amarjit Chandan wonders, asking of a text, 'Where is the line, which is drawn between the idea and the body?'. Susan Sontag, in her essay 'The World as India', echoes Friedrich Schleiermacher and also Walter Benjamin: translation involves the value of 'connecting with something that is different from what we know, with foreignness itself'.[15]

This foreignness, however, is often smoothed out for the sake of a more natural feel in the target language. Is this

smoothing out the correct thing to do? Let's see with a Greek example of Berger's works, although not many of his texts have been translated into Greek. Of these, Berger's *Ways of Seeing* has received a Greek title, which in English would read something like 'The image and the look'.[16] In order to translate the phrase 'ways of seeing' in Greek as it is, a noun (for 'ways') would be needed and either the subjunctive form of the verb *vlepo* (*vlépo*) or an infinitive (for 'seeing'). In the case of the subjunctive form, the phrase would sound alien in Greek. In the case of the infinitive, well, there is actually no one-word infinitive that could be used. Such infinitives have been dropped by modern Greek grammar rules and have been replaced with inconvenient periphrastic wordings. So, my guess is that the translator and/or the publisher came up with this rendition out of necessity: there was no other simple way to render the translation. But was it the same title, after ironing out the linguistic dissimilarities? And how is a Greek reader supposed to understand readily that the Greek book is the same as Berger's famous *Ways of Seeing*? It is a commonplace for such questions to hover above a translator's head, urging her to make a choice between remaining faithful to the text or to its core idea.

Grammar rules are often the cause of translation mismatches, because they involve different matrices of understanding. For Sonja Tirkkonen-Condit, 'every language has linguistic elements that are unique in the sense that they lack straightforward linguistic counterparts in other languages'.[17] These elements may be lexical, phrasal, syntactic or textual.

It's not that they are untranslatable in any sense: they simply don't manifest in the same way in other languages. Language is central to any culture: when attempting to transfer a meaning from one language to another, the translator essentially engages in a cross-cultural dialogue or in an act of cultural synthesis and re/production of meaning.

Nowadays, of course, the terms of discussion tend to be reversed: culture itself is being thought of as a living process of translation. 'As a result, the term *translation* is now defined as a dynamic term of cultural encounter, as a negotiation of differences as well as a difficult process of transformation.'[18] So when Berger tells the story of the four hundred migrants and refugees who were drowned and declares that 'the Tramp is no longer singular', he is actually offering and revealing the grounds for this vigorous new metaphor of migration as translation. Of course linguistically, migration is only one facet of meaning; the contested terms of exile and diaspora are others. Meaning in tension and coexistence like this 'hops into the spacy emptiness between two named historical languages'.[19] This 'spacy emptiness' is a 'fertile and, at the same time, disquieting place where the dynamic interaction of at least two cultures takes place'.[20] Lightly paraphrasing Dingwaney and Maier,[21] we could say that it is the space within which the migrant or the dispossessed person can choose to deliberately mistranslate the foreign script, undermining its authority. To talk about culture as translation, then, is to bring it down to earth, to ground and contest any 'talk of language in terms of religiosity, elevating translation to the level of the sublime'.[22] It

is to become aware of the various interpretations of the world that actually exist, notwithstanding the underlying common places that exist too.

Berger's 'Art of Falling' essay also contains political assertions that can be seen to belong to a larger context and could therefore be interpreted (but not translated) in a different vein. For instance, Berger often translates and interprets local news stories as well as commenting on geopolitical systems. In 'Art of Falling' he writes of Evo Morales proposing a new law that legalises child labour from the age of ten. For Berger, the legislation offers some legal protection to these children. It is his way of interpreting that law. Other people could be inclined to different interpretations and might even talk about child abuse. Elsewhere in the essay he turns his attention to 'the economic global tyranny of speculative financial capitalism (...), whose sole aim is profit and ceaseless accumulation, [and which] imposes on us a view and pattern of life which is hectic, precarious, merciless and inexplicable' or writes that 'the fundamental decisions determining today's world are all being taken by financial speculators and their agencies, who are nameless and politically speechless'.[23] Such *unequivocal* political commentary often emerges in Berger's writings and he can come across in a rather didactic, even harsh way.

Political assertions are (or at least should be) less open to interpretation when translated. The translator's job is not to translate judgementally or to assume the role of a critic. She has to take on a stance of radical passivity. Of course, a translator, as any reader, is moved emotionally and politically by a text

and, consequently, is driven to make specific choices with regard to words that can reveal her allegiances. Nevertheless, the place and the time for such judgements is not within the translation. These relationships, birthed within the text, must move outwards to another time and place, to the 'spacy emptiness' mentioned previously, where they can – and should – become neutralised. This is a subtle and vulnerable point in the translation process where the translator withdraws her most palpable presence in the text, making instead a choice that is profoundly ethical and also challenging.

So from within the space of this essay I can now say, Berger's writings are scarcely about politics and they are not harsh. They are uncompromising, yes, but mainly they speak of a human condition and look upon it tenderly, such as when Berger observes of the ten-year-old Chaplin, 'nowhere is there a hint or trace of any mother-touch'.[24] Such risky identification speaks of extra-linguistic feelings. This is hardly surprising: Berger is keenly aware of what lies outside language and appearance, how translation must 'get behind' a language and culture, and penetrate cultural silences.[25]

NOTES

[1] Berger, J. (2015) Some Notes about the Art of Falling, *Sight and Sound*, January, Vol. 25, No.1, pp. 50–53.

[2] Arrojo, R. (1995) The 'Death' of the Author and the Limits of the Translator's Visibility, in Snell-Hornby S., Z. Jetmmarova and K. Kaindi, eds, *Translation as Intercultural Communication*, Amsterdam/Philadelphia: John Benjamins Publishing, pp. 21–32.

[3] Merrifield, A. (2012) *John Berger*, London: Reaktion Books, p. 22.

4 The term *différance* was coined by Jacques Derrida. It is deliberately homophonous with the French word 'différence', to highlight how the written form is not heard.

5 Arrojo, Limits of the Translator's Visibility, p. 30.

6 Ibid., p. 23.

7 Barthes, R. (1977) The Death of the Author, in his *Image – Music – Text*, edited and translated by S. Heath, New York: Hill & Wang, pp. 142–148.

8 Arrojo, Limits of the Translator's Visibility, p. 23.

9 Berger, Art of Falling, p. 53.

10 Ibid.

11 Berger, J. (2014) Writing is an Off-shoot of Something Deeper, *Guardian*, 12 December, www.theguardian.com/books/2014/dec/12/john-berger-writing-is-an-off-shoot-of-something-deeper

12 Steiner, G. (1975) *After Babel: Aspects of Language and Translation*, Oxford University Press, p. 239.

13 Lewis, P. (1985) The Measure of Translation Effects, in J.F. Graham, ed., *Difference in Translation*, Ithaca, NY: Cornell University Press, pp. 31–62, p. 44.

14 Chandan, A. (2010) *First Person Narrative Between Tongues* (pdf), essay to accompany the 'Between Two Worlds: Poetry and Translation' audio recording project conducted by the British Library in collaboration with Amarjit Chandan, London: British Library, p. 7, http://sounds.bl.uk/resources/betweentwoworlds.pdf

15 Sontag, S. (2007) The World as India, in her *At the Same Time: Essays and Speeches*, edited by P. Dilanardo and A. Jump, London and New York: Penguin Books, pp. 156–179.

16 Berger, J. (1972) *Ways of Seeing*, London: British Broadcasting Corporation and Penguin Books.

17 Tirkkonen-Condit, S. (2004) Unique Items – Over-or Under-represented in Translated Language? in Mauranen, A. and Kujamäki, P., eds, *Translation Universals – Do They Exist?*, Amsterdam: John Benjamins Publishing Company, pp. 177–184, p. 177.

18 Bachmann-Medick, D. (2003) Meanings of Translation in Cultural Anthropology, presentation at the Translations and Translation Theories East and West Workshop Four, 'Cross-Cultural Translation in Theory and Practice', 19–20 June, www.soas.ac.uk/literatures/Projects/Translation/trans4abs.pdf

19 Spivak, G. (1993) *Outside in the Teaching Machine*, London: Routledge, p. 180.

20 Tymozko, M. (2000) Translation of Themselves: The Contours of

Postcolonial Fiction, in S. Simon and P. St-Pierre, eds, *Changing the Terms – Translating in the Postcolonial Era*, University of Ottawa Press, pp. 128–147, p. 141.

21 Dingwaney, A. and Maier, C., eds, (1996) *Between Languages and Cultures: Translation and Cross-Cultural Texts*, University of Pittsburgh Press, p. 9.

22 Chandan, First Person Narrative Between Tongues, p. 6.

23 Berger, Some Notes about the Art of Falling, p. 53.

24 Ibid., p. 52.

25 The Books Interview: John Berger, *New Statesman*, 19 January 2010 www.newstatesman.com/books/2010/01/palestine-rema-israel-england

LOVE

FOR AND EXHILARATION IN THE WORLD

JULIE CHRISTIE

I first came across the work of John Berger years and years ago when I picked up *A Seventh Man*.[1] I had given little thought to migration or migrants but suddenly a window was opened into this human phenomenon, which has been going on since prehistory.

Berger was writing specifically about the Turkish 'guest-workers' of the 1960s and 1970s – though 'the subject was European, its meaning was global; the theme being unfreedom'.[2] What Berger revealed is as relevant now, in the wake of the great refugee exodus across Europe, as it ever was.

The book was like a three-dimensional experience, brought to visual life by the dialogue between Berger's words and the photographs of Jean Mohr and by its non-linear presentation which blended political analysis with poetry; economics with fiction. I had never come across anything like it. It seemed to me an utterly original way of drawing one into an unknown reality, feeding and challenging the reader on many levels.

My art student friends had experienced the same revelation with Berger's *Ways of Seeing*, an extraordinary television series in 1972, which I came to later and which enabled us not only to see in different ways but to think in different ways.

John Berger continues to give us new ways of seeing and of acting, particularly in relation to issues of injustice to which we have become blind, or perhaps numb. His love for and exhilaration in the world in which we live makes me grateful that I live in that world at the same time as he does.

Sometimes it's hard not to think, in these times of war and torture and greed and hunger, that maybe the human race was a terrible mistake. Then I hear a piece of music or see a painting or just read some of John Berger's thoughts and I am given a vivid reminder of our potential for magnificence.

NOTES

[1] Berger, J. and Mohr, J. (1975) *A Seventh Man*, London: Penguin Books, p. 7.

[2] Ibid.

[3] Berger, J. and Mohr, J. (2010/1975) *A Seventh Man*, London: Verso, p. 10.

[4] Berger, J. (1972) *Ways of Seeing*, London: British Broadcasting Corporation and Penguin Books, p. 86.

COURAGE

THE BRAVE DEFENDER OF FREEDOM IN PALESTINE

YAHIA YAKHLEF

John Berger is regarded by Palestinians, and their literati, as one of today's leading representatives of cultural ethics. He is seen as a courageous voice, one that stands firmly at the side of the human condition. In addition to his acclaim as a writer and novelist, his philosophical vision has led to a lifelong commitment to supporting human values.[1] He is considered a symbol who supports the oppressed, and who defends justice and equality. Aspiring to a more just world, Berger looks for a world without war, disease, calamity or poverty. He looks for cultural richness, tolerance and multiculturalism, across all nations.

Berger writes about freedom to oppose justice and oppression; his humanist attitude has fuelled his drive to write about such issues. He has expressed his support for the Palestinians' struggle for liberation and national rights, emphasising his solidarity with the Palestinians by his embrace of creativity. He has remained in communication with Palestinian artists and poets, of whom Mahmoud Darwish was the most engaged.

As Palestinians, we open our doors to free thinking, our windows and our spaces to all creativity. We stretch our bridges to those figures of global cultural ethics that stand with us to represent the people in solidarity against the Israeli occupation. Solidarity with the Palestinian people continues to widen across the world. In Europe, supporters of Palestine have protested peacefully against the Israeli settlements, the wall of racial separation built by the Israeli occupation authorities, and against the demolition of residential properties and the confiscation of territories in the waging of war on the Gaza Strip. Some Israeli citizens have stood in solidarity with Palestinians in the belief in peace and the resolution of the two states. These activists are also exposed to tear gas and rubber bullets, much like their Palestinian counterparts.

The embargo on Israeli goods has widened the awareness and support of Palestinian solidarity through both economic and social actions. The embargo extends to intellectual property and is enforced within some universities and other academic institutions to inhibit Israel's sphere of influence. Without a doubt this intellectual and media standpoint in the West helps to highlight the struggle of the Palestinian people and strengthen their peaceful resistance.

Darwish has said that Berger is a man who is an extra-ordinary intellectual, standing at the forefront of freedom and supporting the Palestinian struggle. Berger's translation of Palestinian texts and poetry into English also has made him a figure who is respected and admired within the Middle East. Berger wrote about his visit to the refugee camps – when

the Israeli army invaded the Palestinian territory in 2002 and besieged Arafat – when global delegations came in solidarity from European civil society.[2] They lived with Arafat in order to experience the harsh siege. Among the delegation were the Nobel Prize-winning writers Jose Saramago and Wole Soyinka and the president of the International Parliament of Writers, Russell Banks. The delegation became aware of the evidence of destruction left by the Israeli military during the invasion of the Palestinian cities in the South Bank. They set up many meetings with Palestinian intellectuals, visited the Palestinian universities in both the WestBank and Gaza, and met President Arafat.

Berger remained an observer of the Palestinian struggle by continuing to visit the Palestinian camps. He was one of the biggest supporters of BDS (Boycott, Divestment and Sanctions) against Israel. BDS is an international movement aimed at pressuring the Israeli government to comply with international law through the use of punitive measures along the lines of the boycotts *et cetera* that happened during the apartheid regime in South Africa. BDS attempts to create international public opinion in order to end the Israeli occupation of the Palestinian territory (occupied since 1967). This would include removing the settlements, resolving in accordance with United Nations Act No.194 the issue of refugees deported from their homes, and enabling self-determination by the Palestinian people to establish their independent national state territory.

John Berger and a number of other writers and creators, including Ken Loach, Judith Butler, Naomi Klein, Sara

Shulman, Aharon Shabtai, and Adrienne Rich, have been among the strongest supporters of this movement. Berger went further with a petition for a cultural boycott, which was signed by ninety-three artists and writers from around the world. This global solidarity from academics and artists illustrates the championship of the values of freedom and the power of culture triumphing over the culture of power, as seen by the Palestinian writer Edward Said.[3]

John Berger continued his relationship with the Palestinians in their towns and villages. He visited Ramallah in 2003 where he met writers, artists and public figures, becoming aware of people's everyday living conditions under occupation. He wrote about his experiences in a piece reflecting his impressions, his human sensibilities and his awakened consciousness (see also 'Spirit' by Nasir, this volume). To quote from his article 'A Place Weeping:[4]

A few days after our return from what was thought of, until recently, as the future state of Palestine, and which is now the world's largest prison (Gaza) and the world's largest waiting room (Cis-Jordan), I had a dream. Gaza, the largest prison in the world, is being transformed into an abattoir. The word Strip (from Gaza Strip) is being drenched with blood, as happened sixty-five years ago to the word ghetto. Day and night, bombs, shells, GBU39 radioactive arms, and machine gun rounds are being fired by the Israeli Defence Forces from air, sea, and land against a civilian population of one-and-a-half million.

Berger described the situation as he saw it, scoring a testament to the tragedy of the Palestinian territories.

During this visit, Berger did not forget to visit the grave of his friend Mahmoud Darwish, who is buried on a high hill in the same neighbourhood of Ramallah. In the same text, he wrote of his visit:

> There's a small hill called Al Rabweh on the western outskirts of Ramallah. It is at the end of Tokyo Street. Near the top of the hill the poet Mahmoud Darwish is buried. It's not a cemetery.
>
> We went to visit the grave. There's a headstone. The dug earth is still bare, and mourners have left on it little sheaves of green wheat–as he suggested in one of his poems. There are also red anemones, scraps of paper, photos.
>
> He wanted to be buried in Galilee, where he was born and where his mother still lives, but the Israelis forbade it.
>
> At the funeral tens of thousands of people assembled here, at Al Rabweh. His mother, ninety-six years old, addressed them. 'He is the son of you all,' she said.
>
> On the now deserted hill I tried to recall Darwish's voice. He had the calm voice of a beekeeper: We have to nurture hope.

Berger's own biography is one of struggle and the pursuit of freedom. His choice to live in a small village in the French

Alps was not a choice of isolation, but one in pursuit of clarity of mind and purity of spirit. He is averse to the limelight. In the French Alps he can be like the wind, free and closer to nature and the simplicity of rural life. Berger has written about the aesthetics of place and defended oppressed and persecuted minority groups. He has addressed his critique against prevailing ideas, which is why his writing is so incredibly varied: political and literary texts, articles, reportage, translation, and engagement with the arts including cinema, music and visual art. It is in all these forms that we see the Culture of Freedom.

Some have called Berger 'The English Bird' for his fondness of nature and free spaces. Much like the eagle that perches at the top of mountains or the tallest branches, so too Berger is a bird of summits and high branches. In this world there is space for reflection and for spiritual practice. There is also plenty of time to cleanse words of any lingering impurities, to rebel against fraud, hypocrisy and falsehood. These commitments to truth are ingrained within Berger's writings.

I salute Berger for his championship of the defence of humanitarian values, both in his life and in his work. I honour too his late friend, the Palestinian poet Mahmoud Darwish, as another great defender of freedom and justice for the Palestinian people. Lastly, I give my respect and humble thanks to all the creative people who have given a moment to the Palestinian people.

NOTES

This essay was translated by Ameer Ahmed.

1 As set out by the United Nations.
2 Berger, J. (2003) A Moment in Ramallah, *London Review of Books*, Vol. 25, No. 14, 24 July, pp. 20–22.
4 Said, E. (2001) *Power, Politics, and Culture: Interviews with Edward W. Said.*, edited by G. Viswanathan, New York: Pantheon Books.
5 Berger, J. (2009) A Place Weeping, *Threepenny Review*, www.threepennyreview.com/samples/berger_su09.html

SOLIDARITY

COMRADE JOHN

AMBALAVANER SIVANANDAN

November 1972 John wins the Booker prize and throws it back in the face of Booker-McConnell Ltd, the sugar barons, in the most creative way possible: half the prize money to go to his work on the exploited and rootless migrant workers of Europe, and the other half to go to the British Black Panther Party's fight against racism.

April 1972 – flashback – the staff of the Institute of Race Relations (IRR) in Jermyn Street, the first and only race thinktank in Europe, after a protracted struggle to retain the institute's independence from government influence and big business interference, overthrows the board of management and its chairman, the chairman of Booker-McConnell, who resign en bloc, taking their money with them. The institute and its library, with what is left of its staff, move to the basement of an old warehouse in the precincts of Pentonville.

1973 John begins work with the photographer Jean Mohr to create *A Seventh Man* (every seventh worker in Europe being a migrant),[1] while we at the new IRR begin working with

migrant workers' organisations across Europe to create the first Congress of Migrant Workers for migrant workers.

1974 John – accompanied by Beverly (editor at Penguin of *A Seventh Man*) who knows about the IRR's struggles and troubles – comes to see us and with his characteristic generosity, and in solidarity, offers us an excerpt from the forthcoming book for publication in our journal (in the throes of being transformed from the academic *Race* to the activist *Race and Class*).

Of such common threads of nay-saying are struggles woven.

John and I meet again as fellow Fellows of the Transnational Institute in Amsterdam (an affiliate of the Institute for Policy Studies in Washington, DC), under the aegis of Eqbal Ahmad, renowned anti-war activist and scholar, who is getting together a group of scholar-activists from across Europe and the Third World to study, compare and support radical initiatives and socialist movements in their areas. And between seminars and workshops, John conducts us through the art galleries of Amsterdam, giving us eyes to see with; not just life through art but lives as lived around us. I knew then what Keats meant when he wrote of 'the holiness of the heart's affection and the truth of the imagination'.

That is the thing about John: his driven search for the truth. It shows when he talks; it's all over his face – that is how he got those leonine lines. It is there in his gestures: that pouting of his fingers as though he is holding the precious seed of a thought

about to burst into flower. It is there in his writings: his stories, poems, plays, scripts, essays – in his essays particularly, where the raw process of the search for truth is beaten out like in the hammering in the Egmont Overture or the Fifth Symphony.

Which evokes the question: how is it that this polymath has not written on music? Or has he? When my back was turned? But then he hears the jagged music of the world (the cliché is fitting). He hears people, he hears pain, he hears the music of art. 'The moment at which a piece of music begins provides a clue to the nature of all art,'[2] he writes.

And that is the other thing about John: he makes a daring pronouncement like that as though it is a given, and then goes on to elaborate on it, embroiders it, runs a ring of metaphors around it so that you are so taken up with the arabesque, you forget to question the original premise. No wonder John likes Walter Benjamin: he also makes what appears to be an *ex cathedra* statement and then goes on to illustrate it so intricately that its meaning is clear, its premise proven. It is a sort of inverted dialectic. And John is a brilliant dialectician. He finds movement, conflict, and change even in stone. The dialectic in him is a felt sensibility.

And it is that quality that he brings to his personal relationships. He sees people in their totality, contradictions and all: he does not judge them, though he would certainly 'judge' their work, their deeds, of which he might be an excoriating critic, but is never *ad hominem*. Equally, John is only too willing to assist those who seek his help. And in that he is not just a source but a confluent passing you on to others who

might be able to help you on in your journey. Above all, he gives of himself.

And that is where I come in – as debtor *par excellence*. I was in the throes of writing my first novel when I approached John. I had written short stories (published here and there) and half a novel (abandoned for fear of rejection). It was not as though I had been to creative writing classes or had connections in the publishing world or could afford a 'broker'. Quite simply I was not qualified. But something John said to me about writing, over a beer in a King's Cross pub, persuaded me that I might well be a storyteller, and storytellers, I told myself, were born not made. And the story I was aching to tell was the broken story of my beautiful country before it descended into the barbarism of race war. I sent John the manuscript, and he was not merely encouraging but exhortatory, urging me through phone call and letter to finish it and send it off to publishers, whatever the result. The result was twenty-one rejections, before a small publisher, Arcadia, under Gary Pulsifer, who coincidentally happened to be a friend of John's from their days in the Writers and Readers Cooperative, decided to publish the book (and subsequently felt his judgement justified when it won a couple of prizes and, more, a flattering review by John in the *Guardian*).[3]

But the owing doesn't end there. John, despite the workload he carries on his peasant back, continues as a member of the *Race and Class* Editorial Working Committee, to be involved in the institute's work, shows solidarity with its causes, appearing on its platforms from time to time, contributing to

SOLIDARITY

the journal from time to time – though present all the time, like a conscience.

NOTES

y">
[1] Berger, J. and Mohr, J. (2010/1975) *A Seventh Man,* London: Verso.
[2] Berger, J. (2001) The Moment of Cubism, in his *Selected Essays*, edited by G. Dyer, New York: Pantheon Books, pp. 71–92, p. 92.
[3] Sivanandan, A. (1997) *When Memory Dies*, London Arcadia Books. For John's review of my book, see Berger. J. (2000) Ties That Bind, *Guardian*, 29 July.

TENNIS

FOLLOWING THE POACHER: FILM AND BOOK COLLABORATIONS WITH JOHN BERGER

JOHN CHRISTIE

In 1988 I was fortunate enough to photograph and direct a series of films for the BBC based on the book *Another Way of Telling*,[1] John Berger and Jean Mohr's meditation on the nature and practice of photography. I'd first contacted John out of the blue four years earlier, in the hope of getting his agreement on the project, and something – perhaps my enthusiasm because we didn't know each other then – had persuaded him to go along with the idea that the book could be translated into a television series. To my surprise he gave me the programme rights to the book and with my friend and producer Anna Ridley, I approached the BBC with the proposal that we make the series as an independent production for them. We were given the final go-ahead four years later just when we'd all but given up hope.

While I was thinking about how to bring the various elements of the book to the screen, John sent me a letter. In

it he suggested a subtitle for the series, '100 Postcards About Photography'. This offered the idea that the theories and stories presented in the text could be divided into long and short 'postcards' (in the final edit the longest turned out to be about six minutes and the shortest, twenty-five seconds). These discrete sections, each with a title and sometimes separated by on-screen quotations from photographers and critics, such as André Kertész and Susan Sontag, became the structure of the programmes. They weave together John Berger's photographic theories and analysis, Jean Mohr's practical photography and stories, plus the pair of them talking about their work together on such influential book projects as *A Fortunate Man* and *A Seventh Man*.[2]. At the beginning of 1988 a fourth, last-minute element was added to the mix in the shape of a photographic workshop in Finland organised by the writer and photographer Martti Lintunen who had translated *Another Way of Telling* into Finnish. The purpose of the workshop was to test out practically some of the ideas outlined in the book, to discover for example, with the help of a group of Scandinavian photographers, if it is possible to construct, without a supporting text, a purely photographic narrative.

The workshop was to be held in a village in the north of Finland, just outside the Arctic Circle, a place in May and June of almost continuous daylight. I travelled there with Anna before the filming to check out the locations and equipment suppliers. It was a wild, sparsely inhabited area of lakes, fast-flowing rivers and dense pine forests. The local children were on holiday and we had the use of the village school as our

workshop/headquarters with four-person log cabins close by the lake for accommodation. The place was almost completely deserted – except, unfortunately, for millions of mosquitoes.

The Finnish owner of the site showed us around, I think still not really believing his luck that anyone would actually come here to stay at the height of the mosquito season. He said we could have any of the empty log cabins along the lakeside and make full use of the site facilities, which included some large, strangely shaped rowing boats. I asked him about the boats and he said they were generally used for 'shooting the rabbits'. In my mind I had the image of an arcane Finnish sport, hunting rabbits with a crossbow or gun, perhaps from a moving boat while the creatures ran through the forest beside the lake or drank at the water's edge. 'Is it a popular sport in Finland?' I asked him. 'Yes, very popular.' 'But quite difficult?' 'Yes, very difficult.' And so on, every question about the activity reasonably answered but leaving me none the wiser. A few days later when we made a group excursion down one of the rivers that fed into our lake it quickly dawned on me that he'd been talking about rapids not rabbits.

Once the sixteen photographers arrived, language difficulties faded because photography became the common purpose. John himself had ridden up on his motorbike from France via Helsinki to the location, and many of the photographers had travelled there by bike too. From the beginning there was a great rapport between them all, and working with them for the eight-day workshop was a very rewarding experience. When I wasn't filming, I sat in on the afternoon

sessions in the schoolroom where the day's photographs were projected using a state-of-the-art Polaroid instant slide system (it was 1988, don't forget). Their photosequences were presented to the group and analysed usually in the first instance by John and picked over by all, with Martti as the translator if needed. Every evening there was the obligatory sauna followed by food and endless discussions, not always about photography, fuelled by one or two glasses of vodka and the ideas of the day. Then, eventually, bed in the early hours. The sun I remember on more than one occasion just touching the horizon before beginning to rise again.

After Finland our small crew travelled to Geneva to shoot Jean Mohr's contributions to the series, and to the Haute Savoie for more filming with John before I returned to London in August to spend the next three months cutting the thirty or so hours of shot material down to the four half-hour programmes. As I settled down to the editing, John sent me a letter with some thoughts on the films: '(that they should have) … a kind of poetry, a brevity, an "inconsequential" style which continually allows life to filter in and out of the photography. As if we were crossing quicksand with a poacher who knows where to put each foot.'

As well as the filmmaking side of my working life, I also have a parallel career as an artist, and an important part of that activity is the making of books. At that particular time these book-works were often limited-edition *livre d'artiste* collaborations with poets and writers whose texts would be paired with etched or silkscreen-printed images. So it wasn't

surprising that one evening during the filming in Finland, a conversation with John turned from photography to books and the observation that many publications whose texts deal with the visual arts and aesthetics are in themselves, as objects, not very aesthetically pleasing, with poor paper and reproductions, bad typography, et cetera. I suggested to him that one day perhaps we might produce a book together, one that would please on all counts.

John has written many poems over the years, which he has generally placed quietly in corners of his essays and novels. In 1993 we decided to make a collection of these scattered poems, and gradually in the following months they began to arrive by post as he went through his archive at home and sent them off to me. Some of the poems were hand-written, some carbon-copied typescripts on flimsy paper, and a few came torn directly from the original newspapers, and the magazine articles and books, in which they'd first appeared. Forty-seven poems in all were chosen, the earliest from 1956, and more than half of them were previously unpublished. I was keen to include some of his visual work in the book, especially a largely unseen poetry/photo sequence called 'At Remaurian' that he'd put together in the early 1960s. This was his only published venture into photography that I knew of, and it had first appeared as a small booklet attached to *Typographica* magazine.[3] John unearthed the original negatives and we were able to add those nine poems and their photos to our growing list for the book. (In Finland, out of curiosity, I'd asked him why he'd never continued taking photos after

making that sequence, and he said he'd had his camera stolen in Naples and decided not to buy another one!). He produced two large foldout pencil drawings especially for the project and also found me an early self-portrait etching made just after the Second World War, which I was able to adapt as a frontispiece for the book. I printed the book by letterpress at the Circle Press workshop, Notting Hill, in the spring of 1994. John called the collection *Pages of the Wound*,[4] and because I'd produced a relatively small edition of 90 signed copies, a trade version was suggested to Bloomsbury. The paperback was published two years later with four additional poems and given to John as a surprise present to celebrate his seventieth birthday. The cover image on the paperback, which looks a little like the foliage of a tree, is actually the reverse signatures left on the blotting paper we'd used when he was signing the original Circle Press edition.

In 1997 I phoned him at his home in France and asked if this might be a good moment to begin a new project. The process of starting a new collaboration with John is a little like a tennis match where ideas are batted back and forth between us. I suggested, as an opening shot, that perhaps we could work on something to do with colour, a wide enough subject, after all, and see where it might lead. Maybe we'd even end up making another film together. This initial idea seemed to go down well and after several passes across the net, I asked him how we might begin. John's final lob was, 'Just send me a colour.' After I put the phone down, this request, given that I had the whole spectrum to choose from, didn't seem quite so

easy as it had at first appeared. A few weeks went by and then
at the funeral of my wife's aunt – someone I didn't know very
well or have any emotional attachment to – my attention was
distracted during the service by some red and white carnations
in a glass jar. When I got home I tried from memory to find the
same red in my watercolour box and settled on cadmium red. I
painted a square of the colour on a folded card and wrote John
a letter describing why I'd chosen that particular red. A week
later I received his reply in the post, written on dark red paper,
in which he reacted to my letter and the colour I'd sent him as
'an innocent red, the red of childhood, the red of young eyelids
shut tight, the red you saw when you did that'.

The colour correspondence went on for just over two
years. Not continuously, because various events in our lives
interrupted the flow; John wrote his novel *King* during this
time,[5] I was abroad filming quite a bit, and my daughter Alice
was born. Very soon after it began we settled into replying to
each other in a particular way. John would almost always send
hand-written letters, some with painted colours as part of the
information (one I remember was coloured with saffron, 'both
a stain and a taste – though it fades very quickly – painting
flowers with saffron is a kind of shortcircuit of collaboration,
no?'). I would reply with a letter accompanied by a small book
I'd made, a way for me to express ideas or thoughts that I found
hard to put into words alone. We wrote to each other about
blue, brown, black (in the disguise of darkness), yellow (as a
representation of light), gold, mother-of-pearl, rust, varnish,
cave paintings, the work of artists including Matisse, Joseph

Beuys and Yves Klein, and many other related and tangential topics that interested us.

In 2000, because of the energy of our mutual friend Eulalia Bosch in Barcelona, the whole correspondence became not a film, as I'd originally imagined, but a book published under the title *I Send You This Cadmium Red*,[6] a phrase plucked by John from that first letter I'd sent him three years before. At the book launch a woman in the audience asked why we had never chosen grey as one of the colours to write about, and we explained that we hadn't started out with a set list, and almost all the colours were there because they had presented themselves to us in one way or another, through books, quotations, exhibitions or everyday experiences – the colour grey had just never presented itself. The following morning we went to an exhibition of Giacometti's work in La Pedrera, one of Gaudi's buildings on the Passeig de Gracia, and John spotted something. It was a quote from the artist answering the question as to why his later paintings seemed to avoid colour and tended towards grey. The essence of Giacometti's reply was that grey, in fact, contained all colours and for him 'signifies life itself'.

Incidents like this chance encounter with the quotation concerning grey on the wall at an exhibition were exactly how the various colours had found their way into our correspondence – if grey had offered itself to us at the beginning who knows where we would have travelled to? Perhaps, though, it was best to begin with cadmium red, John's innocent red of childhood, rather than grey, the mother of them all.

Other collaborations have followed in the years since *Cadmium Red* appeared, including *Cuatro horizontes*,[7] an account of our visit in 2009 to Le Corbusier's chapel at Ronchamp, and another book of correspondence, a kind of companion volume to *Cadmium Red*, due for publication in 2016.

And the poacher's footsteps? Well, John, of course, would deny knowing exactly where to place his feet when approaching or crossing difficult territory – but can anyone think of a better travelling companion?

NOTES

[1] Berger, J. and Mohr, J. (1982) *Another Way of Telling*, London: Readers and Writers.
[2] Berger, J. and Mohr, J. (1967) *A Fortunate Man*, London: Penguin Books. Berger, J. and Mohr, J. (1975) *A Seventh Man*, London: Penguin Books.
[3] Spencer, H., ed, (1965) *Typographica 11*, London: Lund Humphries.
[4] Berger, J. (1994) *Pages of the Wound: Poems, Drawings, Photographs 1956–1994*, London: Circle Press.
[5] Berger, J. (1999) *King*, London: Bloomsbury.
[6] Berger, J. and Christie, J. (2000) *I Send You This Cadmium Red*, Barcelona: Actar.
[7] Berger, J. Christie, J. Hinkley, T. and Kuppens, L. (2015) *Cuatro horizontes*, Barcelona: Editorial Gustavo Gili.

AFTERWORD

JOHN BERGER

SALLY POTTER

John Berger is ninety. An excellent age. In his presence, however, age seems utterly irrelevant. This is not just because John seems to live in a perpetual present, forever scanning the world around him with as much intensity as he might ever scan the world within – and therefore seems to live without a trace of nostalgia – but also because John is full of excitement and curiosity about the future. Especially that part of the future that he may transform, variously, into words or images, or both.

Watching John at eighty, a decade ago, at a number of events in a week-long celebration in London of his life's work, was to witness someone giving his all, a ferociously total commitment to being present and gracious, whilst seeming bewildered by all the attention. Being heaped with praise looked something of a burden. Perhaps the burden was the melancholy that comes for any artist in a series of events that looks like a retrospective. Looking back is not part of John's vocabulary. Even his habitual physical posture resembles someone leaning slightly into tomorrow.

So, now that he has lived and worked for another decade, what is the best way to celebrate John in a way that honours his past – his achievements as an artist, critic and human being – whilst also honouring the gift of his presence in the world right now, along with the many and various possibilities of his future? Perhaps a clue lies in the way John himself expresses so much of what he sees, hears and feels. John lives in stories. Or, at least, he tells it that way. Epic stories about the huge shapes of the world – economic, political, cultural – and small stories about the details of everyday life. When he speaks about Palestine he speaks with the same cadence as he might use to describe a trip to the market that morning. He finds meaning everywhere, for it is everywhere. He is able to narrate what he sees so fully, because he does not respect any phoney hierarchy of importance. This also explains his reluctance to be placed in some field of 'greatness', rather than as a player in the midst of a huge complex matrix, in which the profit motive and rose petals coexist and each requires close examination. For indeed, as he has written, everything matters. Everything.

The story of my encounters with John begins before I was born.

John taught art to my mother. She was a teenager and he was only a few years older. It was probably for no more than a few months, a temporary job in a school in north London. Yet somehow, throughout my childhood, his name floated in my consciousness, conjuring up the image of a dashing young soul, handsome, charming, militant and dedicated to the making of art. At twenty-one, already an inspiring teacher. My mother

must have described him that way. Or perhaps it was a faraway look in her eyes when she mentioned his name, for even then he was able to help those he met lift their eyes to the horizon.

The next moment that John came sharply into focus for me was with his book – and the television series that it emerged from – *Ways of Seeing*.[1] His way of expressing ideas – pithy, plain language, bold – and, above all, the ideas themselves that he shaped with such clarity, had the startling effect of feeling both brand new and yet obvious, in the sense of creating a feeling of recognition. Of course, of course, we all thought; that is how it is; it's just that we hadn't found the words for it before. No one had found the words for it before.

Some years later, sitting in Tilda Swinton's bedroom, surrounded by piles of books and clothes – it may have been in the midst of dissection of part of my screenplay for *Orlando* – she pulled out her copy of *Ways of Seeing* in order to read out one particular sentence to me. It was a sentence with which I was familiar but which bore repetition.

'Men look at women. Women watch themselves being looked at.'[2] This was the sentiment being described and read aloud by Tilda, slowly, deliberately. I was in the process of looking at her, I was already the eyes of the camera in our collaboration. She was being looked at by me and by the phantom camera in my eyes. She was looking at herself being looked at by me. We became conspirators in the conceptual field so neatly laid out by John. Except that I was a woman.

Some years later, after I had finished my journey through the epic process of making *Orlando* and found myself, to my

surprise, wanting to be looked at, as a woman in motion– dancing – I made *The Tango Lesson*. And it was after its release in France, somewhere near the beginning of a long run in a cinema in Montparnasse, that I received, out of the blue, a handwritten letter from John.

This was a miracle. John Berger had written to me saying that he liked my film. But he didn't use the word 'like'. He used long, flowing sentences and short staccato ones expressing with the utmost generosity and precision the experience he had had while watching the film. If I remember correctly, what struck him in particular was its exploration of the nature of relationship; the intimate space existing in the relatedness of all people and all things, the dance of 'I and Thou'. The feeling when receiving and reading John's letter was exactly that: it was he who was creating a space, the space of relatedness, in which what I had given out to the world, not knowing where it would land, had landed in him. He had received it. He had thought about it. He had made the effort to pick up his pen and write a letter to me. The film had become a conversation.

This was the beginning of a conversation with John that has continued to this day. I still can hardly believe my good fortune that I exist somewhere in his field of vision, amongst the many who know and admire him, either close or far.

Distance is no impediment to closeness with John. He has deep meaningful friendships with people on the other side of the world he has never met. This is because he understands the power of correspondence, the art of the letter, the work that goes into relating. So he gives it time. I was by no means the only one he had written an appreciative letter to about their

work. A lifetime of criticism – not in the negative sense that the word is so often understood, but rather the dynamic of an enthusiastic communicator or translator – a bridge-builder between the artist and an often brutally silent world – meant that John seemed to see each offering by an artist that he enjoyed as an opportunity to shape a response. These written responses have been a huge part of his work. And what is so exhilarating about them is that they seem to emerge from an impulse of desire, rather than one of judgement. Therefore, when I heard John speak of Titian, for example, an invisible grey veil of partial understanding lifted and Titian's work suddenly seemed to emerge with radiant clarity. I wanted to see more. I was filled with longing, a longing inspired by John's clear-sightedness and passion.

John does not only know how to listen to and look at work. He also knows how to listen to and look at people. His company is startlingly present and very warm. He has a way of reaching out across the void, past the shyness of others, even when that shyness is disguised as bluster. He cuts through chatter or waits through silences. In his presence you become tinglingly alive. One mutual friend remarked that the quality of his attention makes you feel more intelligent than usual.

On one of my first visits to see him with his long-term Russian companion, Nella Bielski, in Paris, his son Yves turned up after supper with a sheaf of paintings rolled up under his arm. Yves showed them one by one, John kneeling at his feet to hold the painting straight that would otherwise curl up towards the ceiling. In this way he helped create a frame for each of his son's endeavours. He helped us to see the work, literally, but

also metaphorically. He gave a teaching, kneeling before his son, kneeling before us all. It was an indelible image of humility and respect, complete attentiveness, love of Yves and love of the process of art making.

I visited John in midwinter at his home in Quincy, in the Haute Savoie. He met me at the airport on his motorbike and we sped along the icy roads to his farmhouse. Beverley, his wife, stood by the stove in the cosy kitchen as I read aloud to John and to her the scenes and fragments of 'YES', my new script, written in verse. They were the first audience and quite possibly the best. The force of John's attention, the twinkle in his eyes, the way he slapped the table with the palm of his hand, happily, and in his low melodic voice said 'ah' and 'oh', were a kind of nectar. The heartiness of his laugh and those long silences, which I came to know and love, I observed as silences dense with thought, reflection. One could sense an almost delirious rampage through reverie, at the end of which a sentence would emerge that was often surprising, often spare, always to the point. There was never any conceptual waste. No posturing. Not a trace of narcissism.

After a night spent sleeping in a guest room lined with books – we had brushed our teeth standing side by side in the draughty bathroom, laughing – John was at the breakfast table with coffee and a stack of cards. We wrote the names of different scenes and passages on the cards and juggled them around on the table, happy as children in a sandpit. At least, that was how I found it to be, to my astonishment. John Berger, the great John Berger, here, playing with me as if we were peers. It was the first of many examples of his collaborative

instinct. Finding something together, sharing ideas in that mysterious and magical way, when, suddenly, you are not sure where one person's idea ends and the other's begins. Any notion of authorship is subsumed in the sheer excitement of joint discovery.

Over the years we exchanged multiple texts. His playfulness extended to all the new technology. He delighted in sending short quotes from poems by Palestinian authors or cryptic questions about politics, my latest script, or an essay he was writing. The texts were always short, often full of interesting abbreviations. You could feel how John was relishing the new cyberlanguage and how to shape it on the tiny screen.

At one point when I fell into one of my self-lacerating glooms, feeling like a perpetual outsider who could never really be part of a film industry that someone once said was 'an industry for young white men' and seemed, furthermore, to be policed by critics who were older white men who found my ambitions presumptuous and uppity, I wrote John an immensely long letter that was in effect a catalogue of my despairs. As soon as I had put it in the letterbox I regretted burdening him. But he called me almost immediately when he received the letter and spoke in a tone that can only be described as motherly. There, there, he said soothingly.

When Beverley died, John called me and slowly told me the story of her last night, the story of her death. A week later I travelled to the funeral in the small church in the mountains near Geneva. John's address to the assembled mourners consisted of one word, her name. Beverley. There was nothing else to say. He had lost his wife, the mother of Yves, the woman

who had typed all his work from his handwritten pages, liaised with publishers and kept on top of his ever-growing oeuvre, the woman who was the go-between with the multitudes wanting a piece of his time. It was a terrible loss. And yet when some of us gathered afterwards at the house in Quincy, John was able, in the midst of his grief, to spend a few moments with each person, thanking them for their presence, showing us the drawings he and Yves had made of her body after she died.

Even then, yes, even then, John was transforming experience into art making. There was no division between the work of dying and the work of creating, united in the passionate portraits of his dead wife's body.

And now? John's books keep coming, the essays keep appearing in newspapers and magazines. He reminds us how to think about Chaplin, how to listen to songs, how to rage about prisons, how to remember that everything matters. Not just big politics, or big ideas, not just paintings or novels, but also the meal put on the table by Nella or by his own hand, the glass of wine shared; the sweetness in a bearhug, the complicity in a chuckle, the pleasures of a shared rage against injustice.

John the encourager, John the enthusiast, John the true critic, John the friend. John the teacher. John at ninety or at any ageless age. Are we not blessed?

NOTES

1 Berger, J. (1972) *Ways of Seeing*, London: British Broadcasting Corporation and Penguin Books.
2 Ibid., p. 47.

ABOUT THE EDITOR AND CONTRIBUTORS

Yasmin Gunaratnam teaches in Sociology at Goldsmiths, University of London. Her latest book is *Death and the Migrant: Bodies, Borders, Care* (2013).

Amarjit Chandan, poet, essayist and translator, has published many titles in Punjabi, his first language, and three in English translation. He was amongst ten British poets selected by Andrew Motion on National Poetry Day in 2001. English versions of his poems have appeared in various collections, including *Being Here* (1995, 1999, 2005), *Sonata for Four Hands* (2010), prefaced by John Berger, and *The Parrot, the Horse and the Man* (2015).

Ana Amália Alves is a teacher and translator who lives in Brazil.

Doa Aly is a visual artist working and living in Cairo. Aly's videos, drawings and sculptures are centred around the themes of the body, performance and language.

Hans Jürgen Balmes studied comparative literature in Bonn and has published commentaries on German Romantic poets. He works as editorial director at S. Fischer in Frankfurt, is co-editor of the literary magazine *Neue Rundschau*, and has translated from the English works by John Berger, Robert Hass, W. S. Merwin, Martine Bellen and others.

Vikki Bell is professor of sociology at Goldsmiths, University of London. She is the author of four monographs, including *Culture and Performance* (2007) and *The Art of Post-Dictatorship: Ethics and Aesthetics in Transitional Argentina* (2014).

Michael Broughton is a painter. He lives and works in London.

Iain Chambers teaches cultural and postcolonial studies of the Mediterranean at the University of Naples, 'L'Orientale'. He is the author of several publications including *Urban Rhythms: Pop Music and Popular Culture* (1985), *Migrancy, Culture and Identity* (1994) and *Mediterranean Crossings: The Politics of an Interrupted Modernity* (2008).

John Christie is a visual artist, filmmaker and publisher. He has photographed and directed films for broadcast television about art and artists and produced many books in collaboration with writers and poets. Since *I Send You This Cadmium Red* (2001), his other collaborations with John Berger have included *Cuatro Horizontes* (2015) on a visit they made in 2009

to Le Corbusier's chapel at Ronchamp, and *Lapwing and Fox* (2016), a second book of correspondence.

Julie Christie is an actor and patron of Reprieve, Survival International and the Palestine Solidarity Campaign.

Malathi de Alwis is a socio-cultural anthropologist who lives and works in Sri Lanka. She has published widely on nationalism, humanitarianism, social movements, suffering, displacement, 'disappearance' and memorialisation.

Mustafa Dikeç is professor at the Ecole d'Urbanisme de Paris and the Laboratoire Techniques, Territoires et Sociétés (LATTS). He is the author of *Badlands of the Republic: Space, Politics and Urban Policy* (2007), and *Space, Politics and Aesthetics* (2015). His new book on urban revolts in liberal democracies, *Urban Rage*, will be published by Yale University Press in 2017.

Rashmi Duraiswamy is a professor at the Academy of International Studies, Jamia Millia Islamia, New Delhi. She is editor/co-editor of several books, including *Being and Becoming: The Cinemas of Asia* (2002) and *Cultural Histories of Central Asia* (2009). She is author of *The Post-Soviet Condition: Chingiz Aitmatov in the '90s* (2005) and *Guru Dutt: Through Light and Shade* (2008).

Gavin Francis is a doctor and the award-winning author of *Empire Antarctica* (2012) and *Adventures in Human Being* (2015).

Rema Hammami is professor of anthropology at Birzeit University in occupied Palestine. She is the co-translator with John Berger of Mahmud Darwish's epic poem *Mural* (2009).

Salima Hashmi is an artist, art educator and curator. Her publications include *Unveiling the Visible: Women Artists of Pakistan* (2003) and, as editor, *The Eye Still Seeks: Pakistani Contemporary Art* (PenguinBooks India, 2015). She is the daughter of the Urdu poet Faiz Ahmed Faiz.

Francisco-J. Hernández Adrián is lecturer in Hispanic studies and co-director of the MA course in visual arts and culture at Durham University, UK. He writes on islands and littoral spaces, visual culture and film, Surrealism and the avant-garde. He is an associate editor of *Cultural Dynamics*.

Glenn Jordan is a cultural theorist, ethnographer, photographer and curator. He is currently writing 'Thinking with John Berger: On Photography, Intellectuals and Criticism'. Originally from California, he has lived in the UK since 1987.

Christina Linardaki works as an editor at the Centre for Culture, Research and Documentation of the Bank of Greece. She has been working as a translator for more than twenty years.

Tessa McWatt is a novelist and reader in creative writing at the University of East London.

Jean Mohr has been a documentary photographer for nearly 70 years. He is well-known for his many collaborations with John Berger, which include *A Fortunate Man* (1967), *Art & Revolution* (1969), *A Seventh Man* (1975), *Another Way of Telling* (1995) and *John by Jean: Fifty Years of Friendship* (2014). More than eighty exhibitions have been dedicated to his photographic work worldwide. He has worked for numerous international organizations (UNHCR, ILO, JDC) and was ICRC delegate for the Middle East 1949–1950. In 1978 he was awarded the prize for the photographer who had contributed the most to the cause of human rights.

Pushpamala N. has been called 'the most entertaining artist-iconoclast of contemporary Indian art'. In her sharp and witty work as a photo and video performance artist, sculptor, writer, curator and provocateur, she seeks to subvert the dominant cultural and intellectual discourse.

Tania Tamari Nasir is a classical singer and literary translator. She is the soloist on the CD *'Until When?' Songs from Palestine*, music and lyrics by Rima Nasir Tarazi. In 2011 she translated into Arabic (with Fathieh Saudi) John Berger's *From A to X: A Story in Letters*.

Hsiao-Hung Pai is the author of *Chinese Whispers: The True Story Behind Britain's Hidden Army of Labour* (2008), *Scattered Sand* (2012), *Invisible* (2013) and *Angry White People* (Zed Books, 2016).

Nikos Papastergiadis is professor at the School of Culture and Communication at the University of Melbourne. His publications include *Modernity as Exile* (1993), *Spatial Aesthetics: Art Place and the Everyday* (2006) and *Cosmopolitanism and Culture* (2012).

Sally Potter has written and directed seven feature films, including *Orlando*, *The Tango Lesson*, *YES* and *Ginger and Rosa*. She has also made short films, directed opera and other live work, and has written stories and song lyrics.

Nirmal Puwar is a reader in sociology at Goldsmiths, University of London. She has published *Space Invaders: Race, Gender, Bodies out of Place* (2004). Her work solicits creative, critical and public methodologies to both disrupt space and to think space anew.

Ram Rahman, photographer, artist, curator, designer and activist, has shown his photographs in individual and group shows in India and around the world.

N. Rajyalakshmi is one of India's important cultural theorists. Starting her career as a journalist at the *Ideal Times*, Bangalore, she rose rapidly to become an arts columnist and then editor of its arts page. She has devoted her life to interviewing the artist Pushpamala N. and is considered the world's leading authority on the subject.

Alicia Salomone is associate professor at the University of Chile. Her fields of research are Latin American cultural history, memory studies and gender studies.

Rochelle Simmons is senior lecturer in English at the University of Otago, New Zealand. She has written on the intersection of literature, art and cinema, within which field Berger is an exemplary figure.

Ambalavaner Sivanandan is director emeritus of the Institute of Race Relations, founding editor of *Race and Class* and author of the novel *When Memory Dies* (1997).

Ali Smith is the author of twelve books including, most recently, *Public Library* (2015).

Nick Thorpe is East and Central European correspondent for the BBC, a journalist and filmmaker. He has published *The Danube: A Journey Upriver from the Black Sea to the Black Forest* (2014) and *'89: The Unfinished Revolution* (2009).

Heather Vrana is assistant professor of history at Southern Connecticut State University and the author of two forthcoming books, 'Do Not Mess with Us!: Guatemalan University Students and the State, 1944–Present' and 'Beyond 1968: Anti-Colonial Texts from Central American Student Movements' (both 2017).

Yahia Yakhlef is a Palestinian novelist, writer and former Minister of Culture for the Palestinian Authority.

Kathryn Yusoff is senior lecturer in human geography at Queen Mary, University of London. Her forthcoming book is called 'Geological Life'.